# Clement Greenberg

## THE COLLECTED ESSAYS AND CRITICISM

11.

*I met Georges Hugnet, the surrealist poet whose stuff I like, and am to meet Virgil Thompson and Jean-Paul Sartre, the novelist. And Friday I'm to go out to Paul Eluard's home in the country.*

*— I'm ending here in order to get this in the mail.*

Closing page of a letter from Clement Greenberg to his family from Paris, 5 May 1939.

These two phenomena – avant-garde &
kitsch – made a sort of preview appear-
ance in the lit. of England – the most advanced
country in Europe – in the 18th
century: when, as Macaulay
points out, in the interim the
slackening of aristocratic patron-
age threw a whole literary gene-
ration into the indigence of
Grub St Bohemia, from which
it was not rescued until
the appearance of a bourgeois
reading public with money
to spend on literature (in the
latter half of the century. Sensation
literature journalism and sentimental romance fiction,
pre-forms of kitsch (in spite of the
real literary talents involved
here) made their appearance
with Defoe and Richardson "
coincidentally with at the very beginning of the
garret-Bohemia era of English
literature. It was not however
until the Industrial Revolution
had consolidated itselfconquests
that Bohemia and kitsch could

Page from an early draft of Clement Greenberg's essay "Avant-Garde and Kitsch," 1939.

# Clement Greenberg

## THE COLLECTED ESSAYS AND CRITICISM

Volume 1

## Perceptions and Judgments

1939–1944

Edited by John O'Brian

The University of Chicago Press    CHICAGO AND LONDON

Grateful acknowledgment is made for permission
to reprint from *Twentieth Century Authors (First Sup-
plement),* Copyright © 1955 by The H. W. Wilson
Company. All rights reserved.

The University of Chicago Press, Chicago 60637
The University of Chicago Press, Ltd., London
© 1986 by Clement Greenberg and John O'Brian
All rights reserved. Published 1986
Paperback edition 1988
Printed in the United States of America

01 00 99 98 97 96 95 94 93 92     4 5 6 7 8

Library of Congress Cataloging-in-Publication Data

Greenberg, Clement, 1909–
    The collected essays and criticism.

    Includes bibliographies and indexes.
    Contents: v. 1. Perceptions and judgments, 1939–
1944—v. 2. Arrogant purpose, 1945–1949.
    1. Art—Addresses, essays, lectures.   I. O'Brian,
John.   II. Title.
N7445.2.G74   1986   700   85-29045
ISBN 0-226-30621-6 (pbk)
    0-226-30622-4 (pbk)

# Contents

# Acknowledgments

I would like to thank T. J. Clark for first encouraging me to track down, read, and compile the uncollected writings of Clement Greenberg; Anne M. Wagner for arming me with an excellent bibliography that greatly facilitated my work in the early stages; S. J. Freedberg, Oleg Grabar, Serge Guilbaut, Michael Kimmelman, and Henri Zerner for offering advice on publishing matters; the staffs of the New York Public Library, the Widener and Fine Arts libraries at Harvard University, and the Robarts Library at the University of Toronto for responding, always patiently, to inquiries; and Whitney Davis, Friedel Dzubas, Caroline Jones, and Michael Leja for bringing my attention to articles I had overlooked. I must also thank Robert F. Brown, at the Archives of American Art, for helping to locate stray material; Jim and Susan Worts for offering their house in Toronto as a place to work one summer; and Roger Hecht for typing, and Eileen M. McHugh and Jennifer Riley for reading, the manuscript.

Finally, I thank Clement Greenberg himself. He responded favorably to the idea of a "Collected Works," and encouraged the endeavor throughout.

John O'Brian

# Editorial Note

The essays and criticism in this volume consist of published writings only and are arranged chronologically in the order of their first appearance. Each article concludes with a reference stating when and in what publication it first appeared. Reprints are also indicated. The abbreviation A&C is used for the book *Art and Culture: Critical Essays*, the collection of Greenberg's writings published in 1961. Most of the articles in the book were revised or substantially changed by Greenberg for republication. This volume, however, reprints the articles as they appeared originally. Reprintings of revised or changed articles from *Art and Culture* are not cited.

All titles are either Greenberg's own or those of the editors of the publications for which he wrote. In most cases the titles for the essays were supplied by Greenberg himself and the titles for book reviews were supplied by others. Greenberg's column for *The Nation*, which appeared from 1942 to 1949, was written under the generic heading "Art" (sometimes "Art Note" for shorter pieces). In order to indicate the contents of each column, I have supplied descriptive headings in place of the generic ones.

The text has been taken from articles as they appeared in print. Unless otherwise indicated, articles were signed Clement Greenberg or C.G. Some short reviews that appeared in *The Nation* were unsigned and these have been so designated. One article published in *Commentary* in 1946 was signed K. Hardesh; this too has been indicated. Throughout, the titles of books, poems, periodicals, and works of art have been put in italics. Spelling and punctuation have, with some exceptions, been regularized to coincide with the usage in *The Nation* column. All ellipsis points in the text are Greenberg's.

Greenberg used a minimum of footnotes in his writing, and for this edition I have followed his practice in my own footnoting. The text is footnoted only where there is a reference to a topic about which the reader could not be expected to find infor-

mation in another source. The majority of Greenberg's articles were written as one or another kind of journalism and the edition attempts to preserve the sense of occasion for which they were written. The articles, then as now, were unaccompanied by illustrations.

The Bibliography lists other writings by Greenberg, including books, translations from the German, and articles which have not been collected. It also provides a selected bibliography of secondary sources on Greenberg's work. The Chronology offers a brief summary of events to 1949 to give some background to the criticism.

# Introduction

Clement Greenberg would seem to fit F. R. Leavis's understanding of how the effective critic goes about his business: "His perceptions and judgements are his, or they are nothing," Leavis wrote; "but, whether or not he has consciously addressed himself to cooperative labour, they are inevitably collaborative. Collaboration may take the form of disagreement, and one is grateful to the critic whom one has found worth disagreeing with." Greenberg has usually found critics worth disagreeing with, and critics (not to speak of artists) have usually found Greenberg worth disagreeing with.

Some of the articles in which Greenberg disagrees with the perceptions and judgments of other critics are contained in *Art and Culture*, his collection of critical essays published in 1961. Like *The Common Pursuit* by Leavis, from which the above quotation is taken, *Art and Culture* is selective. In it Greenberg reserved for himself the privilege of choosing and revising what had been previously published. He wrote in the preface: "This book is not intended as a completely faithful record of my activity as a critic. Not only has much been altered, but much more has been left out than put in. I would not deny being one of those critics who educate themselves in public, but I see no reason why all the haste and waste involved in my self-education should be preserved in a book."

The present volumes (and the ones to follow) offer a contrary view of "the haste and waste" involved in Greenberg's "self-education." Together, the volumes constitute an argument for the recovery and preservation of the full range of his criticism. If *Art and Culture* was not intended by Greenberg as a "completely faithful record" of his activity as a critic—but rather as a selection of revised and sometimes substantially changed essays and articles—the intention here is precisely that: to record faithfully his activity as a critic. Instead of a few dozen items, revised and polished, several hundred items are offered, unrevised and

in their original form. Except for articles that were jointly written, and an article on twentieth-century American art that was written for Sartre's *Les Temps Modernes* (the English version of which has been lost), these first two volumes unite all the articles and essays known to have been published by Greenberg between 1939 and 1949 (see Bibliography).

The 1940s were the years of Greenberg's greatest activity as a critic. His longer, justly celebrated essays were written primarily for *Partisan Review*, while his shorter, until now mostly unrecovered articles, appeared mostly in *The Nation*. Greenberg had close connections with both periodicals. He was an editor of *Partisan Review* from 1940 to 1942 and the regular contributor on art for *The Nation* from 1942 to 1949. (They are rightly seen as the two periodicals most closely associated with his work during these years.) However, he also published extensively elsewhere. As managing editor of the *Contemporary Jewish Record* in 1944 and 1945, and as associate editor of *Commentary* from November 1945 on, he wrote for both on literary, Jewish, and cultural matters. He contributed reviews to *The New Republic* in 1942, and in the same year responded to an inquiry by *Dyn* into dialectical materialism. At Dwight Macdonald's request he wrote a piece for the inaugural issue of *Politics* in February 1944 and then sent a sharply dissenting letter to the editor, who published it in the second issue. He wrote nearly a dozen book reviews for the *New York Times* in 1947 and 1948, and throughout the decade important essays by him found their way into print outside the United States—notably four long articles in *Horizon*, the magazine edited by Cyril Connolly and Stephen Spender. Last, and by no means least, he published his first book, *Joan Miró*, in 1948.

Greenberg was thirty when his first article appeared in print. "The Beggar's Opera—After Marx," a review of Brecht's *A Penny for the Poor*, came out in the 1939 winter issue of *Partisan Review*; six months later it was followed by "Avant-Garde and Kitsch." These mordant pieces—so unlike anything that might be described as apprentice work—did not escape the notice of *Partisan Review*'s readership. Almost immediately, Connolly arranged to republish "Avant-Garde and Kitsch" in *Horizon* and at the same time commissioned an article from Greenberg on the

politics of the war—"An American View." By February 1941 he was publishing in *The Nation*.

The dissenting tone of Greenberg's voice, quick to reject what seemed meretricious in contemporary culture, was a tone characteristic of a group of New York critics and writers brought together by broadly shared convictions about art and politics. Among them were Paul Goodman, Dwight Macdonald, William Phillips, Philip Rahv, Harold Rosenberg, Isaac Rosenfeld, Meyer Schapiro, Lionel Trilling, Robert Warshow, and Greenberg himself. (It was not malice, or not only malice, that caused Greenberg's predecessor at *The Nation* to refer to him as "Lionel Schapiro.") Greenberg's voice, however, did not break into print *ex nihilo*, and some account of the circumstances leading up to its being heard is needed. In 1955, in an entry written for *Twentieth Century Authors*, Greenberg offered these recollections:

I was born in the Bronx, in New York City, the oldest of three sons. My father and my mother had come, in their separate ways, from the Lithuanian Jewish cultural enclave in northeastern Poland, and I spoke Yiddish as soon as I did English. When I was five we moved to Norfolk, Va., but moved back to New York—Brooklyn this time—when I was eleven. My father had by that time made enough money to change over from storekeeper (clothing) to manufacturer (metal goods). However, I can't remember there ever having been any worrying about money in our family, or any one in it lacking for anything. Which is not to say that we were rich.

I attended public school in Norfolk and Brooklyn, took the last year of high school at the Marquand School, and went to Syracuse University for an A.B. (1930). For two and a half years after college I sat home in what looked like idleness, but did during that time learn German and Italian in addition to French and Latin. The following two years I worked in St. Louis, Cleveland, San Francisco and Los Angeles in an abortive left-handed venture of my father's into the wholesale drygoods business; but I discovered that my appetite for business did not amount to the same thing as an inclination. During the next year I supported myself by translating. . . . At the beginning of 1936 I went to work for the federal government, first in the New York office of the Civil Service Commission, then in the Veterans Administration, and finally (in 1937) in the Ap-

praiser's Division of the Customs Service in the Port of New York. Until then I had been making desultory efforts to write, but now I began in earnest, in my office-time leisure—of which I had plenty—and fairly soon I began to get printed.

Missing from these recollections is some indication of the author's political attitudes. Concerning them, it is not without significance that *The Brown Network: The Activities of the Nazis in Foreign Countries*, put out by Knight Publications in New York, was one of the books translated by Greenberg from the German in 1935; nor that when he first came to publish, it should have been on Brecht, whose work he had admired and kept extensive notes on since the early 1930s. Greenberg's parents, as he has written elsewhere, thought of themselves as "free-thinking socialists." But his own position was more developed and partisan. After 1936 he found himself in conflict with Stalinism and Communist culture and in support of Trotskyism—particularly the kind of Trotskyism reflected in the pages of *Partisan Review*. It is a measure of Greenberg's allegiances that on the news of Trotsky's assassination in 1940 he drafted a poem which he provisionally entitled "Ode to Trotsky" (it remains unpublished, as does all his poetry). And Connolly, when responding to "An American View," did not hesitate to label Greenberg a Trotskyist for his position on the war. It is stating the obvious to say that Greenberg's hold on history and his rejection of the forms and arrangements of capitalism were Marxist in origin. It is worth noting, though, that even when some years later he came to reject the politics of Marxism—in 1948 he styled himself an "ex- or disabused Marxist"—he maintained intellectual positions that owed much to the lessons of Marx. In a 1948 book review he remarked that anyone who had protected his mind as carefully from Marx as Valéry had, had little right to pronounce on political matters.

Also absent from the recollections is any mention of artists and writers, colleagues and friends. Aside from the evident benefits to be derived from writing in an American customs house, it may be asked what else—and who else—played a part in turning Greenberg's "desultory efforts to write" into earnest ones. Shortly after taking the customs position, he began to draw regularly from live models with Igor Pantukhov (at the

time a close friend of Lee Krasner) at a WPA studio in the west Twenties. (As a child Greenberg remembers having been a "precocious draftsman," drawing obsessively from the age of four on; in 1925, at the age of sixteen, he enrolled in Richard Lahey's life drawing class at the Art Students League.) He also attended three lectures on art given by Hans Hofmann at his school during the 1938–1939 academic year. The importance to Greenberg of Hofmann's lectures has often been remarked upon, and perhaps exaggerated, partly because Greenberg has so frequently credited Hofmann with directly influencing his thinking on art. The first mention of Hofmann occurred in "Avant-Garde and Kitsch." Greenberg footnoted a pivotal passage in the essay, referring the reader to Hofmann as the source of his formulation. The passage runs as follows: "Picasso, Braque, Mondrian, Miró, Kandinsky, Brancusi, even Klee, Matisse and Cézanne derive their chief inspiration from the medium they work in. The excitement of their art seems to lie most of all in its pure preoccupation with the invention and arrangement of spaces, surfaces, shapes, colors, etc., to the exclusion of whatever is not necessarily implicated in these factors." The logic of this much-quoted passage was worked through at length in "Towards a Newer Laocoon," published the following year. Together, the essays predict the direction of much of Greenberg's subsequent critical writing, formulating arguments for a compelling theory of Western culture since the mid-nineteenth century—a theory of historically conscious, avant-garde culture.

It must be noted, however, that these essays relate almost as much to literature as to art. In fact, Greenberg's ideas were informed more by literary criticism than art criticism—the cogent example of Meyer Schapiro's criticism of the 1930s notwithstanding. "Gradually," Greenberg wrote about the late 1920s and 1930s, "I [had] become much more interested in literature than in art (which I still find it hard to read *about*), and so when I began to write it was mainly on literature." It was Lionel Abel and Harold Rosenberg—published poets and literary critics at the time—who introduced him to other writers at *Partisan Review*, notably Dwight Macdonald. In February 1939, Macdonald received a remarkable letter from Greenberg which mounted arguments repeated a short while after in "Avant-Garde and Kitsch." In particular, Greenberg wanted to register

his objection to Macdonald's assertion (in an article on Soviet cinema) that "Western art has for centuries lived without associations with the masses." Greenberg considered the assertion a misguided application of Marxist analysis. "It must be pointed out that in the West," he countered, "if not everywhere else as well, the ruling class has always to some extent imposed a crude version of its own cultural bias upon those it ruled, if only in the matter of choosing diversions. Chromeotypes, popular music and magazine fiction reflect and take their sustenance from the academicized simulacra of the genuine art of the past. There is a constant seepage from top to bottom, and Kitsch (a wonderful German word that covers all this crap) is the common sewer." The scornful colloquialism of the last sentence, expurgated in the essay, is appropriately Brechtian in its conflation of a common term with an uncommon idea.

Greenberg continued until 1941 to write on literature, especially on modern poetry, more than on art. His affinity for literature is reflected in his own prose style. One sentence from "Avant-Garde and Kitsch" opens: "The avant-garde's specialization of itself, the fact that its best artists are artists' artists, its best poets, poets' poets . . ."—to which one is tempted to add that its best critics, whatever else they may be, are critics' critics. From surviving manuscripts it is evident that Greenberg habitually pared down, rewrote and recast his criticism, even when working within a journalistic format. His sentences rarely maunder, any more than his judgments on art maunder. Among the poets he reviewed were Marianne Moore, John Wheelwright, Randall Jarrell, R. P. Blackmur, Stefan George, Brecht (twice), and Stephen Spender. In 1942, in his capacity as an editor of *Partisan Review*, he introduced a selection of unsolicited poems—a long poem by Dylan Thomas being the exception—to the magazine's readers. The selections and Greenberg's editorial note brought a letter to the editor, criticizing in detail Greenberg's handling of the enterprise, from Harold Rosenberg. Greenberg replied only: "Mr. Rosenberg seems to read my stuff rather closely."

Greenberg's rejoinders are not generally so brief. They are always compressed, however, and seem to make a virtue of the genre's requirement that a complex critical position be collapsed into a paragraph. In January 1948 Greenberg responded to a

letter critical of his espousal of Jackson Pollock, an attack iron-
ically violent in its condemnation of Pollock as a promoter of
"irresponsible sensationalism" and "unwholesome romanti-
cism," and of Greenberg as the putative champion of such val-
ues. Greenberg answered the charges with an apologia he had
used before (and would use again). This apologia is rooted in a
conviction regarding the place of intuitive experience in judg-
ing art, a conviction corresponding—or partly correspond-
ing—to Kant's formulations about intuitive experience and aes-
thetic judgment. (Kant first became a point of reference in
Greenberg's criticism in 1943.) "As far as I know," he wrote, "I
do not prescribe to art, and I am willing to like anything, pro-
vided I enjoy it enough. That is my only criterion, ultimately. If
I happen to enjoy Pollock more than any other contemporary
American painter, it is not because I have an appetite for violent
emotion but because Pollock seems to me to paint better than
his contemporaries. I also happen to think Matisse the greatest
painter of the day. Is he an exponent of violence, irrationality,
sensationalism, or 'unwholesome romanticism'? Or is cubism
that? For I think cubism the highest school of painting in our
century."

The history of Greenberg's advocacy of Pollock and other Ab-
stract Expressionists is well rehearsed. The subject needs no
elaboration here, except to point out that the texts required for a
proper assessment of that history as it developed up to the end of
1949 are now gathered in one place. But Greenberg's espousal of
Matisse as "the greatest painter of the day" is another matter. It
is not generally realized that Greenberg first came out in favor
of the "controlled sensuality" and "careful sumptuousness" of
Matisse's art as early as 1946, and that the rationale offered for
that judgment—or several rationales, for the argument was
complicated—stands near the heart of his critical practice in the
succeeding years. In Matisse's work Greenberg saw not only a
complete command of medium and a ruthless separation of the
means of painting from the means and procedures of the other
arts, but also a "cool hedonism" which, so he thought, offered
the most fruitful example for advanced contemporary art. The
paradox of espousing Matisse and Pollock at one and the same
time will not be missed, for Pollock's painting does not easily
submit to the epithets applied to Matisse. But, and this is the

telling point, the paradox is what saves Greenberg's predilection for an art of "cool hedonism" from hardening into anything that might be described as prescriptive.

Greenberg's art criticism did not stop at the major figures of modernism, any more than it stopped at the American avant-garde. A broad, almost eclectic, range of interests is reflected in the writings of the 1940s: American folk art, the cartoon, the photograph, Currier & Ives prints, Leonardo da Vinci, Northern Renaissance art, seventeenth-century Dutch painting, Thomas Cole, and British art are some of the subjects he wrote on. He especially relished the opportunity to measure his experience of art against the experience of other critics and historians. Thus Bernard Berenson is found to deserve his reputation as a connoisseur of Italian Renaissance art but to have a "radical and peevish miscomprehension of the art of his own age"; and Lionello Venturi is thought to be excellent on the history of Western painting but inadequate when trying to account for how one actually *looks* at paintings. Greenberg queries, "Doesn't one find so many times that the 'full meaning' of a picture—i.e., its aesthetic fact—is, at any given visit to it, most fully revealed at the first fresh glance? And that this 'meaning' fades progressively as continued examination destroys the unity of impression?"

Beyond the scope of the visual arts his interests were no less varied. Among the more surprising items are an article on a ballet by Anthony Tudor and a report on German prisoners of war encamped in Oklahoma written when Greenberg was in the military ("Goose-Step in Tishomingo"). He also continued to write on literature, mostly in the form of book reviews, but sometimes—as in the case of his work on Kafka—with more expansive aims.

The constant necessity of meeting publishing deadlines while filling an editorial position at *Commentary* eventually palled. In November 1949, Greenberg decided that he had had "a bellyfull of reviewing in general" and resigned as the regular art critic for *The Nation*. At the same time he cut back on his production of book reviews. His explanation (in 1955) for the resignation and the curtailment was the ungrateful nature of art criticism as a serious form of writing. But he also averred that among the kinds of writing that might be considered elevated, art criticism

was "one of the most challenging—if only because so few people have done it well enough to be remembered. . . ." The names of those who have done it well enough to be remembered appear often in the pages of this volume, usually as the authors of perceptions and judgments with which Greenberg finds it worthwhile to disagree. These critics are Greenberg's true collaborators, those against whom he must be measured.

<div align="right">John O'Brian</div>

# Clement Greenberg

## THE COLLECTED ESSAYS AND CRITICISM

# 1939

1. The Beggar's Opera—After Marx: Review of *A Penny for the Poor* by Bertolt Brecht

Brecht was first attracted to John Gay's *Beggar's Opera* because it seemed to offer him a better dramatic legend for the expression of his obsessing theme than any he himself could invent at the time. When he adopted the legend for his own opera, his new-found adherence to communism was not yet sufficiently clarified to prevent him from exploiting it in the direction of his old nihilism. Thus, while the underworld is represented as the truest and frankest expression of the society whose hypocritical rules it disregards, its hero MacHeath, who kings it in this quintessential milieu of capitalism, is celebrated not only for his frankness but also for his *opposition*. This unconscious contradiction, given piquancy by Brecht's talent as a poet and accompanied by Weill's ambiguous music, was responsible in no small measure for the opera's success, which came at a time of deflation in political attitudes, when the rejection of bourgeois standards went hand in hand with the acceptance of the concrete bourgeois world. But this was in 1929.

In 1934, when he came to write a novel on the basis of the legend, Brecht's communism had sunk deeper roots and taken more complete possession of his consciousness. The object of attack is more clearly defined now as capitalist society in the specific. The underworld is no longer cut off cleanly from the remainder of society as its illegal expression but merges with it imperceptibly behind the veil of public hypocrisy; and the action now takes place in a shadowy transitional milieu peopled by lumpenproletariat, racketeers, shady speculators, coney-catchers, future criminals, beggars, bohemians without pretentions—in short, the refuse of all the better organized areas of society. The scene is London during the Boer War—chosen perhaps because in time and place it is the historical apogee of capi-

talism—yet in so far as faithfulness to background is concerned, it might just as well be capitalism among the Yahoos. MacHeath is no longer a cute desperado, but a grim racketeer who operates a chain of stores with stolen goods and succeeds so well in crushing competition that he is able to force his way into respectable financial institutions and pose as a pillar of society in the manner of F. Donald Coster, of whom he is the necessary archetype. Peachum, the best-drawn character in the book, remains the bourgeois bonhomme, the timid and rapacious family father whose most intense emotional and physical sensations are caused by money. The action unrolls in a long-drawn and detailed complication of knavery involving MacHeath's grandiose schemes for power and position, and the struggles for survival of his victims, who are equally villainous, but lack his daring and frankness. In spite of the machinery of commercial transactions with all their faithful details, the novel makes little attempt to be realistic in the common sense of the word, for Brecht intends, not to draw a picture, but to give a dramatic definition of capitalist society, showing it as it is *ideally*, not as it appears or as it is experienced.

For all this, as well as for other reasons, the novel constitutes an experiment. Brecht, like many other contemporary poets who feel that they have to prove themselves in a novel, has approached the form with restlessness and dissatisfaction and has attempted to fill it with a new content. He breaks away from the premise most basic to the novel as we have come to know it, namely, that it shall deal with actual experience, and instead transfers attention from the real to the ideal, from actual behavior to the operative patterns or formulas of behavior. What we are to read is not a sample of life under capitalism, but the paradigm, the non-allegorical parable, of all life under capitalism. An intention such as this can be fulfilled in literature only in the form of the morality play or tale—*Pilgrim's Progress* is the best example—and a morality tale is exactly what *A Penny for the Poor* is.

But Brecht also wants to make propaganda in more emphatic terms, he wants to shock the reader in order to make sure his point is not missed; and so he satirizes what he exposes. He will show the unrelieved viciousness of a world in which the fundamental assumptions of bourgeois society are driven to their final

conclusions. The result, however, must be an absurd world, its absurdity following from the strictness of its logic. The action, therefore, proceeds, not in accordance with the internal necessities of characters and verisimilitude, but in obedience to the external logic of a set scheme that overrides the former. This is well and good in a play or in some other short form, but in a longer form like the novel it is unendurable, for an absurd world can only contain absurd characters and absurd characters produce nothing but farce, whether it is grim farce, as in the present case, or merry farce. And farce palls. After a hundred pages or so, by which time the reader has grasped his point, Brecht's novel becomes something like a stage farce from which the voices and gestures of actors have been excluded, or like a succession of subtitles from a silent movie, which we refuse to believe until we see. Continued the length of four hundred pages in a manner that strains at every point to make its gratuitous irony clear—presumably for the benefit of the untutored reader whom Brecht wants to attract to serious literature—the book ends by becoming nerve-wracking.

In its original German, at least, the novel is to some extent redeemed by Brecht's virtuosity as a master of language. Scattered through the book are splendidly executed passages of irony in a prose which for its firmness and sensitivity might serve as a model to any writer of German. The English translation, much too literal, has caught almost nothing of this, and very little more of Brecht's "collage" compositions in cliché and cant phrase, for which he has an extraordinary ear. Isherwood's versions of Brecht's own poems which are set at the chapter heads are brave efforts, but inadequate since they coarsen Brecht's colloquialisms to the point of banality, something which is entirely absent from the German.

*Partisan Review*, Winter 1939

## 2. Avant-Garde and Kitsch

One and the same civilization produces simultaneously two such different things as a poem by T. S. Eliot and a Tin Pan Alley

song, or a painting by Braque and a *Saturday Evening Post* cover. All four are on the order of culture, and ostensibly, parts of the same culture and products of the same society. Here, however, their connection seems to end. A poem by Eliot and a poem by Eddie Guest—what perspective of culture is large enough to enable us to situate them in an enlightening relation to each other? Does the fact that a disparity such as this within the frame of a single cultural tradition, which is and has been taken for granted—does this fact indicate that the disparity is a part of the natural order of things? Or is it something entirely new, and particular to our age?

The answer involves more than an investigation in aesthetics. It appears to me that it is necessary to examine more closely and with more originality than hitherto the relationship between aesthetic experience as met by the specific—not the generalized—individual, and the social and historical contexts in which that experience takes place. What is brought to light will answer, in addition to the question posed above, other and perhaps more important questions.

## I

A society, as it becomes less and less able, in the course of its development, to justify the inevitability of its particular forms, breaks up the accepted notions upon which artists and writers must depend in large part for communication with their audiences. It becomes difficult to assume anything. All the verities involved by religion, authority, tradition, style, are thrown into question, and the writer or artist is no longer able to estimate the response of his audience to the symbols and references with which he works. In the past such a state of affairs has usually resolved itself into a motionless Alexandrianism, an academicism in which the really important issues are left untouched because they involve controversy, and in which creative activity dwindles to virtuosity in the small details of form, all larger questions being decided by the precedent of the old masters. The same themes are mechanically varied in a hundred different works, and yet nothing new is produced: Statius, mandarin verse, Roman sculpture, Beaux-Arts painting, neo-republican architecture.

It is among the hopeful signs in the midst of the decay of our

6

present society that we—some of us—have been unwilling to accept this last phase for our own culture. In seeking to go beyond Alexandrianism, a part of Western bourgeois society has produced something unheard of heretofore:—avant-garde culture. A superior consciousness of history—more precisely, the appearance of a new kind of criticism of society, an historical criticism—made this possible. This criticism has not confronted our present society with timeless utopias, but has soberly examined in the terms of history and of cause and effect the antecedents, justifications and functions of the forms that lie at the heart of every society. Thus our present bourgeois social order was shown to be, not an eternal, "natural" condition of life, but simply the latest term in a succession of social orders. New perspectives of this kind, becoming a part of the advanced intellectual conscience of the fifth and sixth decades of the nineteenth century, soon were absorbed by artists and poets, even if unconsciously for the most part. It was no accident, therefore, that the birth of the avant-garde coincided chronologically—and geographically, too—with the first bold development of scientific revolutionary thought in Europe.

True, the first settlers of bohemia—which was then identical with the avant-garde—turned out soon to be demonstratively uninterested in politics. Nevertheless, without the circulation of revolutionary ideas in the air about them, they would never have been able to isolate their concept of the "bourgeois" in order to define what they were *not*. Nor, without the moral aid of revolutionary political attitudes would they have had the courage to assert themselves as aggressively as they did against the prevailing standards of society. Courage indeed was needed for this, because the avant-garde's emigration from bourgeois society to bohemia meant also an emigration from the markets of capitalism, upon which artists and writers had been thrown by the falling away of aristocratic patronage. (Ostensibly, at least, it meant this—meant starving in a garret—although, as we will be shown later, the avant-garde remained attached to bourgeois society precisely because it needed its money.)

Yet it is true that once the avant-garde had succeeded in "detaching" itself from society, it proceeded to turn around and repudiate revolutionary as well as bourgeois politics. The revolution was left inside society, a part of that welter of ideological

struggle which art and poetry find so unpropitious as soon as it begins to involve those "precious" axiomatic beliefs upon which culture thus far has had to rest. Hence it developed that the true and most important function of the avant-garde was not to "experiment," but to find a path along which it would be possible to keep culture *moving* in the midst of ideological confusion and violence. Retiring from public altogether, the avant-garde poet or artist sought to maintain the high level of his art by both narrowing and raising it to the expression of an absolute in which all relativities and contradictions would be either resolved or beside the point. "Art for art's sake" and "pure poetry" appear, and subject matter or content becomes something to be avoided like a plague.

It has been in search of the absolute that the avant-garde has arrived at "abstract" or "nonobjective" art—and poetry, too. The avant-garde poet or artist tries in effect to imitate God by creating something valid solely on its own terms, in the way nature itself is valid, in the way a landscape—not its picture—is aesthetically valid; something *given*, increate, independent of meanings, similars or originals. Content is to be dissolved so completely into form that the work of art or literature cannot be reduced in whole or in part to anything not itself.

But the absolute is absolute, and the poet or artist, being what he is, cherishes certain relative values more than others. The very values in the name of which he invokes the absolute are relative values, the values of aesthetics. And so he turns out to be imitating, not God—and here I use "imitate" in its Aristotelian sense—but the disciplines and processes of art and literature themselves. This is the genesis of the "abstract."[1] In

1. The example of music, which has long been an abstract art, and which avant-garde poetry has tried so much to emulate, is interesting. Music, Aristotle said curiously enough, is the most imitative and vivid of all arts because it imitates its original—the state of the soul—with the greatest immediacy. Today this strikes us as the exact opposite of the truth, because no art seems to us to have less reference to something outside itself than music. However, aside from the fact that in a sense Aristotle may still be right, it must be explained that ancient Greek music was closely associated with poetry, and depended upon its character as an accessory to verse to make its imitative meaning clear. Plato, speaking of music, says: "For when there are no words, it is very difficult to recognize the meaning of the harmony and rhythm, or to see that any worthy object is imitated by them." As far as we know, all music originally

turning his attention away from subject matter of common experience, the poet or artist turns it in upon the medium of his own craft. The nonrepresentational or "abstract," if it is to have aesthetic validity, cannot be arbitrary and accidental, but must stem from obedience to some worthy constraint or original. This constraint, once the world of common, extroverted experience has been renounced, can only be found in the very processes or disciplines by which art and literature have already imitated the former. These themselves become the subject matter of art and literature. If, to continue with Aristotle, all art and literature are imitation, then what we have here is the imitation of imitating. To quote Yeats:

> Nor is there singing school but studying
> Monuments of its own magnificence.

Picasso, Braque, Mondrian, Miró, Kandinsky, Brancusi, even Klee, Matisse and Cézanne derive their chief inspiration from the medium they work in.[2] The excitement of their art seems to lie most of all in its pure preoccupation with the invention and arrangement of spaces, surfaces, shapes, colors, etc., to the exclusion of whatever is not necessarily implicated in these factors. The attention of poets like Rimbaud, Mallarmé, Valéry, Éluard, Pound, Hart Crane, Stevens, even Rilke and Yeats, appears to be centered on the effort to create poetry and on the "moments" themselves of poetic conversion, rather than on experience to be converted into poetry. Of course, this cannot exclude other preoccupations in their work, for poetry must deal with words, and words must communicate. Certain poets, such as Mallarmé and Valéry,[3] are more radical in this respect than others—leaving aside those poets who have tried to compose

---

served such an accessory function. Once, however, it was abandoned, music was forced to withdraw into itself to find a constraint or original. This is found in the various means of its own composition and performance. [Author's note]

2. I owe this formulation to a remark made by Hans Hofmann, the art teacher, in one of his lectures. From the point of view of this formulation, Surrealism in plastic art is a reactionary tendency which is attempting to restore "outside" subject matter. The chief concern of a painter like Dali is to represent the processes and concepts of his consciousness, not the processes of his medium. [Author's note]

3. See Valéry's remarks about his own poetry. [Author's note]

poetry in pure sound alone. However, if it were easier to define poetry, modern poetry would be much more "pure" and "abstract." As for the other fields of literature—the definition of avant-garde aesthetics advanced here is no Procrustean bed. But aside from the fact that most of our best contemporary novelists have gone to school with the avant-garde, it is significant that Gide's most ambitious book is a novel about the writing of a novel, and that Joyce's *Ulysses* and *Finnegans Wake* seem to be, above all, as one French critic says, the reduction of experience to expression for the sake of expression, the expression mattering more than what is being expressed.

That avant-garde culture is the imitation of imitating—the fact itself—calls for neither approval nor disapproval. It is true that this culture contains within itself some of the very Alexandrianism it seeks to overcome. The lines quoted from Yeats referred to Byzantium, which is very close to Alexandria; and in a sense this imitation of imitating is a superior sort of Alexandrianism. But there is one most important difference: the avant-garde moves, while Alexandrianism stands still. And this, precisely, is what justifies the avant-garde's methods and makes them necessary. The necessity lies in the fact that by no other means is it possible today to create art and literature of a high order. To quarrel with necessity by throwing about terms like "formalism," "purism," "ivory tower" and so forth is either dull or dishonest. This is not to say, however, that it is to the *social* advantage of the avant-garde that it is what it is. Quite the opposite.

The avant-garde's specialization of itself, the fact that its best artists are artists' artists, its best poets, poets' poets, has estranged a great many of those who were capable formerly of enjoying and appreciating ambitious art and literature, but who are now unwilling or unable to acquire an initiation into their craft secrets. The masses have always remained more or less indifferent to culture in the process of development. But today such culture is being abandoned by those to whom it actually belongs—our ruling class. For it is to the latter that the avant-garde belongs. No culture can develop without a social basis, without a source of stable income. And in the case of the avant-garde, this was provided by an elite among the ruling class of that society from which it assumed itself to be cut off, but to

which it has always remained attached by an umbilical cord of gold. The paradox is real. And now this elite is rapidly shrinking. Since the avant-garde forms the only living culture we now have, the survival in the near future of culture in general is thus threatened.

We must not be deceived by superficial phenomena and local successes. Picasso's shows still draw crowds, and T. S. Eliot is taught in the universities; the dealers in modernist art are still in business, and the publishers still publish some "difficult" poetry. But the avant-garde itself, already sensing the danger, is becoming more and more timid every day that passes. Academicism and commercialism are appearing in the strangest places. This can mean only one thing: that the avant-garde is becoming unsure of the audience it depends on—the rich and the cultivated.

Is it the nature itself of avant-garde culture that is alone responsible for the danger it finds itself in? Or is that only a dangerous liability? Are there other, and perhaps more important, factors involved?

## II

Where there is an avant-garde, generally we also find a rearguard. True enough—simultaneously with the entrance of the avant-garde, a second new cultural phenomenon appeared in the industrial West: that thing to which the Germans give the wonderful name of *Kitsch*: popular, commercial art and literature with their chromeotypes, magazine covers, illustrations, ads, slick and pulp fiction, comics, Tin Pan Alley music, tap dancing, Hollywood movies, etc., etc. For some reason this gigantic apparition has always been taken for granted. It is time we looked into its whys and wherefores.

Kitsch is a product of the industrial revolution which urbanized the masses of Western Europe and America and established what is called universal literacy.

Prior to this the only market for formal culture, as distinguished from folk culture, had been among those who, in addition to being able to read and write, could command the leisure and comfort that always goes hand in hand with cultivation of some sort. This until then had been inextricably associated with literacy. But with the introduction of universal literacy, the abil-

ity to read and write became almost a minor skill like driving a car, and it no longer served to distinguish an individual's cultural inclinations, since it was no longer the exclusive concomitant of refined tastes.

The peasants who settled in the cities as proletariat and petty bourgeois learned to read and write for the sake of efficiency, but they did not win the leisure and comfort necessary for the enjoyment of the city's traditional culture. Losing, nevertheless, their taste for the folk culture whose background was the countryside, and discovering a new capacity for boredom at the same time, the new urban masses set up a pressure on society to provide them with a kind of culture fit for their own consumption. To fill the demand of the new market, a new commodity was devised: ersatz culture, kitsch, destined for those who, insensible to the values of genuine culture, are hungry nevertheless for the diversion that only culture of some sort can provide.

Kitsch, using for raw material the debased and academicized simulacra of genuine culture, welcomes and cultivates this insensibility. It is the source of its profits. Kitsch is mechanical and operates by formulas. Kitsch is vicarious experience and faked sensations. Kitsch changes according to style, but remains always the same. Kitsch is the epitome of all that is spurious in the life of our times. Kitsch pretends to demand nothing of its customers except their money—not even their time.

The precondition for kitsch, a condition without which kitsch would be impossible, is the availability close at hand of a fully matured cultural tradition, whose discoveries, acquisitions, and perfected self-consciousness kitsch can take advantage of for its own ends. It borrows from it devices, tricks, stratagems, rules of thumb, themes, converts them into a system, and discards the rest. It draws its life blood, so to speak, from this reservoir of accumulated experience. This is what is really meant when it is said that the popular art and literature of today were once the daring, esoteric art and literature of yesterday. Of course, no such thing is true. What is meant is that when enough time has elapsed the new is looted for new "twists," which are then watered down and served up as kitsch. Self-evidently, all kitsch is academic; and conversely, all that's academic is kitsch. For what is called the academic as such

no longer has an independent existence, but has become the stuffed-shirt "front" for kitsch. The methods of industrialism displace the handicrafts.

Because it can be turned out mechanically, kitsch has become an integral part of our productive system in a way in which true culture could never be, except accidentally. It has been capitalized at a tremendous investment which must show commensurate returns; it is compelled to extend as well as to keep its markets. While it is essentially its own salesman, a great sales apparatus has nevertheless been created for it, which brings pressure to bear on every member of society. Traps are laid even in those areas, so to speak, that are the preserves of genuine culture. It is not enough today, in a country like ours, to have an inclination towards the latter; one must have a true passion for it that will give him the power to resist the faked article that surrounds and presses in on him from the moment he is old enough to look at the funny papers. Kitsch is deceptive. It has many different levels, and some of them are high enough to be dangerous to the naive seeker of true light. A magazine like the *New Yorker*, which is fundamentally high-class kitsch for the luxury trade, converts and waters down a great deal of avant-garde material for its own uses. Nor is every single item of kitsch altogether worthless. Now and then it produces something of merit, something that has an authentic folk flavor; and these accidental and isolated instances have fooled people who should know better.

Kitsch's enormous profits are a source of temptation to the avant-garde itself, and its members have not always resisted this temptation. Ambitious writers and artists will modify their work under the pressure of kitsch, if they do not succumb to it entirely. And then those puzzling borderline cases appear, such as the popular novelist, Simenon, in France, and Steinbeck in this country. The net result is always to the detriment of true culture in any case.

Kitsch has not been confined to the cities in which it was born, but has flowed out over the countryside, wiping out folk culture. Nor has it shown any regard for geographical and national-cultural boundaries. Another mass product of Western industrialism, it has gone on a triumphal tour of the world,

crowding out and defacing native cultures in one colonial country after another, so that it is now by way of becoming a universal culture, the first universal culture ever beheld. Today the native of China, no less than the South American Indian, the Hindu, no less than the Polynesian, have come to prefer to the products of their native art, magazine covers, rotogravure sections and calendar girls. How is this virulence of kitsch, this irresistible attractiveness, to be explained? Naturally, machine-made kitsch can undersell the native handmade article, and the prestige of the West also helps; but why is kitsch a so much more profitable export article than Rembrandt? One, after all, can be reproduced as cheaply as the other.

In his last article on the Soviet cinema in the *Partisan Review*,[4] Dwight Macdonald points out that kitsch has in the last ten years become the dominant culture in Soviet Russia. For this he blames the political regime—not only for the fact that kitsch is the official culture, but also that it is actually the dominant, most popular culture, and he quotes the following from Kurt London's *The Seven Soviet Arts*: ". . . the attitude of the masses both to the old and new art styles probably remains essentially dependent on the nature of the education afforded them by their respective states." Macdonald goes on to say: "Why after all should ignorant peasants prefer Repin (a leading exponent of Russian academic kitsch in painting) to Picasso, whose abstract technique is at least as relevant to their own primitive folk art as is the former's realistic style? No, if the masses crowd into the Tretyakov (Moscow's museum of contemporary Russian art: kitsch), it is largely because they have been conditioned to shun 'formalism' and to admire 'socialist realism.'"

In the first place it is not a question of a choice between merely the old and merely the new, as London seems to think— but of a choice between the bad, up-to-date old and the genuinely new. The alternative to Picasso is not Michelangelo, but kitsch. In the second place, neither in backward Russia nor in the advanced West do the masses prefer kitsch simply because their governments condition them toward it. Where state edu-

4. *Partisan Review*, Winter 1939. Greenberg wrote to Macdonald about the article shortly after it was published, in a letter dated 9 February 1939. Several ideas raised in the letter are discussed at greater length here. [Editor's note]

cational systems take the trouble to mention art, we are told to respect the old masters, not kitsch; and yet we go and hang Maxfield Parrish or his equivalent on our walls, instead of Rembrandt and Michelangelo. Moreover, as Macdonald himself points out, around 1925 when the Soviet regime was encouraging avant-garde cinema, the Russian masses continued to prefer Hollywood movies. No, "conditioning" does not explain the potency of kitsch.

All values are human values, relative values, in art as well as elsewhere. Yet there does seem to have been more or less of a general agreement among the cultivated of mankind over the ages as to what is good art and what bad. Taste has varied, but not beyond certain limits; contemporary connoisseurs agree with the eighteenth-century Japanese that Hokusai was one of the greatest artists of his time; we even agree with the ancient Egyptians that Third and Fourth Dynasty art was the most worthy of being selected as their paragon by those who came after. We may have come to prefer Giotto to Raphael, but we still do not deny that Raphael was one of the best painters of his time. There has been an agreement then, and this agreement rests, I believe, on a fairly constant distinction made between those values only to be found in art and the values which can be found elsewhere. Kitsch, by virtue of a rationalized technique that draws on science and industry, has erased this distinction in practice.

Let us see, for example, what happens when an ignorant Russian peasant such as Macdonald mentions stands with hypothetical freedom of choice before two paintings, one by Picasso, the other by Repin. In the first he sees, let us say, a play of lines, colors and spaces that represent a woman. The abstract technique—to accept Macdonald's supposition, which I am inclined to doubt—reminds him somewhat of the icons he has left behind him in the village, and he feels the attraction of the familiar. We will even suppose that he faintly surmises some of the great art values the cultivated find in Picasso. He turns next to Repin's picture and sees a battle scene. The technique is not so familiar—as technique. But that weighs very little with the peasant, for he suddenly discovers values in Repin's picture that seem far superior to the values he has been accustomed to find in icon art; and the unfamiliar itself is one of the sources of those

values: the values of the vividly recognizable, the miraculous and the sympathetic. In Repin's picture the peasant recognizes and sees things in the way in which he recognizes and sees things outside of pictures—there is no discontinuity between art and life, no need to accept a convention and say to oneself, that icon represents Jesus because it intends to represent Jesus, even if it does not remind me very much of a man. That Repin can paint so realistically that identifications are self-evident immediately and without any effort on the part of the spectator—that is miraculous. The peasant is also pleased by the wealth of self-evident meanings which he finds in the picture: "it tells a story." Picasso and the icons are so austere and barren in comparison. What is more, Repin heightens reality and makes it dramatic: sunset, exploding shells, running and falling men. There is no longer any question of Picasso or icons. Repin is what the peasant wants, and nothing else but Repin. It is lucky, however, for Repin that the peasant is protected from the products of American capitalism, for he would not stand a chance next to a *Saturday Evening Post* cover by Norman Rockwell.

Ultimately, it can be said that the cultivated spectator derives the same values from Picasso that the peasant gets from Repin, since what the latter enjoys in Repin is somehow art too, on however low a scale, and he is sent to look at pictures by the same instincts that send the cultivated spectator. But the ultimate values which the cultivated spectator derives from Picasso are derived at a second remove, as the result of reflection upon the immediate impression left by the plastic values. It is only then that the recognizable, the miraculous and the sympathetic enter. They are not immediately or externally present in Picasso's painting, but must be projected into it by the spectator sensitive enough to react sufficiently to plastic qualities. They belong to the "reflected" effect. In Repin, on the other hand, the "reflected" effect has already been included in the picture, ready for the spectator's unreflective enjoyment.[5] Where Picasso paints *cause*, Repin paints *effect*. Repin predigests art for the spectator

5. T. S. Eliot said something to the same effect in accounting for the shortcomings of English Romantic poetry. Indeed the Romantics can be considered the original sinners whose guilt kitsch inherited. They showed kitsch how. What does Keats write about mainly, if not the effect of poetry upon himself? [Author's note]

and spares him effort, provides him with a short cut to the pleasure of art that detours what is necessarily difficult in genuine art. Repin, or kitsch, is synthetic art.

The same point can be made with respect to kitsch literature: it provides vicarious experience for the insensitive with far greater immediacy than serious fiction can hope to do. And Eddie Guest and the *Indian Love Lyrics* are more poetic than T. S. Eliot and Shakespeare.

### III

If the avant-garde imitates the processes of art, kitsch, we now see, imitates its effects. The neatness of this antithesis is more than contrived; it corresponds to and defines the tremendous interval that separates from each other two such simultaneous cultural phenomena as the avant-garde and kitsch. This interval, too great to be closed by all the infinite gradations of popularized "modernism" and "modernistic" kitsch, corresponds in turn to a social interval, a social interval that has always existed in formal culture, as elsewhere in civilized society, and whose two termini converge and diverge in fixed relation to the increasing or decreasing stability of the given society. There has always been on one side the minority of the powerful—and therefore the cultivated—and on the other the great mass of the exploited and poor—and therefore the ignorant. Formal culture has always belonged to the first, while the last have had to content themselves with folk or rudimentary culture, or kitsch.

In a stable society that functions well enough to hold in solution the contradictions between its classes, the cultural dichotomy becomes somewhat blurred. The axioms of the few are shared by the many; the latter believe superstitiously what the former believe soberly. And at such moments in history the masses are able to feel wonder and admiration for the culture, on no matter how high a plane, of its masters. This applies at least to plastic culture, which is accessible to all.

In the Middle Ages the plastic artist paid lip service at least to the lowest common denominators of experience. This even remained true to some extent until the seventeenth century. There was available for imitation a universally valid conceptual reality, whose order the artist could not tamper with. The subject matter of art was prescribed by those who commissioned

works of art, which were not created, as in bourgeois society, on speculation. Precisely because his content was determined in advance, the artist was free to concentrate on his medium. He needed not to be philosopher, or visionary, but simply artificer. As long as there was general agreement as to what were the worthiest subjects for art, the artist was relieved of the necessity to be original and inventive in his "matter" and could devote all his energy to formal problems. For him the medium became, privately, professionally, the content of his art, even as his medium is today the public content of the abstract painter's art— with that difference, however, that the medieval artist had to suppress his professional preoccupation in public—had always to suppress and subordinate the personal and professional in the finished, official work of art. If, as an ordinary member of the Christian community, he felt some personal emotion about his subject matter, this only contributed to the enrichment of the work's public meaning. Only with the Renaissance do the inflections of the personal become legitimate, still to be kept, however, within the limits of the simply and universally recognizable. And only with Rembrandt do "lonely" artists begin to appear, lonely in their art.

But even during the Renaissance, and as long as Western art was endeavoring to perfect its technique, victories in this realm could only be signalized by success in realistic imitation, since there was no other objective criterion at hand. Thus the masses could still find in the art of their masters objects of admiration and wonder. Even the bird that pecked at the fruit in Zeuxis' picture could applaud.

It is a platitude that art becomes caviar to the general when the reality it imitates no longer corresponds even roughly to the reality recognized by the general. Even then, however, the resentment the common man may feel is silenced by the awe in which he stands of the patrons of this art. Only when he becomes dissatisfied with the social order they administer does he begin to criticize their culture. Then the plebian finds courage for the first time to voice his opinions openly. Every man, from the Tammany alderman to the Austrian house-painter, finds that he is entitled to his opinion. Most often this resentment toward culture is to be found where the dissatisfaction with society is a reactionary dissatisfaction which expresses itself in revivalism

and puritanism, and latest of all, in fascism. Here revolvers and torches begin to be mentioned in the same breath as culture. In the name of godliness or the blood's health, in the name of simple ways and solid virtues, the statue-smashing commences.

## IV

Returning to our Russian peasant for the moment, let us suppose that after he has chosen Repin in preference to Picasso, the state's educational apparatus comes along and tells him that he is wrong, that he should have chosen Picasso—and shows him why. It is quite possible for the Soviet state do do this. But things being as they are in Russia—and everywhere else—the peasant soon finds the necessity of working hard all day for his living and the rude, uncomfortable circumstances in which he lives do not allow him enough leisure, energy and comfort to train for the enjoyment of Picasso. This needs, after all, a considerable amount of "conditioning." Superior culture is one of the most artificial of all human creations, and the peasant finds no "natural" urgency within himself that will drive him toward Picasso in spite of all difficulties. In the end the peasant will go back to kitsch when he feels like looking at pictures, for he can enjoy kitsch without effort. The state is helpless in this matter and remains so as long as the problems of production have not been solved in a socialist sense. The same holds true, of course, for capitalist countries and makes all talk of art for the masses there nothing but demagogy.[6]

6. It will be objected that such art for the masses as folk art was developed under rudimentary conditions of production—and that a good deal of folk art is on a high level. Yes it is—but folk art is not Athene, and it's Athene whom we want: formal culture with its infinity of aspects, its luxuriance, its large comprehension. Besides, we are now told that most of what we consider good in folk culture is the static survival of dead formal, aristocratic, cultures. Our old English ballads, for instance, were not created by the "folk," but by the post-feudal squirearchy of the English countryside, to survive in the mouths of the folk long after those for whom the ballads were composed had gone on to other forms of literature. Unfortunately, until the machine age, culture was the exclusive prerogative of a society that lived by the labor of serfs or slaves. They were the real symbols of culture. For one man to spend time and energy creating or listening to poetry meant that another man had to produce enough to keep himself alive and the former in comfort. In Africa today we find that the culture of slave-owning tribes is generally much superior to that of the tribes that possess no slaves. [Author's note]

Where today a political regime establishes an official cultural policy, it is for the sake of demagogy. If kitsch is the official tendency of culture in Germany, Italy and Russia, it is not because their respective governments are controlled by philistines, but because kitsch is the culture of the masses in these countries, as it is everywhere else. The encouragement of kitsch is merely another of the inexpensive ways in which totalitarian regimes seek to ingratiate themselves with their subjects. Since these regimes cannot raise the cultural level of the masses—even if they wanted to—by anything short of a surrender to international socialism, they will flatter the masses by bringing all culture down to their level. It is for this reason that the avant-garde is outlawed, and not so much because a superior culture is inherently a more critical culture. (Whether or not the avant-garde could possibly flourish under a totalitarian regime is not pertinent to the question at this point.) As a matter of fact, the main trouble with avant-garde art and literature, from the point of view of fascists and Stalinists, is not that they are too critical, but that they are too "innocent," that it is too difficult to inject effective propaganda into them, that kitsch is more pliable to this end. Kitsch keeps a dictator in closer contact with the "soul" of the people. Should the official culture be one superior to the general mass-level, there would be a danger of isolation.

Nevertheless, if the masses were conceivably to ask for avant-garde art and literature, Hitler, Mussolini and Stalin would not hesitate long in attempting to satisfy such a demand. Hitler is a bitter enemy of the avant-garde, both on doctrinal and personal grounds, yet this did not prevent Goebbels in 1932–1933 from strenuously courting avant-garde artists and writers. When Gottfried Benn, an Expressionist poet, came over to the Nazis he was welcomed with a great fanfare, although at that very moment Hitler was denouncing Expressionism as *Kulturbolschewismus*. This was at a time when the Nazis felt that the prestige which the avant-garde enjoyed among the cultivated German public could be of advantage to them, and practical considerations of this nature, the Nazis being skillful politicians, have always taken precedence over Hitler's personal inclinations. Later the Nazis realized that it was more practical to accede to the wishes of the masses in matters of culture than to those of

their paymasters; the latter, when it came to a question of preserving power, were as willing to sacrifice their culture as they were their moral principles; while the former, precisely because power was being withheld from them, had to be cozened in every other way possible. It was necessary to promote on a much more grandiose style than in the democracies the illusion that the masses actually rule. The literature and art they enjoy and understand were to be proclaimed the only true art and literature and any other kind was to be suppressed. Under these circumstances people like Gottfried Benn, no matter how ardently they support Hitler, become a liability; and we hear no more of them in Nazi Germany.

We can see then that although from one point of view the personal philistinism of Hitler and Stalin is not accidental to the roles they play, from another point of view it is only an incidentally contributory factor in determining the cultural policies of their respective regimes. Their personal philistinism simply adds brutality and double-darkness to policies they would be forced to support anyhow by the pressure of all their other policies—even were they, personally, devotees of avant-garde culture. What the acceptance of the isolation of the Russian Revolution forces Stalin to do, Hitler is compelled to do by his acceptance of the contradictions of capitalism and his efforts to freeze them. As for Mussolini—his case is a perfect example of the *disponibilité* of a realist in these matters. For years he bent a benevolent eye on the Futurists and built modernistic railroad stations and government-owned apartment houses. One can still see in the suburbs of Rome more modernistic apartments than almost anywhere else in the world. Perhaps Fascism wanted to show its up-to-dateness, to conceal the fact that it was a retrogression; perhaps it wanted to conform to the tastes of the wealthy elite it served. At any rate Mussolini seems to have realized lately that it would be more useful to him to please the cultural tastes of the Italian masses than those of their masters. The masses must be provided with objects of admiration and wonder; the latter can dispense with them. And so we find Mussolini announcing a "new Imperial style." Marinetti, Chirico, *et al.*, are sent into the outer darkness, and the new railroad station in Rome will not be modernistic. That Mussolini was late in com-

ing to this only illustrates again the relative hesitance with which Italian Fascism has drawn the necessary implications of its role.

Capitalism in decline finds that whatever of quality it is still capable of producing becomes almost invariably a threat to its own existence. Advances in culture, no less than advances in science and industry, corrode the very society under whose aegis they are made possible. Here, as in every other question today, it becomes necessary to quote Marx word for word. Today we no longer look toward socialism for a new culture—as inevitably as one will appear, once we do have socialism. Today we look to socialism *simply* for the preservation of whatever living culture we have right now.

*Partisan Review*, Fall 1939; *Horizon*, April 1940; *The Partisan Reader*, *1934–1944*, ed. William Phillips and Philip Rahv, 1946; *Mass Culture: The Popular Arts in America*, ed. Bernard Rosenberg and David Manning White, 1957 (abridged); A&C (unrevised); *Modern Culture and the Arts*, ed. James B. Hall and Barry Ulanov, 1967; *Kitsch: The World of Bad Taste*, ed. Gillo Dorfles, 1969 (abridged); *Pollock and After: The Critical Debate*, ed. Francis Frascina, 1985.

# 1940

3.  Towards a Newer Laocoon

The dogmatism and intransigence of the "non-objective" or "abstract" purists of painting today cannot be dismissed as symptoms merely of a cultist attitude towards art. Purists make extravagant claims for art, because usually they value it much more than any one else does. For the same reason they are much more solicitous about it. A great deal of purism is the translation of an extreme solicitude, an anxiousness as to the fate of art, a concern for its identity. We must respect this. When the purist insists upon excluding "literature" and subject matter from plastic art, now and in the future, the most we can charge him with off-hand is an unhistorical attitude. It is quite easy to show that abstract art like every other cultural phenomenon reflects the social and other circumstances of the age in which its creators live, and that there is nothing inside art itself, disconnected from history, which compels it to go in one direction or another. But it is not so easy to reject the purist's assertion that the best of contemporary plastic art is abstract. Here the purist does not have to support his position with metaphysical pretentions. And when he insists on doing so, those of us who admit the merits of abstract art without accepting its claims in full must offer our own explanation for its present supremacy.

Discussion as to purity in art and, bound up with it, the attempts to establish the differences between the various arts are not idle. There has been, is, and will be, such a thing as a confusion of the arts. From the point of view of the artist engrossed in the problems of his medium and indifferent to the efforts of theorists to explain abstract art *completely*, purism is the terminus of a salutary reaction against the mistakes of painting and sculpture in the past several centuries which were due to such a confusion.

I

There can be, I believe, such a thing as a dominant art form; this was what literature had become in Europe by the 17th century. (Not that the ascendancy of a particular art always coincides with its greatest productions. In point of achievement, music was the greatest art of this period.) By the middle of the 17th century the pictorial arts had been relegated almost everywhere into the hands of the courts, where they eventually degenerated into relatively trivial interior decoration. The most creative class in society, the rising mercantile bourgeoisie, impelled perhaps by the iconoclasm of the Reformation (Pascal's Jansenist contempt for painting is a symptom) and by the relative cheapness and mobility of the physical medium after the invention of printing, had turned most of its creative and acquisitive energy towards literature.

Now, when it happens that a single art is given the dominant role, it becomes the prototype of all art: the others try to shed their proper characters and imitate its effects. The dominant art in turn tries itself to absorb the functions of the others. A confusion of the arts results, by which the subservient ones are perverted and distorted; they are forced to deny their own nature in an effort to attain the effects of the dominant art. However, the subservient arts can only be mishandled in this way when they have reached such a degree of technical facility as to enable them to pretend to conceal their *mediums*. In other words, the artist must have gained such power over his material as to annihilate it seemingly in favor of *illusion*. Music was saved from the fate of the pictorial arts in the 17th and 18th centuries by its comparatively rudimentary technique and the relative shortness of its development as a formal art. Aside from the fact that in its nature it is the art furthest removed from imitation, the possibilities of music had not been explored sufficiently to enable it to strive for illusionist effects.

But painting and sculpture, the arts of illusion par excellence, had by that time achieved such facility as to make them infinitely susceptible to the temptation to emulate the effects, not only of illusion, but of other arts. Not only could painting imitate sculpture, and sculpture, painting, but both could attempt to reproduce the effects of literature. And it was for the

24

effects of literature that 17th and 18th century painting strained most of all. Literature, for a number of reasons, had won the upper hand, and the plastic arts—especially in the form of easel painting and statuary—tried to win admission to its domain. Although this does not account completely for the decline of those arts during this period, it seems to have been the form of that decline. Decline it was, compared to what had taken place in Italy, Flanders, Spain and Germany the century before. Good artists, it is true, continue to appear—I do not have to exaggerate the depression to make my point—but not good *schools* of art, not good followers. The circumstances surrounding the appearance of the individual great artists seem to make them almost all exceptions; we think of them as great artists "in spite of." There is a scarcity of distinguished small talents. And the very level of greatness sinks by comparison to the work of the past.

In general, painting and sculpture in the hands of the lesser talents—and this is what tells the story—become nothing more than ghosts and "stooges" of literature. All emphasis is taken away from the medium and transferred to subject matter. It is no longer a question even of realistic imitation, since that is taken for granted, but of the artist's ability to interpret subject matter for poetic effects and so forth.

We ourselves, even today, are too close to literature to appreciate its status as a dominant art. Perhaps an example of the converse will make clearer what I mean. In China, I believe, painting and sculpture became in the course of the development of culture the dominant arts. There we see poetry given a role subordinate to them, and consequently assuming their limitations: the poem confines itself to the single moment of painting and to an emphasis upon visual details. The Chinese even require visual delight from the handwriting in which the poem is set down. And by comparison to their pictorial and decorative arts doesn't the later poetry of the Chinese seem rather thin and monotonous?

Lessing, in his *Laokoon* written in the 1760s, recognized the presence of a practical as well as a theoretical confusion of the arts. But he saw its ill effects exclusively in terms of literature, and his opinions on plastic art only exemplify the typical misconceptions of his age. He attacked the descriptive verse of poets

like James Thomson as an invasion of the domain of landscape painting, but all he could find to say about painting's invasion of poetry was to object to allegorical pictures which required an explanation, and to paintings like Titian's *Prodigal Son* which incorporate "two necessarily separate points of time in one and the same picture."

## II

The Romantic Revival or Revolution seemed at first to offer some hope for painting, but by the time it departed the scene, the confusion of the arts had become worse. The romantic theory of art was that the artist feels something and passes on this feeling—not the situation or thing which stimulated it—to his audience. To preserve the immediacy of the feeling it was even more necessary than before, when art was imitation rather than communication, to suppress the role of the medium. The medium was a regrettable if necessary physical obstacle between the artists and his audience, which in some ideal state would disappear entirely to leave the experience of the spectator or reader identical with that of the artist. In spite of the fact that music considered as an art of pure feeling, was beginning to win almost equal esteem, the attitude represents a final triumph for poetry. All feeling for the arts as métiers, crafts, disciplines—of which some sense had survived until the 18th century—was lost. The arts came to be regarded as nothing more or less than so many powers of the personality. Shelley expressed this best when in his *Defense of Poetry* he exalted poetry above the other arts because its medium came closest, as Bosanquet puts it, to being no medium at all. In practice this aesthetic encouraged that particular widespread form of artistic dishonesty which consists in the attempt to escape from the problems of the medium of one art by taking refuge in the effects of another. Painting is the most susceptible to evasions of this sort, and painting suffered most at the hands of the Romantics.

At first it did not seem so. As a result of the triumph of the burghers and of their appropriation of all the arts a fresh current of creative energy was released into every field. If the Romantic revolution in painting was at first more a revolution in subject matter than in anything else, abandoning the oratorical and frivolous literature of 18th century painting in search of a more

original, more powerful, more sincere literary content, it also brought with it a greater boldness in pictorial means. Delacroix, Géricault, even Ingres, were enterprising enough to find new form for the new content they introduced. But the net result of their efforts was to make the incubus of literature in painting even deadlier for the lesser talents who followed them. The worst manifestations of literary and sentimental painting had already begun to appear in the painting of the late 18th century—especially in England, where a revival which produced some of the best English painting was equally efficacious in speeding up the process of degeneration. Now the schools of Ingres and Delacroix joined with those of Morland and Greuze and Vigée-Lebrun to become the official painting of the 19th century. There have been academics before, but for the first time we have academicism. Painting enjoyed a revival of activity in 19th century France such as had not been seen since the 16th century, and academicism could produce such good painters as Corot and Theodore Rousseau, and even Daumier—yet in spite of this academicians sank painting to a level that was in some respects an all-time low. The name of this low is Vernet, Gérome, Leighton, Watts, Moreau, Böcklin, the Pre-Raphaelites, etc., etc. That some of these painters had real talent only made their influence the more pernicious. It took talent—among other things—to lead art that far astray. Bourgeois society gave these talents a prescription, and they filled it—with talent.

It was not realistic imitation in itself that did the damage so much as realistic illusion in the service of sentimental and declamatory literature. Perhaps the two go hand in hand. To judge from Western and Graeco-Roman art, it seems so. Yet it is true of Western painting that in so far as it has been the creation of a rationalist and scientifically-minded city culture, it has always had a bias towards a realism that tries to achieve allusions by overpowering the medium, and is more interested in exploiting the practical meanings of objects than in savoring their appearance

III

Romanticism was the last great tendency following *directly* from bourgeois society that was able to inspire and stimulate the profoundly responsible artist—the artist conscious of certain in-

flexible obligations to the standards of his craft. By 1848 Romanticism had exhausted itself. After that the impulse, although indeed it had to originate in bourgeois society, could only come in the guise of a denial of that society, as a turning away from it. It was not to be an about-face towards a new society, but an emigration to a Bohemia which was to be art's sanctuary from capitalism. It was to be the task of the avant-garde to perform in opposition to bourgeois society the function of finding new and adequate cultural forms for the expression of that same society, without at the same time succumbing to its ideological divisions and its refusal to permit the arts to be their own justification. The avant-garde, both child and negation of Romanticism, becomes the embodiment of art's instinct of self-preservation. It is interested in, and feels itself responsible to, only the values of art; and, given society as it is, has an organic sense of what is good and what is bad for art.

As the first and most important item upon its agenda, the avant-garde saw the necessity of an escape from ideas, which were infecting the arts with the ideological struggles of society. Ideas came to mean subject matter in general. (Subject matter as distinguished from content: in the sense that every work of art must have content, but that subject matter is something the artist does or does not have in mind when he is actually at work.) This meant a new and greater emphasis upon form, and it also involved the assertion of the arts as independent vocations, disciplines and crafts, absolutely autonomous, and entitled to respect for their own sakes, and not merely as vessels of communication. It was the signal for a revolt against the dominance of literature, which was subject matter at its most oppressive.

The avant-garde has pursued, and still pursues, several variants, whose chronological order is by no means clear, but can be best traced in painting, which as the chief victim of literature brought the problem into sharpest focus. (Forces stemming from outside art play a much larger part than I have room to acknowledge here. And I must perforce be rather schematic and abstract, since I am interested more in tracing large outlines than in accounting for and gathering in all particular manifestations.)

By the second third of the 19th century painting had degenerated from the pictorial to the picturesque. Everything de-

pends on the anecdote or the message. The painted picture oc-
curs in blank, indeterminate space; it just happens to be on a
square of canvas and inside a frame. It might just as well have
been breathed on air or formed out of plasma. It tries to be
something you imagine rather than see—or else a bas-relief or a
statue. Everything contributes to the denial of the medium, as if
the artist were ashamed to admit that he had actually painted his
picture instead of dreaming it forth.

This state of affairs could not be overcome at one stroke. The
campaign for the redemption of painting was to be one of com-
paratively slow attrition at first. Nineteenth century painting
made its first break with literature when in the person of the
Communard, Courbet, it fled from spirit to matter. Courbet,
the first real avant-garde painter, tried to reduce his art to im-
mediate sense data by painting only what the eye could see as a
machine unaided by the mind. He took for his subject matter
prosaic contemporary life. As avant-gardists so often do, he
tried to demolish official bourgeois art by turning it inside out.
By driving something as far as it will go you often get back to
where it started. A new flatness begins to appear in Courbet's
painting, and an equally new attention to every inch of the can-
vas, regardless of its relation to the "centers of interest." (Zola,
the Goncourts and poets like Verhaeren were Courbet's corre-
latives in literature. They too were "experimental"; they too
were trying to get rid of ideas and "literature," that is, to estab-
lish their art on a more stable basis than the crumbling bour-
geois oecumene.) If the avant-garde seems unwilling to claim
naturalism for itself it is because the tendency failed too often
to achieve the objectivity it professed, i.e., it succumbed to
"ideas."

Impressionism, reasoning beyond Courbet in its pursuit of
materialist objectivity, abandoned common sense experience
and sought to emulate the detachment of science, imagining
that thereby it would get at the very essence of painting as well
as of visual experience. It was becoming important to determine
the essential elements of each of the arts. Impressionist painting
becomes more an exercise in color vibrations than representation
of nature. Manet meanwhile, closer to Courbet, was attacking
subject matter on its own terrain by including it in his pictures
and exterminating it then and there. His insolent indifference to

his subject, which in itself was often striking, and his flat color-modeling were as revolutionary as Impressionist technique proper. Like the Impressionists he saw the problems of painting as first and foremost problems of the medium, and he called the spectator's attention to this.

## IV

The second variant of the avant-garde's development is concurrent in time with the first. It is easy to recognize this variant, but rather difficult to expose its motivation. Tendencies go in opposite directions, and cross-purposes meet. But tying everything together is the fact that in the end cross-purposes indeed do meet. There is a common effort in each of the arts to expand the expressive resources of the medium, not in order to express ideas and notions, but to express with greater immediacy sensations, the irreducible elements of experience. Along this path it seemed as though the avant-garde in its attempt to escape from "literature" had set out to treble the confusion of the arts by having them imitate every other art except literature.[1] (By this time literature had had its opprobrious sense expanded to include everything the avant-garde objected to in official bourgeois culture.) Each art would demonstrate its powers by capturing the effects of its sister arts or by taking a sister art for its subject. Since art was the only validity left, what better subject was there for each art than the procedures and effects of some other art? Impressionist painting, with its progressions and rhythmic suffusions of color, with its moods and atmospheres, was arriving at effects to which the Impressionists themselves gave the terms of Romantic music. Painting, however, was the least affected by this new confusion. Poetry and music were its chief victims. Poetry—for it too had to escape from "literature"—was imitating the effects of painting and sculpture (Gautier, the Parnassians, and later the Imagists) and, of course, those of music (Poe had narrowed "true" poetry down to the lyric). Music, in flight from the undisciplined, bottomless sentimentality of the Romantics, was striving to describe and narrate (program music). That music at this point imitates litera-

1. This is the confusion of the arts for which Babbitt [Irving Babbitt, *The New Laokoön: An Essay on the Confusion of the Arts*, 1910] made Romanticism responsible. [Author's note]

30

ture would seem to spoil my thesis. But music imitates painting as much as it does poetry when it becomes representational; and besides, it seems to me that Debussy used the program more as a pretext for experiment than as an end in itself. In the same way that the Impressionist painters were trying to get at the structure beneath the color, Debussy was trying to get at the "sound underneath the note."

Aside from what was going on inside music, music as an art in itself began at this time to occupy a very important position in relation to the other arts. Because of its "absolute" nature, its remoteness from imitation, its almost complete absorption in the very physical quality of its medium, as well as because of its resources of suggestion, music had come to replace poetry as the paragon art. It was the art which the other avant-garde arts envied most, and whose effects they tried hardest to imitate. Thus it was the principal agent of the new confusion of the arts. What attracted the avant-garde to music as much as its power to suggest was, as I have said, its nature as an art of immediate sensation. When Verlaine said, "De la musique avant toute chose," he was not only asking poetry to be more suggestive—suggestiveness after all, was a poetic ideal foisted upon music—but also to affect the reader or listener with more immediate and more powerful sensations.

But only when the avant-garde's interest in music led it to consider music as a *method* of art rather than as a kind of effect did the avant-garde find what it was looking for. It was when it was discovered that the advantage of music lay chiefly in the fact that it was an "abstract" art, an art of "pure form." It was such because it was incapable, objectively, of communicating anything else than a sensation, and because this sensation could not be conceived in any other terms than those of the sense through which it entered the consciousness. An imitative painting can be described in terms of non-visual identities, a piece of music cannot, whether it attempts to imitate or not. The effects of music are the effects, essentially, of pure form; those of painting and poetry are too often accidental to the formal natures of these arts. Only by accepting the example of music and defining each of the other arts solely in the terms of the sense or faculty which perceived its effect and by excluding from each art whatever is intelligible in the terms of any other sense or faculty would the

non-musical arts attain the "purity" and self-sufficiency which they desired; which they desired, that is, in so far as they were avant-garde arts. The emphasis, therefore, was to be on the physical, the sensorial. "Literature's" corrupting influence is only felt when the senses are neglected. The latest confusion of the arts was the result of a mistaken conception of music as the only immediately sensuous art. But the other arts can also be sensuous, if only they will look to music, not to ape its effects but to borrow its principles as a "pure" art, as an art which is abstract because it is almost nothing else except sensuous.[2]

## V

Guiding themselves, whether consciously or unconsciously, by a notion of purity derived from the example of music, the avant-garde arts have in the last fifty years achieved a purity and a radical delimitation of their fields of activity for which there is no previous example in the history of culture. The arts lie safe now, each within its "legitimate" boundaries, and free trade has been replaced by autarchy. Purity in art consists in the acceptance, willing acceptance, of the limitations of the medium of the specific art. To prove that their concept of purity is something more than a bias in taste, painters point to Oriental, primitive and children's art as instances of the universality and naturalness and objectivity of their ideal of purity. Composers and poets, although to a much lesser extent, may justify their efforts to attain purity by referring to the same precedents. Dissonance is present in early and non-Western music, "unintelligibility" in folk poetry. The issue is, of course, focused most sharply in the plastic arts, for they, in their non-decorative function, have been the most closely associated with imitation, and it is in their case that the ideal of the pure and the abstract has met the most resistance.

The arts, then, have been hunted back to their mediums, and there they have been isolated, concentrated and defined. It is by virtue of its medium that each art is unique and strictly itself. To restore the identity of an art the opacity of its medium must be emphasized. For the visual arts the medium is discovered to be

2. The ideas about music which Pater expresses in *The School of Giorgione* reflect this transition from the musical to the abstract better than any single work of art. [Author's note]

physical; hence pure painting and pure sculpture seek above all else to affect the spectator physically. In poetry, which, as I have said, had also to escape from "literature" or subject matter for its salvation from society, it is decided that the medium is essentially psychological and sub- or supra-logical. The poem is to aim at the general consciousness of the reader, not simply his intelligence.

It would be well to consider "pure" poetry for a moment, before going on to painting. The theory of poetry as incantation, hypnosis or drug—as psychological agent then—goes back to Poe, and eventually to Coleridge and Edmund Burke with their efforts to locate the enjoyment of poetry in the "Fancy" or "Imagination." Mallarmé, however, was the first to base a consistent practice of poetry upon it. Sound, he decided, is only an auxiliary of poetry, not the medium itself; and besides, most poetry is now read, not recited: the sound of words is a part of their meaning, not the vessel of it. To deliver poetry from the subject and to give full play to its true affective power it is necessary to free words from logic. The medium of poetry is isolated in the power of the word to evoke associations and to connote. Poetry subsists no longer in the relations between words as meanings, but in the relations between words as personalities composed of sound, history and possibilities of meaning. Grammatical logic is retained only in so far as it is necessary to set these personalities in motion, for unrelated words are static when read and not recited aloud. Tentative efforts are made to discard metric form and rhyme, because they are regarded as too local and determinate, too much attached to specific times and places and social conventions to pertain to the essence of poetry. There are experiments in poetic prose. But as in the case of music, it was found that formal structure was indispensable, that some such structure was integral to the medium of poetry as an aspect of its resistance. . . . The poem still offers possibilities of meaning— but only possibilities. Should any of them be too precisely realized, the poem would lose the greatest part of its efficacy, which is to agitate the consciousness with infinite possibilities by approaching the brink of meaning and yet never falling over it. The poet writes, not so much to *express*, as to create a thing which will operate upon the reader's consciousness to produce the emotion of poetry. The content of the poem is what it does to

33

the reader, not what it communicates. The emotion of the reader derives from the poem as a unique object—pretendedly—and not from referents outside the poem. This is pure poetry as ambitious contemporary poets try to define it by the example of their work. Obviously, it is an impossible ideal, yet one which most of the best poetry of the last fifty years has tried to reach, whether it is poetry about nothing or poetry about the plight of contemporary society.

It is easier to isolate the medium in the case of the plastic arts, and consequently avant-garde painting and sculpture can be said to have attained a much more radical purity than avant-garde poetry. Painting and sculpture can become more completely nothing but what they do; like functional architecture and the machine, they *look* what they *do*. The picture or statue exhausts itself in the visual sensation it produces. There is nothing to identify, connect or think about, but everything to feel. Pure poetry strives for infinite suggestion, pure plastic art for the minimum. If the poem, as Valéry claims, is a machine to produce the emotion of poetry, the painting and statue are machines to produce the emotion of "plastic sight." The purely plastic or abstract qualities of the work of art are the only ones that count. Emphasize the medium and its difficulties, and at once the purely plastic, the proper, values of visual art come to the fore. Overpower the medium to the point where all sense of its resistance disappears, and the adventitious uses of art become more important.

The history of avant-garde painting is that of a progressive surrender to the resistance of its medium; which resistance consists chiefly in the flat picture plane's denial of efforts to "hole through" it for realistic perspectival space. In making this surrender, painting not only got rid of imitation—and with it, "literature"—but also of realistic imitation's corollary confusion between painting and sculpture. (Sculpture, on its side, emphasizes the resistance of its material to the efforts of the artist to ply it into shapes uncharacteristic of stone, metal, wood, etc.) Painting abandons chiaroscuro and shaded modelling. Brush strokes are often defined for their own sake. The motto of the Renaissance artist, *Ars est artem celare*, is exchanged for *Ars est artem demonstrare*. Primary colors, the "instinctive," easy colors, replace tones and tonality. Line, which is one of the most ab-

stract elements in painting since it is never found in nature as the definition of contour, returns to oil painting as the third color between two other color areas. Under the influence of the square shape of the canvas, forms tend to become geometrical— and simplified, because simplification is also a part of the instinctive accommodation to the medium. But most important of all, the picture plane itself grows shallower and shallower, flattening out and pressing together the fictive planes of depth until they meet as one upon the real and material plane which is the actual surface of the canvas; where they lie side by side or interlocked or transparently imposed upon each other. Where the painter still tries to indicate real objects their shapes flatten and spread in the dense, two-dimensional atmosphere. A vibrating tension is set up as the objects struggle to maintain their volume against the tendency of the real picture plane to re-assert its material flatness and crush them to silhouettes. In a further stage realistic space cracks and splinters into flat planes which come forward, parallel to the plane surface. Sometimes this advance to the surface is accelerated by painting a segment of wood or texture *trompe l'oeil*, or by drawing exactly printed letters, and placing them so that they destroy the partial illusion of depth by slamming the various planes together. Thus the artist deliberately emphasizes the illusoriness of the illusions which he pretends to create. Sometimes these elements are used in an effort to preserve an illusion of depth by being placed on the nearest plane in order to drive the others back. But the result is an optical illusion, not a realistic one, and only emphasizes further the impenetrability of the plane surface.

The destruction of realistic pictorial space, and with it, that of the object, was accomplished by means of the travesty that was cubism. The cubist painter eliminated color because, consciously or unconsciously, he was parodying, in order to destroy, the academic methods of achieving volume and depth, which are shading and perspective, and as such have little to do with color in the common sense of the word. The cubist used these same methods to break the canvas into a multiplicity of subtle recessive planes, which seem to shift and fade into infinite depths and yet insist on returning to the surface of the canvas. As we gaze at a cubist painting of the last phase we witness the birth and death of three-dimensional pictorial space.

And as in painting the pristine flatness of the stretched canvas constantly struggles to overcome every other element, so in sculpture the stone figure appears to be on the point of relapsing into the original monolith, and the cast seems to narrow and smooth itself back to the original molten stream from which it was poured, or tries to remember the texture and plasticity of the clay in which it was first worked out.

Sculpture hovers finally on the verge of "pure" architecture, and painting, having been pushed up from fictive depths, is forced through the surface of the canvas to emerge on the other side in the form of paper, cloth, cement and actual objects of wood and other materials pasted, glued or nailed to what was originally the transparent picture plane, which the painter no longer dares to puncture—or if he does, it is only to dare. Artists like Hans Arp, who begin as painters, escape eventually from the prison of the single plane by painting on wood or plaster and using molds or carpentry to raise and lower planes. They go, in other words, from painting to colored bas-relief, and finally—so far must they fly in order to return to three-dimensionality without at the same time risking the illusion—they become sculptors and create objects in the round, through which they can free their feelings for movement and direction from the increasing ascetic geometry of pure painting. (Except in the case of Arp and one or two others, the sculpture of most of these metamorphosed painters is rather unsculptural, stemming as it does from the discipline of painting. It uses color, fragile and intricate shapes and a variety of materials. It is construction, fabrication.)

The French and Spanish in Paris brought painting to the point of the pure abstraction, but it remained, with a few exceptions, for the Dutch, Germans, English and Americans to realize it. It is in their hands that abstract purism has been consolidated into a school, dogma and credo. By 1939 the center of abstract painting had shifted to London, while in Paris the younger generation of French and Spanish painters had reacted against abstract purity and turned back to a confusion of literature with painting as extreme as any of the past. These young orthodox surrealists are not to be identified, however, with such pseudo- or mock surrealists of the previous generation as Miró, Klee and Arp, whose work, despite its apparent intention, has

36

only contributed to the further deployment of abstract painting pure and simple. Indeed, a good many of the artists—if not the majority—who contributed importantly to the development of modern painting came to it with the desire to exploit the break with imitative realism for a more powerful expressiveness, but so inexorable was the logic of the development that in the end their work constituted but another step towards abstract art, and a further sterilization of the expressive factors. This has been true, whether the artist was Van Gogh, Picasso or Klee. All roads led to the same place.

## VI

I find that I have offered no other explanation for the present superiority of abstract art than its historical justification. So what I have written has turned out to be an historical apology for abstract art. To argue from any other basis would require more space than is at my disposal, and would involve an entrance into the politics of taste—to use Venturi's phrase—from which there is no exit—on paper. My own experience of art has forced me to accept most of the standards of taste from which abstract art has derived, but I do not maintain that they are the only valid standards through eternity. I find them simply the most valid ones at this given moment. I have no doubt that they will be replaced in the future by other standards, which will be perhaps more inclusive than any possible now. And even now they do not exclude all other possible criteria. I am still able to enjoy a Rembrandt more for its expressive qualities than for its achievement of abstract values—as rich as it may be in them.

It suffices to say that there is nothing in the nature of abstract art which compels it to be so. The imperative comes from history, from the age in conjunction with a particular moment reached in a particular tradition of art. This conjunction holds the artist in a vise from which at the present moment he can escape only by surrendering his ambition and returning to a stale past. This is the difficulty for those who are dissatisfied with abstract art, feeling that it is too decorative or too arid and "inhuman," and who desire a return to representation and literature in plastic art. Abstract art cannot be disposed of by a simple-minded evasion. Or by negation. We can only dispose of abstract art by assimilating it, by fighting our way through it.

37

Where to? I do not know. Yet it seems to me that the wish to return to the imitation of nature in art has been given no more justification than the desire of certain partisans of abstract art to legislate it into permanency.

*Partisan Review*, July-August 1940; *Pollock and After: The Critical Debate*, ed. Francis Frascina, 1985.

4.   An American View

One important reason for the reluctance of the British and French ruling classes to go to war with Nazi Germany was the realization that in order to go all out in such a war they would have to proclaim an anti-fascist crusade, an "ideological" war, than which there is nothing more repellent to the leaders of the bourgeois democracies. From the point of view of their own class interests they are right. For a capitalist country to raise anti-fascist slogans during a war is to play with fire: slogans re-quire a positive as well as a negative content; anti-fascist slo-gans, when they have any real drive to them begin to suggest too much that is antithetical to capitalism no less than to fascism: such things as social and economic democracy, mass participa-tion in the guidance of the nation, integral freedom of speech and action, etc. The heat of war would force these slogans from the realms of the safely abstract into the regions of the danger-ously concrete. Rather than gamble with this danger, the rulers of Great Britain and France preferred to gamble with what was for them a lesser danger, defeat at the hands of Hitler. Instead of declaring war against a principle and a system, they declared it against a personality and a people. Instead of blaming the war upon fascism, they blamed it, once more, upon a people. In books and magazines the "problem" of Germany—how the corpse was to be disposed of after the kill—was discussed, but very little was said about the problem of fascism. They named the enemy by his family name, they docketed his ancestry and personal habits, but they were very careful not to permit him to stand for anything except the broadest abstractions such as in-justice, tyranny, totalitarianism and so forth. By skipping back

and forth between the very general and the very particular one manages to avoid dangerous topics.

Despite some vague talk about a European federation and the elimination of international injustices, we were given to understand that Hitler must be destroyed in order to restore the *status quo*. But the masses in Britain and France are not satisfied enough with the *status quo* to die for it. Not having experienced a Versailles treaty in the recent past, the prospect of losing the war does not terrify them as much as it does the Germans; and having experienced the disillusion of victory, they expect much less from one than do the Germans. The French workers, moreover, were in retreat when the war broke out. All they had won in 1936 had been taken away from them, and they saw relatively little left to defend against Hitler—not even "national honour"; especially when those who mouthed the phrase most sold it shortest. Yes, for the French, at any rate, the fatherland idea had lost its credit; it couldn't even buy xenophobia, much less fighting spirit. Only a sincere anti-fascist programme could have done that.

The strategical and tactical mistakes made by the allied rulers are but the reflection of their refusal to face the historical situation squarely. Military methods flow from political ones. The defence of the *status quo* of 1918 constrains the British and French to the strategy and tactics of 1918. Hitler's revolutionary methods of warfare derive from his revolutionary political methods—albeit these methods are revolutionary only in the sense that they are new ways of preserving capitalism. Hitler realizes this much: that in order to keep capitalism there must be fascism; Trotsky realizes that in order to keep democracy there must be a socialist revolution. We cannot stand still. We can only keep what we value by adding to it. To preserve, we must change; to meet the attrition of time, we must launch our own offensives. As Goethe says: *"Nur der die Freiheit sich verdient, der täglich sie erobern muss."* Only he earns freedom who must win it daily.

The war no longer permits any straddling. There is not enough room left for that. We must choose: either capitalism or democracy. One or the other must go. If we insist on keeping capitalism then we cannot fight Hitler. He must win. This is the dilemma which faces British and French capitalism and pre-

vents it from fighting the war wholeheartedly. This is why it does not dare to launch anti-fascist slogans. The fate of the profit system is in charge of the enemy. It is no longer a question pure and simple of a redistribution of imperialist loot as it was in 1914, when the Kaiser stood substantially for the same thing as Clemenceau. History never repeats itself that prettily. Today only German economic and military might can assure a capitalist Europe. An Allied victory would but weaken the power to survive of capitalism, for, as Trotsky says, Great Britain and France no longer have the specific economic gravity to dominate Europe. They have done so since the last war only by maintaining at the expense of Central and Eastern Europe a forced and unnatural equilibrium fraught with great dangers for capitalism as a whole in that it created revolutionary situations. (Stalin's Comintern can be thanked for the fact that none of them were taken advantage of.) If Europe is to remain capitalist, then, it must become fascist, and if it becomes fascist it must submit to Germany, for, as I have said, only German arms and the German economy have both the will and the capacity to police Europe for fascism. Fascist Britain and fascist France can no more escape becoming satellites of Germany than Italy and Spain have. The Battle of the Meuse and the demoralization of their own officer cadres—which were themselves rotten with fascists and flirters with fascism—suffice to convince the French capitalists of what a good many of them had already suspected: that the only way out for them is submission to Hitler. To delay will be too expensive. And by climbing aboard Hitler's bandwagon in time they hope to win his leniency. When the interests of capitalism as a whole system come in conflict with those of national policy, capitalists will always decide sooner or later in favour of the former. The case of Spain proves that. And since the rise of Hitler-fascism the national policies of the British and French could not be aligned effectively with those of world capitalism, which can no longer allow itself the illusions of colonial luxury, labour aristocracies and democracy. British capitalism is reluctant to admit, and it has every reason to be, that its salvation lies with Hitler. And in this reluctance lies a danger to itself, of which we must take advantage. For if it does not capitulate to Hitler in time, there will be a revolution in Britain led by the only element in British society that means to fight Hitler in earnest, the

working class. But the problem is not to postpone the capitulation: it is how to make effective as immediately as possible the demand that the working class be given control of the conduct of the war against Hitler.

The very fact of a socialist Britain would knock two wheels out from under Hitler's cart. As long as Britain fights under a Churchill and a Duff Cooper the German masses will remain solidly united behind the Nazis. They well know that all they can expect from Hitler's defeat at such hands is a second and worse Versailles. This fear has converted many a German from an anti- to a pro-Nazi. Without this fear the Nazis would have hardly any more moral reserves at their command than the erstwhile Allies, allowance made for the initial victories. The bright future of plunder which Hitler promises his people only convinces the adolescents.

The dubious future of a federated *capitalist* Europe convinces no one. The only future which offers any hope and any credibility to the masses is that of socialism. But it is a future they cannot take on promise. They must make it themselves. And the first step in that direction is to take upon themselves the task of eliminating Hitler. Over here in America the problem is the same, almost exactly the same.

A socialist revolution in the West would send an answering thrill through the German workers. It would come with idealism and sincerity; it would invite the world to join it in fraternity and love—yes, *love*. It would not be Stalin, it would not be tangled up with the barbarism, accidental to itself, of a backward country. It would have difficulties of its own, no doubt, blood, unpleasantness—for every step forward in history involves tragedy—*but it would come to a world that is ready for it.* [1]

*Horizon*, September 1940

1. Cyril Connolly, in an unsigned article which followed immediately after Greenberg's, rejected Greenberg's conclusions. "The article," wrote Connolly, "represents in extreme form a point of view that is constantly expressed by the English Left—by the *New Statesman, Daily Mirror, News Chronicle*, etc. Being put in such simple and violent terms, and from so far away, it enables the force of the argument to be judged with clarity. It is obvious that this view, which is widely held, rests on an over-simplification of the facts, and if put into practice would lead to disaster." [Editor's note]

# 1941

5. The Renaissance of the Little Mag: Review of *Accent*,
   *Diogenes*, *Experimental Review*, *Vice Versa*, and *View*

There is a revival under way, it seems, in avant-garde writing in
this country. The past fall has seen a burgeoning of little maga-
zines such as has not been in many a year. *New Directions*, the
principal bound organ of advanced writing in America, an-
nounces a crowd of new names for its 1940 issue. The shades of
the Twenties are abroad, returned to daylight for the first time
since politics took over. There are other signs. One can suggest
various factors that account for all this: the collapse of the intel-
lectual authority of Stalinism, which in the past six or seven
years smothered more embers than it fanned; the relative ex-
haustion at this moment of "accepted" writing; the influx of
writers and artists from Europe; with that, the realization that
this country is the only important place left where it is still pos-
sible to pursue culture without the too immediate interference
of events. In other words, we are on the spot. If writing as crea-
tive activity is not to disappear, it is up to us. How much time is
left? And how shall we make the most of it? The answer to the
first question depends on the world, the answer to the second on
ourselves.

Let us hope meanwhile that there will not be too much repe-
tition of the old attitudes, the old affectations, the old stunts.
Not because the new is valuable just because it is new, but be-
cause the old, the conventionalized attitudes of the avant-garde
are bankrupt—and the situation has changed. One picks up the
new magazines in hopes of hearing goodbye said to a good many
of the conventions of Experiment, with all the rites, ignorance,
enfants terribles and boredom that went with them. . . .

*View*, of which three numbers have already appeared, is a tab-
loid-sized "poets' paper" put out by a group of American sur-
realists in New York. From it we gather that the surrealists are

unwilling to say goodbye to anything. And that the American species identifies literature and art with its social life, and that this social life is complicated and satisfying. The gossip is good if you know the names; if you know the people I imagine it might get to be a little too much.[1] Sometimes it is even a little too much for plain strangers. In the second number a letter from France is quoted, written by a person whose name the editor wisely suppresses, and who seems to have read Gertrude Stein and the great French novelists, in which the following is no less than said: "Nantes was too lovely—the Balzac period stopped and Stendhal began. There were all the refugees in big carts pulled by 8 horses or oxen, millions, no one ever saw such a thing as a whole population in migration since the time of the Merovingian kings. After was [*sic*] the 9th army coming back, it was the end of the battle of Waterloo in the *Rouge et le Noir*.[2] Nantes was bombarded quite a lot every day but not much got broken but in the end quite a lot of people had been killed." I am for the extinction of the milieu which has produced this creature.

To go from the putrescent to the pubescent (the last in no derogatory sense), *Diogenes*, published in a good-looking cover from Madison, Wisconsin, is earnest and ambitious, and proposes to devote a good deal of attention to contemporary foreign literature. It promises one new writer, Frank Jones, whose article on Bert Brecht in the initial (October-November) number is first-rate, being positive and passionate. I also recommend the same writer's translation of Brecht's poem *Vanished Glory of New York the Giant City*. The poetry which fills most of the remainder of the magazine is somewhat thin, the usual little magazine verse, with a mixture of old and new names—but it's the only stuff from which our hope can come, and it has to be published. There is nothing else.

Bigger names feature in the first number (November-December) of *Vice Versa*, published in New York. The magazine has a rather English orientation, borne out by its *New Verse* format.

1. In the second number of *View*, October 1940, Nicolas Calas disparaged Greenberg's paintings (which he had seen at Greenberg's apartment) and his criticism. [Editor's note]

2. The battle of Waterloo is described in *La Chartreuse de Parme*. [Author's note]

Its program is poetry, and it does provide us with a good poem in rhymed Fearingese by M. D. Tarantula, a superb translation by Clark Mills of a French poem by Ivan Goll, and a pretty good discursive poem by Auden, which sufers from that common malady of modern poetry, a bad last line. A longish poem by George Barker is filled with the too easy and mechanical vigor of the latest rhetoric about the latest events, but at that it is well done. Most of the newcomers are still tuning their instruments, yet manage to maintain a fairly high standard. There is a very competent and mature review of MacNeice's and Empson's latest books by Dunstan Thompson. However, what I like particularly about *Vice Versa* is the editorials and comment of Harry Brown, who writes with force, impudence and wit. Apparently, he is out to get himself widely disliked. More power to him. But I would prefer a little more positive emphasis to his violence.

The tendency of *Experimental Review*, published out of Woodstock, N. Y., is domestic goods exported to Paris for manipulation and thence re-imported. There is a flavor of cult, and there are saints, living and dead: D. H. Lawrence, James Joyce, Henry Miller, Anais Nin, Kenneth Patchen, and the editor's private saint, St. John Perse. There is a definite, if only negative, direction—negative because it is direction away from rather than towards something; away from the lighted world of distinctions and ordered relations the acolytes go, to spread out and scatter off in different directions into the vast regions of what is not. Unfortunately most are not enough acquainted with what is to be able to determine what is not. The enormous universe of the nether, sub- and unconscious turns out to be rather shabby and provincial for all its glitter moderne, something like California, a refuge for those who have just enough culture to be tired of it. Most of the writing in the second (November) number of *Experimental Review*—I missed the first—is *Schwärmerei*, fake surrealism, *transition* bunk, which a psychiatrist would return to his patients for revision. However, there is a pleasant surprise. One new poet, Sanders Russell, shows a great deal of promise in a set of twelve poems which exhibit a quite original feeling for the pictorial possibilities of language. Virtues shine brightly through a screen of not too serious blemishes. If he is not domesticated by his environment, Russell ought to come to something.

*Accent* comes in a subdued cover from Urbana, Illinois, and presents as a professedly unique feature, an evenly balanced assortment of poems, short stories and critical articles. Its "unbiased" editorial policy belies its name, placing accent upon nothing in particular and asking to be nothing more than a grab bag of good reading. A lot of the names are familiar: two of them, Jerome Weidman and Meyer Levin, come under the heading of definitely safe writers, and I think we can consider Otis Ferguson, Selden Rodman, Richard Aldington and William March as almost equally safe. The poetry is good enough, but is also safe and familiar. There are fine poems by Wallace Stevens and August Derleth; I must however protest against those well-trimmed façades of language, which are the poems of Marya Zaturenska. The short stories by Weidman, Levin and March are pieces of competent triviality, dressed-up gags, which should have no place in a little magazine. And the critical articles and book reviews are either banal or amateurish, or both. As a whole the magazine is unexciting and unambitious. It leaves the reader with a strong thirst for a good refreshing dose of bias. . . .

Nowhere better than in these little magazines is borne out the point about the estrangement of American writers from ideas which Philip Rahv made in his article "The Cult of Experience" in the last number of *Partisan Review*. For the chief difficulty of little magazines in this country is, after money, ideas. The lack of both. The latest crop have no other program than, at best, the wish to experiment and an abstract notion of quality. The want of intellectual adventurousness, the narrowness and the ingrown and exclusive preoccupation with literature are in their way appalling. These are the usual asserverations of non-partisanship, political and otherwise; the only side taken is that of quality. And as usual the editors will probably wait around, wringing their hands, for the good stuff to come through. And meanwhile there will be nothing to fall back upon except the old habits, the old hacks (are there, or are there not, little magazine hacks?) and the old anemia.

Let us assume that the good writing wanted is the good writing of the future and not that of the past. It cannot be found by a blind search. Good writing does not grow like flowers in the fields, which need only a receptacle in order to become fruit, which awaits only a magazine with high standards and an open-

minded policy, to come drifting in on the first wind. The editors of the little magazines don't believe this entirely themselves, for they talk about *stirring up* good writing. The function of a little magazine is to be an agent. In order to act as an agent and stir up good writing there must be some kind of positive notion, some working hypothesis, a bias in a particular direction, even a prejudice, as to what this good writing of the future will be like. As Kant says, you only find what you look for. I don't mean by this that it is necessary to be dogmatic and to have fixed ideas against which everything is to be measured. I mean simply that more thinking and inquiring should be done about the problem. And if the thinking is serious and bold enough, I am sure that important, exciting and germinative ideas will be turned up. Frank Jones's article in *Diogenes* is an example of what should be done; because it affirms the desirability of a certain kind of writing and presents in positive terms the work of a writer who exemplifies that kind of writing.

And if enough thinking and inquiring and speculating is done I am sure that it will be found that the question cannot be solved in exclusively literary terms. What I am leading up to, to put it bluntly, is a call for a return to politics—not the politics of a particular party or faction, but thinking about politics. The revulsion against politics has been too extreme and at the same time, so to speak, defective. There has been a turning away from it, but not from the kind of emotion and the kind of literature politics helped produce. The pathos of Stalinism has been remembered, but hardly any of the ideas connected with the revolution. This pathos persists because politics in some form or other cannot be eliminated today. All important questions become political questions in a much more immediate sense than in the past. The world is that way now. . . . So much of the latest poetry, for example, is alike in that it strives to reach the same tone, one of public portent. And public portent is political portent.

But to be publicly portentous one must have opinions. Even Jeremiah had opinions. He not only predicted and anticipated doom and its emotions, but he also saw the logic of doom, its reason and sense, such as he could or would; i.e., he had opinions about doom. And to have serious opinions one must have ideas—political ideas. But one is afraid of political opinions;

46

they involve you in partisanship and in arguments that have nothing to do with poetry. One is for culture, for everything that's good, but one does not have political opinions.

I have neither the desire nor the capacity to lecture, and there are no prescriptions for good poetry. It is always hard to write, even under Queen Elizabeth. And it is not demanded that political ideas be or not be "injected" into contemporary poetry. Demands upon poetry are silly when they are made too specific. But since so many young poets (and I am thinking about those in *Vice Versa* particularly) cannot tear themselves away from history, its present disasters, since they are always hearing the clock strike twelve, fists against the door, rifles firing in the next valley, since they insist on wondering about what's going to happen to us all, they can be asked to try to understand history as well as they are able. If they do this they will have ideas, and if they have ideas they will have programs, and if they have programs they will take sides. And as for their poetry—it will need less than now to be journalistic and modish in order to be pertinent.

*Partisan Review*, January–February 1941

## 6.  Aesthetics as Science: Review of *The Structure of Art* by Carl Thurston

This book might serve as a text on the typical biases of the American mind: its positivism, its unwillingness to speculate, its eagerness for quick results, and its optimism. Mr. Thurston proposes that aesthetics be treated as a science rather than as a branch of philosophy, and its theories as working hypotheses of which the most that can be hoped is a high degree of probability instead of final certainty. Restricting himself to the investigation of the "spatial" arts which do not involve actual movement, he illustrates a possible scientific method for the use of aesthetics in general. He begins by assuming that the basic "ingredients" of the spatial arts are visual units, empty space, and the human being who perceives them. These "generate" four sets of relationships, which in turn form the "elements" of the spatial arts: "(1) . . . between visible shapes, (2) between such shapes and

the space within and around them, (3) between such shapes and whatever space falls within their spheres of influence and the human observer and (4) relationships developed within the personality of this observer by contact with a work of art." Using these relationships as his working hypothesis and as far as possible analyzing his material in their terms, the author attempts to extract the norms of successful practice and appreciation in the arts of decoration, architecture, sculpture, and painting. He animadverts constantly upon the philosophizers of aesthetics who try to explain everything by deduction from a single theory, and is quite willing, when he comes upon something which resists analysis in his terms, to resort to a plurality of hypotheses. This confuses the reader at times and seriously weakens the coherence of Mr. Thurston's arguments. On the other hand, the author's attention to the concrete contexts in which the artist and the observer work, his respect for the minutiae of art, are refreshing and illuminating. His statement of the "variables" and "invariables" with which the artist must operate points out a path for much rewarding inquiry in the future. And he resolves with far more success than I have seen elsewhere the problem of balance in the graphic arts, restating it as a matter of spheres of attraction emanating from visual points governed by the two "variables" of distance and inherent interest.

But even in an elementary way, Mr. Thurston does not clear up as much as he promises. It is not only that his treatment of theoretical questions is sketchy: some of his unobtrusive generalizations are rash without being imaginative. In fact, they are rashly academic; for example, that "fuzziness of outline" in woodcuts is as a "general style of treatment . . . fatal." Mr. Thurston is practical above all else, and he is interested in results. That which has worked in the past, he implies, must work always. But art can get away with anything. Lord help it if it is ever deterred by statistical norms of success such as those Mr. Thurston comes dangerously close at times to establishing. His book would have been much more valuable if he had shown himself more aware of what a ticklish question norms in art is.

Nor does the application of Mr. Thurston's hypothetical method serve greatly to resolve the focal problem with which the philosophizers of aesthetics have occupied themselves so far: Why does art affect us as it does? In his conclusion, where he

faces the question formally and more frankly, his answers are borrowed from philosophers.

*The Nation*, 22 February 1941

7.    Bertolt Brecht's Poetry

There is a kind of modern poetry that gets its character from a flavoring of folk or popular culture. You will find it in the work of such poets as Apollinaire, Lorca, Mayakovsky and Cummings. Rimbaud and Laforgue are its original ancestors, as of so much else in modern poetry. It is anti-literary and anti-rhetorical. It takes over the attitudes and manners of folk and popular poetry for their tang, sincerity, irreverence and lack of pretention, as against the formality and overstatement of "book" literature, as against the endowed, the established, the respectable, in other words, as against Literature itself. This modernist poetry is racy and exuberant in backward countries like Spain and Russia, where folk culture still survives side by side with the formal culture of the city. In France, England and in this country it become wistful and impudent, and keeps to a minor key. It always has humor and sometimes, as in the case of Lorca, a justifiable quaintness, both of which are created by the transposition of the naive and lowbrow into sophisticated and highly self-conscious modes.

As much as Germany participated in "modern" movements, it never produced a poetry of this sort. Whereas in this country, France and England on the one hand, and in Spain and Russia on the other, popular and folk culture are far enough away from highbrow international culture to have spice and contrast, in Germany folk poetry has so become part of the main literary stream through the work of Herder and the Romantics that it cannot be opposed to it. At the same time German popular literature, including kitsch, is also intimately associated with folk culture. For this reason until rather lately there was no sharp line to be drawn between highbrow and lowbrow in German poetry. Popular songs in Germany are not art, but neither are they half so shoddy as their French and American equivalents. (Compare

the verse of such frankly popular German songs as *Zwei Herzen in Dreivierteltakt* and *Jeden Sonntagabend das Dorfmusic Spielt* with anything on the same order in English or French.) They still show the saving evidences of a recent folk ancestry.

The late development of German culture, which accounts for this, also accounts for the peculiar nature of German avant-garde movements, which were never so detached from and irre-sponsible towards official culture as in France and elsewhere. The fact is, that the Germans do not have enough classic litera-ture, have not produced enough in the past to enable them to dispense with ambitious contemporary work. There is not, ac-tually, enough to read, enough to counterpose to the present. (This is why the Germans translate so much.) So that no sooner did German avant-garde movements appear than they were re-absorbed by official tradition and by society as a whole, no matter how intransigent they may have tried to be. Rilke's poems could sell 60,000 copies, and before Hitler, Germany was the best market for advanced painting. Stefan George and his circle, with all their contempt for the bourgeois herd, found themselves raised very early to the status of official prophets of the beautiful; and their fate was that of almost every avant-garde cénacle in Germany during the late 19th and early 20th centuries.

When Bertolt Brecht found himself pulled in the direction of Rimbaud—the Rimbaud of *Season in Hell*—he had to start from scratch to devise a means of reflecting this influence. He could not learn from Apollinaire, nor from Expressionism or anything else in German. So he proceeded to do something quite original by developing a poetry of *serious* parody, compelled and helped by the peculiar nature of German literary tradition. Popular and folk poetry are but one ingredient of the advanced, experi-mental, international styles of Apollinaire, Lorca, Mayakovsky and the others. In Brecht's first phase the verse technique itself is more or less conventional, experiment being confined to an oc-casional variation of beat or a daring enjambment. It is hardly the kind of poetry we expect from one who as a playwright was under the influence of Expressionism, and whose fellow poets of the same generation were more or less dominated by it. What is new is not what we customarily associate with the new in mod-ern poetry, but consists in the way in which Brecht exploits the

past and popular accomplishments of German poetry for his own subversive and anti-literary irony.

Parody ordinarily finds its end in what it parodies, but in Brecht's hands it became the means to something beyond itself, more profound and more important. The special quality of Brecht's poetry—particularly until 1927 when his *Hauspostille* collection was published, shortly after which he first became a Communist sympathizer—arose from a disparity. He took a form like the German ballad, which is inextricably associated with the countryside and a semi-feudal way of life, and charged it with a new *city* content and feeling too powerful and morbid for the ballad convention to bear. This incongruity is the strength of the poetry, is a good part of it. Now, were one to do this in English the result would be comic and very little else, for there would be too great a disparity to produce anything but humor. The English ballad is literary archaeology, and it is as archaeology that it appears in Coleridge, Keats, Rossetti and Morris, who escape the ridiculous only because—wisely and romantically—they fit it with an appropriate historical content. But the German ballad was in a sense still alive as late as Heine and Mörike; its originals had not yet completely disappeared from the German countryside. And today it is still almost a serious form, too recently dead to be quaint, still taken seriously by several contemporary German poets whose verse is much less stale than John Masefield's. What is true of the ballad is more or less true of most of the other forms parodied by Brecht. The popular and traditional modes which Brecht uses are still strong enough to resist what Brecht wants to make them say in more ways than by producing humor. They still live respectably outside textbooks, and their associations are part of the life of almost every German. Brecht acclimatizes them, and Goethe and Luther as well, to shady neighborhoods. Thus the two poles of Brecht's early poetry are not so much the naive or quaint as opposed to the sophisticated, as the dangerous and irreverent as opposed to the safe and the respectable, the slums and the gutter as opposed to the countryside and suburbs. The incongruities must in some measure proclaim themselves by humor, but it is not the humor of the ridiculous, but rather that of irony.

The stanza, meter and some turns of phrase, even the motif,

of Brecht's *Legende vom Toten Soldat*, or Legend of the Dead Soldier, might be those of an 18th century folk song still sung today in Germany by school-children. Many German ballads are about soldiers and death, and Brecht's theme is really congruent to his form. But his content and feeling are utterly opposed to the content and feeling with which this form and this theme have generally been associated. A great deal of the poem's force springs from this contradiction:

> *Und als der Krieg im fünften Lenz*
> *Keinen Ausblick auf Frieden bot*
> *Da zog der Soldat seine Konsequenz*
> *Und starb den Heldentod.*
>
> *Der Krieg war aber noch nicht gar*
> *Drum tat es dem Kaiser leid*
> *Dass sein Soldat gestorben war:*
> *Es schien ihm noch vor der Zeit. . . .*
>
> *Und sie nahmen sogleich den Soldaten mit*
> *Die Nacht war blau and schön.*
> *Man konnte, wenn man keinen Helm aufhatte*
> *Die Sterne der Heimat sehn.*
>
> *Sie schütteten ihm einen feurigen Schnaps*
> *In den verwesten Leib*
> *Und hängten zwei Schwestern in seinen Arm*
> *Und sein halb entblösstes Weib.*
>
> *Und weil der Soldat nach Verwesung stinkt*
> *Drum hinkt ein Pfaffe voran*
> *Der über ihn ein Weihrauchfass schwingt*
> *Dass er nicht stinken kann.*
>
> *Voran die Musik mit Tschindrara*
> *Spielt einen flotten Marsch.*
> *Und der Soldat, so wie er's gelernt*
> *Schmeisst seine Beine vom Arsch. . . .* [1]

1. And as the war in its fifth spring gave no prospect of peace, the soldier came to the logical conclusion and died a hero's death.

The war was not quite over yet, it caused the Kaiser pain to have his soldier die: it seemed ahead of time. . . .

And they immediately took the soldier along, the night was blue and fine. You could see, if you wore no helmet, the stars at home.

They poured a fiery schnaps into the rotten body and hung two nurses on his arm and his half-naked wife.

The seeming crudeness of the meter, the dry, banal idiom and the economy of details are the setting against which the ballad projects its horror, intensified by the contrast. This is really parody in reverse, for what Brecht does is to raise the ballad form to a dignity it has not enjoyed for a long time, even in Germany. Nevertheless, it is parody. The humor, savage as it is, results largely from the contrast between the situation and the accumulated habitual responses provided by tradition—it is not simply that Brecht uses a certain formal pattern: he uses everything historically connected with that pattern—and what that situation and those responses develop into. The ballad style of understatement is over-extended and, in a way, criticized, by being forced to understate grotesque and ludicrous horror. . . .

Brecht is a consummate parodist because he is above all a playwright and dramatic poet, and by instinct puts on a mask before speaking. He is a satiric poet, but down at bottom not a lyricist. He has to cast himself in a role before the poetry can come. All the poems, save for a few, in the *Hauspostille*, or Homilies for the Home, are parodies in some way or other. Everything is grist for Brecht's mill: the Lutheran hymn, Bible versicles, the waltz song, nursery rhymes, magic spells, the prayer, even jazz songs—which last he succeeds in converting to his purpose only because colloquial German hasn't the banality of its English counterpart and is much less remote from literary language—and at that, even the jazz song tends to become a ballad when Brecht uses it, especially in the handling of the refrain. Because most of these forms are closely connected with music and because Brecht himself is very much interested in music, he was able to collaborate with composers—something rare in modern poetry—and quite a few of his ballads have been set to music, in addition to the librettos he wrote for Kurt Weill and Hanns Eisler.

By parodying forms that are in circulation outside the customary channels of "book" literature, Brecht gained for his poetry a certain sharp contemporaneous quality such as we can

---

And because the soldier stinks of decay, a parson limps to the fore who swings a censer over him so that he can stink no more.

In front the music with ching da-da-da plays a merry march. And the soldier, as he's been trained to do, flings his legs from his arse. . . . [Author's note]

hardly find elsewhere in modern verse. It seems to me that Auden learned much from him and found his example an aid in his endeavors to free modern English poetry from the straitjacket of pure poetry and to make it deal once more with wide ranges of experience. If poets can no longer deal with politics, religion and love on their own terms, and earnestly, because to take too positive a stand would involve them in unpoetic controversy, then they must deal with them ironically. The attribution of influences is dangerous, but I cannot help thinking that Auden learned something from Brecht in the way of working into poetry slang, the modish phrase, echoes of the rhetoric of the past, the scraps of intelligent conversation, the clichés of the intellect and of journalism, and the flat up-to-date wisdom of psychology and Marxist politics. Auden, too, parodies prayers, odes, magic spells and nursery rhymes. His precocious wit is his own, and it is something subtler and more cultured than Brecht's, but he must have got more than a hint from him as to how to metabolize it into poetry. . . .

As much as Brecht is a parodist and strives for an anonymous manner, there is a unified style in the *Hauspostille* poems which constantly breaks through with its personal resonance. His most consistent manner is one of dry understatement, simple, yet indirect, affectedly restrained. But what makes his style most characteristically his own are the shifts in tone and transpositions of key. To put established and well-worn conventions to new uses is to strike discords. Dry matter-of-factness unfurls unto Biblical grandiloquence. The sententious passage collapses abruptly at a banal expression or trivial image, or when the rhyme falls on an auxiliary verb or the main stress on the illogical word. The grim and horrible alternate with the idyllic, the brutal with the sentimental, the cynical with the falsely naive. There is a process of inflation and deflation, a succession of anti-climaxes:

> *Ich, Bertolt Brecht, bin aus den schwarzen Wäldern.*
> *Meine Mutter trug mich in die Städte hinein*
> *Als ich in ihrem Leibe lag. Und die Kälte der Wälder*
> *Wird in mir bis zu meinem Absterben sein.*
>
> *In der Asphaltstadt bin ich daheim. Von allem Anfang*
> *Versehen mit jedem Sterbsakrament:*

*Mit Zeitungen. Und Tabak. Und Branntwein.*
*Misstrauisch und faul und zufrieden am End.*

*Ich bin zu den Leuten freundlich, Ich setze*
*Einen steifen Hut auf nach ihrem Brauch.*
*Ich sage: es sind ganz besonders riechende Tiere*
*Und ich sage: es macht nichts, ich bin es auch.* . . .

*Gegen Morgen in der grauen Frühe pissen die Tannen*
*Und ihr Ungeziefer, die Vögel, fängt an zu schrein.*
*Um die Stunde trink ich mein Glas in der Stadt aus und schmeisse*
*Den Tabakstummel weg und schlafe beunruhigt ein.*

*Wir sind gesessen ein leichtes Geschlechte*
*In Häusern, die für unzerstörbare galten*
*(So haben wir gebaut die langen Gehäuse des Eilands Manhattan*
*Und die dünnen Antennen, die das Atlantische Meer unterhalten.)*

*Von diesen Städten wird bleiben: der durch sie hindurchging, der*
    *Wind!*
*Fröhlich machet das haus den Esser: er leert es.*
*Wir wissen, dass wir Vorläufige sind*
*Und nach uns wird kommen: nichts Nennenswertes.*

*Bei den Erdbeben, die kommen werden, werde ich hoffentlich*
*Meine Virginia nicht ausgehen lassen durch Bitterkeit*
*Ich, Bertolt Brecht, in die Asphaltstädte verschlagen*
*Aus den schwarzen Wäldern in meiner Mutter in früher Zeit.* [2]

This is from the poem *Von Armen B. B.*, or About Poor B. B., in
which Brecht pretends to speak for himself. The mannerisms of

2. I, Bertolt Brecht, am from the black forests. My mother carried me into
the cities while I lay in her body. And the coldness of the forests will remain in
me until my death.

I am at home in the asphalt city. From the beginning provided with every
moral sacrament: with newspapers. And tobacco. And brandy. Distrustful and
lazy and satisfied in the end. I am friendly to people. I wear a stiff hat according
to their custom. I say: they are beasts that smell quite peculiarly. And I say: it
doesn't matter. I'm one too. . . .

Towards morning in the gray dawn the evergreens piss, and their vermin, the
birds, begin to cry. Around that hour I drain my glass in the city and fling my
cigar butt away and go to sleep, troubled.

We have sat, a trivial generation, in houses that were held to be indestructable
(thus did we build the tall structures of the Island of Manhattan and the thin
antennae which entertain the Atlantic Ocean).

Of these cities will remain: that which goes through them, the wind! The

a variety of literary and non-literary attitudes, past and present, are juxtaposed with the flair, humor and seriousness which are Brecht's genius. He dramatizes himself only in order to puncture every false attitude within reach, to exhibit the disparity between literature and the facts.

Brecht misfires occasionally, usually because of a lapse in taste. Sometimes the irony is over-labored, and the grotesque and macabre overdone. Sometimes the understatement is overstated. But at that, it is remarkable how rare Brecht's failures are: there is hardly a really bad poem in the *Hauspostille* collection.

Brecht wanted to write "popular" because, like Rimbaud, his position was that of the pariah who has no patience with the formalities, either of living or of literature. In the *Hauspostille* and in the plays of the same period he does not storm against society; the lumpenproletariat, the gutter men, complain and lament, but they do not criticize. Brecht simply rejected civilization entire and went in for a nihilism of despair which permitted him only one value: comradeship, which he found at its purest where it had the least competition: the Bohemia of tramps, suspicious characters, freebooters and sailors. "Through thick and thin" and "true to the end" were bromides that Brecht took seriously. (One given to that sort of thing might find the Brecht of this period a perfect example of proto-Nazi temperament, with *Führerprinzip*, violence, freebootery, pimps and all.) He celebrates the example of women who out of faithfulness follow their men into degradation, who hang on to their partners through corruption and stench, humiliation and despair. In search of the places where the horror of civilization is most naked, he seeks out its horizontal as well as vertical frontiers. The traditional German wanderlust had become morbid. Brecht had grown up in a post-war Germany whose younger intellectuals were fascinated by low life, crime and perversity, and *aficionados* about the movie America of gangsters and the Wild West. There

---

house makes the eater happy: he empties it. We know that we are transient and that there will come after us: nothing worth mentioning.

In the earthquakes which will come I shall not, I hope, allow my cigar to go out because of bitterness, I Bertolt Brecht, strayed into the asphalt cities from the black forests, in my mother long ago. [Author's note.]

was a push downwards and outwards, away from the street levels of the asphalt wilderness. Wearing a Kipling costume, Brecht made overseas expeditions in verse to tropical hells, Mexico, the Wild West, nameless deserts, uncharted oceans. But it was Kipling in despair, a Kipling who had read Rimbaud, had nobody waiting for him at home, and was bored and sick to death.

Brecht was the poet-laureate of the Germany which had been dislocated by the Inflation, and which found in him a talent and a temperament to express its mood. He scandalized it and he fitted it. It was when all Germany had a consciousness of itself as a pariah among the nations; Brecht universalized and sublimated this consciousness by identifying it with all mankind. He was having plays produced, some of them with success; he had several notable theatre scandals to his credit; he was a very young man with a bright future, not half so isolated from society as he might have been; a good part of his audience agreed with what he said, as shocked as it was, and he did not need to be obscure in his poetry. It was this community of mood that gave his verse its carrying power, circulated it in alert society, and deprived his nihilism of pose and idiosyncracy. The devaluation of money justified the devaluation of every other value. Mankind was exiled from its possessions, tangible and intangible, and every individual was an alien. In spite of his pessimism, it would be wrong to consider Brecht as a case of the *lonely* poet.

However, there is a side of Brecht which cannot be explained by post-war Germany, but is the result of his Lutheran upbringing and is part of the particular personality which he cannot help being. His attitudes have always had a religious color; and underneath his nihilism as well as his Communism there lurks a religious moralist. Brecht's habitual bad temper and sour disposition are not solely the result of dissatisfied egotism; they also belong to one who finds nothing but horror and loathing for the acts of his time, and little or insufficient satisfaction in the constant, sensual pleasures. It is not merely to be sacrilegious or to take advantage of a convenient form that he parodies liturgical style so much. He means to have his tongue in his cheek when he says sin, but his tongue comes out; for Brecht, without believing in religious virtues or being a mystic, is conscious of sin the way a believer is. It fills him with an unaccountable hor-

ror and fascinates him, as it fascinated Baudelaire, because for himself it really has the quality of sin. He is never less a parodist than when he parodies Luther or the Old Testament, whether to curse life in general or only Hitler. It is the style of his temperament.

Until 1927 at least, Brecht rejected everything, Lenin as well as the Kaiser. He wrote a poem about the Red Army:

> . . . *In diesen Jahren fiel das Wort Freiheit*
> *Aus Mündern, drinnen Eis zerbrach.*
> *Und viele sah man mit Tigergebissen*
> *Ziehend der roten, unmenschlichen Fahne nach. . . .*
>
> *Und mit dem Leib, von Regen hart*
> *Und mit dem herz versehrt von Eis*
> *Und mit den blutbefleckten leeren Händen*
> *So kommen wir grinsend in euer Paradeis.* [3]

Since Schiller and the *Sturm and Drang* there has been a tradition in Germany of the young poet as reckless rebel—who finally takes a responsible position towards society. Brecht has in his way followed this trite pattern. Becoming a Communist some time around 1927, he went through what might be called a change of personality. He was converted. He abandoned his passive irresponsibility for an attitude so utterly earnest that it is almost suspect. Turning didactic poet in the most literal sense, he saw beyond the ends of poetry as poetry the obligation to teach the ignorant and poor how to change the world.

It was as a result of his previous poetry rather than because he had set out to write with such an intention, that Brecht began to believe that it was possible to produce contemporary poetry and drama of a high order which would still be palatable to the masses. He devised a theory of a new anti-Aristotelean form of drama which he called the "epic" drama. Instead of involving the spectator emotionally, it would sober and cool him into an objectivity which would enable him to consider the dramatic action, not as one who identifies himself with the roles enacted

---

3. In those years the word freedom fell from mouths in which ice cracked. And many were seen with tiger jaws, following the red, inhuman flag. . . .
And with our bodies hardened by rain, and with our hearts seared by ice, and with our blood-stained empty hands, we come grinning into your paradise.
[Author's note]

on the stage, but from the point of view of his own practical, every-day interests as a member of society. The "epic" drama would teach above all. This theory is enunciated with such meticulous dogmatism that there hovers over it an air of that straight-faced clowning we are always forced to suspect in Brecht. It is as if he were parodying Aristotle and Marx at the same time. The then current Stalinist line on proletarian literature—very much an unknown quantity and the object of a haphazard search—gave free play to Brecht's theories, while both his originality and his dogmatism were encouraged by the exaggerated aggressiveness at the time of the Third International's political line. As he quoted the right authorities and repeated the correct shibboleths, he received more or less official support from the German Communist Party.

Brecht's first stage as a poet culminates in the magnificent libretto of the *Dreigroschenoper*, which was still written in what I choose to call his *Hauspostille* manner, and still somewhat "Aristotelean," although Brecht had already made his turn to Communism. After this his style underwent a radical change. In the choruses and recitatives interspersed through the "epic" *Lehrstücken*, or "didactic pieces," he began to use an unrhymed free verse designed to accord better with the rhythms of contemporary speech and to cut away those non-essential embellishments of poetry which might dissimulate the austerity of the Bolshevik method. In the directions accompanying the printed texts of the didactic pieces Brecht emphasized the necessity of a "dry" delivery. Poetry was to become stripped, bare, prosaic. It was to be settled with large colonies of prose. (I do not want to exaggerate Auden's debt to Brecht, but again it seems to me that he got hints here as to how to assimilate prose phrasing to poetry.) Rhythm was no longer to be metric or musical, but forensic, persuasive and rhetorical. A fair specimen of Brecht's new style is the *Lob der Partei*, or Praise of the Party, from the play *Die Massnahme*:

> *Der Einzelne hat zwei Augen*
> *Die Partei hat tausend Augen.*
> *Die Partei sieht sieben Staaten*
> *Der Einzelne sieht eine Stadt.*
> *Der Einzelne hat seine Stunde*
> *Aber die Partei hat viele Stunden.*

*Der Einzelne kann vernichtet werden*
*Aber die Partei kann nicht vernichtet werden*
*Denn sie ist der Vortrupp der Massen*
*Und Fürht ihren Kampf*
*Mit den Methoden der Klassiker, welche geschöpft sind*
*Aus der Kenntnis der Wirklichkeit.*[4]

Brecht had become so inveterate a parodist that he could not prevent himself from parodying even the Bible in his political poetry—although there may be the influence of Stalin's painfully simplified, catechism style of oratory. However, more than parody is involved. The same protestantism that Brecht showed when he was a cynic manifested itself in his adherence to Marxism. Lenin's precepts became for him an eternal standard of conduct, and Bolshevism a way of life and a habit of virtue rather than a historically determined line of action intended to realize a definite goal. The didactic pieces, the little playlets, the dialogues, aphorisms, even the Lindbergh radio choral, contained in the *Lehrbücher* or Textbooks form a morality literature, hornbooks of Bolshevik piety, Imitations of Lenin. And for all his sobriety, for all the strenuous simplicity and earnestness and angularity of his manner, Brecht remained all poet—in the old-fashioned sense which he tried to repudiate—and when he put Lenin's precepts into poetry he transformed them into parables and their settings into mythology. Whether or not this made Brecht a successful revolutionary poet cannot be discussed here, but it was certainly in harmony with the particular style of devotion which Stalinism instils in its faithful.

The mutations of Stalin's line have had a considerable effect upon Brecht's writing. Especially since Hitler and exile placed him more than ever at the mercy of the Communist Party apparatus for an audience and honorariums. He went along into the Popular Front, submitted to "socialist realism" with the required docility, and put his theories of the "epic" drama on a shelf for future reference, as he himself says more or less in an

4. The Individual has two eyes: The Party has a thousand eyes. The Party sees seven states: The Individual sees one city. The Individual has his hour: But the Party has many hours. The Individual can be destroyed: But the Party cannot be destroyed. For it is the vanguard of the masses and conducts its struggle with the methods of the classical teachers, which are derived from the knowledge of actuality. [Author's note]

extenuating note to the "anti-fascist" play *Señora Carrera's Rifles*. The tautness of the "epic" manner slackens into more conventional prose, and he began to write poems in something of the old *Hauspostille* vein. He arrives at a synthesis: loosely cadenced verse, rhymed and unrhymed, heavier, more uneven, less understated and dry than before. The relaxed rhythms seem to express a slackening political certainty. Brecht begins to lament again and to inveigh. He no longer teaches, he is no longer so positive. But his old skill is still there: he remains as quick and as sure in his sensitivity to language as an animal in its instincts. He can still write a poem like the *Verschollener Ruhm der Riesenstadt New-York* or Faded Renown of the Metropolis of New York:

> *. . . Ach, diese Stimmen ihrer Frauen aus den Schalldosen!*
> *So sang man (bewahrt diese Platten auf!) im goldnen Zeitalter!*
> *Wohllaut der abendlichen Wasser von Miami!*
> *Unaufhaltsame Heiterkeit der über nie endende Strassen schnell*
> *    fahrenden Geschlechter!*
> *Machtvolle Trauer singender Weiber in Zuversicht*
> *Breitbrüstige Männer beweinend, aber immer noch umgeben von*
> *Breitbrüstigen Männern!* [5]

Here Brecht is an outspoken parodist once more. It would be difficult to specify just which of several elegiac manners he is parodying, yet we are definitely aware that he is parodying something. Because what is being parodied is so obscured, the poetry becomes, as always, very much Brecht's own.

It is unnecessary, no doubt, to point out that Brecht is much better known as a playwright than as a poet pure and simple. He began his career in the early nineteen-twenties as a writer of Expressionist plays in prose, whose savage power and originality soon set him apart. Poetry seems to have been a side issue at first. Yet it was largely due, I believe, to the fact that Brecht was a poet and wrote verse with conscience that he was able to develop boldly and to become the writer of *Dreigroschenoper* and *Die Heilige Johanna der Schlachthöfe*, and so the unique force which he

---

5. Oh the voices of its women from the phonograph cabinets! Thus did they sing (preserve these records!) in the golden age! Melody at evening of the waters of Miami! Unceasing cheerfulness of the generations that speed along never-ending streets! Mighty sorrow of singing women weeping trustfully over broad-chested men, yet ever surrounded by broad-chested men! [Author's note]

is. To say this is almost equivalent to saying that Shakespeare would never have been what he was had he not written verse, but we have become too much accustomed lately to accepting the drama as entirely independent of poetry. It is poetry that "sparks" Brecht's work, whether in verse or in prose. His instincts and habits as a poet enforce the incisiveness, shape and measure which characterize almost everything he does. What is remarkable is that this sense of form is part of Brecht's orginality and not a constraint upon it, for it creates forms as strong—in Brecht's hands—as those it violates.

Brecht's gift is the gift of language, and this gift communicates what seems to me the most original literary temperament to have appeared anywhere in the last twenty years. It is Brecht's originality that I want to emphasize, not simply as a virtue in itself, but as a germinative influence, as something that can deflect the course of poets in English as well as in German from over-graced and backward provinces to fresher and richer territories.

*Partisan Review*, March–April 1941; A&C (substantially changed).

## 8. Review of Exhibitions of Joan Miró, Fernand Léger, and Wassily Kandinsky

Shows of the works of three great, or once great, abstract painters held in New York recently afforded an opportunity to consider the present condition of our most advanced painting. The demise of abstract art has been hailed again and again of late; nevertheless it continues to provide our most stimulating pictures. It is my opinion that the fate of our particular tradition of art depends upon that into which abstract art develops. True, three or four great painters still use representation—Picasso, Matisse, Rouault, Vlaminck—but they operate in very personal veins from which there is no issue for the future. They raise up no promising disciples, for those who follow them are imitators, eclectics, and little else. Representation may return, but it will return only on the basis of what we have learned from abstract art.

Of the artists who have produced the best painting of the last five years or so, without doubt one is Miró. His pictures continue to excite. They may puzzle the layman, but they do not bore his eyes. The show of his recent work at the Matisse Gallery impressed one with the extent to which the modern painter derives his inspiration from the very physical materials he works with. In spite of, and perhaps because of, the freedom it offers, canvas imposes upon the painter a style more or less proper to itself. In the course of time even this style with all its flexibility may become something that confines. The artist will grow to desire a medium the very difficulty and novelty of which will help him to conceive freshly. Klee took to painting on plaster, wood, and scratched canvas. Miró has begun to paint on burlap and fiber board, and with promising results. The coarse surface of the burlap has refreshed his invention, compelling him to tighten and compress his design in order to animate and set off the minuscule criss-cross pattern of the rough stitching. Since the burlap does not present a smooth surface, paint must be rubbed rather than brushed on, and so a new quality of "paintedness" is gained. And although the brick reds, the blacks, yellow, and livid whites are reminiscent of Miró's previous work, the result constitutes on the whole a new and brilliant phase in his development.

As if to emphasize the control exerted by the medium, the water colors executed during the same period make the sharpest contrast to the burlap paintings. Necessarily, paper and water call for different treatment, yet the difference between Miró's water colors and his oils, whether on burlap or canvas, is much greater than the difference, for instance, between the water colors and the oils of Cézanne. Miró's water colors are tenuous, precious, and not altogether satisfactory, but there is something too valuable to dismiss in almost everything he has touched in the last few years, at least to judge from the work that has reached this country. One painting must receive special notice: a long, narrow panel on canvas, full of echoes of primitive art, which with its long tentacular bands of dark blue against cobalt and its sudden touches of vermilion, yellow, and white, was the most completely successful single painting of the show.

How arduous is the career of the abstract painter, how difficult it is to sustain his freshness and growth, is made more evi-

dent by Léger's example. The exhibition of his latest water colors and drawings at Marie Harriman's was disheartening. I was never much struck by the bulk of his work, though he does have the ability to integrate seemingly discordant elements into solid, unified compositions. But for a long time he seems to have done nothing but repeat himself under various disguises. By force of repetition Léger's painting has become facile and empty, a matter almost of formula. His color has become more Currier and Ives than ever. Organic objects have replaced the mechanical ones and the abstract forms—Léger was never a consistently abstract painter—and they are used to attain a stale, poster prettiness. In picture after picture the various elements curl themselves into the same neat combinations. There is still that same effect of reconciled flatness and solidity which was one of the most pleasing qualities of Léger's earlier work, but this has become too facile and too decorative; the massiveness is all show. When the abstract artist grows tired, he becomes an interior decorator—which is still, however, to be more creative than an academic painter.

The show of Kandinsky's paintings at the Nierendorf Gallery was composed chiefly of his post-war work (one picture for each year of his career as a painter), but there were enough pictures dating from before 1914 to make manifest how much his work has fallen off since then. The early paintings are semi-abstract landscapes, spontaneous and turbulent in their color; we perceive in them the feeling that went into the actual handling of the paint. Since then Kandinsky's art has become non-objective and excludes all representation. Under the influence, I believe, of some false analogies with the mathematics of music, with music as an art of self-expression, and with Platonic notions of essential form, he paints in precise geometrical figures, all ruled lines and circles drawn with a compass. Instead of a picture, however, a gimcrack is produced. The Slavic peasant colors which Kandinsky favors are rich and strong when brushed with the vigor and freedom of his earlier manner, but they become superficial when fixed with draughtsman's precision in dry, careful, spic-and-span diagrams resembling nothing so much as astronomical charts and patterns for dirndl dresses. I do not hold theories to be responsible for the decline in Kandinsky's art; Mondrian has produced very good painting in terms of pure ge-

ometry, and Mondrian has theories. It is simply that Kandinsky cannot do it, being the painter he is. All this notwithstanding, Kandinsky is even today not a negligible painter. He still turns out good pictures occasionally—very often under Klee's influence. They are best when smallest in format. And this is true of most contemporary painting. For as a rule the modern painter cannot cover large spaces successfully—the revival of mural painting has so far not disproved this. He is at his best when forced to compress and tighten; just as the modern poet finds a page and a half more than adequate to whatever he may have to say in any single poem.

The cases of Kandinsky and Léger demonstrate how easy it is for the abstract painter to degenerate into a decorator. It is the besetting danger of abstract art. We, with our tradition of easel-painting, are not satisfied to have our pictorial art in the form of decoration. We demand of a picture what we demand of literature and music; dramatic interest, interior movement; we want a picture to be a little drama, something, even if only a landscape or still life, in which the eye can fix and involve itself. It is the task of the abstract artist to satisfy this requirement with the limited means at his disposal. He cannot resort to the means of the past, for they have been made stale by overuse, and to take them up again would be to rob his art of its originality and real excitement. That so many abstract artists are not equal to the task does not compromise abstract art—as yet. And when one has exposed oneself long enough to contemporary art, one begins to realize that the unsuccessful pictures of a good many abstract painters are more interesting than the most brilliantly successful pictures of such painters as Grant Wood, Alexander Brook, etc., etc.

*The Nation*, 19 April 1941

## 9.  Art Chronicle: On Paul Klee (1870–1940)

Klee began with one very important personal asset, and his early career seems to have been in many ways a struggle to place himself in the position to exploit it. This asset was the fact that

he had been born and brought up in German Switzerland in the presence of a provincial—almost folk—art with its own local and particular traits, which had something relatively new to contribute to the main stream of Western painting, something at any rate that had not re-entered it since the sixteenth century. Klee did not draw upon provincial art in any very conscious or formal sense, but it was there in the neighborhood of his youth, he allowed himself to be open to it, and its manifestations are unmistakable in his work. There is the presence of something of which the antecedents lie beyond all the familiar formal traditions, even those of modernist details and complications, restless surfaces, carefully contrived and worked-out schemes, and with color keyed higher than is usual in our post-Renaissance painting. In their combination these are much closer to the traditional art of southern Germany and of German Switzerland than Flemish and Dutch painting is to the autochthonous art of its own region.

Klee's way of life may have been cosmopolitan, but his art belongs to the provinces in more than one respect. Its world is a closed one—capable of being divided infinitely, but limited in its expansion. It grew by intensification, not by extension. It is not big-city, cosmopolitan art in the way in which Picasso's is, although it depends upon and reinforces the advanced, international movement in painting. In spite of Klee's own aspirations it pretends to no statements in the grand style; it concentrates itself within a relatively small area, which it refines and elaborates. It moves in an intimate atmosphere, among friends and acquaintances. It belongs to Berne, Basel, Zurich, old-fashioned Munich, a region of bright, alert small cities, where the provincial situated at the intersection of two different national cultures has been modernized and brought up to date, but still remains provincial, a place comparatively remote from the nervousness and personal uncertainty of the metropolis, a place where it is still possible to be a bourgeois and to have a strong personality. Klee himself reminds one of a personage in one of those stories by E. T. A. Hoffmann about the small-town Germany of the eighteenth century: comfortable, musical, modest and fantastic. He welcomes influences and hints from places far off in space and time, but they are thoroughly worked over and assimilated to his own domestic décor. In contrast to

Picasso for whom the primitive and archaic retain their character as such, Klee makes these homely and familiar, much less remote and severe. And for all the shocks with which it provides us, Klee's imagination is not as audacious as one has been led to think; its unconventionality is really that of an eccentric but respectable bourgeois, and its whimsicality and humor are not fundamentally unsettling. Klee's real audacity was his unconscious modesty, which accepted and accomplished the task of making an easel-picture out of almost nothing.

That Klee's painting relates itself so much to provincial art does not make it any the less a part of world painting—not any more than an composer's reliance upon folk music makes him a folk musician. Klee's experience of the great world—of Paris and of Africa too—was a purification that freed him from the historical prejudices of Western Europe's tradition of art. His contact with the works of Cézanne and of Van Gogh and of the Fauves and Cubists delivered him from that awe of Renaissance and classic art which had prevented so many German artists from following their native bents and had constrained them to waste themselves in trying to emulate the Mediterranean. (No one, I feel, did German art a greater disservice than Winckelmann with his institution in Germany of the cult of the antique.) After the discovery of oriental and primitive art our eyes were opened to experiences which violated our old habits. It became possible to find esthetic experience anywhere in history and geography. And finally, the artist was given carte blanche in the choice of his means when it was established that all that really mattered in a work of art was its "purely plastic" qualities, regardless of their antecedents and referents in other terms. Once Klee had appreciated this and once he had trained his talent down to the point where nothing was left except the instinctive co-ordination of eye, hand and material, to which he could surrender almost all decisions in the confidence engendered of a long and very severe discipline—once he had done these things, he was ready to go home and be himself.

## II

Klee does not create unity of design, generally, by a large scheme which the eye takes in at a glance; this is the classical, Renaissance mode, and for the Renaissance pictorial design was

decorative in an architectural sense, a matter of covering walls. Klee's feeling for design is rather what I would call ornamental. He worked in small format, in the tradition of those who illuminated manuscripts and illustrated books and painted pictures for very private possession, and pictures modest in dimension and hung upon the walls of a familiar and personal interior. This is Dutch, German, bourgeois. Because it is small the picture requires close scrutiny. Because it concentrates rather than disperses visual attention it can be detailed and complicated. Most pictorial design to which we are accustomed is spatial; that is, the eye travels continuously along a line or a passage of color. But in Klee's painting design is almost *temporal* or musical. We seem to be more conscious than is usual in graphic art of something that has to be experienced in terms of succession and simultaneity. (Something very similar is to be found in Hieronymus Bosch's crowded, wriggling compositions and even in Hobbema's landscapes.) Klee's *line* plays the all-important part in this. It is not a line along which the eye feels its way, but rather a definition of relations—relations of points, line as Euclid defined it. It seems never to enclose or describe a shape or contour very definitely. It hardly ever varies in its width along a single trajectory, it has little plastic feel; we find it hard to say whether it is soft or sinuous, wiry or angular, and so forth. Adjectives do not fit the case, only verbs. Klee's line indicates, points out, directs, relates, connects. Unity of design is realized by relations and harmonies rather than by structural solidity.

However, precisely because line—and color too—are disembodied elements which do not adhere to bodies and surfaces, because there is an absence of weight and mass, a suspension of the laws of gravity, Klee's pictures have a tendency, when his inspiration flags and no longer sustains the oscillating, flickering, wavering movement which makes them live, to close up on themselves and become too decorative: too even, too balanced, too lacking in stress and relief from stress to be much more than flat, tinted patterns. Yet Klee produced some of his best work when he most consciously and deliberately incurred the dangers of decoration; as in the picture *Pastoral*, which is composed only of horizontal bands of uniformly spaced linear motifs repeated symmetrically from left to right. Nevertheless it is a very successful easel-painting and has little of the static quality of deco-

ration. In it Klee has isolated and concentrated the problem of decoration versus easel-painting, and he was able to solve the problem because he was very much aware of it.

The problem remains one of the most critical faced by abstract and semi-abstract painting today. The direction of painting since the latter half of the nineteenth century has been towards greater and greater emphasis upon the decorative and abstract qualities of pictorial art. This has entailed the abandonment of the representation of three-dimensional space, and the picture plane has become shallower and shallower, until now in the form of the purely two-dimensional abstract painting it has been reduced to its actual physical fact as a flat surface. Almost every attempt to achieve the illusion of depth has been surrendered. The difficulty which besets the abstract painter in so far as he wants to create more than decoration is that of overcoming the inertia into which his picture always risks falling because of its flatness. The easel-painting—and Klee was an easel-painter —relies upon the illusion of depth, of composition in depth and upon dramatic interest for the intensity of effect it must have to overcome its smallness and its isolation. The easel-painting must be a window, a mirror, a soliloquy, something at which one gazes with rapt attention.

Klee could not altogether accept the flatness of post-cubist painting. He showed his dissatisfaction with the impenetrability of the picture plane—impenetrable in that he could not pierce it by perspective and modeling—by worrying the surface of his canvas, by scratching and patching in, by painting on wood or plaster, by mixing his mediums, by returning again and again to water color, in which he could exploit the curl of the moisture-laden paper for the unevenness of surface he wanted. But all this was in the nature of an evasion; it was too mechanical and external, for all that it contributed, to provide a real solution. That had to come from within, that had to be less tangible. Klee attempted to solve the problem by color.

I do not think that Klee's color has the range of his line. Its register is limited, relatively, to tints: light, tender, aqueous, thin. It seldom inheres within definite contours, is seldom thick or solid. Like his line, it hardly defines or describes. It is color that intensifies and fades like light itself, translucent, vaporous, porous. Such coloration achieves a kind of depth, but not one in

which "real" events and objects are probable. We see disembodied lines and flushes of color but whether of the real surface of the canvas or in its fictive depths we cannot tell. Lines wander across areas of hue like melodies across their chords; surfaces palpitate, figures and signs appear and disappear. It is an atmosphere without dimensions. This is the brilliance of Klee's art.

But it is an extremely personal art, and as such unstable. Nor could Klee rest in it. He was driven to new problems—or rather new aspects and new difficulties of the old one. From the very beginning his career had been a struggle with the problematical, and it continued to be that way until the end. In the quest for the irreducible and primary elements of the art of painting in which Klee participated along with such other abstract painters as Kandinsky and Mondrian, he was led in the direction of that same stricter and more geometrical simplification which they practiced. There was the compulsion to renounce representation almost entirely, even in the very figmentary way Klee had used it, and to surrender to the flat fact of the canvas by manipulating color and line in such a fashion as to produce a "purely visual" experience in only two unambiguous dimensions. Temperamentally, Klee could not altogether conform to these specifications. Yet he succumbed to them. Towards the end of his life he began to paint in large, massive, regular shapes, with solidly and evenly applied pigment. His pictures become hard and flat, and at the same time heavy. Line is suppressed as an independent factor, and loses its calligraphic movement, becoming thicker and heavier. The color turns acid and rather garish. It is pretentious painting in a way new for Klee, and one hardly suspects that it is the result of an effort to *purify* his art. There is an absence of that tact and that modesty Klee had accustomed us to expect from him. On the whole the production of his last years is extremely disappointing.

The illness from which Klee suffered towards the end of his life may have been partially responsible for this decline. In one who relied so much on spontaneity and who produced his art in an almost literal sense from the totality of himself, summoning every force he possessed, physical and mental, to the creation of a picture, sickness doubtless had a much more serious effect than would have been the case with a more deliberate artist.

## III

In working for decorative and narrative complications of line and in his use of color as tint rather than as the definition of surface and mass, Klee is to the modern painters of Paris somewhat as the school of Siena was to that of Florence in the early Renaissance. And he is also less realistic and at the same time more literary and sentimental. Space is flatter in the paintings of Picasso, Miró, Mondrian and the others, yet their pictures seem to inhabit a more actual atmosphere than that to which Klee's belong. Picasso's works move about in the world; they take place among other events and other objects. Klee's live in a more fictive medium and require of the spectator a greater dislocation, a greater shift.

## IV

The difficulties in the relations between "literature" and the "purely" plastic in pictorial art are focused most sharply in Klee's painting, because it embodies even better than Picasso's the transition from representational to abstract painting. Klee's insistence upon retaining identities—that is, indications of three-dimensional objects—and upon communicating anecdote and message is an aspect of the struggle to save easel-painting—in this case by saving poetry for it. However, Klee also painted perfectly abstract pictures, many of them almost as non-objective as Kandinsky's in spite of their literary titles. And it is significant that as one becomes more and more familiar with Klee's work little of the important qualities present in his more representational painting is found missing in his abstractions. And one begins to suspect that the virtues by which his art stands or falls have little to do with his denoted or explicit literary content.

We can never be sure as to what takes place when a picture is looked at, and there may be unconscious recognitions of "literary" meanings and associations which affect the observer's experience, no matter how much he concentrates upon the picture's abstract qualities. Yet in the case of Klee and of a good many other contemporary painters we do not have to look into ourselves as much as that in order to find out why we so often overlook or forget the subjects or subject matter of their pictures.

For it is the art itself and the artist himself that may be responsible for our relative insensibility to anything except the abstract qualities of painting. It is not that nature is not imitated faithfully enough, but that nature and the external world are assigned a different role than formerly. Klee was not interested in the appearances of objects as such, and did not derive from appearances the main impulse to paint. He was more interested —so he says—in the meanings of things than in their looks. He indicated and noted objects, but hardly described them. As Grohmann, Klee's commentator, has pointed out, objects served him more or less as words, and like a primitive or child he wrote them down, copying only enough to be legible. He delineated or represented in order to communicate what he had in mind, not so much what he saw or even how he saw. He used the visible figuration of an object as one uses the sound of a word, and was controlled and impelled by appearances as one is in making poetry by the sounds of words.

It seems to me that one of the most important reasons for which Klee resorted to representation was the difficulties of invention, especially for one who worked so much in free line. The hand left to its own impulses dissipates its calligraphy in rhythmic repetitions. Of itself the hand is not very fertile. Nature and the world we see must suggest inventions to it. There must be some external constraint. Klee in a way recapitulated the very beginnings of graphic art, the development from aimless scrawling to the representation of recognizable objects. He would often begin a drawing with no definite intention or idea in mind, guided by nothing but the automatic movements of his hand, letting the line go of its own accord until it was recaptured by unplanned, accidental resemblances. These resemblances would be improved upon and elaborated. One would suggest another and give the impetus to further invention. And then Klee would discover his "message," and with his "message" the title of his picture—both, it seems to me, in the nature of afterthoughts. The picture hardly illustrated the title, but the title might explain the picture.

In its intention Klee's is perhaps the most literary pictorial art that has ever been attempted, since it tries to combine the ideographical and the representational, to be voluble through signs as well as through pictures of things. But to imitate objects or

nature as perfunctorily as Klee does is for us, with our experience of Western art and our ingrained respect for the objective, to degrade nature and to misuse and discard it. Such neglect of the actual appearances of things does not mean, as many have claimed for Klee, a deeper penetration of their essential nature, but the rejection of representational art in favor of a more abstract language for the communication, as in music, of the artist's interior state. We see an arrangement of color and line used not to reveal a human being, a house, an animal, a garden, but to take advantage of the themes they offer for the artist's revelation of his own nature. And resemblances are indicated only to have the reality to which they refer travestied and reduced in the interests of constructing an object largely independent of resemblances for its effect.

To distort and neglect the appearances of the objective and external world does not mean necessarily to derogate it. But it happens that Klee was as much as any one else a child of his time, and expressed its general distrust of objective evidence, commonly held beliefs and attitudes and of the very nature of reality itself. This distrust, this uncertainty, forces the contemporary artist to withdraw into private areas. Mondrian takes refuge among the so-called universal, disembodied, Platonic forms of painting—as private *at this moment* as any dream world; Picasso pays attention only to his own sensibility. He has a feeling of guilt, however, about his abandonment of nature and tries again and again, in spite of himself, to return to a more "universal" and "human" art.

But Klee was rather complacent about the privateness of his art *qua* privateness and strove to accentuate rather than diminish it in his most characteristic productions. Here again he was very much a German, a product of his national culture no less than of his times. He was one more illustration of that bias towards the personal and subjective which runs through so much of German art and literature, asserting the singular emotions and states of mind of the individual to be more important and true than that which is held to be objective reality.

*Partisan Review*, May–June 1941

10.    Poetry Continues: Review of *New Poems: 1940*, edited
       by Oscar Williams

The poetry here is on a surprisingly high level. There are at least
three or four very good poems and perhaps one great one. The
credit belongs of course to the poets, but the responsibility for
the presence of so much good verse in an anthology that confines
itself roughly to a single year is particularly Mr. Williams's. I
like his taste, I like his prejudices—even though I may suspect
occasionally the intrusion of the politics of the professional poet
and the man about poetry. Although he takes in much that
stems from other areas of poetic opinion, Mr. Williams's bias
runs more or less to the school of Auden and his affiliates. Auden
leaves his impress everywhere: most of the poets here borrow or
emulate his chic and timeliness; a good many work within his
technique. Mr. Williams says that "the poetry . . . bears wit-
ness to a new vitality, a kinship with reality, a concern with an
answer in a world reeling with questions." True enough. Behind
most of the poems the reader senses or should sense the presence
of a moment in history great with threats. The poems depend
for their emotion upon this sensed presence. Since there is so
little left in the world that one can take seriously and sincerely
enough to write poetry about, I am inclined to agree with Mr.
Williams that this is a good thing, but not altogether for the
reasons, or lack of reasons, he gives in an introduction shouted
in the best avant-garde style and packed with the usual enthy-
memes with which poets since Shelley have been in the habit of
justifying their trade.

Thirty-six poets are represented in this collection, eight of
them British, the rest American. But the space given to the
British representatives is far out of proportion to their actual
number. George Barker gets more space than any other single
poet—in addition to a foreword by him filled with meta-
phorical definitions, all of which have been heard before. But he
earns it. He has as much energy as Dylan Thomas, by whom he
is somewhat influenced; and if he has less intensity and incan-
descence, he is open to more experience and can talk about more
things. Under Lorca's influence, Barker writes in the simple de-
clarative sentence; his lines pound downhill in trochees and

74

spondees, belaboring our ears with internal rhymes, assonances, and alliteration, jolting our minds with the abrupt stops and turns of his figures of speech. There are a few too many modish tags and epithets, too much of the small change of the latest best poetry, too much talk here and there about Time, but all these things are carried off by the poet's surging energy and somehow made acceptable. Meanwhile, what a sound-box! In Barker as in Auden, English poetry becomes once more loud, orotund, periodic, declamatory.

As verse it is becoming even more irregular. To judge from this anthology, free verse as we knew it has disappeared almost entirely, but while seemingly regular measures are being taken up again, they are being subjected to a steady, subtle, and more dangerous attrition. There is under way a loosening and disintegration of the traditional syllabic and accentual system of English verse by which it seems to be acquiring a kind of "quantitative" character, using the cadenced phrase rather than the brace of syllables as its unit of measure. Syllabic accent has become so subdued that the poet is governed in the placing of his stresses only by sense-rhythm and our habits of breathing. The voice has a tendency to linger upon rather than bear down upon the emphatic syllable—as in prose. And rhymes are imperfect and do not coincide with important words. What is happening is that the cadences as well as some of the very tones of prose are being assimilated to poetry; not that the latter is becoming more prosaic in the sense—mainly descriptive—that free verse became prosaic, but that it is trying to expand its register. It wants once more to generalize, state, argue, and exhort, as well as to sing and describe. If anything, it is becoming more high-flown, and if it admits more ideas than formerly, it deals with them rather hysterically.

A hysterical note sounds through a good deal of the verse in Mr. Williams's anthology. It is justified by the state of our times. Sometimes, however, it is factitious, as in Muriel Rukeyser's poetry; sometimes it gets out of control, as in Mr. Williams's own verse.

But let me signal to the prospective reader's attention such excelling poems in this book as Elizabeth Bishop's *Roosters*, W. R. Rodger's *Summer Holidays*, Barker's *Second American Ode*,

Dylan Thomas's sonnets, John Crowe Ransom's *Address to the Scholars of New England*, and most of all Stephen Spender's *The Double Shame*.

*The Nation*, 21 June 1941

11. Review of *Selected Poems* by John Wheelwright

Only once did this reviewer have the good fortune to meet John Wheelwright, but that once was enough to impress upon him how pertinacious and eccentric the poet as a person was willing to be in being honest. Hence the crotchets, humors, and particularities which crowd his verse are evidence of how much of one piece he was. Such consistency is enough to give others a feeling of guilt. Yet it also affords us a clue to the causes of the defects of Wheelwright's poetry. He has left us a body of work which is something to be reckoned with, but there is little into which we can sink our teeth, little that is completed and rounded off, capable of standing by itself, largely independent of the accidents of the very personal. The events which gave rise to the poetry are not sufficiently removed from their private contexts in the poet's mind; they have not been allowed to subside and cool off into art.

To make his experience, or what he makes of his experience, available to others, the artist must be dishonest with himself to some extent. John Wheelwright was not able or not willing to practice the necessary insincerities of communication; this absolute honesty sanctioned the bewildering, misleading, and seemingly captious items that fill his poems, underneath which the reader will often look in vain for the directive logic, poetic or otherwise, that should organize and sustain them. They seem to be justified by little except the fact that they were of the poet's mind when the poems took place there. But the *real* poet—and Wheelwright was one—should not be too honest. He should have some amount of social expertness, be something of a hypocrite, if only to be good at his craft. Otherwise the intensity and the uniqueness with which he feels will choke him.

There are, however, several successful poems in this rather limited selection—a selection I do not think quite fair to the sum of Wheelwright's work. *Fish Food, an Obituary to Hart Crane* moves in its alexandrines like a wave toward a beach, gathering emotion and setting down that emotion at the inevitably right last moment. The short satirical and epigrammatic poems are particularly good of their kind. There the poet, being forced to revolve his poem around a single point, hasn't the pretext for divagation and must concentrate what he says into one small, but very sharp, bite. The gnomic flavor of Wheelwright's poetry makes the bite all the sharper—once it is felt.

*The Nation*, 30 August 1941

12.   Review of *Rosa Luxemburg, Her Life and Work* by Paul Frölich

This biography hardly pretends to be more than an introduction to Rosa Luxemburg and her ideas. It is just as well that it is so sober as to be almost pedestrian. There is only the danger that someone to whom this great woman is still but a name may fail to gain from it a sufficient realization of her tremendous stature as a revolutionary leader and thinker. For in the twenty years since her death the Russian Revolution has, unavoidably, done much to obscure her true importance. This is the first biography of her to be published in English. The facts are here, and, equally important, Luxemburg's guiding ideas, all presented with a praiseworthy objectivity and a care for the essentials.

A different atmosphere disengages itself from Rosa Luxemburg's life than from those of Lenin and Trotsky. Her biography is easier to write. It permits a greater emphasis upon the personal. (I doubt whether the fact that she was a woman is completely responsible for this.) Lenin and Trotsky were personalities indeed, but they censored the personal in themselves as much as they could. The impression they make—it is a false one, but they are responsible for it—is of a certain lack of intensity in their personal relations, of an unwillingness to grant their

own sensibilities due rights, and of a reluctance to attend to or appreciate the unique and personal in those with whom they deal. Rosa Luxemburg seems more complete as a human being; we get in touch with her at more places. For example—although she was an uncompromising political opponent of Jean Jaurès, she could allow herself to admire and enjoy his personality. Such indulgence is unthinkable in a Lenin or a Trotsky.

What makes this difference worth remarking is that the followers of Lenin and Trotsky—like little men, aping the externals of those they follow—have cultivated in themselves that narrowness which passes for self-oblivious devotion, that harshness in personal relations and above all that desolating incapacity for experience which have become the hallmarks and standard traits of the Communist "professional revolutionary." These men have served as organizers and agitators, they have shown admirable energy, devotion and capacity for self-sacrifice; but as political leaders in the larger sense they have been failures in every case and everywhere. Alas for any movement led by incomplete men. This is the liability Bolshevism brought the socialist movement. And it is the cultivated and trained narrowness, this system which frightens away imagination and spontaneity that is as much responsible as the stultifying smugness and pettiness of the social democrats for the present plight of the working class.

Rosa Luxemburg's "teachings" are as cogent as her personal example at the present moment. They form the only body of post-Marxist revolutionary doctrine that can be counterposed to Leninism. Such a counterpoise is greatly needed. Lenin's organizational principles, which are all that Stalin has preserved in idea of the October revolution, have proved inadequate to the problems of the socialist revolution in the West. Lenin, whether he admitted it or not, developed Bolshevism as a solution primarily to the Russian situation. Naturally, that was where his attention was focused. Nor did he, I think, know the West intimately enough (witness his illusions prior to 1914 about Kautsky and the German Social Democracy). Rosa Luxemburg, on the other hand, was a product of Poland, which even under Russia had its face turned more to the West than to the East, and was more advanced industrially than Russia itself. Her close association with the German socialist movement made it clear to her

that the workers of the West would go into action effectively only under organizational forms which, by allowing the maximum democracy to the rank and file, insured the instantaneous sensitivity of the revolutionary leadership to the moods of the masses. There are, of course, serious liabilities in such organizational forms. But there are equally serious and more vicious liabilities in those of Lenin. It behooves us today to attack the problem with as much attention to what Rosa Luxemburg said as to what Lenin said. The perfect solution will not be found, but some solution must be.

*Partisan Review*, September-October 1941

13.  Venusberg to Nuremberg: Review of *Metapolitics: From the Romantics to Hitler* by Peter Viereck

This is an attempt to present the sources and the development of Nazi ideology. The material is here for an important book, but this happens to be an exasperatingly superficial and misleading one. Its impact should have been that of something fresh and provoking, opening up new perspectives to our understanding of the recent past and the present. Unfortunately, the author's analytical equipment seems to consist only of an assortment of the easy and too simple terms current in conventional anti-Nazi journalism and of some of the more threadbare notions of Harvard Humanism. The banality of Mr. Viereck's point of view would have been less evident if only he had not tried to provide a critique as well as a description of Nazi ideology. For his book does have a certain value as information. Too little is known of Richard Wagner's role as a prophet of reactionary politics; most English-speaking readers have never even heard of Father Jahn, the gymnastics teacher and firebrand of the Wars of Liberation against Napoleon, or of Paul de Lagarde and Julius Langbehn, the "Rembrandt German." To as many it will come as a surprise to learn that the ideas of the Nazis, in more or less their present form, were current among German petty bourgeois intellectuals long before 1914, much less 1933.

*Metapolitics* was a term suggested to Wagner: German poli-

79

tics were to be to ordinary politics as metaphysics to physics. Mr Viereck finds Wagner the chief source of Hitler's ideas, with Alfred Rosenberg today giving them their most extreme and authoritative expression. To these two men, along with Father Jahn, the greatest part of the book is devoted. They and their ideas are bracketed under "romanticism," which was among other things "a cultural and political reaction against the Roman-French Mediterranean spirit of clarity, rationalism, form and universal standards. . . . Thereby romanticism is really the nineteenth century's version of the perennial German revolt against the Western heritage." Romanticism with its passion, its impatience of restraint and its urge to expand and absorb was according to the author the hearth in which Nazism was ignited, and Nazism is its culmination.

German "romanticism," the author goes on, has operated upon "three sweeping assumptions of dubious logic." The first, the "mathematical fallacy," asserts a whole to be greater than the sum of its parts. The second is that of "repetition," i.e., a proposition as to value is supported by repetitious affirmation, not by reasoning: "Why life for life's sake? Always the same answer: because it is life. Nothing is being said except that life is life, nation is nation, ego is ego, x equals x. These modest truths have restated, not answered the question of value judgment." The third assumption is that of "false analogy": because change and evolution govern nature, that which in the world of human affairs changes and evolves is eminently good; the static and permanent is bad, whether it happens to be an elemental organism, a species, a people, a law or a value. From these three "assumptions" comes most of the evil. One is to infer that they made German fascism almost inevitable.

The abstraction of the "assumptions" must have required a good deal of intellectual labor; nevertheless, they are gross over-simplifications. Of the three assumptions, the first—the "mathematical fallacy," or "organic assumption"—is the only one to have actually been employed by the Romantics as an *assumption*. And it is not a fallacy. Does or does not any living organism amount to something greater than the sum of its parts? And is it true or not that a new quality becomes manifest when people group themselves together, not present before in their mere aggregate as individuals? The second assumption is a fic-

tion. The German Romantics did try to answer the question of value judgment. Life, said Schelling, was valuable because it was the Divine working itself out. For Fichte the nation was valuable because among other things it guaranteed the rights of the individual and reconciled conflicting interests. And so on. As for the assumption of "dynamic analogy"—the high value the Romantics set upon change and evolution was not an assumed truth from which they reasoned, but something which they tried to justify; it was also a taste, a temper, a response to a period of transition, or in the case of some a reaction to the triumph of "safe" middle-class standards. It was the state in which those who are radically dissatisfied with the existing order automatically find themselves.

Mr. Viereck seems too unsophisticated historically to realize that in tracing the sources of the Romantic "error" to these "assumptions," he is actually attacking 19th century naturalism with all its radical philosophic and political connotations. And so his book, when it is critical, tends to become a kind of vulgar *anti-moderne* polemic. Whether he knows it or not, the errors of which he finds Romanticism guilty are only *errors* according to an assumed Christian orthodoxy.

The term "romanticism," in the lower case, is an oversimplification. As Mr. Viereck uses it, it implies something that persists beyond historical limitations, a permanent category of human behavior, i.e. "romanticism" is the way human nature shows in general its impatience with reason, tradition and external norms. But it is something that can be refuted: "Time and again romanticism has been correctly refuted, but it always survives its refuters." At the same time, "Civilization's task is not a question of destroying but of harnessing the eternal romantic element." It is painful to see Professor Babbitt's fatuities resurrected to confuse further the already sufficiently confused opponents of Hitler. In repudiating the "French-Roman-Mediterranean spirit of rationalism, clarity and form," German Romanticism did not repudiate all rationalism, all clarity and all form in general. Romanticism as a whole, including its German version, was the expression of a revolt against a *particular* rationalism, a *particular* clarity and a *particular* sense of form. It was the negation heralding a new social order pregnant with its own rationalism, clarity and form. (And the "perennial German

revolt against the West" was in this case as in every other a revolt against a comity of which the Germans as a national cultural whole were the victims instead of the beneficiaries.)

It is indisputable that Romanticism is the most important single source of Nazi doctrine. But there was nothing in Romanticism that made this doctrine inevitable, nothing that made Romanticism *responsible* for it, try as Mr. Viereck may to show the contrary by means of his "assumptions." What then is the filial relationship of Nazism to Romanticism? Any one who tries to answer this question must take into account the inextricable and ambiguous connections that exist between ideas and the milieux in which and the material circumstances under whose pressure they arose. Mr. Viereck treats ideas as the determinants of history; therefore he can *blame* Romanticism for Hitler, and pure Evil for Romanticism, and he can scold them both with that self-righteousness possible only to academists and journalists. Only they can find it so easy to shut out the uncontrollable complexity of that which actually happens. Only academists can "refute" Romanticism, and only journalists Hitler, so conclusively. But they cannot explain either; and certainly they cannot arm us against the latter.

*Metapolitics* does indeed touch upon some of the historical events that share the responsibility for Nazi ideas, but the author treats them on the level of a high school textbook, at their most obvious, and neglects entirely the very fundamental connection between proto-Nazi ideas and the late and hurried development of Germany as an industrial power. Fichte, for example, was a German super-nationalist, but he was not a proto-Nazi. Paul de Lagarde, who appears fifty years later, was. There is a great difference. Why?

But perhaps I am misrepresenting the nature of this book by emphasizing its tendency rather than its substance, and what is left out rather than what is put in. A good half and more is taken up by an account, valuable for its information, of the activities and the ideas of Jahn, Wagner, Rosenberg and others. Mr. Viereck remarks the fact that so many Nazi leaders are intellectuals and artists *manqués*, and correctly makes this responsible for the particular flavor and décor of Hitler's movement, and for that extraordinary bitter resentment of the surface phenomena of capitalist society which could only have come from frustra-

tion—a feeling, Mr. Viereck should have pointed out, peculiar today to the petty bourgeoisie. But it is typical of the book that it should have failed to have hinted even at such things as that; and typical too of Mr. Viereck's weakness for the flashy and vulgar simplifications of journalism that he should call the Nazis "Greenwich Village politicians." The bohemia of putsches and freebootery in which the Nazis learned their politics was no artist's quarter, in spite of the fact that its plots were hatched in cafés.

There are other things that make this book suspect. Thomas Mann is found to be one of Germany's "most courageous . . . thinkers." (Mann did not break publicly with Hitler until two or three years after the Nazis took power.) In referring to the writers there who have more or less assented to Hitler, such entities as Fallada, Paul Ernst, Binding, Carossa, Kolbenheyer and Hesse are called "distinctly major figures." If they are, then Thornton Wilder, the Benéts, John Marquand and Robinson Jeffers are major figures in American writing. It is somehow characteristic that Gottfried Benn, actually the most important German poet after Hauptmann to come to terms with the Nazis, is not mentioned.

*Partisan Review*, November-December 1941

14.  Review of *The Philosophy of Literary Form: Studies in Symbolic Action* by Kenneth Burke

Kenneth Burke's critical writings stimulate, provoke and unsettle me—at least while I actually read them—but they leave too little impression. A short time after putting Burke down, I shall have lost sight of exactly what it was that caused the excitement. My memory is no better nor worse than average, so I feel the fault must be his. Is it not because Burke fails to deal enough with the work of literature, the object itself, and deals instead with the modes, not of apprehending it, but of thinking about it? (Has he given us many really fresh insights into literature? Even his analysis of *The Ancient Mariner* seems to me a restatement in Freudian analysis of so much already well recognized in

the poem.) And is it not that, instead of discussing the processes by which we think about works of literature, he discusses the terminology of these processes? I believe that what Burke really does—and this is what excites us while we read—is make articulate the more or less unconscious assumptions we generally act upon in producing and experiencing literature. He does not criticize these assumptions or relate them in any new way to the rest of experience. He seems to be doing this, but actually he is only wording or re-wording them with a great amount of ingenuity. (Does the statement that every document, literary and non-literary, is "a strategy for encompassing a situation" say anything really new? Does it furnish a new aid to our understanding of literature? Haven't critics always treated works of art as "strategies" more or less, whether they realized it or not?) Burke's brilliance is in the originality with which he associates and combines new terms with old concepts. It is all superstructural. He does not devise new concepts for new aspects of experience nor arrive at new insights which require new terms. We hear him out, are grateful for the illumination, yet go on as before. The illumination has no heat.

However, I wish to make clear that I am not dismissing all of Burke's critical writing in this fashion. I am complaining only that too much of it does amount simply to terminological intrigue conducted within the standing body of truths and errors. Yet we have reasons to expect better things of Burke. He has moments of real insight, frequent enough to be counted a gift; and every once in a while he produces little items of perception for which we cannot be grateful enough. And if he does not conduct us along new paths of investigation, he at least sends us off on them.

But then there is his prose: he has a weakness for that awful pseudo-scientific jargon that has become familiar to us from the activities of progressive educators, psychologists and efficiency experts. Burke at times seems to have a faith in control by labels that approaches a magician's.

*Partisan Review*, November-December 1941

Review of *What Are Years?* by Marianne Moore
and *Selected Poems* by George Barker

Of these two poets one has an excess of energy, the other a defi-
ciency of it. It is not altogether because the one is young and on
his way and the other arrived and settled. Two quite different
national tendencies in contemporary English poetry cross here.
George Barker's energy stems not only from his youth but from a
tradition, while Miss Moore starts almost from scratch. She is
one of that first generation of American modernist poets who in
the teens and twenties went into the wilderness and with the aid
only of a few volumes of French poetry built their Tower of Babel
from the ground up. There is a certain thinness, a certain frailty,
which Miss Moore's poetry has in common with that of W. C.
Williams, E. E. Cummings, H. D., and even Ezra Pound and
Wallace Stevens. It is small-scale poetry, lacking resonance,
lacking really culture, belonging to an outlook that has to break
things into small pieces in order to see them, that has to destroy
the organic unity of everything it treats. Its makers have neither
inherited nor acquired enough cultural capital to expand be-
yond the confines of their immediate experience and of a nar-
rowly professional conception of poetry.

In spite of her fondness for deducing the most serious morals
from her material, the unity of Miss Moore's work is too exclu-
sively a unity of sensibility, without intellectual consistency,
without large opinions, without a felt center of convictions.
Miss Moore makes only aesthetic discriminations; otherwise
everything seems to exist on the same single plane. It is a kind of
aesthetic pantheism. Instead of finding all heaven she finds all
that's nice in a wild flower—or preferably in some more curious
object. The firm yet very intricate verse forms she invents are a
means of controlling this omnivorous and wonderful sensibility;
and express a liking for the rococo, the detailed and involved.
But sometimes they express this liking too well, and so lose
their efficacy as controls; Miss Moore's predilections, being
guided ultimately by nothing outside themselves, can indulge
themselves to the point where the formal features of her verse no
less than its matter seem pure captiousness, pure kittenishness.
This all goes back to the central defect of her poetry—the fact

that its unity and its direction are determined by a sensibility that is too private and that has no means of transcending itself.

So much for what is wrong with Miss Moore's poetry. Its faults are not so much those of execution as of conception. They spring largely from a failure to discriminate between the important and the unimportant, the pertinent and the not pertinent. As with all eccentric writers, either one grants such limitations or one refuses to read the poetry. Perhaps Miss Moore yields to her limitations too easily, but within them her poetry is perfect. Literally that. It delights even when it irritates:

> . . . Odd Pamunkey
>    princess, birdclaw-earringed; with a pet raccoon
> from the Mattapo-
>       ni (what a bear!) Feminine
>       odd Indian young lady! . . .

Feminine odd American young poetess! It would be difficult, I think, to find anything in the past or present analogous to Miss Moore's particular combination of verbal precision and wit. Its exact quality is that of felicity in the purest and most difficult sense. And felicity in all other English poetry is more casual and more abstract. Miss Moore's belongs to the immediate detail; it is the result of concentration upon the minutest and most idiosyncratic features of experience, and of a hypersensitivity to language only possible in the idiosyncratic writer. The typical Moore poem is a process that explores something, preferably curious or unlikely—the pangolin, marriage, a definition of poetry, quartz clocks—shreds it into many small items of perception and association, and from these draws a succession of general observations expressed with deliberate prosiness. With what careful timing, with what verbal tack does Miss Moore shift her prose into poetry. The usual shortness of her lines and their varied indentation serve to show up the voice and the eye, thus exposing the subtler accents of sense and grammar and revealing the "excavated" rhymes; contrivances necessary in a verse so lacking an esoteric, obvious accentual rhythm. For this poetry has a metrical system of its own, for the most part unconscious, which depends upon the repetition of certain extended metrical phrases rather than upon a fixed pattern.

For those who already have a notion of Miss Moore's work

there is little in this latest collection of her poems to change it markedly. But on the whole I think it an advance. Some of these poems I like better than anything she has written before: *Nautilus*, *Rigorists*, *Half Deity*, and *He "Digesteth Harde Yron."* In the title poem, *What Are Years?*, Miss Moore announces that what is praised is no longer just beautiful, but noble and good too. The apothegms and moralizations which she introduces like large images to flavor and give point are no longer quite so arch or so cute. History has overtaken the poetess as it overtakes all of us.

What prejudices one—perhaps too much—in favor of George Barker's poetry is its evocations of the past in English poetry. It is not a question of imitation and influence in any conventional way. Barker owns this past congenitally, has it in his bones as well as his lamp, and proves it by putting the historical conventions and manners of English poetry successfully into the thick of the most recent contests. Among the traditions he taps is first of all that pre-Elizabethan, populist, underground, almost folkish tradition, most of whose poets were plebeians, which runs from late Anglo-Saxon verse through ballads, morality plays, Piers Plowman, through comparatively little of Chaucer but more of Lydgate, through Skelton and many anonymous poets to Blake and Ebenezer Jones. Even the particular way in which Barker lacks humor agrees with this tradition. Like Langland and Blake, he invents visions, stages allegories, sees wildly, and denounces apocalyptically. He draws also on early Elizabethan dramatic verse with its closed, ringing, metallic line, and on the kind of declamatory verse found in eighteenth-century poetry such as Young's. Barker writes genuine pseudo-Pindaric odes and is an *enthusiastick* poet, stagey and full of violence and rant. His verse is loose-jointed, gallops like the old fourteener, and his eyeball is always rolling. As a modern poet he can be located halfway between Auden and Dylan Thomas, without being tributary to either. He is fond of the same poetic past as Auden, capitalizes on similar conventions and devices, allegorizes abstractions in the same somewhat Rilkean way, versifies loosely, and is moved to write by the state of the world. But the actual complexion of his verse resembles more that of Thomas's: passionate, irrational, full of quasi-surrealist images, the lines heavy with stresses, alliterations, internal rhymes, and long vowels. It is not, however, so closely

textured, and its syntax and sense are more obvious. Barker is more extroverted, more conscious of himself in relation to the external.

A fault Barker shares perhaps with Thomas and a good many other of the new English poets is an inability to modulate, to distribute the emphasis so that a poem will move dramatically and take on shape. In Barker's case there is an impression of an unwearying stridency, unrelieved and unshaded. He is capable of other states of feeling than the impassioned, he can be pathetic and elegiac; read closely, his work has sufficient variety from one poem to another—in quality, alas, as well as tone. But it is within the single poem that he has a tendency to be monotonous; once having set his pitch he has difficulty in changing it. This makes Barker hard to read, and it also prevents him from delivering himself as honestly as he might like to. Having begun a poem on the level of the sublime, to descend is perilous; hence the posturing, the padding and the bombast. The themes Barker is attracted to are an added liability. He has as little intellectual energy as Miss Moore—his greater resonance is owed to the tradition that backs him up and guides his voice—but his poetry's main argument, namely, the plight of the times, will not allow him to avoid that limitation so well. More than violence of feeling is needed to make poetry here. The fustian is to cover up intellectual impotence: "Spain and Abyssinia lift bloodshot eyes as I go by"; "I sip at suicide in bedrooms or dare pessimistic stars"; "Stood did my bull in the pool of his passion." Nor is Barker above Audenesque patter: the whale hides its head from war "Among the myths and the ideas/Of Atlantis"; there is a "sexual sky." His public poems can be much, much better than this, but generally his poetry is more substantially satisfactory when the self-dramatization takes place on a smaller stage, where the emotions rise from a more personal argument. An authenticity is missing from the odes and elegies which recommends Barker's earlier poems, strained as they are. Fortunately, it returns in the last poems of the book, the Supplementary Personal Sonnets—in my opinion the most perfect things Barker has yet done.

However, one could wish that instead of modifying his ambition Barker would try the more difficult task of developing his powers to equal it. I am tired of small poetry. Poetry is an art

88

equipped to treat everything and to transform everything into itself. The perfection of Miss Moore's poetry is too narrow; it abandons too much. Barker's pretentions—and the fact that he does not fall short of them too ridiculously—are at least a reminder of what poetry once could do, of what vast thirsts it once could satisfy.

*The Nation*, 13 December 1941

# 1942

16.  America, America!: Review of *The Mind's Geography*
by George Zabriskie and *The Poem of Bunker Hill* by
Harry Brown

One poet is concerned with America simply because he was born
and brought up here. He is not interested *qua* poet in ideas or
his interior life or in culture or politics; so he writes about the
scene. The second poet is in a hurry to be successful; if Ameri-
canism is the order of the day, then Americanism is his thing.

But Harry Brown is the victim instead of the exploiter of
fashion, for fashion corrupts whatever native poetry he may have
in him. *The Poem of Bunker Hill* tries to be an epic, a patriotic
manifesto, and a properly modern poem all in one—which re-
quires no small facility on the part of the poet. Brown has facil-
ity, indeed, but it does not extend to narrative verse. Technically,
the best passages of his poem are the inspirational ones—which
are coincidentally the falsest and most offensive. Nor can I deny
Brown the ability to perpetrate howlers with a certain plausible
finish. Read fast, he can get away with murder. The best part of
the poem so far as I am concerned is the description of the actual
business of the battle, since it gives information, and gives it
with a directness that only a peculiar confusion of genres could
permit. Brown has managed here to get the best, or the worst,
out of both prose and verse. The latter's conventions relieve him
of any trouble about his periods, while prose sanctions his ne-
glect to keep some sort of beat or measure. But since prose is the
lower common denominator, he would have done better for his
reputation as a writer to have kept to it. For example, this is
verse, but awful as verse or prose: "And then he smiled. But his
smile was pitiful/And injured and sad." This is not verse, but
acceptable as prose: "And as they retreated the volleys of the
Americans/Grew less intense."

For the rest this poem is a passage of high-toned flag-waving,
a shameless bid for applause, a dive into the swim, a well-timed

jump upon the band-wagon, executed with pretension and chic. It is impossible today, and has been for a long time, to conceive of a historical event both important and simple enough for epic treatment. Brown is sensitive enough to suspect this but not wise enough to be convinced. He spends hyperbole and affects ignorance in the effort to convince himself as well as others that his theme does meet these requirements. Instead of elevating and simplifying his manner to fit the theme, he must inflate and oversimplify the theme to fit his manner, claiming for the American Revolution a content of such purity and historical force as can just barely be argued for Christianity. (It was all right—within limits—for certain modern poets to be simple-minded about the Socialist revolution, which has not yet happened; it is another thing to be that simple-minded, given the present state of the historical sciences, about something which has already happened.) To keep such a long narrative going in up-to-date verse, the poet pillages almost every notion, catch-word, and device hallowed by the usage of the correct contemporary poets, and by Homer too; does it with an infallible instinct for the chichi that is nothing else but chichi.

There is History, for instance, which is derailed not once but a dozen times in this work. Prescott's men go "walking into History"; they approach a little hill "Where the course of History would begin to undergo/A revision not mentioned in the Sibylline Books"; and "A bud of History was about to burst into flower." Love too, which is beginning to share History's bull market among the younger poets, is pulled in by the feet like Hector's body and thrown on the daedal heap along with the despoiled corpses of Homer, Auden, and sundry others, for ". . . men had walked across the world and found a thing called Freedom,/Discovered a thing called Love. . . ." Love, that is, was discovered by Columbus along with America and syphilis. Poetry like this is produced by a poet without modesty and without convictions. And we would disbelieve the importance of the creation of the world to hear it rehearsed in this idiom. *The Poem of Bunker Hill* is as spurious, flatulent, and vulgar as neo-Americanism itself. American patriotism—the real national kind, not the positive fear of Hitler—is dead, has already happened. As Marx says, the second time anything happens it comes as a bad joke.

George Zabriskie is a different story. The best of this first

book of poems is descriptive, panoramic writing that effaces itself for the sake of the object or scene. It presents the dingy neighborhoods of tin-can-littered lots, the wide dull streets, the neat and airless suburban purlieus of the greater New Jersey that is the America most Americans know. Against this, the poet invokes the escaping railroads, Daniel Boone, and the frontier; he can only fall back on what excited his boyhood. This is slight, strictly minor poetry, of course, but I read it with more immediate pleasure than I have got from the work of better poets. The pleasure is in the smooth sliding numbers, Zabriskie's ease, his remarkable metrical skill, and the poise, unusual in such a young and provincial poet, which enables him to keep everything, even his faults and his influences, under control. There are faults, there are falsities, but never a false tone. This is Zabriskie at his best:

> Westward, the stinking marshlands green with spring.
> And east the Hudson, where the soiled gulls cry
> From docks; for here the ships come in from paradise
> And hell, the soiled waters lick the laden bottoms
> Of a busy world.

"From paradise and hell" is not so good, nor is the last half-line. But the effect of this poetry is not in detail or phrase, it is cumulative; it makes its point by insisting with sincerity and perfect tact.

But Zabriskie's ear is so careful and he has so much tact that he is in danger of having no style at all. His verse is too neutral and almost too transparent, lacking the momentum of a manner of its own to carry it over the inevitable voids. Realizing this, he sometimes tries to force a style in the "modern manner" by combining terse syntax with periphrastic diction:

> In your ears the ivory click of poised precise
> Synthetic spheres, the muttered curse and slight
> Laconic word . . .

(Note, incidentally, the duplicated enjambement and the repetition on the same beat of the adjectival "ic.") The pool-parlor resists the writer's poetic faculties. He cannot intensify what he feels about it into poetry without recourse to artificial means; he strains after a pregnancy of statement where there is nothing to

be pregnant with. (And "muttered curse" is a cliché.) This all relates itself to Zabriskie's most serious defect—thinness of feeling or the inability to touch it. When Zabriskie attempts to evoke more than the immediate scene he falls into air, launches himself on big but used-up words like "torrential" and "shattering" in the effort to approximate emotions he may feel but does not yet possess for poetry. Zabriskie is a recorder, not a maker. But to be a poet is to make. Such skill and tact as his argue a genuine vocation for poetry, but they are not enough. They do not promise enough by themselves. The poet also needs culture. He must leave New Jersey.

*The Nation*, 17 January 1942

17.    Review of *Vlaminck* by Klaus G. Perls; *Paul Klee: Paintings, Watercolors, 1913 to 1939*, edited by Karl Nierendorf; and *They Taught Themselves: American Primitive Painters of the 20th Century* by Sidney Janis

It is possible to get away with murder in writing about art. In the text which he supplies for this latest book of Hyperion's series on modern artists, Mr. Perls discharges himself disingenuously of the obligation to discuss Vlaminck's painting. There is so much disagreement in matters of taste, says Mr. Perls, so few fixed criteria, and it is so hard to pin a work of art down, as it should be, by definition in terms of emotional experience, that "it follows that a book on Vlaminck should not contain a discussion of his artistic qualities." Instead we get biographical facts, valuable enough in themselves, and gush. Mr. Perls should be ashamed of his book. He must have seen much more of Vlaminck's work than all but a few of us, and he should have felt an obligation to describe the development of Vlaminck's art, at least factually, for the benefit of his admirers, most of whom like myself wonder by just what steps this great but not greatly publicized artist came to paint the way he has for the last fifteen years or so. I know, Vlaminck is a repetitious painter, and it is difficult to describe a progression through repetition. But as difficult as that may be, one does not write about art in the first

place without being ready to confront the difficult. The physical qualities of his book are of a piece with its text. However, as bad as the numerous color plates are, their colors are so uniformly off that an indication of their abstract relationships to each other in the original survives, and thus you can get some notion or souvenir of Vlaminck's real quality.

*They Taught Themselves* is first-hand writing about art. It contains a series of descriptive monographs and biographical sketches covering thirty "naive-primitive" American painters of this century, with black and white reproductions of their work. Many of these artists, and some of the best of them, were discovered by Mr. Janis himself, and his book is a record in a way of the operations of his taste, which is spontaneous, cultivated, and of a catholicity that must mean an immense delight in painting for its own sake. I have many objections to the way Mr. Janis writes and to some of his assertions, but behind every one of his choices is a good reason, even if each is not, as André Breton claims, "an intellectual event, or a landmark in the direction of mystery and fire." Nevertheless, it is my opinion that save for their matchless Rousseau—who was, I suspect, more a deliberate than a naive primitive—most contemporary primitive painters are overrated, especially the French: Bombois, Bauchant, Vivin, Eve, et al., all of whom are somewhat spoiled. Cultured painting, for all the crimes of its exponents, has a power to multiply sensations and suggestions that very little primitive painting can equal. And if it is true that some of Mr. Janis's artists can take a place in the front ranks of American painting, it is a sad reflection on our painting. Yet it is true, and it is sad. Morris Hirshfield, to whom Mr. Janis rightly gives the most space, would hold his own against any competition, but if Pickett, Sullivan, Frouchtben, and Tourneur, as good as they are (not Kane, who is overrated), seem so good by comparison to what is shown at the annual Whitney exhibitions, then American painting is in a bad way. I wish Mr. Janis had given more space to Tourneur, whose work I discovered for myself in Washington Square at about the same time Mr. Janis did. His small pinkish landscapes are even more remarkable than *The Siwanoy Night Patrol*, which is reproduced in this book. Tourneur's case points out the need to make some generic distinctions between these self-taught painters. There are those whose art is closer to that of children and

primitive peoples, dateless in everything except subject matter; these are true primitives or naifs; and then there are those who have acquired something of the technical competence of our civilization yet retain an essential naiveté because of their isolation from culture; these I would call eccentrics. There are also intermediary cases. It is significant that most of the naive-primitives began painting in earnest relatively late in life when they were too old to become professional and no longer adaptable enough to turn commercial. It is this late start which has preserved them.

The Klee book is made up of sixty-five well-executed black and white reproductions in chronological order. The only fault to be found is that over half of the pictures reproduced date after 1932, when Klee's best work was behind him, and his style had begun to harden and lose its precious lightness. But this hardness and this heaviness are somewhat attenuated in black and white; the most characteristic perfection of Klee may be missing, but there is enough else. Mr. Nierendorf's biographical and bibliographical notes are informative and, refreshingly enough, to the center of critical gravity, resorting to almost none of the subterfuges of impressionistic appreciation by which most writers on art try to evade the arduous responsibilities of analyzing it. I object, however, to his insistence upon the "poetry" in Klee's art. It is possible to say that all art is successful by virtue of its "poetry," but it does no good then to attribute a large amount of it to one great artist and a lesser amount to another equally great one. Is Beethoven more poetic than Bach? If Klee's poetry is produced by an "ambiguity of plastic relations which speaks through all its elements instead of merely relying on what it means," is Renoir's art any less poetic?

*Partisan Review*, March-April 1942

18. Poems: A Note by the Editor

Most of the younger contemporary poets have to hurdle the overlapping barriers of fashion and taste. One is inescapable, and the other necessary. We all recognize the dangers of fashion,

of not being able to surmount it, but little is said about the no lesser dangers of not being able to surmount good taste. This is an age of good taste in literature, and what displeases me in so much of the competent work of our younger poets is the timidity good taste enforces. These poets go no further than a general good taste, which has been established for the moment by their admiration of Yeats, Stevens and Auden, will take them. Their care to be smooth and correct outweighs every other concern, and they smooth and correct out of their over-contrived verse all the resistances of the personal, temperamental, all the necessary awkwardness and faux pas of original creation. But the poet who allows himself to write only in the way he feels he must write, regardless of taste and fashion, and who wrestles with and exploits, rather than evades, the difficult material offered by his own temperament—such a poet goes further than taste can guide him. And for this reason, whether or not he really is a poet is decided very quickly.

By taste I do not mean the *discipline* of poetry; in going beyond taste the poet does not go beyond discipline, but extends it to new areas, incorporates new regions into the domain of poetry. Nor do I necessarily mean by this Experiment. The poet writes in a new way only because he has to, not because he wants to. And often he does not have to write in a new *way* in order to write new poetry.

Except for Thomas's ballad I have selected the poetry here from unsolicited manuscripts.[1] It represents no one tendency, but it avoids, I hope, two: the tendency of current good taste and the tendency of the enthusiastic ego. None of these poems point out as definitely as would certain poems by Auden and Barker the directions in which for the lack of anything better I hope English poetry will go, but they do point them out to some extent. They have in common, I believe, spontaneity, the comparatively successful digestion of influences, and they show dis-

1. The poems selected by Greenberg were *Patingenesis* by Isabella Fey, *To Whitman* by Jackson Mathews, *The Answer Usually Comes in Words* and *The Mirage* by Oscar Williams, *In the Tunnel* by E. L. Mayo, and *Ballad of the Long-Legged Bait* by Dylan Thomas. In the May-June issue of *Partisan Review*, Harold Rosenberg criticized the selections and took Greenberg to task for writing on art while at the same time referring to "himself, his tastes and opinions no less than 10 times on 1 ¾ pages." Greenberg's rejoinder was brief: "Mr. Rosenberg seems to read my stuff rather closely." [Editor's note]

tortions that result from the effort to deal with resistant material. What is more, in accepting form they accept it as something to be emphatic with, not to be surrendered to.

*Partisan Review*, March–April 1942

19.  Review of *Be Angry at the Sun and Other Poems* by Robinson Jeffers

Jeffers's poetry turns out to be better upon reacquaintance than the reviewer remembers it to have been. And the reviewer is not one to overrate this sort of poetry. But it stays more or less the same, without amplification or development. All that is new in this latest volume—the unrelieved obsession with contemporary events and even the influence of Yeats (one of Jeffers's few admissions that he reads his contemporaries)—is imposed upon an unchanged essence. The new narrative poem, *Mara*, is as bad as ever, if not worse—probably worse. How Jeffers won his reputation on the basis of his narratives I cannot see: they contain some of the worst respectable poetry in English, and couch a humanity too narrow ever to be taken very seriously in poetry or out of it. Elsewhere, in the verse play included in this book and in the short poems, this narrowness does less harm, lacking the space in which to make itself felt.

The verse play, which deals with Hitler at a peripatetic moment of his career, is surprisingly successful in spite of its stilted passages, because its argument is felt strongly and seriously enough to inform the verse with strength and seriousness. Jeffers treats Hitler as a personality valuable in its own right, and thus not simply to be hated and feared but to be understood and delineated for the purposes of poetry, since, after all, it is to figure in a poem. The paths to wisdom, or to a wise attitude, are many, and not all of them are wise. Jeffers's philosophy of history, a compost of Spengler and sophomoric cynicism, enables him to understand events better for the sake of poetry, and perhaps for the sake of truth itself, than does the better-informed, better-intentioned, but more self-indulgent partisanship of liberal anti-fascism. The latter for the right reasons clings to illusions

of which Jeffers has rid himself for the wrong reasons. Wrong reasons and all, this is why the short poems here make up some of the best contemporary literature about the war itself.

But what is Jeffers's merit as a poet? Certainly he has too little and too crude a feeling for language and for the plastic requirements of poetry, too little sensitivity to the weight, texture, flavor, rhythms, and history of words, taking and using them too much as he finds them, failing to exploit their extra-logical qualities. He can state physical detail vividly; yet he has little power to suggest or evoke much beyond that which is actually *stated*. But that is just it. Jeffers's poetry is successful—when it is successful—as statement; one might almost say as charged prose. It is worst whenever the poet reminds himself that he is writing formal poetry and tries to call the reader's attention to the fact. This verse does not enter poetry by its formal merits but because it is driven by a certain force and conviction. It is *about* something. And this something, the experience of a sincere and intensely serious person, is strong enough to transfigure the crudeness and clumsiness of its own means of expression. Given, to begin with, enough intensity and some competence—which Jeffers does have—thoroughgoing sincerity will usually produce some amount of good poetry in a lifetime. With most people fashionable pretensions and the wrong influences get in the way.

For Jeffers there is little question of this last; he is an odd item, a raw poet, out of the main stream, taking nothing from and giving nothing to his contemporaries. Which is his handicap as well as his advantage. He understands too little, knows too little, cherishes too many half-truths, and like all provincials tries to make too few ideas go too far. Thus, not having enough art, he has to rely mostly on his temperament. I can only wonder whether that will be enough to make more than a small fraction of his work permanent poetry.

*The Nation*, 7 March 1942

20.    Review of an Exhibition of André Masson

Oils, gouaches, drawings. Buchholz and Willard Galleries. Masson's failure is in the contemporary grand manner. There is little of the dull or second-rate about his work, and to fail as he does is more worthy than to succeed as any dozen safe and minor artists can. Masson is a surrealist, but he has absorbed enough cubism, in spite of himself, never to lose sight of the direction in which the pictorial art of our times must go in order to be great. His endeavor to expand painting concentrates on the means, not on the subject; color and line are to be detached and disassociated from their old habits of meaning, and made to express or suggest what is inconceivable to anything but the eye's imagination. One can glimpse through the badness of his painting how greatly Masson conceives; and so it is only by some physiological, tactile deficiency in himself that I can explain the collapse of his actual work; the raging sickness of color, the obtuseness with which he rattles together pigment, design, space—the *art nouveau*, the hard, machined insensitivity of line in his drawings, and their maladroit literary flourishes. A débâcle, in which there are at the most three acceptable pictures; but as I have said, little that is second-rate, nothing that is stereotype. Masson could cover up his faults rather plausibly and without too obvious dishonesty, and I praise him for his unwillingness to be anything but himself.

[Unsigned]

*The Nation*, 7 March 1942

21.    Review of an Exhibition of Darrel Austin

Oils, drawings. Perls Galleries. Austin has his *petite* sensation, which furnishes him with one or two provocative pictures, but when he tries to eke out a whole career with it, it becomes a trick, a formula, a routine. The green marsh mist and incandescent gases that dapple his canvases are distilled quite knowingly from the best materials, and designed to satisfy the most dis-

criminatingly modern appetites. In my opinion this is the very
last word in kitsch.

*The Nation*, 14 March 1942

22.    Review of the Exhibition *150 Years of American
       Primitives*

The Primitives Gallery of Harry Stone. This collection of about
forty works, few of which are first-rate in their genre, seems to
support my contention that the best American art has been, and
perhaps still is, primitive or naive. These pictures have a first-
hand quality, an immediacy, which cultured American painting
lacks. This quality alone is not enough for great art, but there is
no great art without it. Incidentally, it is curious to see how the
paintings here, most of them of the nineteenth century, reflect
the influence of their academic contemporaries, with their tonal
monotony, brown sauce and all.

*The Nation*, 11 April 1942

23.    Helter-Skelter: Review of *New Directions in Prose and
       Poetry: 1941*, edited by James Laughlin

These are more than new directions; rather a helter-skelter in
every direction. My most precise reaction is wonder as to the
mind able to organize this tour, this Noah's Ark without helm or
rudder, every animal of which seems to have been included as an
afterthought. One thing is patent: the editor is in the know: a
good amount of the work here, regardless of its merit, owes its
presence to its having been lately puffed in the right quarters.
But Mr. Laughlin's own editorial notes reveal most. About Ezra
Pound he can say: "People who hear him broadcasting for the
Italian government do not realize that possibly he has no choice
in the matter." And to introduce the section of Soviet poetry
(the worst thing in the book, the fault for which belongs to the

impresarios and translators rather than to the poets themselves) he asserts that "It is shameful the way we pay no attention to what is going on in the culture of a country which has again proven itself one of the greatest." Mr. Laughlin is either an out-and-out opportunist, or naive—most likely both. We are grateful to him for publishing some deserving work that would not otherwise see print for too long a time, but I think the job could be put into better hands.

In detail the items are not quite so dull as at first glance; there is relatively little of which you can say with assurance, "This is awful; this is hopeless." Every writer has his ambition, his experience and his little flair. Yet, fundamentally, how mediocre most of it is. What limited objectives are strained for, what a lack is here of curiosity, learning, flavor, force. How minor are the triumphs. (All this applies particularly to the American contributions.) Only in the absence of anything better, only because of the tons of venal literature published in this country, can it be said that more than one-half of *New Directions: 1941* deserve to be printed. Life is short and there is not time to read everything. True, there is a certain hunger for reading matter that can only be satisfied by ambitious contemporary work, and which makes a lot of it seem better, even to the most stringent tastes, than it really is. Nevertheless, it is not blasphemy to say that it would have been a better service to American literature to have left unprinted four hundred out of the seven-hundred-odd pages. The avant-garde cannot indulge itself just because it is the avant-garde.

For all its ups and downs the avant-garde still manages to turn out rather steadily an amount of good writing, especially poetry. Most of the good new poetry in English has come from Englishmen, and they depend on their indigenous traditions, really, just as much as on avant-garde morale—which is about all the American poet has. The defections of such as Brooks and MacLeish would have been unlikely in a country where there was a current of strong ideas and convictions beyond advanced writing, or a rich literary tradition as in England. Ambitious new literature in this country has floated too long simply on a convention of experiment for the sake of experiment, or on purely literary ideas, now become academic. This is no longer enough. When the impulse that came from the first awakening of avant-

garde consciousness in America and from French modernist literature gave out, socialist revivalism was able partly to replace it, but with that gone, nothing is left, nothing at all, not even art for art's sake and contempt for society in general. There is no longer the struggle to control new material; only experiment in a vacuum, renovated exteriors, exhibitionism and careerism, with underneath it all an essential and boring conformism.

The most pertinent cases here are Delmore Schwartz and Paul Goodman, both of whom are more or less conscious of their plight and try strenuously to escape it. Schwartz has curiosity, learning and an amount of talent, but he lacks *material*. In his work we see the writer not writing about something, but trying to provide himself with something about which to write. Too often he works this something up out of his accidental self; hence the posturing, the self-conscious smirking and the execrable bad taste of "Paris and Helen," his verse play in this book. Here as elsewhere Schwartz adapts the Noh-play form in order to put the poet on-stage and keep him there. Paul Goodman has less literary talent than Schwartz and makes quite a different appearance, but starts from the same place and ends at the same. And, like Schwartz, Goodman is a better critic than a creator.

The best work in *New Directions* is by foreigners. Brecht's *Mother Courage* is good in detail, but far from a success as a whole; Brecht has become a writer of scenes, not of plays. Although the translator has failed to get the real flavor in German of Brecht's dramatic prose, he has rendered the songs very well. The most interesting poetry is Hugh MacDiarmid's cogitations in crabbed angular verse on the processes of artistic creation. André Breton's easily translated long poem, *Fata Morgana*, should be read in short snatches, but not as a whole. Also to be read are three or four pages of Georg Mann's satire on a Bolshevik bureaucrat, which is a very good and original idea spoiled by overeager execution. The articles by Calas, Delmore Schwartz and Golffing are worth going through, and then read or do not read the short stories by Field, Liben and Merriam. But avoid as you would all boredom Julien Gracq's *Château d'Argol*, a tour de force in tour de force. Read, of course, Kafka's little story, *E poi, lettore, guarda e passa oltre*.

*The New Republic*, 13 April 1942

The sixth annual exhibition of the American Abstract Artists seems to have released a spate of group shows of abstract art. The high-water mark is the Red Cross benefit exhibition *Masters of Abstract Art* inaugurating Helena Rubinstein's New Art Center on Fifth Avenue. At the same time A. E. Gallatin is showing a selection of recent acquisitions and loans that will remain on view over the summer at the Gallery of Living Art at New York University, Washington Square; and the Museum of Modern Art is presenting for an indefinite period recent accessions and extended loans to illustrate the origins and development of abstract painting and films. All four exhibitions overlap, but their emphases vary.

The A.A.A. exhibition was the most provocative show of all, not so much because of the merits of the individual contributors as because many of them were comparatively young and so could tell us most about the probable future of abstract art in this country. Upon this future a lot depends. The abstract is the one contemporary order in which it is least possible to get away with the chic, the imitative, and the merely facile. While the American abstract movement has been no less chained to its origins abroad than the rest of our art, and has produced its own share of pallid, imitative work, abstract artists are as a group more conscious of their shortcomings in this respect and less comfortable about them. They are unwilling to settle for anything less than a first-hand art.

Aside from the collective impression made by the A.A.A. show—which as a feat of hanging alone induced the exhilaration peculiar to well-housed shows of abstract art—certain individual performances made one feel that here was art in movement; new possibilities were being plumbed that burst the confines of the set easel-picture and sculptured piece. Nor did it matter too much whether the results so far were very successful or not. And there are no great successes as yet: a certain authority is lacking, there is a hesitancy even in the work of the older artists—a hesitancy not present, for instance, in the big painting on view by Jean Hélion, a Frenchman, which manages to retrieve its weak, Vermeerish color and inflated design by what I can only call authority or assurance. But there is a begin-

ning, and *beginnings* can be found almost nowhere else in contemporary American art. Among the most promising evidences were the metal constructions of Ibram Lassaw, clean, intense, and full of animation. However, Lassaw sets himself problems that seem at times too easy; which is also the case with Gertrude Greene, whose polychrome bas-reliefs would be more interesting if color were used to define the planes in depth as well as in extension. As for the paintings themselves, the best seemed to me to be those by Hananiah Harari, Giorgio Cavallon, and Esphyr Slobodkina. They had in common a fluidity of shape and color that seemed least to violate the character of their medium, in contrast to the "geometricians," who treat canvas as though it were concrete or plastic. But there is one painter among these latter, Albert Swinden, who shows as much promise perhaps in his single unsuccessful painting as the others in their successful ones.

Many of the artists whose work appears at the A.A.A. show are also represented at Mr. Gallatin's exhibition. I admire Mr. Gallatin's taste, but sometimes find it too narrow. This may be the reason that his show makes a duller impression, even though there was nothing at the A.A.A. so completely finished as two of the pictures here by Hélion, or one by Mondrian, or the gauzy composition in citrus colors by John Ferren (whose show of more recent work at the Willard Gallery marks a great retrogression from this).

The exhibition at the Museum of Modern Art identifies the origins of the absolutely non-objective in the "suprematism" of the Russian painter, Kasimir Malevich, "who in 1913 began to base his art upon the square and the circle." The works by Malevich and his disciple Rodchenko, by Larionov, the Russian "rayonist" (he analyzed the visible into streaks of colored light), and by Umberto Boccioni, the Italian futurist, all have documentary value but are meager in aesthetic results. Going on to the section of the exhibition devoted to the School of Paris, we see that the great abstract and semi-abstract idiom is post-cubist and French, and that in its heyday, 1910–30, it could work through such comparatively minor talents as Le Corbusier-Jeanneret, Villon, and the sturdier Antoine Pevsner to produce little masterpieces. Even Mondrian, to judge from the work he did during this period, of which there is an example here done in

solid squares of color, was perhaps at his best while still strongly under the influence of post-cubism proper. And if the large and a bit over-aggressive painting by Gorky, an American, is good, it is because he continues the same thing in his own way. And of course there is the splendid still life by Braque and the one by Picasso, which consists of three very good paintings not very successfully put together on a single canvas. Of the rest of the show one can only say, "how interesting." It was certainly worth while to have obtained the examples of sundry other pioneer abstractionists, Wilfred's Lumia compositions and the water-color designs for an abstract film made in 1913 by Leopold Survage, but the practical result—the pleasure to be got from them— is nil.

The *Masters of Abstract Art* is the latest and richest of the four exhibitions, containing as it does works by Picasso, Braque, Arp, Miró, Van Doesburg and others, which have already taken safe and calm places in the pantheon of art. The finest item is a portable mural painted in 1933 by Miró, who, like the other Spaniards Picasso and Gris, belongs mainly to French painting and is one of the few artists of our day able to cover a large area of space so well that the beholder wishes it even larger. At the sight of the cubist paintings by Gris, Picasso, and Braque, one wonders how it was ever possible to say that cubism is a dry, "intellectualized" art without emotions, for these pictures with their brown tones and vibrating planes communicate the pathos of their moment and place with an eloquence more than equal to that of Apollinaire's poetry. However, the special excellence of this show does not lie in its confirmed masterpieces but in the generally high level of accomplishment shown by the work of the lesser men, both American and foreign. There are plenty of bad things here, but I was more than once surprised to discover how well artists whose work I do not particularly care for could paint in given instances.

It is to be wished that this show had the advantage of more spacious quarters so that one could get more than four feet away from some of the pictures.

*The Nation*, 2 May 1942

25.  Study in Stieglitz: Review of *The Emergence of an American Art* by Jerome Mellquist

This is an account, more descriptive than evaluative, of painting, sculpture, graphic art, architecture and photography in this country from around 1890 to date. It presumes without arguing about it the emergence of "an" American art during this period, which begins from Whistler, Sargent, Chase, etc., continues through a "Revolt"—which was Stieglitz, photography, "291" gallery, cartooning, Hassam, Henri, Luks, etc.—and culminates principally in those artists closest to Stieglitz: Marin, Lachaise, O'Keeffe, Hartley, Dove. Although the emergence is indentified with the assimilation in this country of modernism, it can be considered, according to the author, to have commenced with Whistler and Sargent, because in them American artists found for the first time models for their emulation who were compatriots. What kind of art it is that emerges the author does not say, nor whether it is an art noteworthy because specifically American or simply because it is great. The book has the merit of bringing to our attention information from such neglected fields as photography, magazine illustrating, cartooning and art journalism, but otherwise it is singularly devoid of enlightenment.

Mr. Mellquist writes badly, without strictness or distinction, with injected color, cooked-up drama and panting breath. He is really better than his writing, better, that is, than this: "He throbbed—for he is a sensitive man—when he looked at the first Cézannes. Later he vibrated to the Picassos. He 'flowed' after seeing Rodin. He responded always, and at once." Or: "He personalized the factory." Mr. Mellquist allows himself to write this way because he lacks ideas by which to control his material—and himself. And like most people without ideas, he takes too much for granted, failing to question his theme for the distinctions and connections which, after judgments of value, give the most excitement to discussion of art.

As to questions of value: Mr. Mellquist himself writes; "They [the American people] cannot distinguish between the big and the little in our painting. . . . It is the job of criticism to undertake this guidance. Until it does, it remains mere compilation, valuable perhaps as an aimless catalogue, but of absolutely no

consequence in establishing that scale which is necessary to all understanding." Mr. Mellquist's own book runs the danger of being an aimless, if florid, catalogue, for it certainly establishes no scale for the understanding. The various critical estimates have no coherence, and are conceived without reference to any explicit or implicit hierarchy of values. Usually they sound like this:

> Yet, qualify though one may because of Weber's lack of spontaneity, the fact remains that he always composes with authority. One may go far back in his canvases, or from side to side, or up and down, and always there is that indispensable element of space which he has sought in the work of other men . . . when at his best, he revitalizes his concepts, particularly when an innermost intensity leads him into some smoky and tumultuous cavern where the overbending arches are almost insupportable. Here he rises, despite the mental weight of past and present, and accepting at last a spiraled, twisting, lighted center within, embraces the rapture that is rightfully his.

The first sentence is just, however vague. The rest is an impression more than a critical estimate. Mr. Mellquist does not place or evaluate Weber's art. He describes, without conscience either as a writer or critic, his reactions to it. Otherwise, Weber may be no more estimable, for all the author gives us to know explicitly, than any other artist in the book. We gather that he is quite estimable from the fact that he gets half of a chapter to himself, whereas Maxfield Parrish, who is declared to be competent but a synthetic illustrator, gets only a footnote. (Mr. Mellquist is to be commended, however, for noticing such phenomena as Parrish.)

One standard does emerge from Mr. Mellquist's writing, which is more constant than critical, and that is to approve of everything and everyone more or less connected with Stieglitz. The tutelary genius of the acclimatization of modernism in America, and therefore of the emergence of "an" American Art, is Stieglitz. Marin gets more space than any other artist. It is quite possible that he is the greatest living American painter, but in order to define his greatness it is necessary to delimit as well as praise it breathlessly. Mr. Mellquist adds nothing to our conception of Marin's art because he does not put it into any perspective. When we see how seriously the ineffable O'Keeffe and

the saccharine Dove are treated (with a chapter each), it becomes evident that Mr. Mellquist's attachment to Stieglitz takes precedence over everything else. More than once we get the impression that when an artist, Henry Varnum Poor, for instance, or the photographer Walker Evans, is found unsatisfactory, it is largely because he fails to see the Stieglitz circle's notions of what modern art should look like (experimental and somehow esoteric). Alfred Stieglitz's services to American art are inestimable, and he is one of the best photographers there have been, but for all that there is about him and his disciples too much art with a capital A, and too many of the swans in his park are only geese.

*The New Republic*, 15 June 1942

## 26.   Response to "An Inquiry on Dialectic Materialism"

My answers to the first two questions are no.[1] I wish I could say yes. There *ought* to be a verifiable dialectic process; I wonder whether it was this *ought* that more than anything else moved Trotsky to defend Dialectical Materialism—at any rate he was moved by much more than Marxist piety.

I do not consider the third statement valid. But Hegel's "laws" are valuable literary devices for the exposition of the results of theoretical thought, and like all literary devices can effect the processes themselves of thought, especially when these take the forms of historical analysis. After all, are not these "laws" intended primarily as historical laws, laws of the pro-

1. Greenberg's answers are to two questions and a statement posed by Wolfgang Paalen, editor of *Dyn*, in a questionnaire: 1. "Is Dialectic Materialism the science of a verifiable 'dialectic' process?" 2. "Is the 'dialectic method' a scientific method of investigation?" 3. "Hegel in his logic established a series of Laws . . . which are just as important for theoretical thought as is the simple syllogism for more elementary tasks." The other respondents to the questionnaire were Bertrand Russell, Sidney Hook, Albert Einstein, William Heard Kilpatrick, George Hartmann, Pierre Mabille, Dwight Macdonald, Philip Rahv, Goodwin Watson, John L. Childs, Meyer Schapiro, Parker Tyler, Morton G. White and Charles Givors. [Editor's note]

cesses of history rather than those of theoretical thought in general?

*Dyn*, July–August 1942

## 27.   Primitive Painting

"Primitive" painting belongs to the Industrial Age. It emerged toward the close of the eighteenth century and defined itself as independent of tradition, whether that of sophisticated art or that of folk art. It was mainly an effort to find a new outlet for the plebian "artistic energy" that was left without an object by the dying out of folk art in an urban civilization. This outlet could not be found in sophisticated art, because the persons who embodied such "energy" were too poor or too isolated to possess themselves of the culture that sophisticated art presupposes. All this was pointed out by a German scholar, Nicola Michailow, in a very important, almost epochal, article [1] (prompted partly, one may suppose, by the Nazis' solicitude for anything and everything that can be construed as "folk"). The practitioners of *Laienmalerei* (lay or unprofessional painting), as Michailow calls it, had to fill by their own independent efforts the vacuum left by the extinction of living folk art. It is to the lack of formal training and of almost every other advantage of a continuous tradition that their painting owes its "primitive" character. The self-taught painter, Michailow adds, is to be found mostly among the petty bourgeoisie, that much-maligned class, which more than any other has inherited the "primeval creative urge of the *Volk*." Yet, paradoxically, the first individuals sufficiently cut off from all pictorial traditions to paint in the primitive way were aristocrats in comparatively backward regions like North Germany. Thus Frederick William I, King of Prussia, was one of the first "primitive" painters of whom there is any record. It was only later on that the masses became traditionless enough to produce such painters.

Why did so much of this popular "creative urge" find its ave-

1. In *Zeitschrift für Kunstgeschichte*, nos. 5 and 6, 1935. [Author's note]

nue in easel-painting? Michailow does not attempt to answer the question, although it is a crucial one. Answers offer themselves, however. First, there was a demand for portraits and wall pictures by the new middle class arising in provincial towns and villages, which could afford to spend modest amounts on such satisfactions and which at the same time was more or less out of touch with metropolitan culture. This would show that popular painting was in the beginning a move to supply a market as well as to satisfy a "creative" urge. Secondly, industrial methods first made possible the wide circulation of the materials for painting and of reproductions of academic art. The importance of this last is easily overlooked. Michailow and Jean Lipman, in her recent book,[2] both tend to exaggerate by omission the non-derivative character of primitive and popular painting. Yet I feel sure that in most cases it was through acquaintance with reproductions that the purchaser came to want pictures and the amateur to want to paint them. Moreover, it is unthinkable that self-taught artists would have dared to paint, as they did so often, pure landscapes and still lifes, had not sophisticated art already provided them with examples. Consider only how long it was before sophisticated art arrived at the landscape and the still life.

Michailow and Mrs. Lipman also fail to touch on a very important distinction to be made in the corpus of work lumped together as "primitive" painting. There were professional "primitive" painters who made a living by their art, and there were and are amateur primitive painters who paint chiefly for their own satisfaction. The professionals were apt to be more responsible to the influence of contemporary academic painting (some of the portraits reproduced in Mrs. Lipman's book seem to derive their conception, if not their execution, from the fashionable painting of the late eighteenth and nineteenth centuries—and it is not altogether a question of similarity in styles of dress); and there seems also to be a sort of craft continuity between the work of one professional painter and another: they had trade secrets in common and tried to meet the demands of a public taste. The amateurs, on the other hand, paint with less technical competence but with more daring and originality. Although no hard and fast line can be drawn between the two groups, it would

2. *American Primitive Painting*, New York, 1942. [Author's note]

seem that only persons whose painting had nothing to do with money dared to produce work of such a frankly primitive character as is seen today in the pictures of self-taught artists like Hirshfield and Vivin. Such painters are rightly called primitives, but it is the work of professionals, of *popular* painters—including lady water-colorists—not of amateurs and primitives, that largely makes up the American tradition of "primitive" painting with which Mrs. Lipman's book deals; and a *tradition* it was, so much so that it almost escapes Michailow's definition of primitive painting and requires one of its own.

Elsewhere in his article Michailow observes that *Laienmalerei* has flourished most splendidly in those outlying countries of Western civilization over which metropolitan culture was comparatively thinly spread—Germany, the Balkans, and North America. One might add that if it was the absence of tradition that was all important, then our country was ideally situated to produce primitive art; for here we had in the beginning almost no tradition at all of pictorial or decorative folk art among white people. Those who settled our country as its "folk" were iconoclastic Protestants, and whatever art they maintained was until the nineteenth century dependent on transfusions from Europe. Unlike the German or Bulgarian primitive painter, the American suffered from neither the memory nor the competition of an anterior indigenous tradition. He could begin painting as an independent and original entrepreneur, untrammeled by the tariffs, patents, and prescriptions of the past. For this reason, perhaps, the United States produced the most uniquely native and substantial body of popular painting to be seen before the twentieth century.

Mrs. Lipman's conscientious and cooly written text is an important if brief contribution to the subject. It presents the fact of a school, a trade, and a pastime of popular painting which flourished vigorously in New England and the Middle Atlantic states from the last quarter of the eighteenth century until about 1875. Its practitioners were itinerant "limners" or portraitists, scene and flower painters, decorators, lady water-colorists, and pure and simple amateurs. Mrs. Lipman analyzes their art—stressing its "abstract" quality—describes their methods of work, and quotes extensively from the recipes and hints by which the somewhat quaint tricks of this trade were circulated.

(For many amateurs, at least, this painting seems to have been a part of the typically American business of practical self-improvement.) American popular painting was an art characterized by its insistence upon rhythmic design and balance, by comparatively pure color—although not so frank by far as in the work of contemporary primitives, and much more receptive to the half-tones of academic painting—and by strong, un-self-conscious emotion translated in both literary and painters' terms. The artist makes up for a certain repetitiveness by his quiet, steady fervor and his appetite for his work. His painting goes back to the first assumptions of pictorial art and reexamines them in all their original freshness, reminding one again of the excitement there is in simply discovering that it is possible to depict three-dimensional things on a flat surface. But unlike children's art, this painting is not simple-minded; it achieves subtleties by means that seem only in themselves simple and crude. Its best common quality, in fact, is this ambiguity created by the simple thing itself and the richness of its effect.

There are, however, demands which this art cannot ordinarily meet. The reliance upon formulas and ready-made elements is often hardly compensated for by the freshness of invention elsewhere. The tight design and the insistent rhythms, to which the naive artist is always prone to surrender himself, are a liability as well as an asset, for they tend to overcome everything else and destroy dramatic movement; and it is only by its very intensity that even some of the best of this popular painting can retrieve itself from decoration. Nor did many of the self-taught artists who worked in oil take full advantage of their medium; they might just as well have painted in tempera so far as the final result is concerned; and perhaps, given their liking for trim contours, flat surfaces, and large areas of uniform color, they would actually have found tempera a more congenial medium. But on the other hand, one of the real charms of their art is precisely the result of their clumsiness with such a flexible medium as oil. Having made these reservations, I find it possible to go on to praise this painting seriously and without condescension, agreeing with Mrs. Lipman that more than one of these popular artists "arrived at a power and originality and beauty which were not surpassed by the greatest of the academic American painters." This was true indeed of such painters as Joseph Pickett,

Joseph H. Headley (who did townscapes around Troy, New York, between 1840 and 1860), and the anonymous master of the *Runaway Horse* (circa 1850), and several others who painted portraits and still lifes before the Civil War. In the cases of Headley and the master of the *Runaway Horse*, popular painting approaches sophisticated art in its fluency, while in Pickett's case it is wholly primitive and attains a kind of force only possible to primitive art. But significantly enough, Pickett really falls outside this period—his dates are from 1848 to 1918—and his status as a picture painter was strictly amateur.

The American popular painting trade was unable to survive the competition of photography and the cheap reproduction. According to Mrs. Lipman, it can be considered to have died in the eighteen-seventies. Yet it lingered on in some places. It seems to me that there was a pictorial notion in the design and draftsmanship of some of the Currier and Ives prints which continued as well as superseded popular art. What was lost—and as it seems now, irrevocably—was a precious tact in the use of color.

The illustrations in Mrs. Lipman's book do not sacrifice aesthetic merit to documentary interest. Those in black and white are excellent; the color plates, however, are rather poor, and perhaps less well chosen—four of them are detachable from the book. But Mrs. Lipman's book is valuable enough without them.

*The Nation*, 10 October 1942; A&C (substantially changed).

## 28.   Review of *The Seventh Cross* by Anna Seghers

Anna Seghers is perhaps the most talented German novelist to appear since Thomas Mann and Hermann Broch. Her abiding theme is the Socialist revolution—more specifically, the Communist Party's efforts toward it in Germany and Central Europe in the twenty years between the two wars. Her novels are "activized," filled with political activity, its problems and dangers—not those of politics pure and simple but of political action, of performance. Feminine sensibility is caught up by

movement and the drive of large issues. Notwithstanding their theme, her novels really have little of what is commonly associated with the political novel. They cannot be confined within such categories as proletarian literature or "socialist realism"—however much Seghers may have tried to cut her cloth to their measure. She has too much art.

Seghers's latest novel has not the perfection of her first, *The Revolt of the Fishermen* (a fishermen's strike on an island in the North Sea); nor has it the vitality and regional flavor of *The Prince on His Head* (rural Germany on the eve of Hitler); it lacks the panorama and interest of *Companions of the Road* (the Third International in exile and underground in Eastern Europe) and the excitement of *The Road Through February* (the uprising of the Austrian Socialists in 1934). It does not constitute the step in Seghers's development that was to have been expected after her previous book, *The Rescue* (a mining suburb in eastern Germany between 1929 and 1933). This was in some ways her most ambitious work. *The Seventh Cross* is less ambitious and less serious. It wants to move more by the facts of plot than by the modulation of character and situation. The balance between external adventure and interiority so characteristic of Seghers's writing is upset slightly in the direction of the former. Technically, the book is a model of tension and cumulative effect; Seghers knows her trade and her outright talent leaves its trace on anything she touches. Thriller that it is, *The Seventh Cross* has enough of her very original obliquity of perception to place it on a higher level than any other novel about Nazi Germany that has been translated into English.

Seven men break out of a concentration camp in the Rhineland. Six of them are recaptured, alive or dead, within a few days. The seventh, after a week of wandering and hiding and of agonizingly tight scrapes, makes good his escape, aided not only by his own moral and physical toughness but even more decisively by the solidarity among conscious and unconscious anti-fascists in Germany that rises to the surface when acted upon by the right catalyst. That only one out seven should succeed in escaping from a concentration camp is not a defeat; on the contrary, it is a triumph. For "the strong can afford to be wrong at times without loss of prestige, because even the most powerful are after all only human—yes, their mistakes make

them all the more human—but he who claims omnipotence must never be wrong because there can be no alternative to omnipotence except insignificance. If one stroke, no matter how tiny, proved successful against the enemy's alleged omnipotence, everything was won." This is the first of Seghers's novels to have actually as well as morally a happy ending. Before this, the moral victories with which they always closed were unadulterated by any real ones.

The typical motifs of Seghers's previous novels—the fugitive, the awakening of political consciousness, and the intrusion of politics upon the family and the community—reappear in *The Seventh Cross*. No one has got the family and the humble milieu into writing better than she has. The constant argument of her other stories is also here: how one meets the challenge to one's moral and physical courage of revolutionary action. And just as in most of her other books, the narrative is developed along multiple threads. There is a succession of discontinuous scenes, the writing eye now falling on the fugitive, now on his friends, now on the friends of his friends, now on his family, now on his pursuers, now on those whose path he is about to cross. Characteristic of Seghers's writing is the taut atmosphere in which all relations are intense, every fact evidence in a test, and each move results in a disturbance of equilibrium that exposes one to the trials of another test. Sense impressions not only establish for her the physical context but color and are colored by the struggle of the protagonist with his enemies within and without. And her style itself is a triumph, for it *is* as well as communicates her story. The very word order tells something, and her supple prose, with its power of understatement, accounts as much as anything else for the weight, the nervous substantiality, of her world. Much of this cannot come over into another tongue—the present translation, while satisfying the requirements of smooth English, is not adequate to Seghers's unique German.

The difficulty is to puzzle out why, Seghers being as good a writer as she is, her novels are not really first-rate. This latest book gives us perhaps more light than before, because here she has frankly embraced her weaknesses. The task of art is to impose the greatest possible organic unity upon the greatest diversity. The gauge of achievement is not only the degree of unity or perfection of form—any piece of kitsch has that—but also the

resistance of the material unified. How far does the artist strain toward completeness before applying the controls of his art? The material Seghers attempts to shape is diverse, vivid, resistant to any simple logic, and pregnant with the half and double meanings of authentic experience; her initial interest in it seems to go beyond the points she extracts from it. Yet it is all weighted toward a significance and a moral derived from an incomplete—in so far as it is only political—view, which infects everything with its obligatory optimism and makes it come out as it is expected to. The trouble is not with politics in itself but with the incomplete resolutions offered by the merely political view. Either the political artist poses too elementary a situation, or else, which is much more rare, he resolves too simply, as Seghers does, situations presented in all the complexity of the real. The first does business with counterfeit money; the second practices dishonest bookkeeping with genuine cash. Professor Kress and his wife, both of them genuine characters in a genuine situation, are on cool terms, but after they have taken the tremendous risk of sheltering and helping the fugitive they find a new understanding and warmth for each other. Again, one of two friends together in a restaurant recognizes the fugitive and mentions it to the other; they decide not to tell the police, and as a result an estrangement between them is healed. The difficulties of personal relationships, a problem in two terms, is solved in only one.

How could Seghers's feeling for the ambiguity of experience—which she has—have permitted her to invent such a character as Wallau? Moving spirit of the prison break and a leader of the underground opposition, he is without a flaw, infallible in principle and an absolute source of moral power. Such a character makes it too easy to exploit faith, loyalty, fortitude, and physical courage as unshaded virtues. And then there is George Heisler, the hero of *The Seventh Cross*. His character is so given through the memories of a friend that we have trouble in making up our minds about him, as about any character seriously presented in fiction. Yet at the same time his psychology, as it is presented immediately by the author, conforms too patly to what we expect—in our weakness—of the hero of any story. Outside his friend's mind George is just a tough Bolshevik, and the Stalinist prescription for that kind of hero is as trite as any other, almost.

The trouble, however, is not that Frau Seghers is a Stalinist. Let us be thankful that she is at least that, that she is for socialism. Rather—what lack in herself of intelligence or of depth or patience has allowed her extraordinary talents to be short-circuited by her political convictions? It devolved upon her own conscience as an artist to recognize that a good deal of life is as yet only explicable through its imitation in art and that it is the business of the serious novelist to explore questions in person before delivering their answers.

*The Nation*, 17 October 1942

29. Review of *Blood for a Stranger* by Randall Jarrell; *The Second World* by R. P. Blackmur; *Lyra: An Anthology of New Lyric*, edited by Alex Comfort and Robert Greacen; *Three New Poets* by Roy McFadden; and *Ruins and Visions* by Stephen Spender

Randall Jarrell has the talents, the sensitivity, the wisdom and almost everything else that the good fairy can give. He is one of the most intelligent persons writing English at the moment. There is some very profound poetry in this book of his, in the literal sense of that word. But like Fred Astaire, another very gifted American, he seems to have a blank personality. He is swallowed up by his gifts. His writing, critical and poetic, for all its brilliance, lacks a core. I think it is an American middle-class failing—in which we as the most rationalized human products of industrialism come close to the insect kingdom—to be too much at the disposal of our respective trades and in the face of vocational training not to maintain enough the claims of what only seems extraneous. This is quite different from craftsman's humility, which lies in subordinating personal interests to the object being created, not in surrendering the totality of oneself to a professional role. You give up being a friend, a lover, a gossip, an attractive person, the life of the party, in order to be that much more poet, actor, boxer, doctor, businessman. Instead of completing yourself by work you mutilate yourself. (In their impatience with all this, some American writers—Miller,

117

Saroyan, Patchen—go to the opposite extreme and distend themselves by swallowing their professional roles in their personalities.) And for relaxation there is shoptalk; which led Henry James to complain that he could get no material for his art from "down town" New York, from the masculine world of work, that it was to be found only among women in this country.

As discerned through his writing, Jarrell seems to be too much writer and too little anything else. Certainly he writes about himself a good deal, but it is as the abstraction of himself, as fuel for poetry, himself converted into something that has no further relation to himself except as professional poet. The paradox is that he appears to be very conscious of the problem—which is one reason, perhaps, for the conspicuousness of his shortcomings with respect to it. But more fundamental is his lack of temperament; and temperament alone, in the absence of everything else, suffices to give a center, a direction and unity to an individual's work. For lack of it, Jarrell is too easily distracted, is provoked by his own fluency, is at the mercy of every idea that strikes him. Although his single poems are naturally less open to this than his poetry as a whole, even within them the reader is sometimes exasperated by sudden, unjustifiable changes of direction from stanza to stanza and line to line. Add Jarrell's unimmediate, unsigned style, through which other poetry, notably Auden's and Yeats's, seems to have been strained and deprived of savor, and the unity of which is given only negatively by the absence of a personal sensibility—add all this to the poet's uncertain ear, and it becomes inevitable that his book of poems should as a whole be hard reading in spite of its many single excellences. Is it that Jarrell assents to his faculty for making the most concrete, vivid words—of which *blood* is perhaps the least vivid example—take on an abstract flavor, because this gives words greater potentialities of connection, like oxygen atoms? Is it that blood donated for strangers should have only the most general properties of blood, because then it can be transfused into anybody's veins regardless of blood-type? Maybe so, maybe Jarrell is on the way to a great kind of abstract poetry. There are some very good abstract poems in his book. But personal wisdom—wisdom about oneself and one's relation to others—out of which more than anything else Jarrell strives in his plight to realize his most ambitious poetry, needs for that to

be fortified by much more substantial hints as to the problems offered by the poet's own specific personality. For the rest, Jarrell has understood his own case in concept. *The Winter's Tale* is a poem about those "Who made virtue and poetry and understanding/The prohibited reserves of the expert, of workers/Specialized as the ant-soldier . . ." and about "The substitutes of the geometer for existence."

R. P. Blackmur has improved considerably as a poet, but his personality is almost as blank as Randall Jarrell's, and he is much more a victim of good taste. If Jarrell is without savor, Blackmur is without flavor. His poems have no foreground existence, but transpire backstage behind a gauze of literature and Yeats. But his style does have its academic distinction in spite of the mechanical and monotonous regularity with which he divides lines: and four of the nine poems in this thin book are quite successful in their Yeatsian way (repeating only the Yeatsian themes of youth and age): *The Second World*, *Missa Vocis*, *For Comfort and For Size* and *The Dead Ride Fast*. Yet I suspect Blackmur's good poems of having the same relation to genuinely good poems that waxen images have to living beings: they only look the same, the animating principle is missing, for Blackmur is too sophisticated a literary man not to be able to conduct himself in faultless accordance with the best taste and usage of the time. But now and then the orifice through which the soul escapes the body can be detected:

> There is disorder, like heavy breathing in the next
> room,
> Like people making way when no one comes.

All the appurtenances of good poetry are here, but they are only appurtenances: "heavy breathing in the next room" and "making way when no one comes" obnubilate the disorder, are falsely portentous. Blackmur is after the intensity of pure poetry, but he contrives it instead of creating it out of a necessity in himself other than his ambition as a poet.

One generation of English poets now follows hard on the heels of another, the members of this latest one likewise closing ranks to form a mutual admiration society, but even more vocal and more aggressive against opposition. What an amount of back-slapping and acclaiming goes on among them! Meanwhile

it is mostly to the good, for young writers are more helped than hindered by mutual admiration. *Lyra* anthologizes the work of what looks to be their important majority. Abandoning the positions won by Auden's so-called classicist movement, they are in retreat towards a purer and more personal poetry, are all for neater verse, traditional simplicities, descriptions, emotions in the presence of nature, intimate events and their own love affairs—heterosexual at last. In divesting themselves of the conventions of modernism in order to attain a more naked honesty, some of them have not only become "new romantics," but have often mistaken for no conventions at all any antedating Eliot:

> Kiss me before all breaks. Let me touch your dress.
> If we must die, then let it be of love,
> And set the whole world trembling as we kiss.

But whether their poetry is good or bad, and for all their easy sentiment, their know-nothingism and their reversionary aesthetics, these young poets are serious in a way their American contemporaries too frequently are not. For them poetry is not quite so exclusively a trade or profession, but also a means of completing and realizing themselves. They may in some instances be even greater careerists than their American fellows, but they are concerned with their poetry as person, not just as writers; they try to connect it with everything else about which they are concerned; they are superior to literature in that at least they seem interested in more than achieving it; they want from their own work satisfactions beyond those of success. In their resolve to be sincere they are not afraid to write naively and unfashionably. As a result their verse, regardless of its quality, manages to have a great amount of existence (Spinoza notwithstanding). It may be little, but it is not tenuous poetry. Not even Francis Scarfe's three howling lines above.

Unlike some English poets of the preceding generation, a good many of those in *Lyra* are better than they appear to be. However, the best of them are very uneven, to judge from evidence in other publications beside this one. Perhaps they think that honesty requires the publication of their worst as well as their finest poems. G. S. Fraser, poised and quietly powerful, is the least uneven of the lot, and perhaps the best, though he has not the occasional brilliance of some of the others. Nicholas

Moore, whose *Little Black Box* is one of the most original poems of our age, doing better in twenty-nine lines what otherwise only a novel can do, is quite bad when he is not good. Henry Treece alternates between flashes of fire and splashes of water. Wrey Gardiner, Charles Davey and especially Emanuel Litvinoff are promising. Right now I should say that Anne Riddler is the most consistently successful and original of the poets in the book, though she seems rather limited. Like not a few poetesses since Emily Dickinson, she deliberately bends her verse towards prose by suppressing the beat. As for the rest of the anthology, some is fair, some is mediocre, and quite a lot is bad. Exception should be made for Alex Comfort, who along with the other two of *Three New Poets* is also represented in *Lyra*. Comfort has the self-confidence and the sense of what he can and cannot do that usually belongs only to older poets. He creates superb sound effects, and elegiac gravity, the prevailing tone of so much poetry nowadays, receives new shading in his verse:

> Strange that in me the shadow
> moving the substance speaks: strange that such air
> pulls the blue sinew, whom the blood maintains
> whom the heart's coming slight defection
> shall spill, speaks now and holds
> time like a permanent stone, its cold weight judging.

This is the materialist (the poet is a medical student) approaching from a new direction. No virtuoso of punch lines, Comfort, like Moore, Litvinoff and lately Spender, depends for effect on the total unfurling of the poem. He has a good chance of becoming a large and serious writer. Roy McFadden's poetry is slight, and has little beyond its honesty and grace. Honesty is always rewarded in some measure, and McFadden does get off a good passage now and then. Ian Serraillier is also honest, and has a certain originality of language and versification, but he seems even slighter than McFadden because he restricts his subject-matter more. He has a timidity about going beyond the sense-world; within it he describes well:

> And the clouds that pace restless over Llewelyn,
> for ever racing but for ever still
> like runners painted on a vase, shall hold
> their strange stationary course until,

time and the mountains melting, they from the sun
drop to the level world and freely run.

To have shown that it is still possible to write convincingly such nice derivative verse is a kind of triumph, and these young Englishmen are certainly increasing poetry, yet the tendency they embody is regrettable in so much as it surrenders too many positions and goes back too far in the sole endeavor to be honest. These poets are not ambitious enough. They avoid the most difficult, which is usually the most important. If they insist on poetry's being pure again, can they not proceed beyond Auden, instead of short of him, and try, as perhaps Barker is doing, to conquer for pure poetry the areas which the previous generation opened up in its flight from it? Their disillusionment with socialist revivalism and everything else public is not excuse enough for the kind of obscurantism into which these poets fall. Most of their American contemporaries are at least willing to know more than they do. Herbert Read's preface to *Lyra* forms a reply possibly to these objections. He terms these new poets "pacifists in the *poetic* sense," and asserts that the reconstruction they are undertaking requires their poetry to be "projected away from the immediate struggle into the new world which has to be created out of the ruins of our civilization." And he also says, "By the end of the Spanish Civil War, the poetry of action had fought in the last ditch." Well, in the face of those two threatening phrases, "poetry of action" and "war poetry," I still insist on countering with *little poetry*.

Having made my objections, let me say that I share the premonitions of a poetic renaissance which Herbert Read gets from the work of these new English poets. Much talent is abroad among them, talent enough to defy all remonstrances.

On the strength of this second collection of his poems to be published in this country Stephen Spender is already a great poet. At least ten to twelve of his lyrics will not be forgotten, among them in this book *Exiles From Their Land, History Their Domicile, The Past Values, Darkness and Light, The Human Situation, The Double Shame, A Wild Race, Winter and Summer, In a Garden, The Ambitious Son*—and there are some others as great or almost as great.

Since his first book Spender has become less measured and

poised, although he has taken more to rhyme, assonance and set forms. He is much closer to the *Lyra* poets than either he or they seem to recognize. In his "Foreword" he says: "The violence of the times we are living in, the necessity of sweeping and general and immediate action, tend to dwarf the experience of the individual, and to make his immediate environment and occupations perhaps something that he is even ashamed of. For this reason, in my most recent poems, I have deliberately turned back to a kind of writing which is more personal, and I have included within my subjects weakness and fantasy and illusion." (I tend to doubt the deliberateness of this turning.) Spender's work is uneven for the same reason that operates in the case of Moore, Comfort and the others: the determination to write as one must rather than as one would, and to publish all. With respect to Spender it could be wished though, that there was a little less sincerity and a little more honesty. So much of his latest poetry being a personal confession, Spender's excess of sincerity is to state not only the weaknesses on which he has acted, but also the strengths—or rather powers of feeling—on which he did not act. (But you are what you do and not altogether what you feel and know.) It makes a lot of his poetry *pleurnicherie*, exhibitionist self-pity, inflated pathos; especially when he interrupts himself to cry "I too am moved by this!"—as if he would be writing a poem if he wasn't. Many otherwise successful poems are spoiled by over-intimacy, usually towards their close. Also, Spender is seduced by his own eloquence, by his grace and ease of language, into repetition, wordiness and obscurity. His knack—and gift—like Rilke's, of protracting images sometimes runs away with him, and leads him, like Shelley, from the definite to the vague instead of the other way about, too often ending up among flowers, suns and summers, or else snow and ice.

Yet Spender's great poems redeem any number of his bad ones, and the very process of introspection and surrender to himself which occasions his failures is the same one which, pushed a step further, turns out lyrics of an intensity and of such intimate yet universal truth as no one except Yeats has lately equalled, and which like the latter's seem past all style and manner. Some are constructed from but an image, others have the rigorous articulation of a theorem. Spender's own shortcomings are turned to account, there being set up a beautiful contrast

between his softness as a person and his anonymous toughness as an expert, utterly serious poet. He goes beyond solipsism and self-indulgence to discover himself as he exists in the medium of his art; and the very reluctance with which he reduces his enormous demands upon language as self-expression helps produce the great verse.

Ambitious Spender, in spite of his own disavowal, is an eminent type of the poet who strains for completeness. He tries to make as much of the world as he can relevant in his poetry, wanting to include history, politics, even economics; but only after he has passed them through himself and made them personal. Perhaps he insists too much on the personal. There is more poetry to be discovered now in the forces which produced Napoleon than in his own soul, and Spender's poem on Napoleon is bad, even though it is moving—and most of Spender's bad poems are moving, which only increases the momentary irritation—because he makes Napoleon an avatar of himself. Spender as teacher of history is in a false position; but so have been more than one important contemporary poet: Eliot as legislator, Yeats as nationalist agitator, Auden as theologian. It is almost a sign of their importance as poets. Nothing characterizes the unimportant poet today as much as his willingness to stay inside his professional role.

*Partisan Review*, November-December 1942

30. Review of Exhibitions of Pavel Tchelitchew, John Flannagan, and Peggy Bacon

PAVEL TCHELITCHEW. Paintings and drawings. The Museum of Modern Art. Tchelitchew is one of those whose function it is to supply up-to-date art for the forward-looking masses on Fifty-seventh Street. Also, like his fellow neo-romantics and most of the orthodox surrealists, he reverses the anti-pictorial trend of cubist and abstract art to assert again the fictive nature of what the picture frame incloses. The painting becomes once more a window into another world—which in this case is generally supposed to be the artist's most private mind—and the frame is

the unambiguous line of demarcation. Tchelitchew is accomplished enough. But in essence his work is a vulgarized documentation of most of the fashions in advanced painting since 1920, and his pictures, taken even on their own terms, are deadened by their trite and static organization. Everything stays too obediently in its place, the value of one color is too close to the value of every other color in the given picture, tonality is too even, design too balanced. There are, however, three or four likable pictures: two comparatively early harlequin subjects, a gaudy autumnal double-image landscape in gouache, painted recently, and a pretty painting called *In the Madhouse*. In his present phase the artist should stick to gouache or water color; his latest oils with their shrill saccharine color and gelatinous symbolism set a new high in vulgarity.

JOHN B. FLANNAGAN. Sculpture and drawings. The Museum of Modern Art. It is more difficult in these times to be a good sculptor than a good painter. Flannagan was a good sculptor. Yet there can be discerned in his work most of the hesitations that afflict the contemporary artist. His respect for his material, his reluctance to interfere with it, and his greater success in small format reflect among other things his lack of a conviction or certainty definite and strong enough to justify the complete transformation of a large brute block of stone into a man-made monument. Less assurance is required, it seems, to create in two than in three dimensions. In three dimensions one works closer to one's subject; and without the control of some fixed point of view which has an authority more than personal, there is a danger of succumbing to subject matter and verging, as Flannagan threatens to in more than one animal or figure piece, on the sentimental and even the cute. Flannagan is saved only by his sensitivity to the abstract forms dictated by recalcitrant matter; in the nick of time they step in to rescue the work of art. But there were also certain advantages in Flannagan's plight. Very little sculpture in stone has ever permitted the intimacy and the directness yet delicacy of feeling which are to be perceived in his. This is really lyric sculpture. It is quite likely that Flannagan was the best native sculptor we have had in this country.

PEGGY BACON. *Pens and Needles*. Retrospective exhibition of pastels, prints, and drawings. Associated American Artists Galleries. Miss Bacon is a crisp draftsman and, within the limita-

tions of our culture and age, an amusing if rather distracted satirist. Her dry points, beside which her pastels are unimportant, are more effective in their details than as whole pictures. As wholes they are conceived in an offhand, unimaginative way, right in the tradition of the best Anglo-Saxon comic and caricatural art. Miss Bacon is not thoughtful enough to put real sting into her humor. This shows not only in the kind of anecdote she records but also in the very quality of her feathery line.

*The Nation*, 14 November 1942

## 31. Review of an Exhibition of Morris Graves

Gouaches. At the Willard Gallery. Graves works almost exclusively in gouache on paper. He takes most of his motifs from zoology and embroiders them decoratively—birds, snakes, rodents, and the like. All except his very latest pictures are unsatisfactory in one respect or another; yet they have elements of strength in them and make no gestures to fashion or publicity. In spite of the debt Graves owes to Klee in several instances—in addition to his titles, which have the same whimsy-fantasy—he is one of the most inventive painters in this country. His color is somehow not American, being all grays, gray-blues, restrained pinks and madders. Since the artist comes from Seattle, one might argue a Pacific or Oriental derivation. He seems to have, on the basis of his 1941 work, an important future ahead of him. He generates power out of lightness and fragility—that is, in his best work.

*The Nation*, 21 November 1942

## 32. The American Color: Review of *Currier & Ives: Printmakers to the American People* by Harry T. Peters

The Currier and Ives prints represent the transition from the handicrafts to industrialism in popular graphic art, being the equivalent, perhaps, of the player-piano in music. They were

run off in black and white from single stones on hand-operated presses and were colored by hand by a "staff of about twelve young women, all trained colorists and mostly of German descent. They worked at long tables from a model set up in the middle of the table. . . . Each colorist applied only one color, and when she had finished, passed the print on to the next worker, and so on until it was fully colored." A factor that shortened the career of the firm of Currier and Ives was its reluctance to adopt chromolithography, by which the print is colored directly from the block, until almost thirty years after its introduction into this country.

The text Mr. Peters supplies to his beautifully made book gives this information and much more—and excuses the apparent defects of some of the color plates: hand-coloring accounts for the discrepancies between different copies of the same print. Mr. Peters makes little attempt to discuss the aesthetic value of the prints, implying somehow, in spite of his love of them, that they are beneath it. That is a question. Anyhow, it is time someone examined the nineteenth-century mind through them, noting what an appeal to the American imagination the railroad once made and how sex managed to get into pictures of slaves being branded, sailors making rescues at sea, and anything in general combining violence with women.

The work of some of the most respected American painters of the time was reproduced by Currier and Ives, but it seems dull compared to the run-of-the-mill prints designed by the firm's staff artists. The latter may have been a little awkward or naive, but their product was almost always lively. Where the academicist, like Eastman Johnson, muffled recesses in shadow and dwelt upon the texture of a barn door, the staff illustrator put in additional details of interest and information or executed a neat decorative passage. Also the reviewer finds the stars of the Currier and Ives staff, such as the English-born sporting artist Arthur Fitzwilliam Tait, less stimulating than those who had practically the status of hacks, like Fanny Palmer, also English-born. Her want of the finish which Tait had was more than compensated for by her candor and her strong feeling for composition in depth. She specialized in landscape, panorama, and scenic effects, and filled in backgrounds and color in pictures by other artists. I never tire of admiring in her famous *Rocky Mountains: Emigrants Crossing the Plains*, the recession leading from

the stream in the middle distance to the cliffs and peaks in the farthest center background. The features of the landscape are largely imaginary, as Mrs. Palmer never saw the Rocky Mountains. It is too bad that the particular copy of this print reproduced in the book is so crudely colored.

Hardly anything is presumed to be more typically American than the Currier and Ives prints; yet of the six artists responsible for most of the better-known ones, only two were born here: Thomas Worth, cartoonist and limner of race horses, and George Henry Durrie, who so affectionately described New England farm life. Three of the four others—Tait, Mrs. Palmer, and Charles Parsons, the marine specialist—were born in England, where the first two lived until they were adults; while Louis Maurer, centenarian painter of horses and outdoor life and the father of the artist Alfred Maurer, was born and raised in Rhenish Germany. The good majority, too, of the principal lithographers of Currier and Ives were born abroad. The definitely American stamp of the work of these immigrants is to be explained, it seems, by the power of American environment to change quickly anything that comes within it. Not that it possesses this power any more than any other environments, but it is surprising that, never having had and still not having a marked national style, our country should have been able at all to distill such a pervasive and stubborn color of its own. There is nothing in the Currier and Ives prints which cannot be found, conceivably, in English, German, and French traditions of popular illustration; yet almost every one has a tone, a tempering, a shading, or a grain—sometimes no more than a hint— that is enough, quite apart from its subject matter, to distinguish it as American.

The prints were popular in Europe. One wonders how they were regarded there. Were they quaint and exotic in their *gaucherie*, or were they the latest bit of progress from America? Paradoxical as it may seem, there is something glossy and packaged about them. After all, their mode of production was rationalized as far as possible, and the result was arranged and corrected with a view to its sales appeal to a public whose interest in art pertained only to incidentals.

*The Nation*, 28 November 1942

## 33. Review of Exhibitions of Corot, Cézanne, Eilshemius, and Wilfredo Lam

COROT. Loan exhibition. At Wildenstein's. This exhibit covers every phase of the artist's career, more than fifty works being shown, many of them masterpieces. Corot was the last great academic painter, and there have been very few painters more fully in possession of their craft. Even his poorest work is solidly accomplished. That of his latest period has been unjustly depreciated since the acceptance of modernism, although his early landscapes and his figure pieces have gained esteem. Yet as time passes and one sees more and more pictures, the landscapes of the later period begin to recover some of their lost reputation. They have certain generic faults, but anyone not blinded by the *Zeitgeist* can see that they are first-class painting nevertheless. True, subject and handling are repeated over and over, but the gray light, the diaphanous foliage, and the unfailing dot or blob of red in the foreground are a scheme for variations, not a sure-fire formula. Like a symbolist poet, Corot does not try to create a specific world but rather to awaken in the spectator limitless associations, muting the contrasts of light and dark lest things become too definite. Myopia, the influence of photography, and that of impressionism have been variously offered as explanations of his latest manner, but they all seem beside the point; which is to be found in Corot's development.

CEZANNE. Loan exhibition. At Paul Rosenberg's. Cézanne's insights have become so much a dimension of all painting now and provided food for so many epigones that it is difficult as yet to appreciate him properly. It is also the misfortune of a great artist to set standards in his very best work from which one cannot escape in judging the rest. There are three *consummated* masterpieces at this show—*Le Château Noir*, which, as the catalogue says, is truly sublime, *Portrait de Madame Cézanne*, and the still-life *Pichet et Fruits*. Other remarkable canvases are to be seen—*Garçon au Gilet Rouge*, *Mont Ste. Victoire*, the Museum of Modern Art's *Nature Morte*, *Madame Cézanne dans la Serre*, *Chemin Sous-Bois*, *Vase de Fleurs et Pommes*, and one or two more—but compared to the first three, they all become problematical. The fact is that much of even the best of Cézanne's art seems unconsummated. Pictures filled with superb passages such as would by

themselves earn any painter a great reputation fail somehow to coagulate, and remain instances of great painting rather than great paintings. Lacking the simultaneous unity and diversity and the inextricability of part from part of realized wholes, they miss that final perfection which, for example, so many of Renoir's little landscapes had. In a way, Cézanne was too far ahead of his time; as has been demonstrated perhaps by Vlaminck, Derain, and Dunoyer de Segonzac, who went back of the master to work fields which he had stopped at only long enough to survey. And the problem which preoccupied Cézanne—that of translating volume and distance to a flat surface without denying its flatness, solved by substituting accumulated brush strokes of comparatively pure color, distortion and geometrical simplification for atmospheric tone and chiaroscuro—this problem so absorbed him in the means that he would too often lose sight of the end, his own emotion. The result, examined square inch by square inch or part by part, would display miracles of brushwork, but when contemplated as a whole there would be something wooden or lacking in modulation about it. But Cézanne's achievement was so far-reaching and subtle that it is necessary to emphasize reservations in order to define it. This, incidentally, is an extraordinarily rich show.

EILSHEMIUS. Paintings. At Durand-Ruel Galleries. Most of these pictures date from the last ten years of the painter's active career, a period in which almost everything depended upon the mustard yellow that was during this time Eilshemius's version of sunlight. There are four successful paintings here—*South Sea Island*, *Farewell to the Sun*, *The Last Sunlight*, and *Autumn* (No. 15)—but in the reviewer's opinion they are not his best, and the others all seem rather weak. Eilshemius was one of the best painters we have had, but he painted many boring pictures. In his catalogue notes Professor Venturi rejects as nonsense the suggestion of an affinity between Eilshemius and Rousseau Douanier. The pertinacious professor is right as far as their art in and of itself is concerned. But it is worth considering that both artists were indeed a little bit mad; both wanted to paint academically; both showed real facility at times (Eilshemius in the beginning, Rousseau at various moments between 1885 and 1891); and neither, in spite of himself, did paint academically. For which we are thankful.

WILFREDO LAM. Gouaches. At Pierre Matisse. With gouache this Cuban painter achieves the boldness of oil. He has an idiom all his own, when he manages to escape Picasso—an abstract treatment of floral and animal motifs against dun and light-gray backgrounds, derived apparently from Amerindian art. Lam draws with a great deal of flair. But all is ruined—in some pictures by a straining after bravura effects, by showy motions, in others by obsessive rhythms and the inability to be more than decorative. And in two instances the artist's reliance upon Picasso for ideas is so great as to be parody. Yet something may come of it. Lam has a gift but doesn't seem to know what to do with it. The painting in ink-red which he showed at the recent Surrealist exhibition is far better than any here.

*The Nation*, 12 December 1942

## 34. Review of a Joint Exhibition of Joseph Cornell and Laurence Vail

Objects and Bottles. At the Art of This Century gallery. Any free-standing object can be a work of art in its own right and for its own sake. Surrealism continues what Dada was the first to teach by actual examples. Dada stemmed, no matter how deviously, from art for art's sake, which asserted that works of art are self-sufficient and not required inevitably to be either mirrors of reality or decoration. In Vail's bottles and even in Cornell's objects surrealism encourages a tendency it often opposes—the abstract. The bottles do not owe their beauty to the things represented on the scraps of pictures Vail cuts out of magazines and pastes around the glass, but rather to the way the bottle shape is married to the color and design of the collage. One of Vail's best bottles is a Rhine shape merely daubed with cobalt paint and solidified chalk to which petrified sponges cling. Obviously, this art derives from modern French painting, post-cubism in particular. The stuffed birds, thimbles, bells, cardboard cut-outs, and so forth which Cornell puts into boxes faced with glass please by their arrangement and the unspecified associations they call up, but mean or represent nothing not themselves.

They too derive from modern painting, from Chirico and Ernst —and Kurt Schwitters's "trash" objects. (Cornell's only unsuccessful compositions, those relying on thimbles, have an emptiness resembling the duller canvases of Chirico.)

Vail's bottles do not appear at their best in a gallery. They are too intimate as yet and belong rather to one's private surroundings; there they lose all associations of ornament and become, even more than Chinese vases, autonomous and dramatic, competing with pictures and sculpture. Put one of them next to the piece that won José de Creeft the first sculpture prize at the Metropolitan's contemporary show (of which more next week), and it would make the de Creeft look a little phony. Cornell's boxes could be well used to electrify some of the blatantly dull galleries at the Metropolitan extravaganza.

Both artists have only begun to explore their new mediums; an infinite prospect lies ahead. Vail could put his collage around an equestrian statue, as he has around a screen; Cornell could construct landscapes ten feet square inside his boxes. I am in dead earnest. For besides being explorers, both of them are greatly gifted artists.

*The Nation*, 26 December 1942

# 1943

1942−43 ANNUAL EXHIBITION OF CONTEMPORARY AMERI-
CAN ART, at the Whitney Museum; ARTISTS FOR VICTORY, at
the Metropolitan Museum of Art. For the tenth time the
Whitney Annual gives us a chance to see how competently and
yet how badly most of our accepted artists paint, draw, and
carve. The Annual is aided this year in its nefarious purposes by
a grandiose *Artists for Victory* show at the Metropolitan, with six
times as many items. Competent, amazingly so, is most of the
work shown at the two places. These second-hand Renoirs,
Cézannes, Vlamincks, Eakinses, Winslow Homers, Maillols,
Rodins, these archaizers, these academicists and eclectics have
ascertained quite well—up to a point—what made yesterday's
art successful, and they rehearse the success with greater dex-
terity than its initiators. If you like art passionately enough and
have the endurance, you can get pleasure from both exhibitions.
Comparatively few single pictures or pieces of sculpture are as
bad as is either show as a whole. (When enough similar things
are added together a new quality is produced which was only
latent in each before that; sometimes this new quality is a gain,
sometimes, as in this case, a loss: indicating that the trouble
with our *accepted* contemporary art is the lack of an invigorating
common impulse.) But no matter how well these artists paint
and model, they do not *affect* us enough.

Moving art in any age is that which wins new experience for
human beings. Such conquest arouses the sensation of increased
power we get from the work of Third Dynasty Egyptian and ar-
chaic Greek sculptures, from Giotto, Veronese, and Cézanne.
They were the first to discover and possess certain kinds of expe-
rience through their mediums, and this sense of firstness keeps
their art forever fresh. But the artists at the Whitney and the

Metropolitan are satisfied to rework old areas, and are merely pleasing at their best, seldom moving. They try for the new only by means of startling subject matter or technical stunts—guaranteed to impress art juries made up of curators seeking to prove they are not academic.

The Metropolitan is more coy in its selection and hanging of "radical" art, and it has no four or five works as good as the best four or five at the Whitney, but it has staged a better show on the whole, if only because it gives the preponderance to landscapes and still lifes. For American painters, and to a less degree most painters since Modigliani, can no longer handle portraits and figures with true feeling. Society does not circulate an adequate notion of the human personality to which they can refer. They try to make up for this by over-expressing whatever half-baked or stereotyped conceptions they themselves happen to have, and without thinking about the problem very much. The result, which may be seen at the Whitney, is either fulsome or banal. Not to mention the horrors of the sculpture section. (The sculptors take refuge from the problem by going in for animals, melodrama, and academicism.) Nevertheless, there are some good things among the abstract paintings and sculpture at the Whitney—by Roszak, David Smith, Harari, Greene, Tomlin, Knaths; among the landscapes—by Heliker, Fortress; and among the water colors—still lifes and landscapes by Berlandina, Feininger, Marin and Weber. But most of this work is still quite repetitive. The same can be said of the good items at the Metropolitan. The one exception there is a water color by Steve Wheeler which shows the successful digestion of Klee's influence and is the most striking piece of work in the exhibition, handicapped though it is by one of those whimsy titles that are the curse of Klee's legacy: *Man with Short Haircut.* Two landscapists were discoveries to me: William Sommerfeld and Walter Stuempfig, Jr., whose work gives modest but very substantial pleasure. There is a fine *Mining Town* by Arnold Blanch, and if evidence is wanted for my contention as to the incapacity of contemporary painting to handle the human being, compare this picture with the same artist's *This is a People's War,* probably the worst painting in the place. Helen Rátkai's flower piece also is worth noticing.

The awarding of the prizes which the Metropolitan made

available is a scandal, at least in the oil paintings and the sculpture. The medal for the best painting in the whole exhibition was presented to a carefully manipulated piece of tripe, by Ivan Albright, which is a vertical canvas about eight feet high, showing a wormy lavender-dark door with a wreath in its center and a woman's hand on the jamb, everything iridescent with decay, everything confected and concocted, everything the painter had in the way of time, diligence, and bad taste thrown in. The jury was seduced, I imagine, by size, by subject, and by the rhythmic mottlings and even patina that hold the picture together. The first money prize was given to a big wheezing machine of a landscape by Curry which will end up one day in a museum's cellar or a Roadside Rest. It has, however, its heavy charm. Of the prizes for oils, the only ones deserved were a fifth to Bohrod's aqueous, tricky *Reflections in a Shop Window*, a third to Feininger's *A Church,* and perhaps a sixth to a landscape by Evergood. The water-color section at the Metropolitan is quieter and stronger than any other—as a friend says, you can't do as much damage in water color, even if you try. The prints are not too awful either. Nor is the sculpture quite as bad as that at the Whitney gave reason to fear. A fourth prize to Frances Lamont's spiraling metal *Gallic Cock* was well earned, and so, I suppose, was Calder's fourth, though he has done better work. Peter Dalton's *Seated Figure* and Rhys Caparn's *Johannes Steel* should have got prizes, but they must have been too staid for the live-wire jury.

The important question is whether contemporary American art is as unenterprising as these two shows make it out to be. I think not.

*The Nation*, 2 January 1943

36.   Review of an Exhibition of Hananiah Harari

Oils. At the Pinacotheca. Harari, just thirty, is one of the most promising abstract painters in the country. There is the strength and originality of his color, or rather of its tonality; there is his liveliness. But in order to attain virtues, and precisely as a manifestation of his vitality, Harari has to dare to sin—grievously. He

fools around with Harnett's style of *trompe l'oeil*, with Stalinoid "class consciousness" and other nonsense. He plays with all sorts of rash notions, mixing together formal elements such as no artist living or dead could organize, and the combination of which simply violates the laws of pleasurable vision. Some of Harari's paintings are frightful. One, dealing with fascism, sinks to a comic strip; another called *Rococo*, shows what—I am told—is the degeneration of capitalism by means of arabesques, scroll work, floral curlicues, and the halftones and sickly-dark colors of Victorian wallpaper. It may be a joke, but it is too expensive.

Harari exposes himself turn by turn to the influences of Picasso, Miró, Klee, and others. He is ready to be anything—apparently on a moment's notice. But this dashing about, the facing in many directions at once, is a sign among other things of a tremendous energy. Harari is vulgar but seldom banal. Underneath is a talent sensuous and powerful, able in certain pictures to order things to its own unique purposes. At his best Harari continues in the line of post-cubism, is two-dimensional and abstract. In *Figurations* and *Green and Pink* flat patterns of tan, pink, and cream—which with brown are the artist's most successful colors—are used to make paintings as rich as any done by an American lately. *Autumn Tonality* and one or two others are more original but not quite as finished. In these Harari tries to relieve the flatness of the two-dimensional by tonal harmonies. He has something new to say in this vein, and it is probably his most sincere and important one. The work marked by Klee's influence is also successful within the limits of the derivative.

Harari has many strings to his bow and plucks them one after another with an erratic abruptness that is the effect either of indecision or of Picasso's misunderstood example. It is to be hoped that he will settle down and proceed consecutively in the direction which, as he himself ought to realize by now, is his most serious one—the flat abstraction. It will contain all his emotion and his desires for variety, let him have no fear about that. Meanwhile, he has had his fun.

*The Nation*, 9 January 1943

## 37. Steig's Gallery: Review of *The Lonely Ones* by William Steig

We are all lonely. Marx predicted us almost one hundred years ago: alienating society with its alienated members. But we still have some sort of culture in common, and with attitudes popularized by reading and elevated conversation each dramatizes and justifies his loneliness. The titles of Steig's drawings—*Who Are All Those Others?, I Can't Express It, I Recreated Myself, I do Not Believe in Misleading People, Why Pick on Me?*—are not, as Wolcott Gibbs claims in the foreword, simply clichés expressing the private obsessions by which odd types set themselves off from everybody else. They are the means of self-defense and self-assertion that we all resort to in the various times of our various humors. For just who are the other boys and girls whose humors, according to Mr. Gibbs, are not quite like these? If the "rest of the world" really exists and is not just a class distinction, then Steig's drawings do not mean so much as they seem to. But I think Steig has got us all down, the whole well-informed class of us who read the liberal magazines, the *New Yorker*, and Modern Library books, whose hearts are in the right things.

Never in all history has there been so lonely a mass of people. The peculiar social form this loneliness takes is the convention of unburdening the heart. Tell all, disarm others, and assert yourself. It must be realized that before the eighteenth century there was hardly such a thing. Confession was the furthest one could do. To unburden the heart is to use confession as a weapon, as personality insurance, and not for relief. The gift-bearing Greeks in Steig's gallery are self-assertive even when in postures of surrender.

Aside from the humor, the specific virtue of Steig's drawing is the directness with which he communicates his ideas to paper and our eyes. There is little pause between the impulse and its expression. But just because the shorthand is so quick and so efficient, it is not quite art. What makes cartoons usually something less than art is their dependence upon closed systems of representational signs in which little is ever improvised and reinvented. Line in cartooning is not felt for its own sake but used for conveying concepts. A face is made like this, an arm like that, surprise has exclamation marks, raised eyebrows and pop-

ping eyes, put in with a prescribed number of lines curving and meeting in a prescribed way. Steig tries to fight free of the cartoonist's habit and succeeds now and then, as in *Why Pretend?*, *People Are No Damn Good*, and *Meditation Will Reveal All Secrets*. These cartoons are so intensely cartoons that they become something more, pure expressions of ideas. (Klee, coming from a different direction, did things similar if on a much higher level.)

But why ask the artist to do something he did not intend; why not take him for what he is? For what he is, Steig is certainly very good, but I am not sure that he is satisfied to be taken just for what he is. He is after a new genre in these psychographs, a new combination of literature and picture, and he does well enough to be judged by severe standards.

*The Nation*, 16 January 1943

38.  Review of the Exhibition *American Sculpture of Our Time*

At the Buchholz and Willard Galleries. There has been a renaissance of sculpture in this century. How much of one becomes evident when you try to recall the names of outstanding sculptors between Houdon and Rodin. Thorvaldsen? Barye? Rising industrial capitalism, with its concern with distances, energies, and dreams, found sculpture too literal a medium in which to express itself well. Rodin, finally, managed to put into stone something of the nineteenth century that had been expressed by others in poetry, painting, and music, but in doing so he dissolved the Renaissance tradition of sculpture. It is mainly the work of painters Cézanne, Renoir, and even Seurat and Van Gogh—that has made sculpture once more possible as a great form. In our time there have been Maillol, Despiau, Lehmbruck, Brancusi, Lipchitz, Laurens, and others; the occasional sculpture of painters such as Renoir, Matisse, Picasso, Braque, Gris, and Masson; and the production of the constructivists and their similars—Pevsner, Gabo, Vantongerloo, Giacometti, Gonzales, and Arp. Significantly, these last derive their anteced-

ents from painting rather than sculpture, and their work, except for Arp's, is more pictorial than sculptural in its effect.

The renaissance has reached our country. In the twentieth century we have had for the first time two professional American sculptors worth mentioning. Flannagan and Lachaise, and the constructor or fabricator, Calder. Now there is David Smith, whose work puts in the shade almost everything else at the Buchholz and Willard exhibition. Not that many of the other sculptors and the examples of their art are not well chosen. A small bronze nude by Lachaise is the best I have seen in his bulbous style, the distortions of which usually seem gratuitous; there are also two good bird themes of Flannagan's, an excellently compact stone frame by Heinze Warnecke, heads by Burlingame and Laurent, a fine Calder mobile, a wooden lady by Steig, and even a heroic stone head by William Zorach that is not quite so pompously inflated as most of his work. Peter Grippe, using cubism in a way that does not remind one of the cubist sculpture of painters, and adding a bit of Picasso's latest style of decomposition, has hold of an idea which he has not yet succeeded in embodying in his terra cotta.

All this shows the comparatively high level sculpture has reached since the nineteenth century—leaving aside the hideous expressionistic, "functional," and stylized statuary of which only contemporary sculpture is capable, and of which there are enough samples present. Yet of the better work none comes close enough to great art. None except David Smith's *Interior*. Smith, who, fittingly, is more smith than carver or modeler, has welded and molded rods of steel and bronze into a sort of horizontal cage figuring the skeleton of the organism which is the family, and whose corporeal identity is the house. Molded into the framework and given by the merest resemblances are a key, a wall picture, a reclining female, and other domestic items. Smith shows for almost the first time that a house can be a proper subject for sculpture in the round. However, the work does not stand on its symbolism but on its formal energy, for which the symbolism is only a springboard. One's eyes are led along the rods without a misstep; the divisions of empty space within them have a life of their own and develop and change the chords in music; and the rust on the metal adds the right final touch.

It is obvious that Smith aims at effects closer to drawing than to sculpture. He employs the "metaphysics" of line to direct and connect across intervals of space; the essentially sculptural, on the other hand, presents itself with more solidity, its form rise from a central mass and are related to each other by it, with the sense of possible touch and weight brought into play. (See G. L. K. Morris's interesting article on the connections between sculpture and painting in the current *Partisan Review*.) But Smith's linear style is perhaps closer to the nature of metal itself as we feel it today, for metal has become pliable under the welder's tools as it never was for those who could shape it only by casting and hammering.

Smith is thirty-six. If he is able to maintain the level set in the work he has already done—of which other fine examples may be seen in the back room of the Willard Gallery—he has a chance of becoming one of the greatest of all American artists.

*The Nation*, 23 January 1943

## 39.   Review of the Peggy Guggenheim Collection

Art of This Century gallery. Permanent. A tendency dominant in painting since cubism is that which, by means of abstraction, collage, construction, and the use of extraneous elements such as paper, cloth, sand, cement, wood, string, metal, and so forth, tries almost literally to disembowel the painting. Its pictorial content no less than the physical fact of the canvas itself is to enter the actual presence of the spectator on the same terms, and as completely, as do the walls, the furniture, and people. What takes place within the borders of the picture has the same immediate status as the borders themselves. The new gallery Frederick J. Kiesler has designed for the Guggenheim collection of modern art carries this tendency to an ultimate conclusion by still other means. Unframed paintings are suspended in mid-air by ropes running from ceiling to floor, hung on panels at right angles to the wall, thrust out from concave walls on arms, placed on racks at knee level, or, with seeming paradox, put into peepshows and view-boxes.

That Mr. Kiesler knows what he is about is evidenced by this last; for paintings by Klee are seen in the peepshow and view-boxes; and Klee was almost alone among the more abstract artists to maintain the fictive nature of the world within the picture frame. And in a different way Marcel Duchamp insisted upon the same thing in his little quasi-cubist paintings, shown here—with less success—in a glass cage.

The surrealist pictures, thrust out on rods from tunnel-like walls, seem, because of the dramatic lighting, which switches at intervals from one group of canvases to another, to hang in indefinite space. This is exactly right, because it emphasizes that traditional discontinuity between the spectator and the space within the picture to which most of the surrealists have returned.

Except for the surrealist room, the gallery is, however, a little crowded and scrappy. Mr. Kiesler overdid the functionalism in not providing the other rooms with a more unified background. The ropes should have been covered with dark cloth and the walls toned more darkly to set off the high-keyed colors and pale tints of the abstract and cubist paintings. As it is, the eye is unable to isolate them easily.

Nevertheless, the décor does create a sense of exhilaration and provides a relief from other usually over-upholstered or over-sanitary museums and galleries. And inadequate as it may be in each single department, the collection itself is one of the most comprehensive in this country of cubist, abstract, and surrealist art as a whole. In addition to the very fine Klee in the peepshow, there is a large orange painting by Ernst and a classical view of Chirico which are the best examples of these artists' work I have seen in this country.

*The Nation*, 30 January 1943

40.  Pioneer and Philistine: Review of *American Pioneer Arts and Artists* by Carl W. Dreppard

Between 1750 and 1850 there was much amateur, professional, and semi-professional activity in this country in the figurative arts. A surprising quantity of paintings, miniatures, drawings,

carvings, castings, stencil-work, and sundry decoration and ornament has been uncovered lately. Mr. Dreppard rightly objects to "primitive" as an inclusive term for all this work, the quality of which varies so much. He would prefer "pioneer." "Pioneer" is all right as a historical denominator, but it is valueless as a generic one, and rather inaccurate too. Most of the art which Mr. Dreppard calls pioneer was made in places already settled for generations. But then Mr. Dreppard claims that everything good about this country is the work of the "pioneering mind"—time-saving, railroads, and the popularity of tomatoes. But just what in this early American art distinguishes it as pioneer by contrast to similar work done in Europe at the same time? He does not say. As a matter of fact, Mr. Dreppard could have showed—but he would have had to think, and multiply distinctions—that a certain amount of American applied art is specifically pioneer in that its workmanship and conceptions were conditioned by its remoteness from places where the professional division of labor obtained.

Mr. Dreppard himself is a kind of primitive in art history. He inveighs against the "twaddle" of theory and appreciations and assures us that to understand and enjoy pioneer art it is only necessary to come to it with a full heart and empty mind. Writing in that homespun style which consists in stepping up close and shouting confidentially in your ear, sometimes he is almost illiterate. It is the price he has to pay for avoiding highfaluting flapdoodle. And because he has no theory he cannot organize his material. His book does contain, however, a lot of facts, names, dates, and reproductions.

It is startling to find Comrade Rockwell Kent writing the foreword to a book in which you read that "American pioneer art has nothing in common with such aberrations as cubism, surrealism, and kindred expressions . . . which derive from decadent strains of European and Near East peoples."

*The Nation*, 13 February 1943

41. Review of the Exhibition *From Paris to the Sea Down the River Seine*

Landscape Painting, French and some English. At Wildenstein's. The course of the Seine was illustrated by some of the greatest painters of the nineteenth century. This is a magnificent show, containing an unbelievable russet and orange landscape by Renoir, *Argenteuil*, Bonington's view of the Tuileries, and masterpieces, too numerous to take in on one visit, by Sisley, Boudin, Corot, Monet, and Seurat. But why is Corot the only one of the Barbizon School to be represented? Did they never stir outside their forest, or is it that their stock has fallen too low?

*The Nation*, 13 February 1943

42. Review of Exhibitions of William Dean Fausett and Stuart Davis

WILLIAM DEAN FAUSETT. Paintings and Water Colors. Kraushaar Galleries. Fausett is an utterly academic painter save for the frankness of his color—and that is unacademic only in relation to 1880. The interest of his case lies in the fact that his landscapes remaining as they do within conventions stale by now—the sweet, smooth surface, the seductive tones, the equally sweet glazes—give valid pleasure nevertheless. Coming from Utah, Fausett has a feeling for the green of deciduous foliage and the contours of grass fields which affects every part of the picture and unifies it. This very particular emotion about a particular thing is enough by itself to transform the conventionality of his style and to make of some of his landscapes works of art. Apart from this Fausett is a mediocre painter. He cannot do figures or still lifes or landscapes without foliage. He cannot define and simplify large masses satisfactorily, as is witnessed by the hard, superficial treatment of the farthest distances in his landscapes. He must rely on nature's more obvious organization and what its details suggest; thus the brilliance with which he handles skies, foregrounds, and middle distances. In the end Fausett has only this one emotion and its cause, the green of our

143

Eastern countryside, and his work at the most constitutes a
pleasant minor incident in contemporary painting.

STUART DAVIS. Selected Paintings. At the Downtown Gallery.
The total impression made by Davis's nineteen paintings hang-
ing in their square grey-walled room is amazing, and more
effective than any single picture itself. This impression defines
Davis's limitations. He is a superb wall-decorator, without
being either a muralist or a first-rate easel painter. His pictures
contain a great deal; yet they do not answer sufficiently the de-
mands made of pictures which claim to be more than decora-
tion. Nevertheless, they are more than decorative. Davis has
stayed too long inside a formula: the Dufyesque dance of line
against flat areas of high, dry, acid color. It is encouraging to see
the artist abandoning this formula in his 1942 paintings by
using more compact shapes in new greens and blacks. *Arboretum
by Flash Bulb* is particularly successful. But *Report from Rockport*,
painted in 1940, is, for all its echoes of Miró, even more so.

*The Nation*, 20 February 1943

43.   Review of *Poems* by Stefan George

Toward the turn of the century Germany, Austria, and Bohemia
produced a triad of first-rate poets—Rilke, George, and von
Hofmannsthal. Their careers ran parallel in more respects than
that of time. All three began as "decadents," aesthetic and pre-
cious, importing the *fin de siècle* from France and England and
exaggerating it into a pose which lacked, in Dowden's phrase,
reality rather than sincerity. All three looked to the post-Baude-
lairean poetry of France for their models rather than to anything
in German; all three were pure poets in the sense that they were
interested, in the beginning at least, only in poetry. Their earli-
est verse was excessively mannered, over-pathetic, and cloying,
and strained too much after effect—though exception should be
made for von Hofmannsthal, who at seventeen was a fully devel-
oped poet and whose work already manifested the perfection of
those qualities which in Rilke and George were still liabilities.
All three brought to German poetry a new and stricter con-

ception of form, seeking to make their verse more dense and self-contained by the renunciation of explicit content and by emphasis upon symbol, sensuous detail, texture, and feats of technique. Hofmannsthal remained always more or less what he was as a boy; for Rilke and George, however, verse became eventually the means to instead of the end of all other experience. They became saints of poetry, expounding the doctrine that through the poetic consciousness rather than through religion the absolute was to be grasped.

Rilke was without doubt the greatest of the three. Yet while they were all alive George wielded the greater influence; Rilke and von Hofmannsthal were affected by him, but he himself was comparatively little affected by them. George was the center of a cult whose members were so galvanized by his personality and example that they succeeded in making the cult almost popular among cultured Germans. In spite of his own proclaimed and sincere intransigence, the upper strata of German society were ready for him when he appeared, and he penetrated their tastes as no other German poet since Goethe seems to have done. That Friedrich Gundolf, one of George's most ardent disciples, was a teacher who had had great influence upon Goebbels—in spite of his being a Jew—and that George himself was a reactionary in every sense except that of his art, these factors are not enough of themselves to explain why the Nazis honored and courted the poet and so estimated his prestige that they have not yet allowed his repudiation of them, as they allowed Thomas Mann's, to become public knowledge in Germany.

George, in a role not unlike that of Oscar Wilde and the Pre-Raphaelites in England, was the first in Germany to proclaim in a loud voice the beautiful as a way of life. He set an example by his own way of life, its décor, his clothes, the format of the books he wrote and of the magazine he published—he even designed their type himself. The beautiful, being the noble, hence the aristocratic, could only be pre-bourgeois. The blight of the trader, the liberal, and the skeptic lay upon our times. The salvation prophesied by George was the kingdom come of a hierarchical, feudal-classical Third Reich led by a new elite which would be brave, courtly, and fair, as equable as ancient Greeks and as fervent as Crusaders. There would be a time of fulfilments, announced by a herald—who was very important in

George's scheme; this herald was envisioned as a dazzling ephebe, now a god, now an angel, now a most specific and particular youth addressed as "Maximin," whom George was in love with. The fantasy was composed of elements not so very original either in themselves or in combination, but only in the very personal intensity which George gave them and in the quite absurd egotism with which he identified his own sexual yearnings with the future of society. It was his art and his tone that won him the consideration he received as a sage and oracle. And to consider him in any other light than that of his art is to diminish him.

What of the poetry then? If the distinction may be made, George was more artist than poet; a Parnassian who was a molder and fashioner of poems rather than a speaker of them; his emotion was more caught up—if another really illegitimate distinction be permitted—by the plastic than the expressive possibilities of language. George's earlier poetry, written under the aegis of symbolism, I now find somewhat disappointing, for all its elegiac splendor and the originality of its rhythms. George was never capable of the long, sustained poem, and here he seems to make too much of a virtue of this shortness of breath. Poem after poem gives only the climax of a mood, the *moment exquis*, with no befores or afters, too soaked in pathos, too static, and too exquisite. There are only cryptic objects, pregnant but unimplicated details of sight, sound, and smell; and always the dying fall to conclude the poem, with a repetitiousness which is not excused by the truth that George's trochees and dactyls and his use of the feminine ending are almost the most brilliant of all his contributions to poetry—in English as well as in German, since they have reached our language at second hand through the medium of Rilke's influence upon a number of contemporary English poets who read German. The weakness of George's earlier work can be attributed to the fact that symbolist poetry stands under a quantitative limitation. Because of the narrowness of its range of modulation, one can read only so much of it at a time.

Like Rilke, George was over-anxious to become a poet, valuing the vocation inordinately for its own sake. But like Rilke again—and Dante no less—he would not have become so good a poet had not his first swaggering eagerness for the role preceded the consciousness of a mission. George derived his most

profound impulses and perceptions from the verbal and rhythmic substance of poetry, that is, from its most tangible medium. Ernst Morwitz, in his introduction to the book at hand, remarks correctly if exaggeratedly of George's later verse that "as in the Greek drama, language is not the means to arouse fantasy; it is an end in itself. The wisdom and the laws of the new life . . . are born from an intrinsic rhythm."

In his later verse George consummates the ideal of the short poem. The climactic moment is now no longer exquisite but magic, and the poem, tightened and made terse by George's masterly renovation of archaic words and syntax, becomes that goal of modern poetry, the spell or charm, something small but of illimitable power. The poetry means nothing except itself, yet works on the nerves and senses as if it were concrete experience entirely, not merely something whose meaning we glean through words. George's practice of poetry abstracted from it everything except its definition or the definition of its prime virtue or greatness. The reviewer happens to have a particular fondness for the slightly longer and more declamatory poems of this period, where a cherished moment of history is evoked and made magnificent again. Here George's breath has a fulness and his matter a reference impossible in the compressed and dateless, placeless purer poetry of the shorter pieces. I think the editors of the present book have included too few of these longer poems.

George possessed a limited stock of simple ideas which he relied upon too unqualifiedly. He wrote some of the greatest poems in any language; yet he missed being a great poet because he lacked roundedness. He did not cope enough with the antipathetic and distasteful; it sufficed him to condemn without examining. Rilke, on the other hand, became a great poet only after having in the *Duineser Elegien* gone as far as he could into dirty, difficult, and definite streets. George invented myths, like Rilke's, animated by sex and history, but they remained too personal; whereas Rilke's self-created myths had enough objective vitality to walk out into the world and receive significations given to them by others than the poet.

The translations in the present book, which includes the originals too, are extremely bad. Whether they are faithful or not is unimportant in the light of their badness. If the original

poems were too difficult to permit of adequate English versions, as I am ready to agree, then they should have been put into prose, at whatever sacrifice, but not into this:

> Then you, our son, from native stock appeared,
> Confronting us in naked glows of god-hood . . .
>
> When bent on brimming seas around me reel
> New thunders of the tempest . . .
>
> In torrid frenzy running . . .
>
> A rapid rhythm drove the troops to trotting . . .
> And more and more battalions and the selfsame
> Stridor of fanfare-tone . . .
>
> You say it is much you took as yours
> All I possess . . .

George sometimes let himself go in turgid young-German-romantic visions in the manner of his much-admired Jean Paul Richter, his muse mounting from one iridescent cloudiness to another into regions where not only the mind's eye but the words of any other language than German are unable to follow. But none of the things quoted above are from versions of such poems. The translators lack the excuse even of having had to conform to rhyme schemes, for their renditions of unrhymed poems are as bad as those of the rhymed ones. One merit, however, which cannot be denied Miss Valhope and Mr. Morwitz is that of having elucidated some of the many difficulties of interpretation to be found in George's poetry. They know how to read, if not translate.

*The Nation*, 22 May 1943

## 44. Goose-Step in Tishomingo

Tishomingo,[1] Alfalfa Bill Murray's home town, in south central and darkest Oklahoma, was chosen with good reason as the location of a prison camp. God help the fugitive who tries to hide himself in the unsubstantial foliage of its gullies or to slip past the squinting eyes of the Bible-pounding natives. If they don't

---

1. Greenberg, who was in the Army Air Force, was stationed at Tishomingo, Oklahoma, when this article was written. [Editor's note]

catch him, the Indians certainly will, or he will perish of bored inanition on Tishomingo's broad main street. The camp itself is a little under two miles to the south, on Route 99, close by the banks of the erratic Washita. It was finished over a month ago. Except for a tall double fence of wire, with a tower at each corner, inclosing one of the two clusters of green-roofed barracks, it looks like any ordinary small military camp. When I first visited it, the guards, a Military Police unit of 150 men, were already there, complaining of the isolation. They knew that the prisoners they were to guard would be prisoners of war, and had heard that they might be Germans but were not sure. Anyhow, whoever they turned out to be they would be put to work cutting down the nearby woods, for the land surrounding the camp will be flooded when the Denison Dam is completed. After the woods are cut, the camp will be torn down and the prisoners sent elsewhere.

Eighteen days later, on April 22, I saw a file of open trucks debouch into the main street of Tishomingo. Every other one was filled with helmeted soldiers armed with tommy-guns and shotguns. Sandwiched between were trucks packed with standing men in blue uniforms something like our old fatigue denims, with the fronts of the trousers red and and the letters *PW* painted on the backs of the jackets. Some of the men in blue returned our gaze with smiles; others were grim or had the perturbed and doubtful expressions of persons looking for the first time at a place to which they have been brought against their will and in which they expect to remain too long. Most of them were boys or hardly more than that, and a good half were blonds. They were Germans all right, for I heard them talking.

The following Sunday I walked over to the camp again. Sunday is the only day on which outsiders are allowed in the immediate area. The camp is at a point where the rolling country descends and smooths itself out into a flat valley. Little fat pigs were wallowing in the deep ditch where the road to the camp forked from the main road. Farther on a soldier in green fatigues was playing with a blacksnake four and a half feet long, holding it up by its tail. It kept raising its small sharp head to get at his hand but could not get enough leverage to reach all the way back.

Men were running and bounding about behind the barbed live wires of the high fence. I was allowed to come no closer than

twenty-five yards to it, and the prisoners were held off another ten yards on the other side by a chalked line. If they crossed it they would be fired at after three commands to halt. The first prisoners I saw distinctly were a group of about twelve sitting on the new spring grass and playing cards. This time their clothes puzzled me, for many of them wore well-fitting blue breeches that looked not at all like fatigue dress. The guards told me that they were dyed World War I uniforms which had been issued by the German army as fatigues, and of which every prisoner had three sets.

One pink-skinned young blond wearing nothing but shorts was running around inside the chalk line with nice form except that he bent too far forward—probably because he had been trained to run with a pack on his back. Two or three others almost equally naked were doing cartwheels and somersaults in best German gymnastic style. Some were sun-bathing. Everybody's skin was surprisingly white but almost everybody looked well set-up and athletic. One, as he walked and talked with a companion, every now and then kicked up his legs in a smart-looking goose-step—whether it was done absent-mindedly, out of physical exuberance, or to keep in practice, I could not tell, but it seemed to annoy the guards. "Look at the son of a bitch!" they would say every time the German began to swing his legs. A stout sergeant said that the lot of them should never have been taken prisoners in the first place but shot on the spot. (I can understand why it is the army's practice to change the guards at prison camps every two months or so; they may either become too attached to the prisoners or else get so irritated with them that they will shoot at them on the slightest provocation. Neither the guards nor anyone else is allowed to talk to the prisoners.)

It was from the guards that I got most of my information. There were 310 prisoners in all, part of an original group of 1,000 brought from Africa, all whom had been placed in camps in Oklahoma. Some of them had been through twelve days of continuous action before being captured; some had seen service before on the Russian front. I was told that one of the prisoners was only fourteen years old. Two I saw could not have been more than fifteen. They were walking back and forth and talking to each other with the gravity and the economy of movement and gesture of much older persons. Several others showed by twisted arms or scarred necks and faces that they had been wounded.

The quiet, relaxed self-confidence with which the prisoners handled themselves surprised me; it was in such contrast to the dejection or resignation or maybe shamefaced relief one would expect of prisoners. But, then, they had told the interpreter stationed here that the guards would soon be handing their guns over to them. One of them, while being brought through New York, had expressed surprise at seeing the skyscrapers still standing. He had been told that New York had been bombed. When they had been asked why they got themselves out of their barracks at 4:30 in the morning to exercise when their reveille came only at 6, they had answered that they wanted to keep themselves fit for the day when the Führer would arrive in America. A week after my visit, on May 1, they celebrated the holiday the Nazis have substituted for *Pfingsten* by bringing a tree back to camp, setting it up in the compound, decorating it with garlands of flowers and birds cut out of cardboard, and then strutting around making speeches and heiling—although, according to the guards, it is against prison regulations to salute in Nazi fashion or *shout* "Heil Hitler."

As it happened, May 1 came on a Saturday, and the prisoners did not have to work. On their arrival each of them had been given the choice of signing up for work or doing nothing; but once having signed up, a man has to work every day except Saturday and Sunday, whether he wants to or not. Working hours are from around 7 to around 2:30 in the afternoon. The pay is 70 cents a day, of which 40 cents is placed to the prisoner's credit at the post exchange and the remainder withheld until eventual repatriation. They are issued the same food as their guards, and it is prepared in German style by their own cooks. The guards told me that at mess they never leave a scrap of food on their plates, so used are they to scarcity. But I, with my melodramatic imagination, wondered whether they might not be storing it for a break. One prisoner has lately got on the nerves of the guards by standing for hours on the chalk line, examining the fence and the tower installations with purposeful eyes. I myself noticed how intently the prisoners watched when the guards were being changed and were marching along the fence. But it may have been only a professional interest in things military, which the prisoners certainly have. They are intrigued by every military formality or piece of equipment they see.

The prisoners maintain their own army discipline under two

top sergeants, who seem to be the only men among them close to forty. They rate salutes, unlike the non-commissioned officers in our army—whom the prisoners nevertheless insist on saluting as they do their own. In the German army the most common punishment for mild offenses is to deprive the culprit of a meal or two. The next degree of punishment is, rather abruptly, corporeal. One of the top sergeants asked the M.P. mess sergeant to withhold food from a disobedient prisoner—I believe it was a case in which the prisoner had chosen to obey an order from the lieutenant of the guards which conflicted with the top sergeant's orders. Anyhow, the mess sergeant refused the request and fed the man. The top sergeant immediately came into the mess hall where his man was eating, pulled him outside by the collar, and gave him a beating. I was told the man did not lift a hand in self-defense.

The guards admit that the Germans are willing and capable workers, eager to be helpful and lending a hand with any work they see being done around them even when they are not ordered to do so. They are also given credit for their stoic qualities. One of them who had gashed his foot with an ax and was brought to the medical officer attached to our Air Force unit sat in the dispensary and stolidly watched the wound being sewn together without making a sound.

To remark these qualities in the prisoners is not encouraging. Unquestionably, Hitler has had good human material, from a military point of view, to work with. However, their age and their physical condition and the fact that the majority of them are parachutists or *Panzer* personnel indicate that most of these prisoners are picked troops, not altogether typical of the average German soldier. That they make such a show of Nazi ardor is more disquieting. It is possible to explain this—but not very convincingly, I feel—by the fact that they are more or less at the mercy of their non-commissioned officers, who could make life miserable for any prisoner not quite 100 percent a Nazi.

*The Nation*, 29 May 1943

45. Review of Mondrian's *New York Boogie Woogie* and
Other New Acquisitions at the Museum of
Modern Art

Something of the harmony of the original white square of canvas
should be restored in the finished painting. But harmony a
thousand times more intense, because it is the result of the suc-
cessful resolution of a difficult struggle. The simplest way al-
most of accounting for a great work of art is to say that it is a
thing possessing simultaneously the maximum of diversity and
the maximum of unity possible to that diversity. For lack of the
first the new painting by Mondrian called *New York Boogie
Woogie*, now on view at the Museum of Modern Art with several
other new acquisitions, is, for all its sudden originality, some-
thing a little less than a masterpiece. The checkered lines of
orange squares produce a staccato rhythm—signifying jazz—
too easily contained by the square pattern and white ground of
the picture. At hardly any point does the rhythm threaten to
break out of and unbalance this pattern enough to justify the
latter's final triumph. There is resolution, but of an easy struggle.

*New York Boogie Woogie* is a radical step forward in Mondrian's
evolution, which since his arrival in this country and to this
point has been concerned mainly with the widening of his color
spectrum. Now not only have new and for the first time slightly
impure colors been introduced, but the hitherto immutable ele-
ments of Mondrian's space composition have begun to break up:
the straight black, almost incised, lines into parti-colored
chains of squares, and the great dominating rectangles into
smaller rectangles and squares of contrasting colors. The artist
has not yet possessed himself fully of these new configurations,
not yet rendered them controllable to his total purpose, but the
gamble is well worth taking. Unless the artist die to the suc-
cesses of his old work he cannot live in his new. Repetition is
death. One more thing: the picture at hand suffers from the ab-
sence of that very neat and precise mechanical execution that
used always to characterize a Mondrian painting. It is either a
failure of manual dexterity, a deliberate effort to be a little more
fluid, or simply the impression left by the weak yellow and the
purple that appear in a Mondrian painting for almost the first
time. The picture has a floating, wavering, somehow awkward

quality; the color wanders off in directions that I am sure belie the artist's intent. Yet *New York Boogie Woogie* is a remarkable accomplishment, a failure worthy only of a great artist, and its acquisition was more than justified; it was mandatory.

Of the other acquisitions the Matta painting is slightly untypical, has an almost valid surface charm, and is certainly better than those iridescent burlesque-house decorations, style of 1930, he usually paints, which are little more, really, than the comic strips of abstract art. Again, the painting by Masson is one of his better recent ones; turgid and dense, the tone hot but subdued. It has, however, an unpleasant pretentiousness about it. I don't think Masson will ever again turn out work comparable to that he did in the twenties.

The presence of the picture by the Mexican Tamayo evidences, along with that of Matta and Masson, the extreme sensitivity of the museum to trade winds on Fifty-seventh Street. The museum shows taste in that when it buys the work of inferior artists it at least chooses their best work—untrue here only in the case of Tamayo—but this does not atone for its masochistic fondness for the social and other epigones of the School of Paris.

*The Nation*, 9 October 1943

## 46.   Reconsideration of Mondrian's *New York Boogie Woogie*

My memory played tricks when I discussed last week the new Mondrian at the Museum of Modern Art. The painting has no orange, purple, or impure colors. Seeing it again, I discovered that it was the gray which Mondrian uses here in a new way for him that made me remember his scarlet and two shades of blue as purple and impure, and the yellow as orange. But I have the feeling that this after-effect legitimately belongs to one's first sight of the painting. The picture improves tremendously on a second view, and perhaps after an aging of six months or so it will seem completely successful.

*The Nation*, 16 October 1943

47.   The Jewish Dickens: Review of *The World of Sholom
      Aleichem* by Maurice Samuel

The Russo-Polish Pale, the last or latest metropolis of the Di-
aspora, accounts more than anything else for what the West now
knows as the Jew. Its liveliest memorial was created by one of the
few great folk writers whose names and personalities are a
matter of historical record. Sholom Aleichem (né Rabinovitch)
was an "emancipated" Jew, acquainted with Western culture
and with one foot already outside the ghetto. This distance, per-
haps, was a necessity to his writing.

The intrinsic interest of its subject sustains Mr. Samuel's
book, which deals with what Sholom Aleichem wrote about
rather than with the writing itself. But Mr. Samuel himself
writes with a too evenly diffused warmth and blurs everything.
In any case it is hard to talk in English about the virtues of
Sholom Aleichem's work. The verbal wit, liveliness, and Eliza-
bethan fluidity of Yiddish do not survive translation; nor does
the shop talk of Talmudic scholarship—something a Jew got in
his bones without ever having read the Talmud. The contexts are
difficult to render unto Gentiles, and unless it is understood
how the contexts are being wrenched, much of the humor fails
to come through.

Inevitably, Sholom Aleichem is called the Jewish Dickens.
Such parallels are objectionable on principle, but this one does
provide some illumination. Like Dickens's humor, that of
Sholom Aleichem is comic and verbal and depends less on situa-
tion than on character, local color, and dialect. Personages are
comic because they do not take a sufficiently pessimistic or re-
signed view of themselves and of their condition, or because
they handle too colloquially the big, pompous truths of life.
This is of the essence of most humor about the poor. Sholom
Aleichem's humor sometimes comes close to farce but never ac-
tually reaches it, for the absurd is too near at hand in the reality
that is imitated. I think that Sholom Aleichem goes deeper than
Dickens. His humor can take control of and intensify a tragic
situation; it deals really with what is a tragic situation in the
main. But to show the disparity between the Jew's visions of
heaven, space, security, and wealth on the one hand and his
cramped and precarious confinement on the other was no job for

the tragic muse unmasked. And then the ghetto was not quite what it seems. The Jew there was not nearly so middle-class as he has since become in Brooklyn and as he became in Germany. He managed to produce a real folk life in the tenements and back alleys and even the suburbs. Many of Sholom Aleichem's characters take the fact that they are Jews for granted, and this great favor was allowed them nowhere else on earth than in certain communities of the Pale, where Jews performed all the functions of society and were not penned within an economic caste.

The ghetto taught the Jew to keep his eye on the main thing, the main thing in any interest, not only his own. Therefore his impatience with etiquette. The poor everywhere are impatient with etiquette, if not decorum, but none so much as the Jews. For them the only etiquette impervious to ridicule is that of ideas. Why deny that man lives by cruel competition in this particular world? Nor is there any valid reason to curb the extravagances of one's temperament. It is no wonder that the best literature the ghetto has produced in recent times is humorous and that its *folk* life can be defined as peculiar to a people who live in the constant presence or under the perpetual threat of the joke. The ghetto Jew may have been retarded in many respects, but in this he was the most advanced of all human beings— "Oriental" perhaps in his poverty and in the denseness of the atmosphere in which he lived but not in his realism and in his abhorrence of hypocrisy. (The last thing the Jew is, is tricky, and the last thing he thinks of is his front to the world. The ostentatious Jew—that myth of the Anglo-Saxon world—is ostentatious only about his wealth, and unlike maharajas and Vanderbilts, makes no other claim by his ostentation than that of wealth. And when he loses it he does not bother to keep the lace curtains hanging in the front parlor.)

There is another reason why the Jews live on such close terms with humor. In the last two thousand years they have been unable to play any striking role as a whole people, with the result that history has not presented them with fresh infusions of glory and dignity from above to act as sedatives upon their critical sense. The persecutions they endure, because these involve fundamentally meaningless suffering, relevant only to the persecutors themselves, neither sharpen their sense of tragedy nor

dry up their wit. The effect is the opposite. True, the Jews have acquired a phenomenal capacity for suffering, but pure, irrelevant suffering in itself—no less than the competitive life of the ghetto—has made them only the more impatient with all the devices by which the necessary cruelties of existence are dignified and sublimated. They have learned that the best or at least the safest way to protect oneself against what for Jews would be insupportable otherwise is humor.

The Jew's almost quixotic insistence upon directness in relations and his unwillingness to allow himself or anyone else to be identified by or with his functions or position in society is succinctly illustrated by Sholom Aleichem's story of the old Jewess who refuses to pay her fare to the conductor of a trolley car because he happens also to be the young son of a neighbor, whom she has known since he was a baby. It strikes her as ridiculous beyond words to enter into such a formal relationship with him as would be denoted by paying him fare. Aside from the fact that it is to her own interest not to pay the fare, she doesn't—for his own sake—want him to make a fool of himself.

Sholom Aleichem's characters are unsatisfied by their emotions; they insist on worrying them into ideas and on posing them so that they best catch the gleam of logic's rhetoric. "I will extol Thee, my God, O King (what good would it do me if I didn't?)" Tevyeh, the wagon driver, prays. He is full of pleading and submission, there is no question about his piety, and he has at that moment permitted himself a glance at the wretched panorama of his life; but he cannot defend his feelings from the examining and comparing intellect. It is this that the Nazis profess to complain of most in the Jews.

Capitalism, in the sense that capital is the most valuable form of wealth, was nothing new to the ghetto, as we all know. The Jew has been a capitalist more or less ever since the beginning of the Diaspora or whenever it was he rid himself of the instinctive reliance upon ponderous or immobile possession. It has always been the speculative, commercial, pre-industrial aspect of capitalism, not the exploitation of other people's labor through the possession of their tools, that has attracted the Jews. Nevertheless, though speculation may have built the ghetto, it was the first—in its more modern forms—to violate its privacy and breach it to the outside world. It is responsible

157

for that most typical phenomenon of recent Jewish life, the *Luftmensch*, the man who lives in, by, and on air, the fixer, the promoter, the go-between, the man who always has a deal on hand and never a vocation, the visionary whose dreams are full of calculation and the grossest actualities, the practical man who suffers from pathological optimism—a malady without which many Jews would be unable to go on being Jews. Sholom Aleichem hints, I believe, at the Jew's weariness of this sort of thing. He is tired whether he knows it or not of the adventures of capitalism, bored by them; he understands capitalism too well and has begun to have a sense of guilt about it—not that the Jews in particular are the ones responsible or that all Jews are capitalists, but that most Jews grow up to be entrepreneurs by culture and psychological habit. Now one part of them yearns for a new order, while another turns backward to Zionism and a pastoral life that is nothing but a literary reminiscence. In the wretchedness and beyond the humor of Sholom Aleichem's world both hopes begin to stir. The Jews like cities, gregarious life, and the fluidities of commerce; they still like them but at the same time they yearn to stop liking them. Security lies in another direction.

Yet the Jews in a way relish their fate, as in a way everyone does. For they still are chosen, chosen at least to be always confronted by or to confront the alternate finalities of the human lot. Think: they have been and still are the most particularist people on earth; yet they have been accused of making it their particular mission to destroy particularity, to internationalize, to create the brotherhood of man. They are accused of self-seeking; yet they produced the supreme example of the gratuitous and disinterested man who is not an ascetic. They are supposed to be materialists; yet none have been so foolhardy in exposing themselves for an idea. And at the same time they are stubborn, they go on manifesting vitality, swarm, pullulate, enjoy, and multiply; yet they were the first to distinguish between the wholesome and the unwholesome and to find fertility rites an abomination— perhaps because they have always been more convinced than anybody else of the essential dignity of man. This may explain why they are so ready, as in Sholom Aleichem's case, to submit themselves to the attrition of humor.

*The Nation*, 16 October 1943

## 48.   Review of Exhibitions of Alexander Calder and Giorgio de Chirico

ALEXANDER CALDER. Sculpture, Constructions, Jewelry, Toys, and Drawings. At the Museum of Modern Art. GIORGIO DE CHIRICO. Early Paintings. At Art of This Century gallery. Calder's accomplishment is the invention of a new microcosm of art. Its flora and fauna are made of wire, sheet metal, piping, glass, wood, and anything else tangible. Its plants can be conceived as those objects with leaves of metal, its animals those with flanged and bolted haunches, its geology the involutions of wire, string, and pellets, while its machines are really machines—motor driven—with no purpose other than the dance of their own movements. The modality of this world is linear, two-dimensional in spirit if not in fact, an inheritor of painting. Here also the mischievous word of E. E. Cummings's poetry is made flesh. Calder's art is always called gay and exuberant, and it is. But more seems to be wanted. This particular world lacks history. Lots of things go on in it but nothing happens; for its laws have no necessity and are not sufficiently determined by a driving purpose working itself out variously and progressively in fulfillment of the will or inherent nature of its creator. Its creatures differ as much in design and scale as can be wanted, but they all have the same personalities. Calder's chief asset is felicity: so few of his objects lack it; but felicity exhausts their content—as is most obvious in the larger pieces. It becomes plain then that the fundamental aesthetic concept setting Calder in motion is good taste—a good taste already established by others, since his shapes and especially his color stem entirely from the works of Picasso, Miró and Arp. Good taste has its advantages, and Calder is one of our best artists. I do not think that he is in the same class as David Smith, who works in a similar medium and derives from the same ancestry, but he comes next.

Chirico is an inventor, too, not of a world but of an atmosphere and décor. A stereopticon view of a desolation cleanswept and orderly, haunted, abandoned, Graeco-Italian, etc., etc. Ichabod the glory has departed, leaving elegiac and lyric shadows in the late October sun. Not crumbling matter but the absence of people—more, the absence of animal life—signifies decay, or the embalmed immobility of their partial presence in rooms cluttered with geometrical paraphernalia. Those who la-

ment the degeneration of Chirico's art into its present state of buff torsos, white-washed horses, and chalk drapery would be less dismayed if they looked more searchingly. Aside from atmosphere explicitly denoted as such, the originality of these early Chiricos (1911 to 1917) lies only in the neat bisection and re-bisection of space—a parody of Renaissance composition—and in the declamatory contrasts of dark and light, the light being expressed by color unusually flat with respect to the deliberately academic black of the modeling and shading. But the color is stale Florentine sugar, and the texture of the painting superficial and lifeless. Perhaps this came in part of the artist's desire to paint in the spirit of his theme; if so, he overdid it. The *alla prima* thinness expresses the defeatism of Chirico's art itself more poignantly than it does the defeat of the world conjured up by its means. His art is a literary feat sustained for only a moment's view. Then it dies—or goes on to survive best in black and white. Let me except *The Rose Tower* from the last; it is notable for its flesh pink no less than for the placing of its horizon lines, used so well to evoke melancholy.

*The Nation*, 23 October 1943

## 49.   Review of Exhibitions of Van Gogh and the Remarque Collection

Sixty-eight of Van Gogh's oils and eleven water colors and drawings (at Wildenstein's) go to make up the most important show of the artist's work since that at the Museum of Modern Art in 1935. The Van Gogh Problem, of which we are reminded from time to time by single pictures, asks again for solution. Exactly how great a painter was he? The problem is made no easier by this exhibition, in which the complete masterpieces are too few and far between.

It is more difficult to judge painters fairly than writers and composers. The difficulty is physical. Color and texture cannot be reproduced in their full values for purposes of circulation. Because a sufficient number of the originals of a painter's masterpieces are seldom present in any one place at any one time, we

fall into the habit of demanding the absolute measure of his talent from every picture, good or bad, as long as it's an original. We do not ask as much of the lesser works of writers and composers simply because their best is just as accessible. I think it hardly fair to pronounce on Van Gogh without having seen all his masterpieces, but that is part of the inevitable presumption of writing about art.

A roomful of Van Goghs has an impact. Yet all but some seven or eight of the paintings here lead to the question whether the impact has as much to do with art as with that emotion or quality or strikingness which Kant distinguishes as analogous to the beautiful, but only analogous, in that its presence makes us linger on the object embodying it because it keeps arresting our attention. It is the quality to which primitive art, at its best or worst, owes its inevitable effect upon the cultivated observer, and which is part of the emphatic physical presence of the work of art that exposes to full view its inner workings, its means of effectuation. With Van Gogh there also enters the power of an original temperament frustrated by its rupture with that world of logic, competition, and compromise in which it found itself.

I do not hold with Dr. Alfred M. Frankfurter[1] that in the means of expression Van Gogh chose for himself he was never "other than an amateur with a divine genius." There is too much good painting in his bad pictures to say that. Van Gogh's distortion of vision, induced no doubt by his psychopathic state (compare with Rousseau Douanier and Eilshemius), arrived at results of the same order as those of Cézanne's inability to draw with academic correctness. The "rarity with which Van Gogh touched complete mastery"—to quote Dr. Frankfurter again—was due to a faulty command not so much of his medium as of his temperament. Van Gogh became too obsessed by the pattern glimpsed in nature. The frenzied insistence with which he tried to reproduce this pattern in his separate brush strokes and give it the same emphasis over every tiny bit of canvas resulted in pieces of violent decoration the surfaces of which had been ornamented instead of painted into a picture. Similarly, Cézanne's preoccupation with the justness of color values down to the last millimeter

1. Frankfurter, who was the editor of *Art News*, wrote the introduction to the Van Gogh catalogue. [Editor's note]

in the delineation of space and volume made him lose sight at times of the whole in view. In his case, though, segments at least of otherwise unsuccessful pictures survive as superb texts in the painter's art. It was Van Gogh's misfortune and distinction that, unlike Cézanne, he could not rejoice in the limitations of his medium.

The appreciation of an artist has its own history. At this moment several of the Van Goghs of the Paris period (1886 to 1887) seem to please even more than the later work—though they are not quite as original—especially the Renoiresque *Bridge Across the Seine*, in which subtle touches of pure, high color are so well placed to define space and its tensions. The self-control here and in the *Corn Field*, the flower pieces, and the two self-portraits of the same period unsettle some of the usual notions about Van Gogh's art. Yes, mistakes of temperament, not of craft, account for most of the disappointments. It can be argued perhaps that the failure of Van Gogh's art or craft lay precisely in its failure to react upon and discipline his temperament; he should have been checked by this refusal of his art to respond to his exorbitant demands upon it as a means of utterly direct expression. But that would be expecting too much. Van Gogh's shortcomings as an artist are a translation into another language of those that belonged to him as a human being.

The loan exhibition of the novelist Remarque's unusual collection of School of Paris pictures (at Knoedler's) contains three of the best Cézanne oils in this country, a number of water colors from the same hand—these are a bit too perfect—and items in oil, water color, pastel, and pencil by Daumier, Degas, Van Gogh, Utrillo, Toulouse-Lautrec, Delacroix, and Pissarro. Also two good Fayum portraits. The collection itself is a work of art, being the result of a personal but consistent taste that has looked to French nineteenth-century painting for only what it and no other school can give. I do not believe I have ever seen discrimination so fine embodied in possessions. Of course, Remarque confined himself to safe masters, but even so—

*The Nation*, 6 November 1943

162

50.　Review of Exhibitions of Charles Burchfield, Milton
　　　Avery, and Eugene Berman

CHARLES BURCHFIELD. Water colors at Frank Rehn Galleries.
MILTON AVERY. Water colors at Paul Rosenberg's. EUGENE
BERMAN. Oils and Drawings at Julien Levy Gallery. Burchfield's
kind of painting is a staple of contemporary American art. A
cautious acquaintance with nineteenth-century French paint-
ing, the example of Winslow Homer, and one or two small but
valid sensations give a semblance of animation to a style other-
wise academic and dull. Eight over-size water colors on card-
board, painted dryly and with a heaviness uncharacteristic of the
medium, organize in a routine way details such as hundreds of
other water colorists in this country note every week and orga-
nize in much the same manner. One subject that rouses Burch-
field's talent is the frame-house neighborhood gone to seed.
*Winter*, with its weather-worn house slouching in the loom of a
black factory, is the picture of this show. Burchfield felt that
house.

Avery is a "light" modern who in oil can produce offspring of
Marie Laurencin and Matisse that are empty and sweet, with
nice flat areas of color. For water color he goes to school with
Marin, and his art becomes as period American as Burchfield's, if
much more delicate and elegant. The painting is almost faultless
within its limitations, but it has been seen before—the reticent
color, the hinted and the actual black-and-whites, the tactful
emotions about nature. They are the ingredients of a uniquely
American contribution to landscape art; only Marin has summed
it up already, at least in this vein.

Eugene Berman, Neo-Romantic, is, I suppose, a painter.
But we can save trouble by taking him as simple specialist in
*frissons* for the cocktail hour. Given that he has discovered essen-
tially nothing about his art that Raphael didn't know, he is very
dextrous. That is, he can paint any way he wants to, provided
the way has already been discovered by someone else. The pre-
scription for Berman's thrill this year, and thrill it is, is to take a
Florentine master, clean him thoroughly, rearrange the figures,
reheat and remix the subject, and then freshen up everything
with Böcklin syrup. Piquancy is also gained by doing the canvas
without ground or underpainting while yet striving after the

same effect. There is an effect, a wonderful-rich effect, but it belongs to journalism and mode. It is as if Time Inc., were re-writing and simultaneously imitating the Harvard Classics. Berman's pictures, crowded as they are into a relatively small space, are too overpowering, too decadent, too spurious, and, really, too well done to be dealt with in measured words. If this is art, the age is doomed.

*The Nation*, 13 November 1943

### 51. Review of Exhibitions of Marc Chagall, Lyonel Feininger, and Jackson Pollock

MARC CHAGALL. Oils and Gouaches, at Pierre Matisse Gallery. LYONEL FEININGER. Oils, Water Colors, Drawings, Etchings, and Woodcuts, at Nierendorf Gallery. JACKSON POLLOCK. Oils, Gouaches, and Drawings, at Art of This Century gallery. Chagall's art turns from the main stream of ambitious contemporary painting to follow its own path. It is pungent, at times power-ful, but opens up no vistas beyond itself. Chagall's position, cu-riously enough, resembles that of Odilon Redon in the late nine-teenth century. The present exhibition, composed entirely of work done in 1943, indicates a crisis in the painter's career. He is no longer mellowing in Paris; he is being challenged by events and by the imperatives of his artistic development. The soft, blandishing French tones, the harmonic suffusions, that have characterized his painting in the last fifteen years or more— never enough, however, to submerge his native robustness— are on the way out. Returned is something of the flatter, less tonal brushwork of his earlier period, its harshness too, but all much less crude, being modulated by everything Chagall has since discovered about the orchestration of frank colors. A new yellow plays a role, along with more ambitious or more sur-realist subject matter—crucifixions and monsters. Usually when an artist exhausts one phase it takes time and error to as-similate the next. Chagall's two or three new major efforts— major in size and pretension—abound in patches of interesting painting, but none is fused into a complete and organic work of

art. The variables of defined form are not related with sufficient visual logic to the murky, indeterminate *fond* that is the constant against which they appear. Yet lack of success in the new is worth any number of successful repetitions of the old. The most achieved picture at the show, the gouache *La nuit se mêle au jour*, happens to repeat Chagall's previous success with royal blue. I would gladly trade it—considerations of size and effort being irrelevant—for the large and unresolved *Crucifixion* with its yellowish malaise.

The Feininger exhibition covers the artist's work from 1911 to 1938. What began as a German marriage of expressionism with cubism evolved after 1915 into a province of Paul Klee's art. Until then Feininger's heavy and obtuse color oppressed his more genuine talent as a draftsman. Klee's influence seems to have lightened and thinned his color and perhaps made him realize that his eyes—like Marin's—conceived instinctively in darks and lights. The best pictures are those altogether in black and white and gray, as the pen-and-ink wash *Feininger am Kai*, or those in which the palette is narrowest, such as the water color *The Barque*, with its mere black, sky blue, lavender, and white. Feininger always paints with honesty and grace. He is not important in a large sense, but he has a very definite and secure place in contemporary painting.

There are both surprise and fulfilment in Jackson Pollock's not so abstract abstractions. He is the first painter I know of to have got something positive from the muddiness of color that so profoundly characterizes a great deal of American painting. It is the equivalent, even if in a negative, helpless way, of that American chiaroscuro which dominated Melville, Hawthorne, Poe, and has been best translated into painting by Blakelock and Ryder. The mud abounds in Pollock's larger works, and these, though the least consummated, are his most original and ambitious. Being young and full of energy, he takes orders he can't fill. In the large, audacious *Guardians of the Secret* he struggles between two slabs of inscribed mud (Pollock almost always *inscribes* his purer colors); and space tautens but does not burst into a picture; nor is the mud quite transmuted. Both this painting and *Male and Female* (Pollock's titles are pretentious) zigzags between the intensity of the easel picture and the blandness of the mural. The smaller works are much more conclusive: the small-

est one of all, *Conflict*, and *Wounded Animal*, with its chalky in-crustation, are among the strongest abstract paintings I have yet seen by an American. Here Pollock's force has just the right amount of space to expand in; whereas in larger format he spends himself in too many directions at once. Pollock has gone through the influences of Miró, Picasso, Mexican paintings, and what not, and has come out on the other side at the age of thirty-one, painting mostly with his own brush. In his search for style he is liable to relapse into an influence, but if the times are pro-pitious, it won't be for long.

*The Nation*, 27 November 1943

## 52. Review of Exhibitions of Louis Eilshemius and Nicolas Mocharniuk

EILSHEMIUS. Paintings of 1909. At the Valentine Gallery. NICHOLAS MOCHARNIUK. Wood Sculpture. At the Marquié Gallery. Arbitrary though it might appear, no better selection of Eilshemius's work than his production of 1909 could have been made as a starting-point for the revaluation of his art. The quality is surprisingly high and consistent; yet the year marks a critical station in the artist's career. The simplification of his later—or what I choose to call "deranged"—period, with its yellows, acid greens, oranges, tans, and pinks, begins to emerge even as the comparative academicism of his earlier period reaches its fruition. We see that Eilshemius was a comparatively thin but very intense talent. Within certain rather narrow limits he pushed landscape painting to a maximum; where and when he strains beyond these limits he may become more original, but he lacks the sustenance of total feeling and of learning. The febrile, erratic intensity comes from a level too near the agitated surface of Eilshemius's experience, is the result of a mutilation, is fancy with imagination. Like all the deranged, Eilshemius lived toward the end only in a province of himself. This having been said, it can be said further that he was one of the best artists we have ever produced. The brushing of the trembling, loosely defined masses of color in *Sunburst—Delaware Water-Gap* antici-

pates, yet with a sensitivity to texture all its own, the best post-Cézanne landscape painting. But Eilshemius apparently grew to want his immediate emotion first, his painting last. Almost every other picture here is successful within its own terms—especially *Girl Waving* and *New York Docks*—but there is a gaucherie in the emotional blues; or the flatter, less recklessly handled light greens and yellows, played off against the top elementary composition of lights and darks, turn into something of a picturesque formula. Really, Eilshemius became too radical. His painting was at its best when it retained enough of academicism to give it body, complication—and control.

The work of the young wood-carver Nicholas Mocharniuk is worth being concerned about—if only to point out that he is captured too readily by facile and decorative rhythms suggested by nature, primitive art, and his medium. He should study the problems of form in its more abstract incarnations—and realize that whatever he may do he belongs to the Gothic-baroque, pre-expressionist tradition of wood-carving, with its closely articulated forms and concentrated detail, rather than to the smooth mass and simplified line of most modernist and primitive sculpture. The fact is, wood seems rarely an appropriate medium for modernist art.

*The Nation*, 18 December 1943

53.  Seurat, Science, and Art: Review of *Georges Seurat* by John Rewald

The mystery of intuition must be taken for granted in aesthetic experience. The calculation that lies under the maker's activity seems at times more mysterious than the intuition. This is nothing new. Originally, the operations of reason were in the charge of priests—the first geometry, the Pythagorean pseudo-science of numbers, and magic. The hieratic tone of Seurat's art and of his personality was a concomitant of his effort to reduce or expand painting into a rational method. He had a system; the artist who professes that the role of his genius is to apply a system rather than create originally comes as one armed with se-

crets. It is implied that we can all become artists in the same way as we can all be saved by true faith. This means in effect the socialization of art, as Protestantism by making every man his own priest meant the socialization of religion. The temple of the artist's genius is broken into and its sanctities made common property. Seurat was not the first to have this idea, but he was the first to invoke the aid of the natural sciences. Not that he proposed really to socialize art; he was jealous of his "discoveries" and exploited them privately, or wanted to, like a good capitalist. And he realized quite well the gap between a system and its application. He never bothered to answer the critics who charged him with attempting to eliminate the role of original talent.

The impressionists tended also to make painting scientific, but Seurat was the first to seize the full implications. He was one of those fanatics whose mission it is to realize and fulfil immediately what others have only groped toward. He found nothing that can be called a solution, but by drawing the logical conclusions he exhausted the question. It has not been raised again except by crackpots.

Seurat's enterprise, no less than Zola's delusions about scientific novel-writing, involved really the general purification of the arts undertaken by the French avant-garde after the decline of romanticism. Hitherto the practical theories of painting had been concerned chiefly with the reproduction of nature. Seurat's interest was to secure for painting most economically and expeditiously the maximum of the effects proper to it as a two-dimensional art imprisoned on a plane surface. Scientific method exemplified a way of eliminating irrelevant factors from a problem. With such precedent in mind, Seurat unwittingly arrived at the notion of pure painting überhaupt. He himself seems not to have recognized it, but it was there, in his practice and in his theory. The emphasis of his system lay mostly upon the abstract elements of painting—tone, color, mass, line. He was the first to take the frame into account as part of the picture and to insist on indicating it by painting a border within the picture itself, and he was thus the first to attack the concept of the easel painting as a window.

Seurat was concerned above all with formulating a theory of color and tone; yet his own painting excels by the inviolable

order and mathematical calm of its arrangements of line and mass, especially in the landscapes. And toward the last such pictures as *Le Chahut* and *Le Cirque* show abstruse and dazzling counterpoints and harmonies of contour. But color and surface remain unsatisfactory. They make a shimmering, variegated mist which contour and mass have to break through; *pointilliste* color does not inhere in or define form; surface is paper-thin and translucent, ready to be peeled away. It vibrates outward only— but in this it foreshadows some of the effects that post-cubism aimed at: surface and texture as elements which spring toward the spectator instead of drawing his eyes on into the depths of the picture.

For the "inhumanity" of which modern art has been accused we can blame history, but Seurat was one of the principal channels by which it entered painting. In this his subject matter played almost as great a part as his theory and technique. Like Manet, Toulouse-Lautrec, Renoir, and other contemporaries, he was fascinated by the mass-produced recreations of city life which the nineteenth century had conventionalized into circuses, night clubs, dance halls, cafés, and variety theaters. Seurat seems to have been sensitive to the outside-looking-in attitude that modern entertainment forces upon the spectator. More than the entertainment itself, the inhuman glamour of the entertainers keeps us at a distance. Both the entertainers and the spectators in *Le Chahut* and *Le Cirque* are cartooned; their faces and bodies are part of a weird, alienating humor that speaks from every diagonal, vertical, horizontal, and curved line. See how the forked coat-tails of the man dancer in *Le Chahut* echo his moustache, the bows on the slipper of the girl next to him, her fixed smile, and the smirk on the face of the single visible spectator. It is a world most of us will never enter. Twenty years after Seurat, painting entered a world not unlike it and left a good many of us standing outside.

The objectivity, coolness, and carefulness of research in Mr. Rewald's monograph shows how facts about art should be presented. I think it unfortunate, however, that he limited his intention so strictly. "This study," he writes, "is limited to an account of Seurat's life, of the process by which his ideals—and paralleling them, his works—developed, and of the reception accorded them. . . . It is for others to study Seurat's place in the

history of art or to analyze his paintings." This disclaimer does not excuse a certain sketchiness, even as to the facts. We gather that Seurat never had to work for a living. What sort of income did he have then? A small point, but it has its own importance. I think too that the exemplifications of Seurat's theories in his work could have been examined in more detail. And as a matter of editing, the locations of the works reproduced—all in black and white—should have been given. The translation by Lionel Abel from Mr. Rewald's French is remarkably smooth.

*The Nation*, 25 December 1943

## 54. Review of an Exhibition of John Marin

Oils, Water Colors, and Drawings. At An American Place. For several years now Marin has been seeking to advance his development through oil rather than water color. He is better in oil, I think, than is generally admitted. Yet in this show of his latest work the only oil that comes off at all is *The Three-Masted Schooner*, which has a four-square pictorial compactness which is strange to Marin and to which the "self-decorated" frame may contribute largely. As for the water colors, vividness is gained from the introduction of a blood red, but there is nothing that expands the notion of Marin's style in the medium. More startling is the pink used against aquamarine in the oil *3 Figures and Sea Shore*, where decorative nudes suddenly appear. At this point Marin's painting definitely stops threatening to retreat into black and white. The six excellent lead-pencil drawings *Pertaining to the Sea* show, however, the reason for this threat. The colorist in Marin has not yet got the complete ascendancy.

*The Nation*, 25 December 1943

# 1944

55. Review of the Whitney Annual and the Exhibition
*Romantic Painting in America*

American art, like American literature, seems to be in retreat at
the moment. This year's Whitney Annual (at the Whitney Mu-
seum of American Art) is more disheartening than ever. It
hardly matters that some of the work shown was executed sev-
eral years ago; the dominant note is of 1943. There is evident a
general softening up, a relaxation into the appealing and the
meretricious, and a fatigue that is particularly visible in the ab-
stract section. The impulse to the exploration of form, some
people say, is exhausted. The collective showing abstract art
makes at the Whitney, its pursuit of safe effects, might tempt
one to believe this if it were not that the other varieties of art
present, for all their advantages of quicker surface pleasure, are
even less interesting and hopeful. Just as naturalism at the time
of the Bellinis in Venice was the only tendency which promised a
future to painting, in spite of the wonderful sideshows staged by
Carpaccio and Crivelli, so abstract art today is the only stream
that flows toward an ocean. It is the only mode by which paint-
ers and sculptors can still master new experience; it furnishes the
only profoundly original contemporary art; and the three best
things at the Whitney are a piece of cast-iron and bronze sculp-
ture by David Smith which obliterates almost everything else in
the sculpture court, a pencil and crayon drawing by Arshile
Gorky, and a Marin water color—the first two entirely abstract
in feeling. These works, along with the limited successes that
are a seascape by Feininger in oil, a snow landscape of Martyl's,
also in oil, and Minna Harkavy's cast stone figure, help redeem
the mediocrities, brilliant, spurious, and otherwise, which sur-
round them. As usual, everybody shows a high level of compe-
tence, everybody is learned in the excellences of the past, but a

community of excitement and ambition and a real richness of culture are missing.

The show of *Romantic Painting in America* now at the Museum of Modern Art harmonizes beautifully with last year's *American Realists and Magic Realists* exhibited at the same place. One sings alto to the other's bass, but the tune is the same. Both are phases of that campaign against modern art which began ambiguously among the surrealists twenty years ago, affirmed itself in the neo-romanticism of Christian Bérard, Tchelitchew, and the Bermans, and is now beginning to celebrate a triumph, such as it is, in New York and California during a period in which dry bones are being reclad with flesh, corpses resuscitated, and illusions revived by our failing nerves in every field of endeavor. It is the fag end of a boring, very great, and violent war. The superficial, true, and damning interpretations of these phenomena will all be made. But the most searching interpretations will also furnish apologies for them. Dali, who was really the baptizing John of the neo-baroque and the neo-romantic—Chirico being its unconscious Isaiah—felt that modern art isolated him from society, to which he wanted and wants very much to belong, and whose attention he needs no less than its money. The neo-romantics, surrealists, and others who took their cue from him and returned to the academic may have been impelled by the same motives—certainly their painting is the first "modern" art to have become a social success on the spot—but underneath, I feel, was also a yearning to put their art into a more explicit relation with the rest of their lives than post-cubist painting and sculpture seem to allow. Cubism, or abstract art, gives the artist no room to express his *immediate* feelings about sex, for instance. They must first be transposed. It is impatience with the thought and feeling involved in the transposition of the aesthetic to and from the rest of experience that leads the Museum of Modern Art, or James Thrall Soby, to exclude the possibility that post-cubist art can be as "romantic" as anything else. The question is whether one is really interested in making "romanticism" actual and not merely a ribbon to decorate nostalgia for the academic. I think we all have that nostalgia more or less, but it should not obscure a truth which does not ask too much patience and reflection to feel and discover: namely that Picasso, Miró, Braque, Arp, Lipchitz, Brancusi, the "inhuman" Mondrian, and the "in-

tellectual" Gris have given the "romantic" as well as the "classi-
cal" aspects of contemporary life their most intrinsic expression
in visual art.

The latest "romantic" revival in paintings—paralleled by a
curiously similar revival among the younger poets in England
and a new interest there in Pre-Raphaelism and the literary as-
pects of painting in general—stands historical romanticism on
its head. For it does not revolt against authority and constraints,
but tries to establish a new version of security and order. The
"imagination" it favors seems conservative and constant as
against the "reason" it opposes, which is restless, disturbing,
ever locked in struggles with the problematical. "Reason" leads
to convictions, activity, politics, adventure: "imagination" to
sentiment, pleasure, and certainties. The new "romanticism"
gives up experiment and the assimilation of new experience in
the hope of bringing art back to society, which has itself been
"romantic" for quite a while in its hunger for immediate emo-
tion and familiar forms. A nostalgia is felt for a harmony which
can be found only in the past—and which the very technical
achievements of past art seem to assure.

Hence the inevitable charm which, for example, the nine-
teenth-century American landscapes at the "Romantic" exhibi-
tion have for us. Their singleness of view, their obvious but self-
contained emotion make them more enjoyable at first glance
than the contemporary pictures, which, despite greater force in
many instances, seem fragments by comparison, organized on
only one level.

The new "romantics" and the neo-romantics, American and
otherwise, look to the past for qualities of sentiment and for for-
mal schemes by which to assure the unity and effect of their
paintings. They borrow certain innovations of pre-cubist mod-
ern art—free brushwork, high color keys—only to subordinate
them to the methods and moods of mannerist, baroque, Ger-
man and French romantic painting. The result is art of a deca-
dent flavor. Only the relinquishing of the effort to conquer new
experience makes possible these seductive harmonies of paint
and sentiment. Here are the limited objectives of a safe world,
where we all understand each other because we have agreed to
banish disturbing questions or are no longer capable of recog-
nizing them; a wistful art that confirms our reluctance to take

risks. (Such refusal of new impressions and influences is a characteristic moment of every decadence. Though one keeps on looking for new sensations, they must all be of the same order.) There are thrills, of course—but never upsetting ones. It is art that has the shock of the fashionable: it creates unconventional effects by conventional means. The diabetic colors are sex; the careful handling is anal, represents money and the unwillingness to spend it on anything but pleasure. Sex and money are the two indisputable and perhaps the only exciting facts we have left. Yet this painting is not altogether to be despised; for it has inherent interest as phenomena, and in some cases its creators are extremely gifted. (See Walter Stuempfig's show at Durlacher Brothers.) And I say they know what they are doing. They have renounced the adventures and gambles of modern art. They want to be loved in a hurry. And they are. They sell well.

It should be added that relatively few of the contemporary American "romantics" at the Museum of Modern Art's show belong to the above manifestation. The "fantasists" Graves and Fett are akin to Klee and Masson; while such painters as Mattson, De Martini, Weber, Blanch, Bohrod, Karfiol, Evergood, and Palmer go back to French painting before cubism and recapitulate it in American terms, sometimes calling on the aid of Ryder or expressionism. Each has made a contribution, usually in landscape. It would be wrong to sneer at them because they lack power or are not quite up to date either as experimenters or "romantics." The fault most of them share is a narrowness of intention that compels them to repeat themselves after a certain point, and with repetition they degenerate woefully, woefully, into sweet effects. (A case in point is Bohrod's late show at the Associated American Artists.) The main reason I can see for Mr. Soby's insistence on their "romanticism" is that they never got too closely involved with anything later than fauvism or German expressionism. Weber and Evergood are perhaps the only exceptions.

*The Nation*, 1 January 1944

Technically one of the most gifted of all painters, Derain has always suffered from a bad character. His technical accomplishment is not merely a matter of dexterity: it is so solid and profound that it assimilates to itself some of the traits associated with genius. The Chardinesque frying pan in the 1939 *Still Life with Fish* (in the show of his work at the Pierre Matisse Gallery) is painted with what I can only call a purchase on the resources of his medium that no painter of the age can match. Yet the picture as a whole suffers from a heavy matter-of-factness, a numbness, which converts it into a controlled demonstration of Derain's prowess and a maneuver of his vanity. It fails to impress one as an end in itself. But tradition can at times humble Derain by the accumulation of its great examples and force him to paint on his knees in spite of himself. And certain mysterious aspects of nature quell his ego. His forest interiors, with their green-yellow gloom and scaffolding of brown tree boles, where light becomes one solid among others, show the artist *mis à nu*. The theme compels him to measure himself frankly against the past and to confess how much his art lacks the completeness which can only be attained by an infinity for reverberations. Derain's natural bent is toward an art rationally founded, breathing the sentiment of a space defined by massive forms and impermeable surfaces, all organized in a clear, logical system. His most valid feeling is what might be termed the sentimentality of materialism, which Courbet had too. On the other hand, when he mistakingly follows the example of Cézanne, who ventured into a sphere where Cartesian logic and Newtonian physics cannot operate, Derain betrays his disorientation by his failure to concern himself with more than mere surface. His obtuseness is exposed by the very brilliance with which he achieves just what he has set out to do and no more. See the big brittle landscape called *Valley of the Lot at Vers*, painted in 1912. As for Derain's portrait heads, much that is good in them is smothered by the ambition to contrive a new thrill out of the solid and the chic.

Derain's place in modern painting, as well as that of Vlaminck and Dunoyer de Segonzac, has never been fixed satisfactorily. I think it can be said that all three of them are revising the academic or traditional in terms of some of the discoveries made by

Cézanne. Abandoning the expanded color ranges they handled while Fauves, though retaining the higher color keys, they go back to the unity of tone of the old masters, whose range of values—or darks and lights—far exceeded their range of color intensities. The gradual transitions from value to value which were axiomatic for the old masters and expressed their sense of the unity of life are replaced by abrupt contrasts and broader and flatter definitions of values—which give the modern sense of the disunity of life and the superior unity of art. For modern art is able, apparently, to reconcile the most violent contrasts, something that politics, philosophy, and religion have been incapable of doing lately. Derain, Vlaminck, and Segonzac are thoroughgoing conservatives in every respect except their art, and even there they are not by any means radicals. The narrowness of their palettes manifests their concern with unity and order. Their painterly virtues lie in the manipulation of values, not of color. They may flavor their painting occasionally with a pinch of intenser color—Vlaminck being the most daring in that he imposes his system of values over two or three intense colors and sometimes even expresses value by intensity—but essentially, they are what can be called, for lack of better terms, "tonalists."

*The Nation*, 22 January 1944

## 57. Under Forty: A Symposium on American Literature and the Younger Generation of American Jews

This writer[1] has no more of a conscious position toward his Jewish heritage than the average American Jew—which is to say,

---

1. The editors of *Contemporary Jewish Record* asked contributors to the symposium to respond to the following questions: "Has the writer formed a conscious attitude toward his [Jewish] heritage or does he merely 'reflect' it in a passive, haphazard, and largely unconscious fashion? Is there any valid sense in which one can speak of differences between the work of Jews and non-Jews—differences possibly relating to both the choice of literary material and to the imaginative use made of it? Are there certain themes or ideas that are characteristic of modern literature as a whole but toward which the Jew is more responsive, or responsive in a somewhat different way, than his Christian colleagues? Lastly, to what extent, and in what manner, has his awareness of his

hardly any. Perhaps he has even less than that. His father and mother repudiated a good deal of the Jewish heritage for him in advance by becoming free-thinking socialists who maintained only their Yiddish, certain vestiges of folk life in the Pale, and an insistence upon specifying themselves as Jews—i.e., to change one's name because it is too Jewish is shameful. Nevertheless the reflection in my writing of the Jewish heritage—is *heritage* the right word?—though it may be passive and unconscious, is certainly not haphazard. I believe that a quality of Jewishness is present in every word I write, as it is in almost every word of every other contemporary American Jewish writer. It may be said that this quality derives from a heritage and not from a racial psychology, but it is very informal, being transmitted mostly through mother's milk and the habits and talk of the family.

The differences between the work of Jewish and non-Jewish writers can be attributed in part to the Jewish past and in part to the contemporary Jewish plight. There is a Jewish bias toward the abstract, the tendency to conceptualize as much as possible, and then there is a certain *Schwärmerei*, a state of perpetual and exalted surprise—sometimes disgust—at the sensuous and sentimental data of existence which others take for granted. This is probably connected with the Jew's chronic conception of himself as a wanderer even when he has lived in the same place all his life. But this is not too specifically Jewish, as Saroyan, an Armenian, outdoes any Jew in this vein. Centuries of existence as an insecure minority make people conceive of themselves as always coming into the world from outside it.

It is difficult to separate the Jewish plight from the Jewish past, but there are certain differences between the work of Jewish and non-Jewish writers in this country which arise almost entirely from the situation of Jews in America here and now. American Jewish novelists and poets have in common their preoccupation with the autobiographical. Again and again they de-

---

position as artist and citizen been modified or changed by the revival of anti-Semitism as a powerful force in the political history of our time?" Other contributors to the symposium were Muriel Rukeyser, Alfred Kazin, Delmore Schwartz, Lionel Trilling, Ben Field, Louis Kronenberger, Albert Halper, Howard Fast, David Daiches, and Isaac Rosenfeld. [Editor's note]

scribe escapes or, better, flights, from the restriction or squalor of the Brooklyns and Bronxes to the wide open world which rewards the successful fugitive with space, importance, and wealth. Sometimes it is flight from loneliness into identification with a cause. Flight—as well as its converse, pursuit—is of course a great American theme, but the Jewish writer sets himself off by the more concerned and more immediately and materially personal way he treats it. His writing becomes essentially a career which provides him with the means of flight. "This writing is my wings away." It is for this reason that the American Jewish writer is so reluctant to surrender himself to a truly personal relation with an objective theme. His personal relation is to the success of his writing; the writing becomes almost altogether a way of coping with the world. All writing is that to a certain extent, but there is a limit which is overstepped by the Jewish writer. He is too open to the corruption of success. It is characteristic of American writers in general to suffer this liability, but again, the Jewish writer is forced to the crux of the problem by the greater social pressure upon him. He is unable to withhold himself from the need and the temptation to prove himself in every possible social direction. His real need, of course, is a greater feeling of integration with society, which will by the inevitable antithesis make him less dependent upon its approbation and rewards. I do not believe this will be possible for him except under socialism. Thus his plight becomes like every other plight today, a version of the alienation of man under capitalism; all plights merge, and that of the Jew has become less particular because it turns more and more into an intensified expression of a general one.

The problem of integration as solved by the non-writing Jew in this country—and some sort of solution it is—only adds to the difficulties of the writing Jew. Jewish life in America has become, *for reasons of security,* so solidly, so rigidly, restrictedly and suffocatingly middle-class that behavior within it is a pattern from which personality can deviate in only a mechanical and hardly ever in a temperamental sense. It is a way of life that clings even to those who escape from it in their opinions and vocations. No people on earth are more correct, more staid, more provincial, more commonplace, more inexperienced; none observe more strictly the letter of every code that is respectable;

no people do so completely and habitually what is expected of them: doctor, lawyer, dentist, businessman, school teacher, etc., etc. (The fault is not theirs but that is immaterial for the moment.) The reaction of the unexceptionable Jew to the exceptions proves how exceptional these are. The result of this situation, paradoxically, is to increase further the pervasiveness of the autobiographical in American Jewish writing. The Jewish writer suffers from the unavailability of a sufficient variety of observed experience. He is forced to write, if he is serious, the way the pelican feeds its young, striking his own breast to draw the blood of his theme. (This is perhaps responsible for the exhibitionism in so much American Jewish writing.)

Such are the liabilities of the American Jewish writer. His assets lie mostly in an area that has a direct relation to himself but only an indirect one to his writing. The Jew has at least a way of life, a code of behavior, a felt if not conscious standard to which he conforms and which protects him from the ravages of Bohemianism. The trouble is, as I have indicated, that this code is too utterly middle-class to inform the Jewish writer's attitude to what he writes about. He is hard put to justify it to himself, much less criticize society in its terms. The Jew hangs on to it because as the member of a minority under hostile pressure he requires it for the struggle.

*Contemporary Jewish Record*, February 1944

58. Review of *Napoleon III: An Interpretation* by Albert Guérard

This rehabilitation job is part of the ransacking of the past now going on among sedentary people who look for some scheme to insure the future against class warfare. Mr. Guérard, like the late Ferrero and others, feels enough responsibility to go back no further than the nineteenth century. But it is not only because he is afraid and because he has no serious capacity in political social matters that he goes to the past. He is also penetrated by an unconfessed nostalgia for the attractive culture of the Second Empire, and he would have done better to have admitted it.

Marx and many others called Napoleon III a horse-thief, loafer, swindler, roué, and what not. But Mr. Guérard says that "Within the last fifty years, Napoleon III has won the respect and sympathy of practically every critical historian. . . . He was a better European than Bismarck or Gambetta, and a better socialist than Karl Marx, because he was less narrow than they and not poisoned with hatred and pride." I wish some of these critical historians had been quoted. Anyhow, Napoleon III stood for "Caesarian" or "direct" democracy—the will of the majority of the people expressed directly through a single individual for "Romantic Humanitarianism"—he was a Saint-Simonian Socialist—and for the principle of nationalities—he wanted Poland to be independent.

The facts that Mr. Guérard himself cannot help mentioning refute these assertions so utterly that it becomes almost of greater interest to discover the source of these hallucinations in his own mind than to investigate the evidence. What made Mr. Guérard think it possible to accept Napoleon on his own say-so, which is what his vindication amounts to?

Political meetings were banned under the Second Empire until almost the last. But Napoleon III did represent the interests of the numerical majority of Frenchmen during most of his reign. That much of Mr. Guérard's interpretation is true—but it is still far from making a democrat of Napoleon *le petit*, for he never believed in *rule* by the people, which is what democracy means. The most numerous class in French society was and still is the peasants and small proprietors, who enjoyed order and security under the Second Empire. They were Napoleon's basis, but what energy his regime manifested came from the financial aristocracy and the rising industrial entrepreneurs, the latter of whom were guaranteed freedom from interference and given access to the credit so essential to their ventures. This was Napoleon III's "Saint-Simonism." Meanwhile the working class was being sat on so that capital could be accumulated from its hide. Here indeed is the historical logic of Napoleon III's career. The unrest among the proletariat in France and England during the first half of the nineteenth century did not represent socialist aspirations so much as it did resistance to the bitter exploitation compelled by young industrialism's need to accumulate capital for its expansion. England controlled the situation, after 1850,

by a mixture of main force and concessions, the means to the latter coming from imperial prosperity.

Napoleon III was the answer in France's case; and he did provide a temporary solution that enabled economic life to flourish and industrialism to get on its feet without interference from the "ground." French capitalism required a dictatorial regime at that moment because the liberal bourgeoisie of 1848, by calling for the aid of the proletariat, had set loose something they could no longer control. Certainly nothing in all this demonstrates Napoleon III to have been anything other than what he is generally termed: an opportunist adventurer whose chief aim was power and who ingratiated himself with the forces in society best able to assure it to him. His career until 1848 seems to have been designed to form just such a man; and only such a man could have exploited the political impasse French society had reached by the middle of the last century.

Mr. Guérard's reasons for calling Napoleon a socialist are that he himself said he was one, that he wrote a pamphlet advocating work relief for the unemployed, that he deplored poverty, and that he was first and above all for order—and "the first step toward Socialism is the restoration of order." In addition to this Napoleon encouraged cooperatives in a mild way and in the sixteenth year of his rule abrogated an article requiring courts to accept the word of an employer against that of an employee. In the same year trade unions began to be "tolerated." Mr. Guérard's conception of socialism can be excused only by referring to the general idiocy of these times. Yet it is a hopeful sign that he finds it so necessary to attach socialism to his hero—cost what it may in intellectual circles.

The heart of Mr. Guérard's apology is that Napoleon III, with his kindly personality and good intentions, had everything settled correctly in theory and is not to be blamed if application always turned his theory into its opposite. But why go on? The value of Mr. Guérard's book is symptomatic, and only that. It offers the case of a respectable American liberal apologizing for the "right" kind of totalitarianism and offering it as a contemporary program. It is also symptomatic of the present state of political discussion that political illiteracy such as Mr. Guérard's can find the confidence to write a book and offer a program. The program, I should hasten to say, is offered to France, not to us.

Mr. Guérard writes in his closing chapter: "It might be well for France, when she resumes the normal course of her destiny, to borrow her inspiration from the United States rather than from England. If she did so, the Constitution of 1852 would be for her a better starting point than the Constitution of 1875. And she would be fortunate indeed if she found again, under such a regime, a leader with the unfailing gentleness, the quiet intellectual courage, the profound generosity, of Napoleon III." The Constitution of 1852, according to Mr. Guérard himself, puts autocratic power, both legislative and executive—far, far more than the American president wields—into the hands of the chief of state, and reduces deliberative bodies to impotent symposia. Such a regime is to defend "collective domestic security" and be the "greatest common denominator of all private interests. . . . Automatically it will be devoted to the welfare of the most numerous class, which is also the poorest." And "it is the business of the state to prevent famine, but not to provide luxuries." All this and heaven too, for Napoleon III was also a religious man. If only capitalism weren't around.

*Politics*, February 1944

59. The Federation of Modern Painters and Sculptors and the Museum of Modern Art

The Federation of Modern Painters and Sculptors is an organization that includes a good many of the most advanced and important artists in this country. Early in January the federation released to the press a letter attacking the Museum of Modern Art and pointing out the "increasingly reactionary policies of that institution toward the work of American artists." The letter specifically criticized the museum for its exhibition of "works rightly considered academic and outmoded even in the Victorian era" (for example, *Romanticism in America* and *American Realists and Magic Realists*); for its displays of material "interesting only on scientific and ethnographical grounds"; for the adopting "one set of standards for . . . European art . . . and a thoroughly different one for its American selections"; for its policy

of sacrificing "seriousness of purpose for publicity" (the *Contemporary Portraits* exhibition); and for its interest in "such ephemeral fads as the output of certain refugee-surrealists and types of American scene-illustration, [which] have been exaggerated out of all proportion to their qualities as art." The letter went on to call for an exhibition of the museum's entire permanent collection, "which presumably represents the considered judgment of the staff," and to ask that "the museum indicate more openly the individuals or groups who are most directly responsible for its recent policies."

On January 20 the Museum of Modern Art's Department of Painting and Sculpture sent a letter, with a self-addressed postcard inclosed, to a selected group of seventy members of the federation, asking that the recipient indicate on the card whether or not he or she had seen the federation's letter before it was mailed. The card did not seem to require a signature, and the assurance was given that "this information . . . will be used only for a report to a museum committee."

That the museum's first reaction to the federation's letter was to make it an issue of personalities is saddening—aside from the questionable taste of its procedure, which seems to derive from the Stalinist telephone-pressure campaigns of a few years ago. It is possible, but quite irrelevant, that some members of the federation call the museum's grapes sour mainly because the museum has not shown their work. But charges similar to those in the letter have been leveled against that institution by persons whose motives cannot be similarly impugned. Nor would the charges be invalidated could it be proved that a majority of the federation's membership had not seen the letter before it was released. The museum should have felt it imperative to answer the criticism on the same plane as that on which it was formulated. If the federation is wrong, a point-by-point rebuttal would reinforce the museum's position and, even more important, promote a discussion that might help clarify very important issues at stake in contemporary American art. Alas, the federation is not wrong, even though it failed to make some necessary distinctions.

The function of a museum of *modern* art is to discriminate and support those tendencies in art which are specifically and validly modern, regardless of general appeal or vogue. Both the golden

and the silver ages of modern art are over, seemingly—at least in Paris—and those forced in the past by the vitality of modern art to censor their dissatisfaction with it have begun to come out into the open again. The presumably enlightened rich, who support art in this country as in every other, have relapsed into self-indulgence; their aesthetically ascetic period is past. With no young Picassos in sight they have found the courage to ask once more for the kind of art they really like: "Give us the romantic, the realistic, the descriptive, the immediately erotic, and the chic. It fits us better, mirrors us better, and moves us quicker. Since we pay for art, we have a right to the kind we want." The recent policies of the museum reflect not so much the increasing strength of this element as an enormous gain in its self-confidence—it has always been strong, and its contributions have kept the museum alive from the beginning. If its influence is unchecked, it will finish by making the Museum of Modern Art an educational annex to the Stork Club.

*The Nation*, 12 February 1944

## 60. Thurber's Creatures: Review of *Men, Women and Dogs* by James Thurber

The cartoon began as a reprover and corrector of mankind. For the liberties which it takes with the human form I think two things are largely responsible: the breakdown of the Renaissance conception of the personality and industrialism's mutilation of man. Being the first to witness the latter development, the English produced in Hogarth and Rowlandson the first great cartoonists. Thurber, another Anglo-Saxon, continues in his own minor way the criticism of humanity and society which they began.

Thurber's cartoons express the shamed amusement at itself of our literate middle class, with its frustration and boredom, its inability to be spontaneous except when drunk, its impersonal energy, and its desperate, sociable aggressiveness. The incompleteness of his creatures grows out of their surrender to simultaneous environmental and internal pressure which squeezes to the surface the unattractiveness that is inside us all. There it

clamors for love, attention, and excitement—and the less we get the more we want, being the neurotics we are. "Please let every moment be an adventure." The convulsive passes Thurber's creatures make at one another, their bursts of violence, exhibitionism, and irrelevance express the profoundest dissatisfaction with contemporary experience and, by inference, with society.

Thurber, whether he knows it or not, aims at a specific class—the people who read reviews like this and find or might find that the *New Yorker* satisfies a need. Humanity in general is not an issue.

The deepest emotion we receive from Thurber's drawing involves our lack of any desire to have his creatures actually exist, as, say, we might want Mutt and Jeff to. It is a part of our reaction to neurotics and neuroses—which in our time seem the only things capable of compromising human beings in their very essence, as sin once could. And then Thurber's art itself does not *do* enough. To a drawing by Rowlandson, you can say that only part of you is like that; the art itself shows how much of the hopeful is still left to be said. But seeing yourself reflected in a Thurber drawing, you are forced to admit that accidental resemblances are disastrous; if you are in any way like that you are hopelessly compromised. The fact is that Thurber is not good enough to take us out of the plight in which he finds us. The great defect of any humor less than first-rate is to define our limitations without by that very art transcending them. The only world it knows is the one you never made—whereas first-rate humor avows that everything can be converted into consciousness and the world become thereby one of our own making. Of course, the fault is only partly Thurber's. In Rowlandson's time it was still possible to conceive of an attainable way of life possessing dignity and interest. Today we can scarcely even dream of one.

*The Nation*, 26 February 1944

61. Letter to the Editor of *Politics*

Sir:
Louis Clair is too quick to dismiss the hopes some radicals derive from the prospect of industrialization and agrarian revolution in

Eastern Europe under Stalin's aegis.[1] "What value," he asks, "is attached to technical and economic development if it is coupled with the physical destruction of all progressive independent forces, if it is linked with a reaction throwing culture back beyond the period of the Enlightenment?" I hope no one will accuse me of being a Stalinist sympathizer if I remark that the problem is not quite as simple as that. It demands some of the unpleasantly bloodless thinking which is obligatory for Marxists.

Industrialization and agrarian revolution in Eastern Europe would inevitably raise production—whether for consumers' goods or military purposes. If enough of production were devoted to the former, the standard of living would rise, and politics and culture would eventually be liberalized. This flows from a Marxist tenet by which all liberalism in social relations is historically explained. (Or will it be claimed that liberalism reflects the free market relations of pre-monopoly capitalism?) It seems to me that to contradict this tenet is to assert the compelling force of inherent evil and omnipotence of the past. And to maintain that nothing good can conceivably come of Stalinism amounts to the same thing.

Marxism asserts that men oppress each other when there are not enough goods to go around, and those who possess find it necessary to protect their possessions and their exploitative means of acquiring them from those who do not possess. There is no oppression in some primitive societies because the means of production are so elementary that no individual's labor can be spared, or because the material level of culture is so low that the exploiters require a relatively small share of social labor power to satisfy their demands.

The question Mr. Clair ought to have asked is whether or not the industrialization of Eastern Europe would eventually raise its standard of living. This would entail the question of the stability of international relations in post-war Europe: will the demands of armament deflect too much production from consumers' goods? Or will the exploitative accumulation of capital goods that industrialization and reconstructon make necessary tend to keep the standard of living down for too long a period?

1. This letter is part of a correspondence arising out of Louis Clair's article "Stalin's Policy in Europe" (*Politics*, February 1944). [Editor's note]

On the other hand, is there a possibility that an increase in production and productivity, coupled with the slackening of foreign danger, may release the socialist tendencies which Trotsky said lay locked in Soviet economy? Will the absence of the profit motive be enough to cause the bureaucracy to disappear, once there is plenty? Or will its violent overthrow still be necessary?

Of course, Stalin will muzzle, imprison, or execute all bona fide working-class leaders and liberals in any country he gets control of. Such would be the immediate cost of Stalinism to Eastern Europe, as it has been and still is to Russia itself. But is it too heartless to hazard that this sacrifice may be redeemed by historical forces which Stalin himself may set in motion and be powerless to control for his own ends?

There are no certain answers to any of these questions, but one should at least be aware of them in undertaking to speculate, as Mr. Clair does, on Stalin's post-war policy.

<div align="right">Clement Greenberg<br>New York City</div>

*Politics*, March 1944

## 62.  Obituary of Mondrian

Piet Mondrian, the great Dutch painter, died in New York on February 1 at the age of seventy-one. He came to this country two years ago from London, where he had been living since 1939, after twenty years spent in France.

Mondrian was the only artist to carry to their ultimate and inevitable conclusions those basic tendencies of recent Western painting which cubism defined and isolated. His art has influenced design and architecture more immediately than painting but remains easel painting nevertheless, with all the concentrated force and drama the form requires. At the same time it designates the farthest limit of easel painting. Those whose point of departure is where Mondrian left off will no longer be easel painters. Excluding everything but flat, unmodulated areas of primary color and rectilinear and rectangular forms, his art returns painting to the mural—the mural as a living,

modern form, to the archaeological reconstruction of Puvis de Chavannes, Rivera, and the WPA projects. I am not sure whether Mondrian himself recognized it, but the final intention of his work is to expand painting into the décor of the man-made world—what of it we see, move in, and handle. This means imposing a style on industry, and thus adumbrates the most ambitious program a single art has ever ventured upon.

Mondrian's own explicit intentions were somewhat different. There is no need to take his metaphysics on its own terms, but it certainly helps us to understand the creation of his masterpieces. He said that his art was concerned with man's deliverance from "time and subjective vision which veil the true reality"—I quote from his essay "Toward the True Vision of Reality."

> Plastic art affirms that equilibrium can only be established
> through the balance of unequal but equivalent oppositions.
> The clarification of equilibrium through plastic art is of great
> importance for humanity. It reveals that although human life
> in time is doomed to disequilibrium, notwithstanding this, it
> is based on equilibrium. . . . If we cannot free ourselves, we
> can free our *vision*.

Mondrian's pictures attempt to balance unequal forces: for example, one area, smaller than another, is made equivalent by shape and spatial relations. Further:

> At the moment, there is no need for art to create a reality of
> imagination based on appearances, events, or traditions. Art
> should not follow the intuitions relating to our life in time,
> but only those intuitions relating to true reality.

In other words, the vision of space granted by plastic art is a refuge from the tragic vicissitudes of time. Abstract painting and sculpture are set over against music, the abstract art of time in which we take refuge from the resistance of space.

Mondrian's painting, however, takes its place beside the greatest art through virtues not involved in his metaphysics. His pictures, with their white grounds, straight black lines, and opposed rectangles of pure color, are no longer windows in the wall but islands radiating clarity, harmony, and grandeur—passion mastered and cooled, a difficult struggle resolved, unity imposed on diversity. Space outside them is transformed by their

presence. Perhaps Mondrian will be reproached for the anonymity with which he strove for the ruled precision of the geometer and the machine in executing his paintings: their conceptions can be communicated by a set of specifications and dimensions, sight unseen, and realized by a draftsman. But so could the conception of the Parthenon. The artist's signature is not everything.

Mondrian was of the type of artist-hero who immolates himself for his work, sacrificing the customary amenities of life, or making his art carry desires frustrated in other directions. He never married—he expressed a desire to but complained that he could not afford it—and he seems to have had few friends. He gave the impression of being inarticulate in conversation, and said once that he preferred not to argue about the problems of art *viva voce* but to read and write about them. His appearance was as dry and ascetic as a superficial acquaintance with his work might lead one to expect. But there were in both the artist and the art an intensity and passion which it needed only a second glance to discover. His one great diversion, surprisingly or not, was dancing, and I am told that he liked it so much that he often danced by himself in the studio.

*The Nation*, 4 March 1944

63.   Review of *Great American Paintings: From
       Smibert to Bellows, 1729–1924* by John Walker
       and Macgill James

The twenty-page introduction to this book of fine black-and-white reproductions (the few in color are of uncertain quality and mar the effect of the whole) provides a résumé of the history of American painting that is all the more illuminating because it is biased. The main line, the authors say, has been a particularly uncompromising and native kind of realism. Consequently, the early Copley, Stuart, Sully, Homer, Eakins, and Bellows are allotted the greatest space, while Whistler, Cassatt, and Sargent are the only non-realists in this sense to receive more than two plates each. And of course, Ryder. But Blakelock is not repre-

sented at all, nor Newman, nor the Hudson River and the pan-
oramic schools. And only one of Washington Allston's canvases is
reproduced. The authors push their thesis a little too far.

[Unsigned]

*The Nation*, 21 March 1944

64.   War and the Intellectual: Review of *War Diary*
      by Jean Malaquais

The book could have been published at this moment only be-
cause the army in which Malaquais served is out of the fighting.
Its great novelty is that it is the product of a contemporary con-
sciousness, one of the few of this kind to appear in recent years
—which accounts for its cogency, sharpness, and most probably
for the strong reactions it has aroused. Malaquais is contempo-
rary because he is alienated, disabused, radical, and ambitious.
For someone—like myself—who has served in a latter-day
army, his book rings bells, is the first piece of writing I know of
(except for some of Randall Jarrell's recent poems) to say any-
thing to the point about behind-the-lines military life during
World War II.

Beginning his diary, Malaquais seems to have made a Gidean
resolution to be sincere: he would put down whatever he hap-
pened to think and feel, regardless of how it would look to a
second person. He is well aware—as some reviewers have failed
to realize—that certain of his reactions are priggish. And if
many of his generalizations sound jejune, it is because the efforts
of an amateur at philosophy to lift himself above an unpleasant
situation by making philosophy out of it cannot but result in the
jejune. He should be excused when he writes: "To say of life that
it is the breast of a young girl, pointed toward the sky. That you
have the right to be inebriated with life, to the ultimate ecstasy."
He also writes: "I don't give a rap for 'accumulated experience.'
This lost time will never, never, be regained."

An intellectual with subversive notions, you are put into mo-
bile confinement together with a conglomeration of males under
the assumption that the purpose of the confinement transcends

all personal considerations. If the assumption is not acted on, brute force admonishes. Since you are cynical about the end being served by the confinement, you find that everything that happens to you and that you do in your official capacity as an inmate is irrelevant when not repugnant. It is worse for you than for the others because your vocation is a personal concern, you have sacrificed in order to make it so, while the others have allowed themselves to be at the disposal of the necessity of making a living. This is not snobbery. All of us are paying for our failure to be revolutionary and socialist, to take our lives in our own hands. The war itself is one of the forms of that payment. But at the same time your principles make you liable to certain exalted sentiments: solidarity with your fellow men, the sharing of their fate, etc., etc. Malaquais found himself in an engineers' battalion along with a bunch of peasants whose conduct startled him into a new realization of how abject, dirty, and trivial human beings could be. There were also the ignominious details of routine and the incompetence and posturing of those in authority. You believe in the dignity of man and in his capacity to control his own fate. "That nothing, nothing, not man nor beast nor god, should be able to dispose of your life, except yourself." Your own life has been a struggle to make yourself do in the first place only what is relevant to yourself as the particular human being you are. You try to be conscious, to put yourself beyond the mercy of the petty detail, you don't fight for your place in line or quarrel as to whose turn it is to sweep the floor. But all around you you see men refuting every claim you make for them: insentient, foul, rude, servile, petty and obtrusive. Soon, your most anxious concern becomes to save yourself from the community of degradation and drabness which every person and every circumstance try to foist on you. You are willing to go through the same hardships—but only alone, for the mass of your fellow soldiers seem to vitiate every purpose you extract from the hardships. Contemplating them, smelling and hearing them, you fall into the sentimentality, perhaps true, of thinking what a sad thing a human being is. You desire to evolve, personally, into a new species.

You wince, hearing a man tell the barracks what he did with his wife while on furlough, not at the details so much as at the shamelessness and at what the exhibitionism typifies. You also

mind it because you must go on hearing it without choice, because you cannot separate yourself sufficiently, and because it is not impossible that you may descend to the same level. Of course this is priggish, but how else are you going to react?

Malaquais anticipates the objection. Though congenitally a lonely character, he is enough a product of the generation of Hemingway, Stalinism, MacOrlan, Malraux, and Jean Gabin to feel the categorical imperative to be tough and regular. He worries about his inability to get along with his fellows, who persecute him mildly and accidentally because he cannot keep himself from remonstrating with them. Derisively, they call him "the aristocrat." On November 4th, 1939, he writes in his diary: "A. G. [presumably André Gide, with whom Malaquais is on close terms] tells me that I ought to practice evasion. Compromise. Try to adapt myself to them. Dissimulate. Avoid head-on collisions. Play my subtlest game of wits with people for whom subtlety is a dead letter. All of which, after all, I am radically incapable of doing. Ah, these great men, these dispensers of counsel—why don't they begin with themselves?" Malaquais fails to solve the problem to his own satisfaction, takes refuge in bouts of verbose and pretentious philosophizing. But later, when the actual fighting begins, he breaks out of his isolation by showing himself to be more enterprising and comradely than the average under fire. From then on his diary becomes like any other war book, his reactions as correct as any book-reviewer could desire. Not that this is stated explicitly. For all his conceit, Malaquais does not dream of dramatizing himself in the face of danger.

His experience posed under what were almost laboratory conditions the problem of the right attitude towards his fellow men, in the flesh, of the Marxist who is supposed to love them in the abstract. The conclusions which I would draw from Malaquais's (and my own) experience are rather trite. Man is lovable in the abstract and in the individual but not in the mass. Living together in boredom, men exhibit their lowest common denominator, which in the present state of civilization is usually their raw human animality, the pool of their most elementary demands. On November 30th Malaquais complains: "I wonder whether life in common does not engender some kind of moral virus which has the property of decaying and rotting the indi-

vidual. Because each one of these men taken separately, put back in his own setting, returning to his native soil, his farm, his shop, is what is ordinarily called a 'good egg.' But, as someone said—I've forgotten who—that does not suffice to make a man." The rudeness of Malaquais's peasants—and they were as rude to each other as they were to him—may be ascribed to their lack of culture. They had enough for private life but were unequipped for any sort of communal life. Hegel seems to be right in his contention that one of the aims of culture is to transform the private into the public (Kierkegaard notwithstanding). Another common denominator exists among human beings, a paradoxical one, formed of that in each which is original and private. Culture enables the individual to communicate and appreciate inwardness, and make it objective. Whereas the failure of individuals to express their inwardness converts them into a mass, whereby they are denoted as having in common merely their membership in the human species of animal—or sinner. Malaquais's loneliness stemmed just as much from the absence of those who would have given him more of themselves to understand as from the absence of those who would have understood *him*. (Incidentally, the most surprising revelation in his diary is that the French peasant is just as badly off culturally as the Detroit factory worker.)

*Partisan Review*, Spring 1944

## 65. A Victorian Novel

It is characteristic of the more robust Victorian novelists that they let their scenes and creatures get out of hand. The obvious formal considerations came last for such a writer as Trollope, and he was always ready to sacrifice the planned shape of a work, a loose thing at best, to the resistances and deflections he met in the writing of it. As with Dickens, a character that insisted strongly enough could snatch more than its allotted space from his pen. Thus, by the curious vitality one of its personae arro-

gates to himself, Trollope's *The American Senator* ascends into a realm the author may not have planned to enter. It becomes one of the most interesting novels in English, and that it has received so little recognition as such can only be blamed on its deficiencies of form, rocked as it is from side to side by three intermittent narratives which barely connect with each other in any but a thematic sense—and that sense hard to discern.

The primary and serious narrative is the halting romance—halting, because it takes place, so to speak, in Purgatory—of Reginald Morton and Mary Masters, a Victorian set piece only partly redeemed by its incidentals. Reginald is a studious recluse, son of gentry, embittered for some inadequate reason, chaste, intense, pipe-smoking, Byronic-proud: a Brontë type whom Trollope is not sufficiently interested in to rescue from what was already fictional desuetude. Reginald walks through his part like a dummy. Larry Twentyman, a mildly prosperous young farmer, is desperately in love with Mary, daughter of the town lawyer and compendium of the negative virtues. She prefers Reginald, who is much more romantic, in spite of being forty. For it was improbable in Trollope's time that anyone under the upper middle-class should appear romantic unless he or she were a criminal. But as a character in fiction Larry has all the vitality his rival lacks. He does not have to function as a hero: his difficulties are organic, are not going to be solved by a straightening out of misunderstandings. He is in his fix for good, and the Victorian pathos of that fix is lingered over. Larry suffers in the limbo reserved by the English for those who are not quite gentlemen or ladies nor altogether plebeian either. "There was a little bit of dash about them—just a touch of swagger—which better breeding might have prevented." Reginald objects through clenched teeth to Larry's billycock hat, and the wrong as well as the right people call him by his first name. The real anguish of Larry's hopeless suit is the suspicion that snobbery is at the bottom of his rejection. The author, willing to allow for it but no̅ to admit it, tries to invalidate the suspicion by having Mary's vulgar stepmother voice it comically—and by making Reginald's dead mother the daughter of a Canadian innkeeper, for which reason Reginald himself is a victim of snobbery. But the suspicion only flowers the more; Trollope pours too much independent life into his creatures, and the harangues of Mary's

stepmother are the liveliest speeches in the novel. Trollope really assents to the snobbery and knows that his readers do too—not in principle perhaps but certainly in practice, and he was the good novelist he was because he did not allow his principles to deviate too far from practice. The readers know also that another two hundred and fifty pounds a year would have made Larry a gentleman, swagger or no swagger.

The secondary plot, Lady Arabella Trefoil's hunt for a husband within the lists of English social form, takes place in Hell and is the richest vein in the book, as episodes in Hell usually are. It is written with a freer hand, since interclass relations are not involved, only the criticism of an upper class on its own terms. The depravity of European life being for Trollope nothing so esoteric as to be revealed by the stripping away of successive veils, the baseness of the Trefoil family is presented straightforwardly. Trollope was more interested in the phenomenon itself of evil than in the principle at its root. He lacked that horror of the specific sin which functioned for James almost as the shaping rule of fiction. The latter saves the reader from the local experience of evil by transforming its revelation into a cathartic exercise of the aesthetic faculties; such an exercise delivers perhaps more of the force of evil in general. Nothing was remoter from Trollope. In one sense he aimed at corrective criticism of a particular society, in another he assumed the role of a spokesman of accepted opinion. But first and last he was a yea-sayer, a connoisseur of things as they are. It is because of his intense sense of the actual, his avidity for social facts and acts, and because of his feeling for his art, which to him meant substance rather than form, that we can derive a more fundamental criticism of society from his work than he himself seems to have intended.

Nearing thirty and poor for her station, Lady Arabella lives on her social connections. The notions of comfort and prestige inculcated in her by her milieu give her little other alternative than to hunt for a rich and wellborn husband. Trollope would have held her entitled to one, perhaps, if her need were not so desperate. It is hard to tell whether her bad character comes from her need or vice versa. Lady Arabella "rather liked being hated by women and did not want any man to be in love with her—except as far as might be sufficient for the purposes of mar-

riage." Her ambition was to be "one who might be sure to be asked everywhere even by the people who hated her." When she appears on the scene she is engaged to John Morton, a diplomat, squire of Bragton and Reginald's cousin. But catching sight of the sporting Lord Rufford, a more spectacular prize, she changes course and rides into what is eventually a horrible situation. The lord, one of those stupid, successful, and attractive persons all societies find indispensable, almost proposes to Arabella in a moment of exuberance. Her effort to use the rules of Victorian social form to press the lord into accepting the consequences of an actual proposal lead her through a circle in Inferno called humiliation. The moral justice of fiction deprives her of the lord but rewards her for a momentary impulse of pity towards John Morton—who eliminates himself by dying—with an upright and wellborn, if not rich, husband. Thus Arabella's episode, coming under the heading of satirical comedy, ends on an unexpectedly cheerful note.

The morality is of money. One notices that sinners as well as victims in Trollope's novels almost always suffer from financial or social insecurity: they are either the low-born rich or the blue-blooded poor. Their limitations are imposed by society rather than inherent in their natures. And the moral of most of Trollope's fiction is that people should abide by their limitations. (In drafting his novels, Trollope would assign an income in exact figures to most of his characters, as part of their essential definition—and also of the process of making them come alive.)

The character who gets out of hand is the American senator himself, the honorable Elias Gotobed (the name is one of the worst Trollopisms) from the state of "Mickewa," visiting England to study conditions there. The part he plays is peripheral to the two main narratives, and paradoxically, his share of space shrinks even as his abstract importance grows. Yet his story, which conducts us into the Paradise matching the Purgatory and Hell of the other two plots, gives the novel an ambiguity and depth of irony rare in Victorian English fiction. What begins as a standard 19th century caricature of the Yankee swells gradually to a figure of Reason incarnate, stalking and castigating the English land. The senator's twang fades away, his cigar dwindles and finally disappears. At the last all we see is purity and all we hear is logic. The author's attitude to the senator is

highly ambiguous. He seems to have been intended primarily as a mouthpiece for Trollope's own strictures on English society; secondarily as a caricature. But the two aims are in contradiction. Criticism is attributed to the senator with which it is obvious that Trollope does not agree, designed as it is to characterize the senator rather than the objects of his criticism. But it is very difficult to draw the line between this and the criticism with which the author does agree. Thus the criticism as well as the senator's personality attains an objectivity beyond the author's control. The senator may appear a bit simple-minded to those who acquiesce in what seem the necessary anomalies of any social order, but his simple-mindedness is such as to make ridicule pointless and in the end remind the more sophisticated of their own insensitivity.

The senator is qualified to act as the representative American by having his opinions compounded of Jeffersonianism, Abolitionism, Radical-Republicanism, Rationalism, and Utilitarianism, a combination turning out to be much more radical than the author expected. The senator uses such phrases as "the demand for progressive equality which is made by the united voices of suffering mankind," marvels at the docility of the English lower classes, and is reluctant to admit "that one man should be rich and another poor is a necessity in the present imperfect state of civilization. . . ." He is the type of the anti-aesthetic man whose eye is so intently on the ball, on the principle, the universal, that he has become obtuse to all particular instances, moods, shades, tones, and the reactions of the people he talks to. The type can be depressing, but it also compels our respect. Trollope, with his relish for the petty, feels some guilt towards the senator—goes as far as to allow him to attack his own beloved sport of fox-hunting on grounds well-taken. And since fox-hunting can be defended only aesthetically, Trollope can file his rebuttal only by writing two or three hunting scenes.

The senator arouses widespread animosity by his outspoken surprise at the injustices and anomalies of the English social order and by siding with a disreputable farmer in his litigation with Lord Rufford for indemnity for crops eaten by the lord's game pheasants. Finishing his study, which he has carried out with great conscientiousness, he gives a sensational lecture in London at which he tells a distinguished and overflowing audi-

ence just what he has found wrong with England: namely, the irrationality of Englishmen. The audience riots and he is unable to finish. "He had not much above half done yet. There were the lawyers before him, and the Civil Service, and the railways, and the commerce of the country, and the labouring classes." But no matter, he is already apotheosized, and floats high above the rest of the Trollopian world, drawing reluctant admiration from it. By dint of having been consistently exaggerated in one direction, the senator passes beyond the grotesque and reaches the highest seriousness.

His Americanism turns out to be a kind of moral imperialism, quite different from the Americanism of Henry James's pilgrims, who carry their innocence to Europe humbly. But the senator does have a few Jamesian twinges, just to prove that he is not a simple, silly, holy, irrelevant man with no awareness of human susceptibilities. He writes home of his admiration of the "easy grace" and "sweet pleasant voices and soft movements" of English aristocrats, and that there is a "pleasure in associating with those here of the highest mark which I find hard to describe."

The senatorial flourish excepted, the book ends weakly. Reginald discovers that he loves Mary, and they get married—but these two were a dead loss from the beginning. Poor Larry's fate is left in suspension. Lady Arabella goes off to Patagonia with her husband on a minor diplomatic mission. But her story had seemed to be working up to some more exciting denouement, which would have left it ringing in the reader's memory. Patagonia is not enough. In the end only the senator remains. Trollope's inferiority to Dickens lies in his surplus of realism, in that satisfaction with "the normal machinery of experience" of which Sadleir, his biographer, approvingly accuses him. It is the price he pays for his particular virtues. His fiction answers too well at times an important but crippling demand made on the novel: that it be the recital of events made more interesting in their texture than in their resolutions.

*Partisan Review*, Spring 1944; A&C (slightly revised).

## 66.   Abstract Art

The full significance of the revolution in Western painting dur-
ing the last sixty years will not become apparent for some time.
But that part of its meaning which concerns the concrete me-
dium itself is already plain. It is only necessary to put it in his-
torical perspective.

The previous great revolution in Western painting led from the
hieratic flatness of Gothic and Byzantine to the three-dimen-
sionality of the Renaissance. Its stimulus was a fresh awareness
of space provoked by expanding economic and social relations in
the late Middle Ages and by the growing conviction that man's
chief mission on earth is the conquest of his environment. The
immediate problem in painting was to fit the new perception of
depth and volume into the flatness of the picture surface; the less
obvious though more difficult and crucial problem was to syn-
thesize depth, volume, and surface in both dramatic and deco-
rative unity. Within the conservative format of the wall paint-
ing, Giotto created a synthesis which, through simplification of
shapes and surfaces and the exclusion of small detail, made his
murals hieratic and decorative, yet at the same time dramatic
and three-dimensional. The profane appetite for the round was
disciplined, volumes were inflated at low pressure to acknowl-
edge the flatness of the wall, and the background was pushed no
deeper than the backdrop on a stage.

The Sienese a little later arrived at perhaps an even more con-
servative synthesis in the altar piece and easel picture. Sassetta
subordinated three-dimensionality to decorative principles bor-
rowed from the Gothic or Oriental miniature. The format of his
*Journey of the Magi*—in the recent Griggs bequest to the Metro-
politan—is surprisingly small: the spectator has to get close
enough to *read* it. Against a neutral-toned background in low
relief, color is picked out in a staccato pattern of flat notes by
forms handled with a slight attempt at volume. The drawing is
fairly correct, but the claims of correctness are not allowed to
interfere with the decorative function of line. For the moment
Sassetta's art has arrested the transition, having found a style in
which the artist is fairly sure of saying exactly what he wants
to. This contrasts with the insecure style of another fifteenth-

century Sienese, Giovanni di Paolo, in his *Presentation in the Temple* (in the Blumenthal bequest to the Metropolitan), where the old tradition of the Gothic and Oriental miniature is shown in outright conflict with the new one of naturalism. The flat, shallow, but richly detailed architectural background does not provide room for the figures in the foreground; the sculptural modeling of their garments bulges from the picture surface and creates an effect of overcrowding. In his figures Giovanni has explored the illusion of the third dimension farther than Giotto, but since his background is even more strictly two-dimensional, he has failed to attain either structural or decorative unity.

With the aid of the flexible medium of oil, the conflict between three-dimensional form and the plane surface was resolved finally by the annihilation of the second. The Italian or Flemish painter of the fifteenth century managed so to immerse himself in the illusion of the third dimension that he instinctively conceived of his canvas as a transparent rather than an opaque surface. Yet some of the difficulty of controlling the emphasis on volumes still remained. There was a tendency to insist simultaneously on the brilliance of surface which oil permitted and on highly sculptural modeling, a combination often too rich. But the Quattrocento was preoccupied with techniques and the accumulation of data: its painters preferred, for instance, to portray old people because their faces offered more details to the brush. They had not yet reached that point of repletion at which there is a readiness to sacrifice and simplify for the sake of large effects.

It was only toward the close of the fifteenth century and in the sixteenth that Verrocchio, Leonardo, Perugino, Raphael, Michelangelo, Correggio, Giovanni Bellini, Giorgione, and Titian perfected means of consistently achieving structural, tonal, and decorative unity in three-dimensional painting. These were—aside from scientific perspective, which could disorganize as well as organize a picture—the indication and ordering of the illusion of vacant three-dimensional space which forms interrupt (Raphael), the subordination of local color to a dominant tone or key, and the patterning of shade and light. It was necessary to believe enough in the illusion of depth to organize elements within the illusion and at the same time to suspend the illusion sufficiently to see them as the flat forms they are in

physical reality. But the tendency was to forget almost all about the last, and thus there was a loss involved here as well as a gain. Post-Renaissance painting sacrificed too many of the qualities intrinsic to its medium. Pictures were organized too exclusively on the basis of the illusionist effect and with too little reference to the physical conditions of the art.

The nineteenth century began to dissolve the facts and make obsolete the general conceptions under which illusionist art had functioned. It came to be realized that the earth could no longer afford to Western man, or his economy, indefinite space in which to expand; that verified facts were the only certainties; that each of the activities of culture could be exercised with assurance only within its own province and only when that province had been strictly defined. The age of specialization and of limited intellectual and spiritual objectives sets in—after Hegel, for instance, philosophers stopped constructing world systems.

And with Manet and Courbet Western painting reversed its direction. Impressionism pushed the faithful reproduction of nature so far that representational painting was turned inside out. Incited by a positivism borrowed from science, the impressionists made the discovery—stated more clearly in their art than in their theories—that the most direct interpretation of visual experience must be two-dimensional. The new medium of photography helped provide evidence for that. Sensations of a third dimension are not given by sight *qua* sight but by acquired associations with the experience of movement and touch. The data of sight, taken most literally, are nothing but colors. Notice, therefore, how a flatness begins to creep into impressionist paintings, how close to the surface they stay, in spite of "atmospheric perspective," and how openly the physical nature of the canvas and of the paint on it is confessed—by way, too, of emphasizing the difference between painting and photography.

The successors to impressionism have made all this more explicit. Painting, become anti-idealist, has surrendered itself once more to the literal plane surface. Correctness of drawing, black-and-white chiaroscuro, three-dimensional light effects, atmospheric and linear perspective, etc., etc., have been progressively, though not consistently, eliminated. The uniformly smooth and transparent surface behind which the picture used to take place has been made the actual locus of the picture in-

stead of its window pane. To acknowledge the brute flatness of the surface on which he was trying to create a new and less deceptive illusion of the third dimension, Cézanne broke up the objects he depicted into multiplicities of planes that were as closely parallel as possible to the canvas's surface; and to show recession, the planes were stepped back with comparative abruptness—even the receding edges of objects keep turning full-face to the spectator like courtiers leaving the presence of royalty. Furthermore, Cézanne's parallel, roughly rectangular touches of the brush echo the outline of the canvas. And it was the new realization of the importance of every physical factor that also compelled the distortions of his drawing, and of Van Gogh's and Gauguin's—determined just as much by the tensions between the frame of the picture and the forms within it as by expressive compulsions. There were still other ways in which the physical nature of the medium and the materialism of art were asserted: pigment was sometimes applied so thinly that the canvas showed through, or it was piled in such impastos that the picture became almost a kind of relief. (There was a paradox in the fact that both Van Gogh and Gauguin were trying to rescue painting from the materialism into which they accused the impressionists of having sunk it.)

The Fauves, early in the first decade of this century, constructed pictures with flat, high-keyed color which was arbitrary in any representational sense and more or less dissociated from contour. Cubism, parodying by exaggeration the traditional methods of rendering volume and light in a despairing effort to restore the third dimension by Cézanne's method, finished by annihilating the third dimension; resulted in paintings that were completely flat—and thus accomplished the counter-revolution in principle. Picasso, Braque, Gris, and the others through whose art cubism evolved refused to accept its ultimate conclusions, and once they had arrived at pictures from which the identities of objects had disappeared, they did an about-face and returned to representation; other artists, however, later on accepted in full the logic of cubism and became outright abstractionists, resigning themselves to the non-representational and the inviolability, more or less, of the plane surface. With a speed that still seems amazing one of the most

epochal transformations in the history of art was accomplished.

The deeper meaning of this transformation is that in a period in which illusions of every kind are being destroyed the illusionist methods of art must also be renounced. The taste most closely attuned to contemporary art has become positivist, even as the best philosophical and political intelligence of the time. Fiction, under which illusionist art can be subsumed, is no longer able to provide the intensest aesthetic experience. Poetry is lyric and "pure"; the serious novel has become either confession or highly abstract, as with Joyce and Stein; architecture subordinates itself to function and the construction engineer; music has abandoned the program. Let painting confine itself to the disposition pure and simple of color and line, and not intrigue us by associations with things we can experience more authentically elsewhere. The painter may go on playing with illusions, but only for the sake of satire. If he finds the limited depth of the plane surface too confining, let him become a sculptor—as Arp, originally a painter, has done.

But even as a sculptor the artist can no longer imitate nature. There is nothing left in nature for plastic art to explore. The techniques of art founded on the conventions of representation have exhausted their capacity to reveal fresh aspects of exterior reality in such a way as to provide the highest pleasure. But the trouble lies also with exterior reality itself. Byzantine art was abstract in tendency because it subordinated exterior reality to a dogma. In any case reality was not appearance. Naturalist art submits itself to appearance; if any dogma is involved it flows from appearance and appearance is assumed to be the true and the real. Today we know that the question what a corporeal object is can be answered in many different ways, depending on the context, and that appearance is only one context among many, and perhaps one of the less important ones. To give the appearance of an object or a scene at a single moment in time is to shut out reference to too many of the other contexts in which it simultaneously exists. (And have not science and industry dissolved the concept of the entity into the concept of a process?) Instead of being aroused, the modern imagination is numbed by visual representation. Unable to represent the exterior world suggestively enough, pictorial art is driven to express as directly

as possible only what goes on inside the self—or at most the ineluctable *modes* by which that which is outside the self is perceived (Mondrian).

Painting approaches the condition of music, which according to Aristotle is the most direct and hence the most subjective means of expression, having least to do with the representation of exterior reality. The gain that helps cancel the loss entailed by the restriction of painting and sculpture to the subjective lies in the necessity that painting become, in compensation, all the more sensitive, subtle, and various, and at the same time more disciplined and objectivized by its physical medium.

Art is under no categorical imperative to correspond point by point to the underlying tendencies of its age. Artists will do whatever they can get away with, and what they can get away with is not to be determined beforehand. Good landscapes, still lifes, and torsos will still be turned out. Yet it seems to me—and the conclusion is forced by observation not by preference—that the most ambitious and effective pictorial art of these times is abstract or goes in that direction.

*The Nation*, 15 April 1944

## 67. Review of an Exhibition of Arnold Friedman

As Bonnard and Vuillard show, there were possibilities in impressionism which the nineteenth century failed to exhaust. Some of the last of these have been capitalized by Arnold Friedman in his most recent landscapes, in which, after years of working in a neo-Ingresque vein, the artist has discovered himself as an impressionist. His current show (at the Marquié Gallery) demonstrates that something can still be said with atmospheric envelopes, complementary colors, and optical mixtures. In Friedman's successful pictures vibrating color surfaces move toward and away from each other like incidents in a well-told story. In his unsuccessful paintings there is that tendency to monotony and excessive naiveté which has always been a liability of the impressionist method: there is a failure to emphasize, accent, modulate: only paint quality and texture are offered, while

the compositional elements cancel each other by their equivalence. This is particularly true in the still lifes, which are too evenly focused, and in some of the landscapes, where the approach is frontal and four-square. But when the artist can rely on atmospheric interference to select and unify, he produces paintings which dramatize art as well as nature. One such picture, *Approach to Town*, in small format, points out a path beyond impressionism which Friedman should follow farther: abandoning broken tones and crusty impastos for the orchestration of facets of flat color. By and large Friedman's painting is praiseworthy for its honesty, for its renunciation of tricks and stunts—it is obvious that he has the equipment to paint as fashionably as anyone on the market, but it is also obvious that he has character.

*The Nation*, 15 April 1944

## 68.   Review of Exhibitions of Mark Tobey and Juan Gris

The showing of Mark Tobey's latest paintings (at the Willard Gallery) deserves the most special notice. A man of fifty, Tobey has only comparatively recently discovered himself; yet he has already made one of the few original contributions to contemporary American painting. Like Morris Graves—whom he has influenced, it seems—Tobey comes from Seattle. He has a similar affinity with Chinese painting and likewise takes advantage of the carte blanche which Klee's example has latterly given to the graphic imagination. Tobey and Graves have also in common their renunciation of frank color. In the case of Tobey color is a delicate affair of pale tints, intensity being reduced by an omnipresent gray which filters every hue. Tobey's great innovation is his "white writing"; the calligraphic, tightly meshed interlacing of white lines which build up to a vertical, rectangular mass reaching almost to the edges of the frame; these cause the picture surface to vibrate in depth—or, better, toward the spectator. Yet this seems little out of which to compose an easel painting. The compensation lies in the intensity, subtlety, and directness with which Tobey registers and transmits emotion usually considered too tenuous to be made the matter of any

other art than music. And yet again—his painting is not major. Its mode, which consists in dividing and subdividing within a very narrow compass of sensations, gives the artist too little room in which to vary and amplify. It is obligatory that Tobey work to expand his range.

Those who question the capacity of the twentieth century to produce *final* statements in art should see the cubist still lifes and collages executed by Juan Gris in 1916 (in the representative show of his work at the Buchholz Gallery). They are already archaic—in the best and fullest sense of the word. There is the same counterplay of the structural and the rhythmic, the symmetrical and the dynamic: monumental silhouettes in creamy blacks that seem to include the whole spectrum are counterpoised by the lyrical space between their edges and those of the canvas. Gris's best cubism was synthetic rather than analytic— that is, he dissected his theme and only put it together again when new relationships between its parts had been invented. The reconstruction was usually embalmed under a heavy waxen finish which gave it an old-master look of inevitability and permanence. But much more than a finish is responsible for the old mastery of Gris's art. A picture such as the *Still Life with Collage* is the best touchstone I know by which to compare and assess the work of the ambitious painters of our time.

*The Nation*, 22 April 1944

69. Review of *The Story of Painting: From Cave Pictures to Modern Art* by Thomas Craven

The title of this book is a misnomer, for it is concerned only with Western painting. Mr. Craven writes less brazenly than usual. Something has taken the wind and vinegar out of him, and he seems to be addressing himself to children. All the standard facts and interpretations are here, with now and then some egregious error, such as the statement that Leonardo "invented chiaroscuro." Mr. Craven credits Burchfield, Curry, Grant Wood, Marsh, and Benton with being "leaders of the most important art movement thus far produced in America." He also

says that Seurat, Renoir, and Cézanne utilized the discoveries of Monet, Sisley, and Pissarro, when the opposite would be much closer to the truth.

[Unsigned]

*The Nation*, 20 May 1944

70. Review of Exhibitions of Joan Miró and André Masson

Miró belongs among the living masters. He is the one new figure since the last war to have contributed importantly to the great painting tradition of our day—that which runs from Cézanne through fauvism and cubism. During the last ten years his work has maintained a very high level with a consistency neither Picasso nor Mondrian has equaled. The adjectives usually applied to Miró's art are "amusing," "playful," and so forth. But they are not quite fair. Painting as great as his transcends and fuses every particular emotion; it is as heroic or tragic as it is comic. Certainly there is a mood specific to it, a playfulness which evinces the fact that Miró is comparatively happy within the limitations of his medium, that he realizes himself completely within its dominion. But the effort he must exert to condense his sensations into pictures produces an effect to which playfulness itself is only a means. This is "pure painting" if there ever was any, conceived in terms of paint, thought through and realized in no other terms. That Miró's imagination is ignited by its contact with the anatomy of sex takes nothing away from the purity. In Picasso, who is indeed a more profound artist, we can sense a dissatisfaction with the resources of his medium; something beyond painting yearns to be expressed, something which color and line laid on a flat surface can never quite achieve. Miró, on the contrary, seeks the quintessential painting, is content to stay at the center of that exhilaration which is only felt in making marks and signs.

Picasso is more ambitious, more Promethean; he tries to reconcile great contradictions, to bend, mold, and lock forms into each other, to annihilate negative space by filling it with dense

matter, and to make the undeniable two-dimensionality of the canvas voluminous and heavy. Miró is satisfied simply to punctuate, inclose, and interpret the cheerful emptiness of the plane surface. Never has there been painting which stayed more strictly within the two dimensions, yet created so much variety and excitement of surface. With an exuberance like Klee's, Miró tries other textures besides canvas and paper—burlap, celotex, sandpaper—a kind of experimentation Picasso usually finds irrelevant to his concerns. Picasso piles pigment on the surface; Miró sinks in. Yet despite the restricted scope of his ambition, one or two of the large canvases which Miró executed around 1933 are in my opinion more powerful demonstrations—because more spontaneous and inevitable—than Picasso's *Guernica* mural. And Miró's smaller pictures frequently during the last five or six years before the war manifested greater conciseness and lucidity than anything produced by Picasso during the same period, except for his drawings and the *Femme endormie* of 1935, the *Femme assise au fauteuil*, and the *Girl with the Rooster* of 1938.

The present Miró exhibition (at the Matisse Gallery) contains paintings done between 1934 and 1939, with one oil dating from 1927. Most of this work has not been seen in New York before, and it confirms, if it does not raise, Miró's standing.

André Masson has been an ambitious painter from the beginning, one who accepts and tries to solve the most difficult problems proposed by art in this age. Very little he has done is without interest; yet little so far seems capable of lasting. There is some lack in Masson of touch or "feel"—a lack dangerous to an artist who relies, or professes to rely, so much on automatism or pure spontaneity. A line either too Spencerian or too splintery weakens his drawings; an insistence upon multiplying and complicating planes, while combining two such color gamuts as violet-blue-green-yellow and brown-mauve-red-orange, renders his painting turgid, overheated, and discordant. Energy is dissipated in all directions.

Masson strains after that same *terribilità* which haunts Picasso, is obsessed by a similar nostalgia for the monstrous, the epically brutal, and the blasphemous. But being nostalgia, it has something too literary about it—too many gestures and too much forcing of color, texture, and symbol. The latest showing of Masson's oils and drawings (at the Rosenberg and Buchholz

Galleries respectively) does reveal a small advance, especially in two recent oils, *Pasiphaé* and *Histoire de Thésée*. In the first, black-brown, a dull red, and a mouldy yellow-green are unified into a whole that is cooler and more clarified than any of its parts, with a surface which is alive but not restless. In the second, happily, almost everything except calligraphic line is eliminated. Self-control, elimination, and simplification would seem to be the solution for Masson. But not as these operations are exemplified by two paintings in a new style, which permit thin, curling lines to describe figures over diluted lavenders, mauves, pinks, and greens, arriving at a kind of fermented-sweet decoration. This is impoverishment, not simplification. But even here, possibilities can be glimpsed of better things. There is a chance Masson will surprise us all some day.

*The Nation*, 20 May 1944

71.  Review of a Group Exhibition at the Art of This Century Gallery, and of Exhibitions of Maria Martins and Luis Quintanilla

Peggy Guggenheim's spring salon for abstract and surrealist artists under forty (at the Art of This Century) is a much-needed project. Nothing of very high order is shown, but enough that manifests promise. It is true that these young painters and sculptors lack force and erudition, lack profound obsessions, and aim at felicity more often than complete expression; but most of them have discovered at least the direction in which art must go today in order to be important. Fannie Hillsmith's oil is evidence—it is perhaps the best thing shown—also David Hare's large plaster construction, which needs only a more dominant and insistent rhythm. Quite a few other items give pause to the observer. In Phyllis Goldstein's brownish painting felicity almost makes up for the absence of strength. Robert Motherwell's large collage is perhaps the most interesting work present, but it lacks a certain forthright emphasis which collage usually requires. Perle Fine's Miróesque gouache, Jacqueline Lambda's painting, Eileen Agar's crayon drawing, Hedda Sterne's

piece of femininity, Richard Pousette-Dart's over-elaborated oil, Aaron Ehrlich's retarded cubism, Virginia Admiral's dispersed version of Miró, and Jackson Pollock's inflated pastel and gouache —for all their shortcomings, their lack of *pressure*, these deserve attention. William Baziotes has painted an experiment rather than a picture, but it makes one more curious about his particular future than about that of any other painter present. The salon serves its function by arousing curiosity.

The *cire-perdue* bronze groups of the Brazilian sculptress, Maria Martins (at the Valentine Gallery), are perhaps the last completely living manifestation of academic sculpture. The nature of metal almost denies itself in this monstrous and happy proliferation of plant and animal forms. The impulse is baroque, not modern, and is given by Latin colonial décor and tropical luxuriance. This sculpture expresses conceptions which Western European industry imposed on metal in the first excitement of the discovery that it could be poured into the most pliant and complicated shapes. Mme Martins's subject matter—the exhibited fertility of the open-bellied female figures, the different varieties of life growing out of and into each other in the chaos of an un-Biblical creation—animates the form, but is not quite strongly enough felt to produce more than decorative effects. Design is symmetrical; the formal relations are transparent and predictable. This is the crux of the sculptress's problem. But none of this contradicts the fact that she has immense talent. Look carefully at the piece in metal leaf called *Le Couple*, and at the *Macumba* group; also the sculptured jewels, which are the best contemporary examples I have seen.

Luis Quintanilla's temperament seems unsuited to the theme —"Totalitarian Europe"—around which a showing of his latest work in water color and crayon is grouped (at the Knoedler Galleries). Line is too graceful, color too limpid and singing. The formal combinations are delicate but irrelevant to their motifs. Color is the chief trouble. Even Goya and Picasso felt compelled to restrict themselves to black and white when confronting the horrors of war.

*The Nation*, 27 May 1944

72. De Profundis: Review of *The Bottomless Pit*
by Gustav Regler

The events in which Gustav Regler took part compelled him
and all others involved to choose in the end between betraying
and being betrayed. Regler chose the latter course and could not
help doing so. He has paid for it with everything short of his
life. Still believing in socialism and the brotherhood of man, he
has come to distrust passionately every method proposed for
their realization; and his disillusionment with methods and
means—with reason itself, it almost seems—causes his an-
guish. It is not defeat at the hands of the enemy but betrayal by
friends that compromises beliefs.

These poems of Regler's—written in free strophes and seek-
ing objective equivalents for an emotion which without the
check-rein of art would become hysteria—are his testament for
the time being. They have a flavor of Young German romanti-
cism, Jean Paul Richter's; yearning, pessimistic, exuberant in
their visionary quality, embittered in their content, disregard-
ing the laws of space but forced to obey those of time by the
inability of the mind in which they originate and of their me-
dium to exist in any other dimension. One hesitates to remons-
trate with a man like Regler; yet one cannot help asking that
he give us something more positive. If the present slogan, as
Regler says, is "Workers of the world, distrust one another," it
is up to reason to substitute a better one. And it is up to the
Reglers, who know most about the workers in their heroic mo-
ments, to translate that experience into thought, which is
viable, as well as into emotion, which is viable only in art, and
therefore too uncertain.

The German of Regler's poetry is accompanied by a parallel
translation into English and by five very interesting drawings
by Marie Louise Vogeler-Regler. It is to be hoped that more of
Regler's writing will be published—in this country as well as
in Mexico.

*The Nation*, 3 June 1944

A New Installation at the Metropolitan Museum of
Art, and a Review of the Exhibition *Art in Progress*

Several hundred of the Metropolitan Museum's best paintings—
shipped off more than two years ago for protection at a time
when air defenses were less adequate—have been returned to
Fifth Avenue and were last week put on exhibition once more.
Only about twenty of the canvases have been cleaned or restored;
yet most of them seem to have acquired fresh luster during their
absence. The impression is partly owed, no doubt, to the re-
decorated galleries—on which the museum staff is to be con-
gratulated. In two or three cases the color scheme may be unfor-
tunate, but this detracts little from the total effect. Seeing the
pictures again calls forth a surprising amount of joyous emotion.
These are among the relatively few indisputable achievements,
the integrity of which history and circumstances will never
overthrow, even when the canvas rots. That one can experience
their actual presence, and not merely reproductions, seems a
miracle.

The Museum of Modern Art's fifteenth-anniversary exhibi-
tion, *Art in Progress*, is another source of pleasure. All three gal-
lery floors of the museum have been filled with displays of paint-
ing, sculpture, architecture, industrial design, stage design,
photographs, movie stills, posters, and more. The material,
much of it borrowed, some of it owned by the museum, has been
selected with an eye both to intrinsic and representative quality.
This, in effect, is the modern movement as it is embodied in the
more visual arts and crafts. The works in the painting and sculp-
ture sections—beginning with Renoir, Degas, and Maillol
among the French, Eakins and Homer among the Americans,
and Lehmbruck and Barlach among the Germans—are well
chosen; most of the examples have been borrowed and are more
or less unfamiliar to the New York public. Matisse is shown at
his best, and the spectator is reminded, as he needs to be, that
the old Frenchman is the only living painter to offer Picasso any
competition as a dominating force. But the absence of Vlaminck
and Segonzac is unjustifiable; and I differ strongly with the mu-
seum on many of the younger artists whose work has been in-
cluded—though some of the weakest of them are shown at their

strongest. On the other hand, the notion given of American abstract painting is insipid and very unfair.

If the remainder of the exhibition is no better than it is, it may be because modern architecture, industrial design, and their allied fields are no better than they are. It is possible that there are errors of omission or inclusion, but I am not competent to decide. The architecture section seems to make the point, not intended, that no adequate modern style has yet been developed for the dwelling. I found nothing to quarrel with in the photography section except that Ansel Adams is given an undeserved amount of space, while only nine of Walker Evans's prints are shown. Evans is certainly our greatest living photographer since Stieglitz. Among the posters those of A. M. Cassandre, the French artist, which take advantage of every hint offered by the painting of the school of Paris, are superb.

The Museum of Modern Art does much in this show, as it did in its previous one, *Modern Drawings*, to redeem its sins. Yet the redemption is a negative one. The best of what has already been accepted is made available, but the selection indicates no positive policy in respect to the art being produced at the moment. The museum continues to show an uneven catholicity to contemporary art beside which the present policy of the Metropolitan in regard to the art of the past appears narrow and dogmatic. The younger museum needs some of that strictness. The masterpieces at the Metropolitan furnish a standard which the Museum of Modern Art can well use to test the merits of contemporary art. Not that the works admitted into its galleries have necessarily to meet such a standard, but simply that they ought not to be completely irrelevant to it—as irrelevant, say, as the examples now on view of the art of Blume, O'Keeffe, Dali, Portinari, Zorach, Tchelitchew, Berman, Tanguy, Pereira, Robus, and more than a few others. The extreme eclecticism now prevailing in art is unhealthy, and it should be counteracted, even at the risk of dogmatism and intolerance. Inevitably, the museum makes enemies. Let it make them for good reasons.

*The Nation*, 10 June 1944

74. Review of *Camille Pissarro: Letters to His Son Lucien*,
edited by John Rewald

Pissarro wrote to his son Lucien in 1896: "We are on the right
track, be faithful to your sensations." During the twenty years
(1883 to 1903) covered by these hundreds of letters the old
painter changed his mind more than once. But to "nature" and
his "sensations" he remained true from first to last. His shifts of
attitude in other respects came not from a vacillating tempera-
ment but from humility and an ineradicable hope, derived from
analogies with science, of finding the Method.

Painting had begun to move fast in Pissarro's day, faster than
it had in three hundred years; he in particular must keep pace
with it. The Method, if discovered, would consummate and at
the same time stop the development of art, just as the fulfilment
of socialism would, according to Marx, stop history. Pissarro be-
lieved in the possibility of the Method because he believed in the
nineteenth century. He was naive and optimistic, a complete
materialist in philosophy, a Proudhonian anarchist in politics.
The counter-romantic fifties and sixties had made him, and he
remained immune to the aestheticism and mysticism which
came into style during the later decades of his life. Aestheticism
he characterized as "a kind of romanticism more or less com-
bined with trickery." Nature was too productive to be compre-
hended within it: "There must be an element of nature in my
canvases which hurts certain aesthetes." Of the neo-Catholicism
with which aesthetic London tempted Lucien in the nineties he
wrote: "It is philosophically outside the ideas of our time." "The
ideas of our time"—this was the way Pissarro liked to express
himself.

With the exception of Seurat, all the neo-impressionists,
among whom Pissarro belonged for a time, professed anar-
chism. Pissarro's, however, was of earlier date and less an avant-
garde gesture—the anarchism of an artisan rather than of an art-
ist. He was the only one of the original impressionists to concern
himself with revolutionary politics; Degas was a reactionary,
Cézanne a conservative, while Renoir, Manet, Monet, and Sisley
seem to have been more or less indifferent. The neo-impression-
ists—who were the most positive agents of the so-called classical
reaction in French painting during the eighteen eighties, insist-

ing on prescribed techniques and the primacy of objective laws over individual humors—were the first after Courbet to join avant-gardism to radical politics. By their time the opposition of entrenched society to advanced art had become an established fact from which political conclusions were to be drawn. But later on, when the market for advanced art began to expand, the avant-garde again turned away from politics, and all it concluded from its experience was that bourgeois society was ugly and crass, yet could be circumvented in private life. Hence aestheticism and religiosity—while the generation of artists and writers that rose in Paris after 1900 occupied itself with neither politics nor religion but went in for experience, that is, bohemianism, when it went in for anything at all besides the practice of art.

None of the original impressionists was bohemian in his actual way of life, least of all Pissarro, a family man with seven children. He was the only notable advanced painter of his time to attempt to support a family on the proceeds of his work, even before its market appeal had been issued. This happened relatively late—later than in the cases of Renoir and Monet, who waited for financial success before acquiring families. The trials of Pissarro's course are reflected in his constant complaining about money and difficult relations with his dealers. Again and again he had to run to Paris and peddle his work to raise money. But he loved Paris, and he does not seem to have lived badly, and there may be some exaggeration in his complaints. Certainly he would fall into that rhetorical paranoia so habitual with the French, and talked of "enemies," "plots," "machinations," and so forth. But it was little more than rhetoric, and the old man usually doubted his own suspicions.

In himself he was one of the most decent persons ever to have won renown in art. Degas—who was anti-Semitic, while Pissarro was a Jew—Cézanne, and others have testified to that. He never dramatized himself as an artist, his humility was utterly sincere, and, rarest of all in a painter, he was seldom jealous, or grudging in his praise of contemporaries. The evidence is in these letters.

Pissarro's lack of egotism was responsible perhaps for certain shortcomings of his art—its tendency toward monotony, its frequent lack of incisiveness and motion. He sacrificed too much of

his temperament to whatever method he happened to be practicing. He was greatly concerned about the "synthesis," the harmony or unity of a work of art, and rightly so, for a painting, like a living organism, exists by the simultaneous relation of its parts. But the total final effect of the flat rectangle was often a paralyzing obsession for him. He allowed his perception of the free atmospheric diffusion of light to hush and merge all silent features, was too egalitarian in his treatment of the canvas—like another materialist, Courbet—and would mistake uniformity for unity. Yet his virtues redeem and more than redeem his faults. He could be a great draftsman, as his work in black and white shows. And he had a certain innocence of eye which permitted him to love phenomena the way no other painter of his time could. His relish of the pictorial, his fresh sense of what a picture does and how it relates to that which it pictures, gained him some of the qualities of primitive art without its liabilities. Pissarro was simple but not poor. He had a wealth of his beloved sensations, and could not have had that wealth without being learned in his art. Only someone who has experienced painting as a world in which it is possible to immerse as well as divert oneself can appreciate the inflections of Pissarro's painting. Shock and immediate effects are sacrificed for the sake of subtleties, passages, modulations, the mediation of contrasts. And little masterpieces are to be found complete in themselves in the dozen or so brushstrokes with which such a detail as a cab is indicated. It was only Pissarro's inhibiting preconception of unity that prevented him from treating the whole canvas in the same manner.

He was one of the few professionals to write professionally about art—from the inside, without high-flown verbiage or spectacular paradoxes. Everything is to the point—the authentic shorthand which even the layman will recognize as such. Pissarro was addressing himself to his son, upon whose equal familiarity with craft problems he could rely. The milieu and the period were under intense critical pressure, created, as is usually the case, by competing activity in the exploration of new possibilities rather than by the words of the critics. The monolithic opposition to the new painting was in itself valuable because the writers who embodied the opposition—not the academic paint-

ers—were often learned and really interested in painting. Unlike the advanced artists of the period after 1918, when the reputation of being advanced was a goal in itself and meant eventual rewards, Pissarro and his fellows had little to encourage them except the excitement of discovery. Judgment could be exercised with relative purity and was unwarped by issues accidental to art. Whatever came out of the studios aroused an immediate, keen, and uncompromising response. Comparatively few of the judgments of Pissarro and his friends have needed posterity's correction; they knew how to value Cézanne and Gauguin; and Pissarro's own work was during his lifetime put to as searching and intelligent a criticism as any it has received since. All this appears in these letters, which form one of the most fertile of all sources of insights into the nature and state of mind of nineteenth-century French painting—not to mention their richness in aperçus of painting in general. Translated from the manuscripts, they appear in this book for the first time in any published form.

*The Nation*, 24 June 1944

## 75.   Mr. Eliot and Notions of Culture: A Discussion

1. Mr. Eliot[1] decries the assumption that "clerical labor is more dignified than manual labor," yet he identifies the elite with culture. He admits that a new upper class means a new Culture; he allows that our present upper class is in a state of decay; yet he wishes to preserve our present Culture. He pronounces the late stage in the Culture at which skepticism begins to corrode the religious cult to be "indeed a necessary one," yet he desires to suspend that stage—without suggesting how. Mr. Eliot's article is rendered inconclusive in the main by a conflict in himself between historical fatalism and utilitarian hope. And

1. The editors of *Partisan Review* asked Greenberg, R. P. Blackmur, William Phillips, and I. A. Richards to respond to the essay "Notes Towards a Definition of Culture" by T. S. Eliot. The essay had been published in the previous issue of *Partisan Review* (Spring, 1944). [Editor's note]

given the familiar assumptions of its argument, his article could have made a contribution only had it offered concrete proposals. But there are none.

2. One of Eliot's underlying premises seems to be that the generic form, Culture, *qua* form and *qua* entelechy is immutable. Both primitive and advanced Cultures obey the same basic laws as regards their development and operation; they differ only in scale and content. The emphasis put on religion as the activator of the Culture excludes almost all perspectives of change in its generic form. The schematic structure of the Culture in its various stages is regarded as fixed. Here Mr. Eliot agrees more or less with Spengler. Yet even Frobenius, who was almost as reactionary as Spengler but knew a great deal more anthropology, held that the Culture as a form has since the beginning of history been evolving in a more and more secular direction; and that in the long run the central function of religion has diminished. With this there has been a change in the very structure of Cultures. Meanwhile religion itself has undergone an evolution, its focus narrowing from the practical, the magical and propitiatory to the ultimate and the metaphysical. Thus religion's control over behavior shrinks, its place being taken, at least theoretically, by ethics. The Christian may appeal more frequently to moral postulates but he does not negotiate with the supernatural as constantly as did the Egyptian, ancient Jew, the Hindu, or even the fifth-century Greek. And the typical personality produced by Western Christianity is the least religious in history. But this has not made our Culture necessarily inferior to any other in art, politics, economic life, or morality.

A new or revived total Culture of the future is likely to diminish still further the importance of religion. It may be that religion will dissolve itself into the ethical, discarding revelation and the envelope of the supernatural. Or what is more likely and less banal, it will be superseded by an ethos resting on a conviction of the absolute and integral value of the human personality. It is up to Mr. Eliot to show that an ethos other than a revealed religion cannot of necessity function as the "common faith and order" he declares indispensable to a high total Culture.

3. Mr. Eliot maintains that culture is "something to which a few can be raised," and "that a high degree of culture in an equalitarian society can only be attained if the great majority of

men can be raised to a level, and kept at a level, which has never been remotely approached in the past." The same can be asserted of religion: that only a few in the past have been capable of religion, and that the religion of the mass of mankind has so far been little more than superstition. Witness the unceasing complaints of medieval churchmen as to the quality of their peasant parishioners' faith, which they denounce as crude superstitiousness. Witness the fact that over eighty-five percent of the saints come from the upper classes. Religiosity seems to have depended on much the same factor as culture: leisure, which depends in turn on the economic level and security of the individual. It is conceivable that if socialism were to provide leisure with economic security at a sufficiently high level to most of humanity, a great many more people would discover a religious vocation in themselves.

There are questions on which religion has given, and in most cases still gives, more immediate psychological satisfaction than science and philosophy: questions as to the purpose or significance of existence, the assignment of responsibility, the justification for the basic unsatisfactoriness of life, and so forth. In these connections the consolations of a naturalistic outlook are pretty lame, aesthetically speaking. Certain people may continue, therefore, to find some sort of religion indispensable, and most likely there will always be religious natures. But socialism could not countenance institutional religion as the authority for public discipline, nor could it countenance official specialists in the religious "mysteries." It will be enough for socialism that every human being—his body no less than his soul—is regarded as an end in himself. It is necessary to add, I suppose, that men cannot regard each other as ends in themselves unless they are freed from the necessity of exploiting and being exploited by one another.

4. A circumstance which partly determined the nature of total Cultures in the past is the fact that each has been territorially circumscribed and that no one Culture has ever had the field to itself—not even the Culture of the Egyptians. Now, however, that Western industrial capitalism is in the process of establishing a global economy with coordinated methods of production on all continents, the possibility of a global Culture appears. Only socialism can realize such a Culture, and it could do

so only by accepting and even encouraging regional variations. Meanwhile our deteriorating Western Culture duplicates—and will do so increasingly—the imperialist and exploitative role of Western capitalism. The colonial Cultures, most of them decrepit in any case, are being done to death by mass-produced, ready-made commodities exported from New York and California. There will soon be little diversity of Cultures for Mr. Eliot's common religious faith to unify. There will be just greater and lesser degrees of backwardness; and the unifying agents will be movies, comic books, Tin Pan Alley, the Luce publications (with editions in all languages), Coca Cola, rayon stockings, class interests, and a common boss. These are all quite compatible, incidentally, with religion, but not at all with socialism.

*Partisan Review*, Summer 1944

## 76.   Review of Two Exhibitions of Thomas Eakins

Naturalism does not altogether explain the art of Thomas Eakins. The hard-headed, mathematically founded account he gave of what met his eyes when he looked at the model or scene was the framework on which he projected an ideal chiaroscuro, unobtrusive only because worked out according to nature but not found there entirely. Eakins's imagination realized itself in the disposition of values—darks and lights—which transfigured the literal facts without violating them. Often he insisted on contrasts not too far from the poetic effects of such of his American contemporaries as Ryder, Robert Newman, and George Fuller. Chiaroscuro was a characteristic expression of the American sense of the poetical in the nineteenth century. It appears in literature in Hawthorne, Poe, and Melville, even in James. (For instance: blackness and night are the dominants of the first few chapters of *Moby Dick*: the hero, stumbling through pitch darkness, finds a Negro prayer-meeting going on behind the first door from which he sees a ray of light. All of which is to prepare us at long remove for the violent contrast of the whiteness of the whale.) This American version of chiaroscuro opposes

the unexplored to the explored, the mysterious to the known; man is isolated in a universe he can only make meaningful through symbolic or esoteric experience.

A good deal in Eakins argued against such a romanticism. Particularities, observed facts of light and texture, elicited some of his strongest painting. He had to acknowledge and state the given material before he could project his imagination. And not only did he show a new sensitivity to local color; he even intensified the literalness of his art—in an actual if not, fortunately, in a painterly sense—by beginning to model volumes in degrees of tone and color rather than in greater or lesser saturations of black or brown shading. Yet his impressionistic tendencies were usually overtaken by a sentiment of the dramatic and the psychological which always involved chiaroscuro—even when, toward the end, he began to see colors in the background shadows and their opacities began to dissolve and gleam.

Eakins had almost no manner, which explains why his paintings so often lack immediate presence and require a longer gaze to make themselves felt. But he did have a style, and that style evolved. His earliest work is the product of French influence in the sixties. Curiously enough, he reacted to Courbet and Delacroix in somewhat the same way Cézanne did; by simplifying and summarizing forms, caking his paint, and opposing his values sharply. This freedom seems to have been soon abandoned for another. There come pictures in which local colors are permitted to assert themselves with an intensity new for that period—here Eakins and Homer approach closest to each other. The effect of the large uniform areas of high color in a painting of the artist and his father hunting reed-birds (1874) is modern; the *Biglen Brothers Turning the Stake* (1873), a rowing scene, is almost revolutionary in its vivid spots of blue and the throbbing, suppressed luminosity of its sunlight. But Eakins appears then and there to have lost the gift for the transparent shadow and the broken, traveling highlight that made his interior pieces and female portraits of the early seventies so powerful. He showed other sides of his talent, a greater enterprise in the investigation of appearances, and he was always able to make a successful picture out of any subject that showed light falling on or through soft fabric, but nothing he gained quite redeemed this loss. No

longer under the inspiration of the French, his development became one of private involution rather than of public expansion; he reentered academic painting, to destroy it by its own logic but not to add a new impulse to painting in general.

The ridges of paint which duplicate the flesh tones and follow the contours of a female nude done as a study in the early eighties are from the brush of a master. But many of the portraits of that time, especially those of men, show a mere pedestrian honesty, succumbing too frequently to the social or professional types of the sitters. Nevertheless, it can be held fortunate, I think, that the failure of Eakins's genre painting to win acceptance—or perhaps his own self-recognition—made him limit himself more and more to the portrait. For his later genre pictures, including those really original examinations of subject and atmosphere which are his prize-fight scenes, lack a final emphasis, some called-for tension between dark and light; while he continued in spite of everything to produce fine portraits to the end of his career, arriving at a way of defining variously lit planes in flat high tones with sharper divisions—as in the portraits of Mrs. Kershaw, Mrs. Eakins, and Ruth Harding. Here lighted surfaces *displace* rather than emerge from surrounding shadows. A synthesis of Manet's impressionism with Rembrandtian psychologism was pointed to, which no one after Eakins could sustain under the conditions of the twentieth century. Eakins's art, as Lloyd Goodrich says, founded no school. His realism caught up with that of the French and produced some discoveries tending beyond realism itself, but he did not change the basis of his painting on their account or incorporate them in a new style. He remained a realist, a profound one, and he also remained of the nineteenth century.

The present loan exhibition of his paintings (at Knoedler's) is in celebration of the hundredth anniversary of Eakins's birth, and was preceded by a large centennial show during April and May in Philadelphia, the birthplace and home of the painter. Both exhibitions are on the way to establishing a canon of his masterpieces; but some of the best examples of his art are not included—the portrait in the present Museum of Modern Art show, and one of a woman in a blue dress which was displayed two years ago in the show of modern portraits at the same place—while four or five of the pictures now on view ought not

to be put in any exhibition that intends to present Eakins at his strongest.

*The Nation*, 1 July 1944; A&C (substantially changed).

## 77. Alone: Review of *Dangling Man* by Saul Bellow

The plot of this novel—the situation of a man in Chicago, waiting to be drafted—is but its pretext. Not yet a soldier, nor quite a civilian, Joseph, the hero, finds himself isolated. No one around him can rightly appreciate his suspended position. His successful older brother's answer to all problems is money. Most of his friends who have escaped the draft see their solutions in careers as petty bureaucrats. His wife offers her capacity to feel, but how can she understand? A mistress can give him a momentary sense of escape—but it is only momentary, and more shabby really than anything else. All that happens to him Joseph finds irrelevant. He has to work out his solution in private. Society can no longer define him by assigning him a vocation, for he has given up his job and waits alone all day in a furnished room for the mailman. A woman lies dying in the house. An eccentric old bachelor shuffles about next door and gets on Joseph's nerves in a variety of ways. Over-reaction, under-stimulation—Joseph ends up by going to his draft board and asking to be called ahead of time.

The book suffers because its theme is not adequate to the more general and profound plight of which the author tries to make it a metaphor. The peculiar circumstances of Joseph's isolation do not fully account for his detachment, his failure to sympathize and participate, to commit himself. His attitude has deeper antecedents than his present fix, and for these the author does not search enough.

Joseph is that kind of special case which is the intensified expression of a much more general one. He is the latest homeless generation. A Jew—as is to be gathered from his milieu—and a petty bourgeois and an intellectual who keeps in step with his period, he has been in and out of radical politics and has read, like Faust, all the books. But now he is more at a loss than before

for a position on which to take his stand, an attitude equal at least to his personal problems. Self-realization and self-perfection are what he has come to want more than anything else, not to cope with history and collective difficulties—or to do that only to the extent that self-perfection requires. Meanwhile he refuses to commit himself. For his fellow beings he has nothing but snobbishness and priggishness, and his only standard is a literary notion of distinction. (The stilted gravity, the almost Kafkian formality of Bellow's style express this perfectly.) But the reader begins to suspect that Joseph's longings are more worldly than the author confesses. Perhaps all he needs is a change of environment, the company of really distinguished intellectuals and beautiful women. The suspicion persists because Joseph's disdain is not funded sufficiently with principles and is more a reaction to a particularly circumscribed way of life than to life in general.

I do not want to quarrel with this novel's defeatism in the same stupid, disgraceful, and paranoiac terms as did one of the editors of *Time*. Anyhow, I share that defeatism. But Bellow's narrative itself does not sustain it for the purposes of art. Joseph's crises are too internal and over-strained. Lacking movement and shape, the journal, which is the fictional device by which the story is told, converts the novel into itself and makes it a journal of confession in real fact, and with all the limitations of that fact. It is a book with many telling passages of insight and generalization, but these do not redeem its failure to hold the reader's attention firmly. One reads it with the same lack of tension with which one rads an actual journal.

Yet all these qualifications, all these serious demerits, take away surprisingly little from the real distinction of *Dangling Man*, which is its contemporaneity. Bellow is an advanced writer, aware of the true problems of writing as well as of experience in our time. He is ambitious on the level of great literature. He may lack the ease and knowledge to state his theme on the plane of a world novelist, but for all that his book is worth almost the entire remaining output of American fiction in the past year. It raises the relevant issues in a relevant manner, as no other recent American novel does.

The question as to what ideas one can live by in this period without betraying the fullest claims of consciousness and reason is

one that most American writers are poorly equipped to handle. It is for lack of aid from Bellow's colleagues—for lack of an objective novelistic framework—that this novel fails. Joseph, its hero, remains in the last analysis the raw material for one character among several others in a hypothetical and much longer novel.

*Contemporary Jewish Record*, August 1944

## 78.   Surrealist Painting

### I

Surrealism is the only programmatic and more or less compact aesthetic movement aside from Pre-Raphaelitism to affect directly more than one of the arts. The number of parallels between the two movements—already glimpsed by Herbert Read and R. H. Wilenski—are surprising. Both are inspired by an ambition which looked first to change the décor and then the structure itself of industrial society. Dissatisfaction with the state of the arts grew into a more radical dissatisfaction with the very quality of life, which could vent itself only through politics.

Like the Pre-Raphaelites, the Surrealists have gone, although less consciously, in two different directions. Morris and Ruskin made their way to revivalist socialism, while the other Pre-Raphaelites, reconciling themselves to the status quo, became fashionable missionaries of aestheticism and religiosity. The orthodox Surrealists have stood firm on socialism, yet their stand has not kept Surrealism from becoming largely identified with the younger generation of smart international bohemia, to whom the movement has furnished a new principle of taste. The desire to change life on the spot, without waiting for the revolution, and to make art the affair of everybody is Surrealism's most laudable motive, yet it has led inevitably to a certain vulgarization of modern art. The attempt is made to depress it to a popular level instead of raising the level of popularity itself. The anti-institutional, anti-formal, anti-aesthetic nihilism of the Surrealists—inherited from Dada with all the artificial nonsense entailed—has in the end proved a blessing to the restless rich,

the expatriates, and aesthete-flaneurs in general who were repelled by the asceticisms of modern art. Surrealist subversiveness justifies their way of life, sanctioning the peace of conscience and the sense of chic with which they reject arduous disciplines. Not all the steadfastness of its leader in protesting against corruption wherever he could see it has prevented this ambivalence in the effects of Surrealism from eating back into and corrupting Surrealism itself.

The Pre-Raphaelites, for all Ruskin's insistence on going to nature "in all singleness of heart," looked mostly to the past for inspiration as to motifs, style, and décor. The Surrealists, promoting a newer renascence of the *Spirit of Wonder*, have cast back to those periods after the Middle Ages which were fondest of the marvellous and which most exuberantly exercised the imagination: the Baroque, the late eighteenth century, and the Romantic and Victorian nineteenth century. Surrealism has revived all the Gothic revivals and acquires more and more of a period flavor, going in for Faustian lore, old-fashioned and flamboyant interiors, alchemistic mythology, and whatever else are held to be the excesses in taste of the past. Surrealism is "advanced," but its notion of the future is not too unlike the comic-strip fantasies about the twenty-first century.

The effects of Surrealism in art and literature have differed in much the same way as did those of Pre-Raphaelitism. In both cases literature has benefited more than painting—English poetry through the Rossettis and through Swinburne (who was at least influenced by Pre-Raphaelitism); French letters through Eluard, Aragon, Breton, and others. Both movements were essentially literary and placed all emphasis on the anecdotal, notwithstanding that the Pre-Raphaelite movement was made up largely of painters and that both Pre-Raphaelite and Surrealist poetry bears a strong pictorial impress. The pictures of the Pre-Raphaelites form a doubtful contribution, ratifying literary vices habitual to English art; while in the arts and crafts Morris and his followers practiced little more than antiquarianism. A good deal of Surrealist painting has similarly suffered from being literary and antiquarian.

## II

Surrealist writing more or less fulfils the Surrealist theory of creation as an automatic procedure uncontrolled by reason or the

deliberate consciousness. Inspiration is induced by surrender to immediate impulse and to accident; thus the writer—or painter —reveals his unconscious to himself and to his audience, whose own unconscious is stirred by echoes. But in the practice of painting it is much harder than in that of poetry—though equally difficult in theory—to tell where the unconscious stops and the reasoning will takes over. The poet, subjecting his invention to meter or rhyme or logic, knows that he thereby suspends the automatic process. But the Surrealist painter, beginning with the first thing that comes into his mind—with accidents met in the manipulation of his tools, or with hints from the seams and texture of Leonardo's old wall, finding in these ways suggested resemblances to actual objects, which he proceeds to improve upon—the painter is not so apt to realize that he interrupts the automatic procedure the moment he begins to enhance these resemblances by methods taught in art school. For the trained painter can exercise the consciously acquired habits of his craft while seeming to absent his mind's attention and rely solely on his hand and eye. This, however, is not the same as automatic creation. Rubens had Plutarch and Seneca read to him while he painted, but he did not withdraw his conscious attention from his work, he simply divided it, like any painter one knows who can carry on a conversation while working. There was indeed an element of automatism in Rubens's art, as there is all successful art, but it was not the primary factor in the process by which it was created.

The difference between automatism as a primary and as a secondary factor is responsible for the two different directions in which Surrealist painting has moved. On the one side are Miró, Arp, Masson, Picasso, and Klee—the last two of whom are claimed by the Surrealists without their ever having formally attached themselves to the movement. On the other side are Ernst, Tanguy, Roy, Magritte, Oelze, Fini, and a myriad more, including Dali, who was several years ago excommunicated by the orthodoxy for political, not artistic, deviations. With the first group automation may be relatively complete or incomplete, but in either case it is primary as a rule and intervenes decisively—even though it is impossible to determine with any satisfying exactness where in their painting the automatic stops and the conscious begins. The artist may doodle his picture from start to finish, or he may elaborate accidentally discovered repre-

sentational elements, or he may begin with a definite eidetic image. But he will never use methods learned at art school, and the resemblances to actual phenomena will be schematic rather than realistic. A dog barking at the moon is indicated by certain unmistakable signs, but these are in the nature of provocations to the artist's "painterly" imagination, which seizes upon the signs as excuse for elaborating shapes and colors which do not image anything possible even as an idea off the flat picture surface. The dog and the moon become the springboard, not the subject of the work. Here the reliance upon the unconscious and the accidental serves to lift inhibitions which prevent the artist from surrendering, as he needs to, to his medium. In such surrender lies one of the particular advantages of modern art. Surrealism, under this aspect and only under this, culminates the process which has in the last seventy years restored painting to itself and enabled the modern artist to rival the achievements of the past.

The other direction of Surrealist painting can best be charted by fixing the almost invariable point at which the automatic procedure stops. Here too inspiration is sought by doodling, or in accidents of the medium, but it is found most often in images offering themselves spontaneously and irrationally to the artist's mind before he picks his brush up. Sometimes he claims to do nothing more than transcribe a dream. But even the doodling, the rubbing of pencil on paper over a rough surface, or the observation of Leonardo's old wall is a means primarily of anticipating or inducing images, not of creating the picture itself. Automatism is made a secondary factor; for this type of Surrealist painting wishes to preserve the identifiable image at all costs, and complete automatism goes too far in the direction of the abstract.

Having received his inspiration, the painter most consciously goes to work to clothe the given image in pictorial forms that will produce a strong illusion of its possible existence in the world of real appearances. The subject matter is different, but the result is the same that the nineteenth-century academic artist sought. It makes no difference that the creatures, anatomies, substances, landscapes, or juxtapositions limned by the Surrealist violate the laws of probability: they do not violate the modalities of three-dimensional vision—to which painting can now conform only by methods that have become academic. For all the problems involved in transferring faithfully the visual ex-

perience of three dimensions to a plane surface have been solved by this time, and where all the problems have been solved only academicism is possible. The Surrealist represents his more or less fantastic images in sharp and literal detail, as if they had been posed for him. Seldom does he violate any of the canons of academic technique, and he vies with and sometimes imitates color photography, even to the very quality of his paint. Dali's discontinuous planes and contradictory perspectives approximate photomontage. Ernst's volcanic landscapes look like exceptionally well manufactured scenic postal cards.

### III

The Surrealist motive for a naturalistic technique is plain. The more vividly, literally, painstakingly the absurd and the fantastic are represented, the greater their shock. For the sake of hallucinatory vividness the Surrealists have copied the effects of the calendar reproduction, postal card chromeotype and magazine illustration. In general they prize the qualities of the popular reproduction because of its incongruously prosaic associations and because the reproduction heightens illusionistic effect by erasing paint texture and brushstroke.

Another motive is the desire to sin against decorum, violate all the rules, do the disreputable thing, and attach oneself to whatever seems discredited. Advanced painting since the impressionists has established a certain decorum, a notion of the aesthetically relevant, which the Surrealists find pompous, as they profess to find all relevancies pompous (this makes another of the possible rationalizations of the disassociated or disconnected image). Dali turned on post-cubist painting, praised Meissonier and commercial illustrations, and asserted his contempt for "formal" values by the deliberate but just as often unconscious negligences of his own painting. Thus he made a virtue of his shortcomings. Granted that irreverence has a necessary function in our time, yet irreverence as puerile and as widely welcome as Dali's is no more revolutionary than fascism. But of course Dali is not to be taken seriously as anything other than a symptom. He is the Ossian of our day.

### IV

The decisive question is whether the Surrealist image, as illustrated in the works of Ernst, Dali, Tanguy, and the other painters

of their kind, provides painting with a really new subject matter. That is, must hitherto untapped possibilities of the medium be explored in order to accommodate the Surrealist image? As far as painting alone is concerned, does it involve a new way of seeing as well as new things to be seen? For such painters as Miró, Arp, Masson, and Picasso, it certainly does. But not for Ernst, Dali, Tanguy, Oelze, Roy, Magritte, Dominguez, Brauner, Delvaux, Fini, *e tutti quanti*, who do indeed see new things, but no differently in essence than painters of the past would have seen them had they accepted Surrealist notions of subject matter. The Surrealist image is thus a new object to be posed and arranged, but it requires no fundamental change in the conventions of painting as established by the Renaissance. Given the same subjects, Meissonier, Ford Madox Brown, or Greuze would have approached the same effects. There would be the same modelling, shading, and spacing, and the same color schemes, although the hues themselves would be a little less saccharine or brassy and a little less unbroken.

The Surrealist image provides painting with new anecdotes to illustrate, just as current events supply new topics to the political cartoonist, but of itself it does not charge painting with a new subject matter. On the contrary, it has promoted the rehabilitation of academic art under a new literary disguise. The maxim *nulla sine narratione ars* is true enough, now as before, but the Surrealists have interpreted it vulgarly to mean that there can be no picture without an anecdote. The tradition of painting which runs from Manet through impressionism, fauvism, and cubism has created the first original art style since the French Revolution, and the only original one our bourgeois society has been capable of. All its other styles are revivals. That style is now threatened for the first time from the inside by Surrealist painters, and by the Neo-Romantics and "Magic Realists" who bring up their train. These painters, though they claim the title of avant-garde artists, are revivers of the literal past and advance agents of a new conformist, and best-selling art.

The Surrealists have, like the Pre-Raphaelites, reinvigorated academicism by their personal gifts—which are undeniable—and by going to either a remoter or a more discredited past for guidance; in distinction from self-confessed academicists, who try to keep abreast of the time by watering down yesterday's advanced art. Taking their lead and most original impulse from

Chirico—that archaizer who made a small but valid contribution—the Surrealists prefer Mantegna, Bosch, Vermeer, and Böcklin to the Impressionists. This does not make their painting any the less academic, but it does make it livelier, disturbing, and more attractive to new talents: adroit talents who read Rimbaud, have a sense of format, finish, and *mise en scène*—and can at least draw seriously. (The drawings of Ernst, Dali, and especially Tanguy are adventurous and original in a way that their paintings are not. The compelled economy of the line exposes their art to problems which are on the order of the day and which they otherwise evade by taking refuge in the ancient arsenal provided by the traditions of oil painting.)

Prompted by a real dissatisfaction with contemporary life, the art of these Surrealists is essentially one of vicarious wishfulfilment. Its very horrors are nostalgic and day-dreamy, having associations with a more pleasant-seeming past, which is resuscitated in brighter, iridescent colors, smoother contours, glossier surfaces, and sharper outlines. The artist shows us how he would prefer life to look or how—as children do—he would prefer to be frightened. His wish is painted with such an illusion of super-reality as to make it seem on the brink of realization in life itself. The result is indeed a new and interesting kind of pictorial literature, but it is more literature or document than painting or art.

It is possible, I believe, to construct faithful duplicates in wax, papier maché, or rubber of most of the recent paintings of Ernst, Dali, and Tanguy. Their "content" is conceivable, and too much so, in other terms than those of paint. But the pictures of Picasso and Miró attain virtuality as art only through paint on a flat surface, and they would disappear utterly if translated elsewhere. Which is also true of the works of the old masters.

*The Nation*, 12 and 19 August 1944; *Horizon*, January 1945.

79.   Review of an Exhibition of José Guadaloupe Posada

An exhibition of some six hundred prints and blocks from the hand of José Guadaloupe Posada, with photostat enlargements of several of the prints, has just opened at the Brooklyn Mu-

seum. Posada was one of the most original of the exponents of an indigenous popular art in post-Columbian North America; his prints are somewhat equivalent to those of Currier and Ives but far superior to them as art. His memory has received much attention lately, and his work much praise. Dying in 1913 at forty-one, he left behind more than twenty thousand wood and metal engravings and lithographs, not one of which seems negligible. Their crudeness of texture reinforces their effect, and that effect is macabre, humorous, and subversive. Their virtues as illustration are inextricably involved with the power of the design and draftsmanship which went into them. And Posada sensed as very few graphic artists ever have the potencies of black and white as sheer color above and beyond the context in which they act only as descriptions of line, mass, and space.

Still, all this ought not to be exaggerated. Posada's art was after all limited in its range. The same points are made again and again. The patterns in which the picture rectangle is organized are unerring yet repetitious—the center of gravity usually coinciding with the dead center of the page—and the grays, for all their strength, are always used in the same way. Nevertheless, the prints of this Mexican artist remain of almost inexhaustible interest.

*The Nation*, 30 September 1944

## 80. Review of an Exhibition of Abraham Rattner

Talent, ambition, and a sojourn in Paris have done as much as they could for Abraham Rattner. The rest must be supplied by the pressure of intelligence and feeling. What Rattner has produced so far is more the proclamation than the result of emotional pressure. Rattner should not let himself be over-tempted by the succulence of paint; he should relinquish some of the richness and ripeness, the hot vitreous color, and the attempt to synthesize Rouault, stained glass and its leading, cubism and Picasso.

Rattner's latest work (at Rosenberg's) shows he has advanced, nevertheless, in the last year or so. The elements of a tighter and

less clamant art begin to appear in the small, fractured, prismatic details in the central passages of some of the new pictures. The energy, however, is wastefully concentrated at the geometric center of the canvas and dissipated elsewhere. The orange sun at the top and the brown banjo at the bottom of the big *Clowns and Kings* jump out of all relation to the powerfully invented pattern in the middle. Like Masson, Rattner remains one of those artists who seem never to be able to escape the state of promise.

*The Nation*, 14 October 1944

81.  Context of Impressionism: Review of *French Impressionists and Their Contemporaries*, prefaced by Edward Alden Jewell

Impressionist painting was one of the graces of the Third Republic, and like the Third Republic it was a historical episode, not a classification or genre. In his preface to this book Edward Alden Jewell, the art critic of the *New York Times*, makes a despairing attempt to decide just which painters the impressionist label belongs to. He considers the hallmark of impressionism to be "divisionism," or divided tones and colors: colors optically blended by juxtaposition on the canvas rather then by mixture on the palette or by glazing or scumbling. But he admits that this principle was constantly violated by everyone except the "post-impressionist" Seurat, and that Monet was later on the only one to show the disregard for composition that is supposed to be another standard trait of impressionists. Mr. Jewell gets into all this trouble because he has somehow forgotten that impressionism began with neither the divided tone nor the accidental composition.

As R. H. Wilenski has pointed out, impressionism emerged from realism in the early eighteen sixties with Manet's *peinture claire*, which eschewed under-painting and worked from light to dark instead of the other way about, as was the academic practice. *Peinture claire* was a means of painting more quickly so as to seize fleeting effects, and was also a response to the new way

shown by photography of describing variations of light. Manet, Monet, and Pissarro painted under photographic influence well into the eighteen seventies, suppressing local color in order to follow the play of light and dark by tinted tonalities of gray. The work they produced in this phase is just as much a part of impressionist painting as the rainbow-hued pictures painted under Renoir's lead in the eighties and later. Degas, who, according to Mr. Jewell, was never an impressionist, felt this influence of photographic light values at about the same time as the others —his franker, smoother use of color ought not to obscure this; and he also owed to photography the impulse toward his innovations in design. Moreover, Degas's pastels rely greatly on broken or divided color—above and beyond the fact that the nature itself of that medium has a tendency to impose divisionism on the artist who uses it for more than a sketch.

The question as to who were and were not impressionists is relatively unimportant. Divisionism was only a phase of impressionism, and impressionism was a historical phenomenon. The main thing is that what Manet, Monet, Renoir, Pissarro, Degas, Sisley, Morisot, Cézanne, Van Gogh, Gauguin, Seurat, and Toulouse-Lautrec had in common was more important historically and for the purposes of terminology than what they did not have in common. What they shared was an attitude and practice which, having originated in an attempt to limn nature with the utmost fidelity, culminated in the exaltation of painting as something capable of producing results in its own terms superior to the results of the imitation of nature as practiced in the nineteenth century.

*French Impressionists and Their Contemporaries* marks an advance in American standards of reproduction. Several of its fifty-one color plates approach the level of Austrian and German work in this field. For this André Gloeckner, who supervised the production of the book, deserves credit. In addition to works of the artists mentioned above, examples are reproduced in black and white as well as in color from the hands of Corot, Monticelli, Boudin, Guillaumin, Redon, Forain, Signac, Cassatt, Carrière, Bonnard, and Vuillard.

*The Nation*, 21 October 1944

The occasion for a disappointing show of Winslow Homer's work at the Whitney Museum is the publication of a definitive biography of the artist by Lloyd Goodrich, the research curator of the museum. The book is disappointing too, and Homer's responsibility for that is even greater than in the first case, since the museum may have wished to compose its show mainly of pictures unfamiliar to New Yorkers. And while Mr. Goodrich could have put more life into his book by trying to situate Homer in a larger context, the fact remains that Homer himself had practically no life aside from his art.

It was characteristically American that Homer should have distrusted tradition, books, and the art of others, that he should have been unable to learn from them and have taught himself to paint. It was characteristic of a certain side of New England that he should have been incapable of marrying or of living with others. But it was not characteristic of such a rough-and-ready artist—however so it may have been of more cultured protagonists of the arts and letters in this country—that Homer's store of vital energy should have been so limited or his fear of experience so intense. He liked to fish and go on camping trips. He was attached to his father and one of his brothers. He was afraid of strangers. He saw something of the Civil War. He lived in New York for a time, went to Europe twice, traveled in the West Indies, and spent most of the latter half of his life on the Maine coast. He was small, dapper, reserved, and dull. He had no inner life worth mentioning. He was able after a while to support himself comfortably by his art; he did not sell too well but not too badly either. By the time he was sixty he had become accepted as one of our greatest artists. He died in 1910 at the age of seventy-four. Mr. Goodrich's intelligent, conscientious, and complete account of this life makes, of necessity, hard reading.

But this takes nothing away from the fact that Homer was of real consequence as an artist. Though he never really touched greatness, he demonstrated originality and strength. He founded an American school of water-color painting, and in oil he developed, independently, certain revolutionary tendencies parallel to those of his more illustrious contemporaries in France.

To my taste those pictures Homer painted in the very beginning, in the late eighteen sixties and early seventies, just after he gave up working exclusively as an illustrator in black and white, are the best of his oils. Possessing an innate and sophisticated draftsman's talent and enough professional competence to keep his values and color intensities aligned, he began with warmly toned canvases in the then prevailing genre style which set themselves apart immediately by their crispness of drawing and design and a new, even if crude, clarity of color. Mr. Goodrich ventures that Homer may have been influenced by the general atmosphere of French painting during his stay in France in 1867, but the evidence does show that he had already independently anticipated the style founded on photographic light values that Manet was establishing—and it is doubtful whether Homer saw any picture by Manet at this time.

Apprenticed to a lithographer in his youth, Homer had copied portrait photographs. And the sharp, simplified opaque contrasts of shadow and light in his earliest oils, as well as their flatness of modeling and hot, laid-in color, which decorates rather than contributes to the expression of form, may be owed to this early acquaintance with the camera's results. What may also have been responsible was Homer's practice at first of making his painting from sketches done outdoors under the hard, blazing light of an American summer—a kind of light he was unlearned and naively naturalistic enough to try to capture without interposing preconceptions based on atmospheric effects belonging only to the experience of European light.

Eakins likewise produced his best oils at the beginning of his career, in the late sixties and early seventies; which leads one to speculate whether there wasn't some fertilizing current abroad in those years which transfigured for a moment at least the art of any instinctive realist young and open and talented enough to receive it. Once this moment had passed, both Eakins and Homer withdrew into themselves and paid no further heed to revolutionary outside influences. And in the eighties, if not thereafter, the art of both men suffered a decline.

Homer in the eighties succumbed to a sentimental, picturesque, middle-keyed genre style then popular among French academicists and much imitated by Anglo-Saxon artists; it had for its principal subjects melancholy landscapes and peasants, pref-

236

erably female. In Homer's case it was the English fisher girls at Tynemouth, where he spent most of 1881 and 1882. Afterward, or concurrently, he seems to have come somewhat under the influence of the Whistlerian tone poem, lowering his color key still farther and confining himself to cool and neutral tones, with the emphasis laid on subtle displacements of darks and lights—a reaction perhaps to the violence with which he had treated them before.

Given Homer's essential tenacity to his own proper gift—not to mention his supposed immunity to influences—a more learned artist would not have been so easily distracted by contemporary fashion. Even so, there were some rewards: mysterious scenes of beaches at dusk in deep blues, violets, mauves, and admixtures of gray, with female figures in the foreground. The poetry was undeliberate but all the more effective for that. Maybe it expressed something of the diffidence and trouble with which Homer approached women. What it certainly did carry was his special feeling for the sea.

There was a streak in him of the popular romanticism of the violent and melodramatic. At Tynemouth he first felt that fascination of the sea in its menacing aspects which was not to leave him the rest of his life. The sea seems for Homer to have been subconsciously connected with sex (for Poe too). One of his chief themes during the eighties was that of women being saved from drowning or shipwreck, their wet clothes clinging so tightly that their figures approximated the nude—which Homer hardly ever attempted otherwise. Later on the theme was to be merely the raging surf, with now and then a woman's figure on shore. As with Stephen Crane, another would-be literal realist, Homer's matter-of-fact vision, directed out of doors, usually alighted on something that moved dramatically, were it only waves or a fish leaping.

In the middle seventies Homer began to use water color seriously. Most critics agree that he made his greatest contribution in this medium, showing a sensitivity to its assets and liabilities such as he never manifested in his oils, whose form remained thin and papery, and color brittle in spite of everything. The quick and summary brushwork in his water colors, the bold modulations of values to define form and recession, the advantage taken of the transparence of water and the texture and white

of the paper to secure luminosity, the sure instinct with which he laid out, flattened, and simplified his main masses—all this gave something new and important to the art. But it took the brilliance and color of the West Indies to justify Homer's daring to himself. He had not intended to innovate. The brilliance was there before him; he painted it. And it was all part of the logic by which his naively possessed but far from naive gift had to develop.

Some of the lightness and discreet splendor of the water colors flashed into the oils occasionally. But he could never quite cure himself of a coarseness of execution in the latter medium, an inability to exploit the texture of paint for increased resonance of tone and color. The cause lay, I think, not only in the fact that Homer had taught himself to handle oil, but also in a curious contempt he had for the physical substance of his art, for physical substance in general—which contempt had less purchase in the more ethereal and direct medium of water color. Homer's methods of work seem to bear all this out. He would spend weeks and months pondering a motif, waiting for the right weather and light, but once he started to paint he worked fast and almost impatiently. That is, he placed too high a price on the final result and valued the activity itself of painting too little.

It is an anomaly that a New Englander like Homer should have been one of our greatest painters. It seems even more anomalous that he should have been an irreligious materialist— which he was without being aware of the implications—and that at the same time he should have had such disdain for matter. But the anomaly is only a seeming one. The materialist can condemn matter as much as any mystic. Like a good American—and Homer was one—he can love the abstract fact more than anything else.

*The Nation*, 28 October 1944; A&C (substantially changed).

83. Review of *Art in the Armed Forces: Pictures by Men in Action* and *Of Men and Battles* by David Fredenthal and Richard Wilcox

Two volumes of pictures by men in the service have recently appeared: *Art in the Armed Forces: Pictures by Men in Action* and *Of Men and Battles*, with pictures by David Fredenthal and text by Richard Wilcox. Both items are negligible as art but they do have value as documents and reportage. They remedy some of the omissions of the camera's record of the war—omissions due less to the limitations of photography than to those of contemporary photographers. The camera shot has become and will continue to be a formula until the newspaper and magazine photographers who are the chief sustainers of the medium approach their art with a little more self-consciousness and ambition. David Fredenthal and the artists in the armed forces have their full quota of clichés, but it has become a firm tradition by now that whoever works with pencil or brush practices art and has a right to the pretension and daring that go with art. So that even some of the clichés are daring. These drawings and paintings lack the vivid, immediate, upsetting truth of photography, but they describe and narrate more completely and much more connectedly. They tell you not so much what the army and navy look like as what it is like to be in them. Even Matthew Brady could not show that.

*The Nation*, 4 November 1944

84. Review of Exhibitions of William Baziotes and Robert Motherwell

All credit is due Peggy Guggenheim for her enterprise in presenting young and unrecognized artists at her Art of This Century gallery. But even more to her credit is her acumen. Two of the abstract painters she has recently introduced—Jackson Pollock and William Baziotes—reveal more than promise: on the strength of their first one-man shows they have already placed themselves among the six or seven best young painters we possess.

239

Baziotes, whose show closed last month, is unadulterated talent, natural painter and all painter. He issues in a single jet, deflected by nothing extraneous to painting. Two or three of his larger oils may become masterpieces in several years, once they stop disturbing us by their nervousness, by their unexampled color—off-shades in the intervals between red and blue, red and yellow, yellow and green, all depth, involution, and glow—and by their very originality. Baziotes's gouaches had their own proper quality, which is the intensity of their whites and higher colors. But many of his pictures were marred by his anxiety to resolve them; the necessity of clinching a picture dramatically, also the sheer love of elaboration, led him to force his invention and inject too many new and uncoordinated elements into the coda, so to speak. This coda was usually found near the upper left-hand corner of the canvas, where *shapes* would first appear, while the remainder of the surface would have been dealt with in terms of the division and texture of *area*, and asked to be resolved according to the same logic. Baziotes will become an emphatically good painter when he forces himself to let his pictures "cook" untouched for months before finishing them. He already confronts us with big, substantial art, filled with the real emotion and the true sense of our time.

Robert Motherwell's first one-man show, also at Art of This Century, makes Miss Guggenheim's gallery almost too much of a good thing. Motherwell is a more finished but less intense painter than Baziotes, less upsetting because more traditional and easier to take. One is Dionysian and the other Apollonian. Motherwell's water-color drawings are of an astonishing felicity and that felicity is of an astonishing uniformity. But it owes too much to Picasso, pours too directly from post-cubism. Only in his large oils does Motherwell really lay his cards down. There his constant quality is an ungainliness, an insecurity of placing and drawing, which I prefer to the gracefulness of his water colors because it is through this very awkwardness that Motherwell makes his specific contribution. The big smoky collage *Joy of Living*—which seems to me to hint at the joy of danger and terror, of the threats to living—is not half as achieved as the perfect and Picasso-ish *Jeune Fille*, yet it points Motherwell's only direction: that is, the direction he must go to realize his talent—of which he has plenty. Only let him stop watching himself, let

him stop thinking instead of painting himself through. Let him find his personal "subject matter" and forget about the order of the day. But he has already done enough to make it no exaggeration to say that the future of American painting depends on what he, Baziotes, Pollock, and only a comparatively few others do from now on.

*The Nation*, 11 November 1944

## 85.   Review of an Exhibition of Eugène Delacroix

Baudelaire, no less incomparable as an art critic than as a poet, wrote that one of Eugène Delacroix's prime qualities is that he is "essentially literary. His painting has not only traversed the field of high literature with unfailing success, not only has it translated, not only has it constantly visited Ariosto, Byron, Dante, Walter Scott, Shakespeare, but it is also able to reveal ideas of an order higher, subtler, and more profound than the greatest part of modern painting. And observe carefully that it is never by the detail, by the grimace, or by tricks of technique that Delacroix obtains this great result, but by the ensemble, by the deep and complete accord of color, subject, and drawing, and by the dramatic gestures of his figures."

I should like to add: observe also how small a part of this "literature" inhabits the clear, warm, and banal realm of the anecdote, the only realm accessible to those who demand of painting that it address itself *directly* to curiosity and reason. The test of art for them is its viability in words. Despite all the "human drama" bodied forth in Delacroix"s pictures, such spectators are kept at a distance by a sense that the point of his painting lies elsewhere than in the explicit meaning of that drama.

The slanting arabesque of *Desdemona at Her Father's Feet* tells nothing as to why Desdemona is at her father's feet; instead, it generalizes her attitude beyond anything even so unspecific as supplication. It gives a hint of the quality of *all* emotion. The reaction awakened can be named but not defined or limited by its cause on the canvas: the subject is but a pretext—local and specific only because it is of the nature of art to require its pre-

texts to be so, since the generalizing function belongs chiefly to the medium. (The picture in question can be seen at the magnificent Delacroix exhibition now at Wildenstein's.)

Delacroix was one of the greatest painters, known or unknown, who ever lived. Unlike Picasso's, his temperament was equal to his gifts, though at moments he ran the danger of being confused by them—as Picasso often is. For his art was perturbed by a typically romantic set of contradictions. Arch-romantic, he sometimes bridled when called a romantic. He yearned for serenity, yet gave himself up to passion and excitement, in his life as a man about town as well as in his art. By natural bent and according to all the theoretical conditions of his practice he was an easel-painter par excellence, yet his greatest performances are mural panels and decorations. By instinct a *peintre de métier* if there ever was one, he was at first contemptuous of *cuisine* and eager for quick effects, and used bituminous colors which shortly plunged the deeper passages of many of his early pictures into opaque darkness. (The tempo of his century could not let Delacroix wait two years, as Titian had waited, for a layer of paint to dry before applying the next glazes.) He had a fine intelligence, much culture, and wrote well on art, music, and literature; yet he was carried away, like an adolescent, by enthusiasms. He painted what in an illustrative sense is still the most revolutionary of all pictures, *Liberty Guiding the People*—in which he, preeminently painter of the exotic and historical, introduced a top hat for the first time; yet he was chronically bored by politics, sold his pictures to the state with peculiar success, and was richly honored by the Second Empire. (There is a plausible supposition that Delacroix was an illegitimate son of Talleyrand.) And nevertheless he was a man of 1848 for whom, as for Baudelaire, the anti-climaxes of 1848–52 liquidated a certain emotional investment in current history. (Sad to relate, for a Socialist like myself, the conviction both Delacroix and Baudelaire acquired from then on, that art was the only field of meaningful achievement left, redounded to the great benefit of their practice.)

Delacroix's painting relies on antitheses as much as Victor Hugo's poetry. It is all confrontation, contradiction, opposition, and exchange. The swirling, intersecting diagonals of his pictures are checked and rebuked by a framework of superbly ad-

justed values. The secret of his color, that glorious color which flamed out as Delacroix approached his fiftieth year, lies in the antithetical interweaving of warm and cool tones: a touch of blue or green tinctures the red; a touch of pink or yellow modifies the blues and greens: red in the deep shadows, blue in the half-tones. A dark mass in the nearest plane asserts its right to its place by turning into deep violet and coming forward (see the dog at the very bottom of the great panel *Diana Surprised by Actaeon*). Beneath the magnificence is scattered an underpainting of white tempera which infuses a glow into every dominant tint. And all is handled with bravura, a high indifference to detail and finish, and a broad laying on of the brush which leaves the canvas still vibrating.

Delacroix's contemporaries, hypnotized by the feats of Ingres's line, asked whether he could really draw. For us it is self-evident. As if draftsmanship were separable in the end from the totality of the accomplishments of a great painter, except in so far as it is a compensation for the lack of some other accomplishment—Ingres's lack, for instance, of aptitude for color. (As Ruskin first suspected, we praise Michelangelo's drawing more than Tintoretto's because among other things Michelangelo's color is so much inferior.)

Yet Courbet, as quoted by Georges de Batz in the Wildenstein catalogue, put his finger on something when he mentioned Delacroix's "shapeless form"—Courbet, whom Delacroix accused in turn of "impotence in the matter of invention." Being delivered over so much to movement and rhythm, romantic form would become somewhat flaccid, disjointed, and tend to spread unduly over the surface. It was too late for Delacroix to recapture that simultaneity of contour and color which was the great consummation of the Venetians. The flat plane surface was already beginning to push up from the depths of the picture and deflate the sculptured volumes. Reflected light cross-mating with reflected light—impressionism was on the way.

Eugène Delacroix marked one of the great turning-points in the history of Western painting. He was the first artist since the mid-eighteenth century to look back at Rubens and the Venetians; but after him and Courbet—who looked back at the Dutch—all turns and goes toward a new future. From then on none of the great figures except Renoir will stop to cast more

than a comparatively fleeting glance back at the Renaissance past, however much they haunt the Louvre and talk of rendering Poussin according to nature.

*The Nation*, 18 November 1944

## 86.   Review of an Exhibition of John Tunnard

The abstract painter John Tunnard, of Lincolnshire and Cornwall, is being introduced to this country by a show of gouaches at Nierendorf's. Tunnard's Gothic fragility, his singing webs and neutral color are too gossamer for the watery medium and need the heaviness of oil to hold them down and solidify them. It is perhaps to accommodate himself to gouache that Tunnard has ventured to use larger masses and more varied colors. But whereas his oils have a tendency to succumb to the temptations of the felicitous and of good taste, his gouaches come very close to the kind of esoterica the Baroness Rebay sponsors and fosters at Art of Tomorrow. It is unfair, however, to judge Tunnard exclusively by them. His oils are usually a different matter, sacrificing nothing to their delicacy, and enjoying the benefits thereof without most of the liabilities. Yet, even so, whether Tunnard has anything very important to say becomes a moot question in the light of these gouaches.

*The Nation*, 18 November 1944

## 87.   Review of *Leonardo da Vinci: His Life and His Pictures* by R. Langton Douglas

R. Langton Douglas's *Leonardo da Vinci: His Life and His Pictures* is devoted mainly to fact-finding: yet in the course of his investigations the author manages to say more sensible things about Leonardo and his art than I have yet seen elsewhere. To be sensible about Leonardo is to debunk him a bit. Universal genius he was—but also inconstant, easily bored, careless, and

lacking in tenacity and thoroughness: a master of promises not of fulfilment. His very range of interests was produced in part by his incapacity to sustain his own interest in any one project. Thus he left behind only a small number of finished paintings, and of these only two or three have resisted time, weather, and natural chemical action as they should have. Mr. Douglas ventures to say that "Leonardo, whilst he was one of the greatest of men, was not one of the greatest of painters." However, "he was an innovator, a pioneer, who helped blaze the trail that other leaders of art movements were destined to follow." The first statement is absolutely necessary to the health of art criticism.

*The Nation*, 2 November 1944

88.  Some Excellent Reproductions: Review of *Paul Klee, Drawings* by Will Grohmann and *Masterpieces of Painting from the National Gallery of Art*

The standard of color reproduction at popular prices set for this country by several of the plates in Hyperion's recent *French Impressionists* is surpassed in *Masterpieces of Painting from the National Gallery of Art*. The quality of the eighty-five color plates in this book—all of works in the National Gallery at Washington—is much more constant. Each reproduction is accompanied by a quotation from a famous writer—Ovid, Dante, Hegel, Henry James, Berenson, T. S. Eliot, and many others. The excerpts could not have been better chosen.

And there has just been republished in portfolio form a book of excellent reproductions of Paul Klee's line drawings, edited by Will Grohmann, which first appeared in 1934 in Germany, only to be confiscated as "degenerate art." Grohmann's original and valuable introduction is given in English. These drawings exhibit the essence, the very nerve fibers, of Klee's art.

But perhaps it is necessary to remind the reader that reproductions are never completely satisfactory and that there is no substitute for a visit to the originals.

*The Nation*, 9 December 1944

Landscape and still life are the genres in which painting since early in the nineteenth century has been most at home, particularly in this country. In their treatment of nature and the familiar, handled object, our minor painters found an inflection all their own, expressing a hesitance, a delicate diffidence toward the world around them. The result was pathos, charm, domesticity; somewhat the same attitude produced somewhat the same result in English painting. But an art ambitious in any real sense must discard reserve and treat nature high-handedly, coloring it with more subjective emotion or imposing anthropological order upon it. Anglo-Saxon painting was usually not ambitious enough—yet achieved in compensation a unique lyric charm.

Marsden Hartley was half lyricist and half architect, then half fauve and half expressionist; this was his difficulty and the source of the unevenness for which he is blamed. The many different influences, impulses, and aspirations woven into his art sharpened these contradictions. Alternately or simultaneously he converted his means from Rouault, Ryder, Cézanne, Derain, Vlaminck, Segonzac, Courbet, cubism, Oriental art.

In 1928 Hartley wrote that he was renouncing "imagination." "I have lived the life of imagination, but at too great an expense. . . . I have made the complete return to nature, and nature is, as we all know, primarily an intellectual idea." But intellect had always played a large role in his painting, though not in the way he imagined. Hartley's notion of modern art was that of stylization: impressionism, expressionism, cubism, abstractionism were for him so many different modes of stylizing, and his effort to stylize was deliberate—and characteristic of that sad misapprehension of "modernistic" art under which so many of the first attempts to acclimatize post-impressionist tendencies over here were made. Cubism, for instance, was taken for something decorative, to be *applied*. The organic, internal necessities from which cubism, and nothing else, had to issue were not felt.

Hartley was preeminently a man of emotion, and started from emotion. But he succeeded only when his applied aesthetic broke down and the emotion broke through—that is, when he

kept his eye on the end instead of on the means. Yet even in his best work a final pressure is missed that could have come only from a higher spontaneity. A certain excess of feeling, which he could not quite handle in paint, sought its way out through an unconscious symbolism of stylized shapes that partook more of writing than of painting, where it seemed an unwarranted, un-painterly, too deliberate intrusion. It was not for nothing that Hartley wavered between poetry and painting. The sadder re-sults of stylization can be seen particularly in his later figure pieces with their raw reds and hot blues, where design becomes arithmetical, stiff with symmetry, parallel verticals, and objects arranged seriatim in rows. Few of these strictures apply, how-ever, to his still lifes, which are most free of stylization.

In Hartley's best work every color is successfuly related to black—as in Rouault. After his early fling at the high palette of the later impressionists and of the fauves, he went to earth col-ors, prussian blues, dark grays, and blacks and chalky whites. He painted his strongest still lifes in earth colors, adopting the tonal keys and the massive simplifications of shape and value of Derain and Vlaminck. For a while during the last war he flirted with cubism and a kind of abstractionism, giving the latter a German accent and typically and almost completely misunder-standing both. But he soon returned to his dark still lifes and to monumental landscapes influenced, I think by Segonzac and certainly by Ryder. He was never quite at ease in the landscape and made it too much a matter of architecture, which was wrong, because his gift was for the close at hand, the tangible, not for the ambiguities of space—or rather he could not organize space that he could not touch. Thus his still lifes show far more three-dimensional quality than he ever attained in landscape or seascape, where his habit of reducing the salient incidents of surface as well as form to drastially definite and monolithic silhouettes denied space by decorating it. Even the best of his open-air pictures—and some of them are very good—have a disturbing thinness; one wants something more under the paint surface itself.

There was in Hartley something of the seer and enthusiast in the William Blake line. He eschewed the oracular, but his art still seems to yearn toward an esoteric center. The stylization, the objects—the birds, fish, the archaic formalization—the

carved clouds, hammered surf, modeled mountains—all hint at yang and yin, the cabala of fish, trees, and old shoes. The resemblances in Hartley's painting to Oriental art, more a question of spirit than of matter or influences, are not accidental.

Hartley died in 1943 at the age of sixty-six. The present comprehensive exhibition of his work at the Museum of Modern Art and the joint show at Knoedler's and Rosenberg's reveal him as of greater stature than one had thought. He was not a great artist, and, as I have said, he was radically uneven, but his reputation will grow as time passes. The limitations of the art are in some peculiar way redeemed by the large character of the man.

*The Nation*, 30 December 1944

# Bibliography

## Works by Greenberg

### Uncollected Writings, 1939–1949

"An Interview with Ignacio Silone." *Partisan Review* 6 (Fall 1939): 22–30.

With Dwight Macdonald. "10 Propositions on the War." *Partisan Review* 8 (July-August 1941): 271–78.

With Dwight Macdonald. "Reply" (to Philip Rahv, "10 Propositions and 8 Errors," in the same issue). *Partisan Review* 8 (November-December 1941): 506–508.

"L'art américain au XXe siècle." *Les Temps Modernes* 2 (August-September 1946): 340–52.

### Books

*Joan Miró*. New York: Quadrangle Press, 1948.

*Matisse*. New York: H. N. Abrams, 1953.

*Art and Culture: Critical Essays*. Boston: Beacon Press, 1961.

*Hans Hofmann*. Paris: Georges Fall, 1961.

### Translations from the German

*The Brown Network: The Activities of the Nazis in Foreign Countries*. Introduced by William Francis Hare. New York: Knight Publications, 1936.

With Emma Ashton and Jay Dratler. Manfred Schneider, *Goya: A Portrait of the Artist as a Man*. New York: Knight Publications, 1936.

Franz Kafka. "Josephine, The Songstress: Or, the Mice Nation." *Partisan Review* 9 (May-June 1942): 213–28.

With Willa and Edwin Muir. Franz Kafka, *Parables*. New York: Schocken Books, 1947.

With Willa and Edwin Muir. Franz Kafka, *The Great Wall of China: Stories and Reflections*. New York: Schocken Books, 1948.

Paul Celan. *"Fugue."* *Commentary* 19 (March 1955): 242.

## Works on Greenberg

Most of the literature on Greenberg dates from the appearance of *Art and Culture* in 1961. Before then Greenberg's criticism was not subjected to any sustained analysis, at least not in print, although it was referred to with increasing frequency in articles and books. The fullest attention it received was in several reviews that followed the publication of *Joan Miró* in 1948, in George L. K. Morris's article of the same year, and in Alfred H. Barr, Jr.'s book on Matisse in 1951.

*Art and Culture* thus marked a shift in the kind of critical attention paid to Greenberg's work. The book seems to have clarified the extent to which his writings were informed by a developed theory of modern art and the extent to which he understood the practice of art criticism to be marked by peculiar limits and constraints that reflected the peculiar limits and constraints of its subject. In short, it clarified what he meant by modernism. Since 1961 most of the extensive discourse on Greenberg's critical practice has dealt with the implications of his modernist stance. The following list of selected secondary sources reflects this interest.

Barr, Alfred H., Jr. *Matisse: His Art and His Public*. New York: Museum of Modern Art, 1951.

Brook, D. "Art Criticism: Authority and Argument." *Studio International* 180 (September 1970): 66–69.

Calas, Nicolas. "The Enterprise of Criticism." *Arts Magazine* 42 (September-October 1967): 9.

Carrier, David. "Greenberg, Fried, and Philosophy: American-Type Formalism." In *Aesthetics: A Critical Anthology*. Edited by George Dickie and R. J. Sclafini. New York: St. Martin's Press, 1977.

Cavaliere, Barbara, and Robert C. Hobbs. "Against a Newer Laocoon." *Arts Magazine* 51 (April 1977): 110–17.

Clark, T. J. "Greenberg's Theory of Art." *Critical Inquiry* 9 (September 1982): 139–56.

———. "Arguments About Modernism: A Reply to Michael Fried." In *The Politics of Interpretation*. Edited by W. J. T. Mitchell. Chicago: University of Chicago Press, 1982–1983.

Crow, Thomas. "Modernism and Mass Culture in the Visual Arts." In *Modernism and Modernity*. Edited by Benjamin H. D. Buchloh, Serge Guilbaut, and David Solkin. Halifax, N.S.: Press of the Nova Scotia College of Art and Design, 1983.

Curtin, Deane W. "Varieties of Aesthetic Formalism." *Journal of Aesthetics and Art Criticism* 40 (Spring 1982): 315–26.

Dorfman, Geoffrey and David. "Reaffirming Painting: A Critique of Structuralist Criticism." *Artforum* 16 (October 1977): 59–65.

Foster, Stephen C. *The Critics of Abstract Expressionism.* Ann Arbor, Mich: UMI Research Press, 1980.

Frascina, Francis, ed. *Pollock and After: The Critical Debate.* New York: Harper & Row, 1985.

Fried, Michael. Introduction to *Three American Painters: Kenneth Noland, Jules Olitski, Frank Stella.* Exhibition catalogue. Cambridge, Mass.: Fogg Art Museum, 1965.

————. "How Modernism Works: A Response to T. J. Clark." *Critical Inquiry* 9 (September 1982): 217–34.

Goldwater, Robert. "The Painting of Miró." Review of *Joan Miró*, by Greenberg. *The Nation* 168 (26 February 1949): 250–51.

Guilbaut, Serge. "The New Adventures of the Avant-Garde in America." *October* 15 (Winter 1980): 61–78.

————. *How New York Stole the Idea of Modern Art: Abstract Expressionism, Freedom and the Cold War.* Chicago: University of Chicago Press, 1983.

Halasz, Piri. "Art Criticism (and Art History) in New York: The 1940s vs. the 1980s; Part Three: Clement Greenberg." *Arts Magazine* 57 (April 1983): 80–9.

Harrison, Charles, and Fred Orton. Introduction to *Modernism, Criticism, Realism: Alternative Contexts for Art.* New York: Harper & Row, 1984.

Hess, Thomas B. "Catalan Grotesque." Review of *Joan Miró*, by Greenberg. *Art News* 47 (February 1949): 9.

Higgens, Andrew. "Clement Greenberg and the Idea of the Avant-Garde." *Studio International* 183 (October 1971): 144–47.

Hoesterey, Von Ingeborg. "Die Moderne am Ende? Zu den ästhetischen Positionen von Jürgen Habermas und Clement Greenberg." *Zeitschrift fur Ästhetik und allgemeine Kunstwissenschaft* 29 (1984): 19–32.

Kees, Weldon. "Miró and Modern Art." Review of *Joan Miró,* by Greenberg. *Partisan Review* XVI (March 1949): 295–97.

Kozloff, Max. "A Letter to the Editor." *Art International* 7 (June 1963): 89–92.

————. "The Critical Reception of Abstract-Expressionism." *Arts Magazine* 40 (December 1965): 27–33.

Kramer, Hilton. "A Critic on the Side of History: Notes on Clement Greenberg." Review of *Art and Culture*, by Greenberg. *Arts Magazine* 37 (October 1962): 60–63.

Kroll, Jack. "Some Greenberg Circles." Review of *Art and Culture* and *Hans Hofmann*, by Greenberg. *Art News* 61 (March 1962): 35, 48–49.

Kuspit, Donald B. *Clement Greenberg: Art Critic.* Madison, Wis.: University of Wisconsin Press, 1979.

————. "The Unhappy Consciousness of Modernism." *Artforum* 19 (January 1981): 53–57.

Morris, George L. K. "On Critics and Greenberg: A Communication." *Partisan Review* XV (June 1948): 681–85.

Natapoff, Flora. "The Abuse of Clemency: Clement Greenberg's Reductive Aesthetic." *Modern Occasions* 1 (Fall 1970): 113–17.

Orton, Fred, and Griselda Pollock. "*Avant-Gardes* and Partisans Reviewed." *Art History* 4 (September 1981): 305–27.

Ratcliff, Carter. "Art Criticism: Other Eyes, Other Minds: Clement Greenberg." *Art International* XVIII (December 1974): 53–57.

Reise, Barbara M. "Greenberg and The Group: A Retrospective View." *Studio International* 175 (May-June 1968): 254–57, 314–16.

Sandler, Irving. *The Triumph of American Painting: A History of Abstract Expressionism*. New York: Praeger, 1970.

Shapiro, David and Cecile. "Abstract Expressionism: The Politics of Apolitical Painting." *Prospects* 3 (1977): 175–214.

Stadler, Ingrid. "The Idea of Art and of Its Criticism: A Rational Reconstruction of a Kantian Doctrine." In *Essays in Kant's Aesthetics*. Edited by Ted Cohen and Paul Guyer. Chicago: University of Chicago Press, 1982.

Steinberg, Leo. *Other Criteria: Confrontations with Twentieth-Century Art*. New York: Oxford University Press, 1972.

# Chronology to 1949

### 1909
January 16. Clement Greenberg born in the Bronx, New York City, oldest of the three sons of Joseph and Dora (Brodwin) Greenberg. His younger brothers are Sol and Martin.

Both parents were born into the Lithuanian Jewish cultural enclave, his father in White Russia in 1881, and his mother in northeastern Poland in 1886. They came to the United States, in their separate ways, in 1900 and 1899, and were married in 1907. In politics they were free-thinking socialists. Their culture included Italian opera and Russian novels; at home they spoke Yiddish for a long while.

### 1914–1925
In 1914 the family moved from New York City to Norfolk, Virginia, where Joseph Greenberg was a storekeeper (clothing).

In 1920 the family returned to New York City, this time to Brooklyn, where Joseph Greenberg changed occupations to manufacturer (metal goods).

Clement Greenberg attended high school in Brooklyn, first at Erasmus Hall and then at the Marquand School where he combined the last two years in one.

March–May 1925. Enrolled in Richard Lahey's life drawing class at the Art Students League.

### 1926–1930
Fall 1926. Entered the freshman class at Syracuse University, N.Y., and studied languages and literature. In addition to French and Latin, learned in high school, studied German and Italian.

Spring 1930. Graduated with an A.B.

### 1931–1932
Worked at home in New York City, continuing to study languages and literature, writing poetry and short stories (unpublished).

### 1933–1934
Employed by his father in a family venture into the wholesale dry-goods business; worked in St. Louis, Cleveland, San Francisco, and Los Angeles.

30 March 1934. Married Edwina Ewing in San Francisco; in 1935 had a son Daniel; in 1936 was divorced.

1934. Published a magazine adventure story; in 1936 published another story.

## 1935–1936

For Knight Publications, New York, translated from the German *The Brown Network: The Activities of the Nazis in Foreign Countries*; collaborated on the translation of *Goya: A Portrait of the Artist as a Man*, again from the German.

Beginning of 1936. Became employed as a clerk, first in the United States Civil Service Commission, New York City, then briefly in the Veterans Administration, New York City.

## 1937–1938

1937. Took a job with the United States Customs Service, Appraiser's Division, in the Port of New York, Department of Wines and Liquors. Remained with the department until late 1942.

Began drawing regularly from live models with Igor Pantukhov (at the time a close friend of Lee Krasner) at a WPA studio in the west Twenties. Attended three lectures by Hans Hofmann at his school (1938–1939 academic year). "Hofmann has not yet published his views [on modern art]," Greenberg wrote, "but they have already directly and indirectly influenced many, including this writer—who owes more to the initial illumination received from Hofmann's lectures than to any other source" (1945).

Introduced by Harold Rosenberg and Lionel Abel to the circle of writers around *Partisan Review*, notably Dwight Macdonald.

## 1939

Published first article in the winter issue of *Partisan Review*—a review of *A Penny for the Poor* by Bertolt Brecht. Greenberg had encountered Brecht's work in the early 1930s and had written (but not published) on it previously.

April–June. Traveled for the first time to Europe—England, France, Italy and Switzerland. In Paris introduced to Paul Eluard, Jean-Paul Sartre, Georges Hugnet, Virgil Thomson, Jean Arp and his wife Sophie Taeuber, and Hans Bellmer by Sherry Mangan, who was *Time* magazine's correspondent in Paris. In Zurich interviewed Ignacio Silone for the fall *Partisan Review*.

Also in the fall issue of *Partisan Review*, published "Avant-Garde and Kitsch." The essay had been worked on extensively before the trip to Europe; Dwight Macdonald read and commented on a preliminary draft.

## 1940–1941

January 1940. Became an editor of *Partisan Review*; other editors at that time were F. W. Dupee, Dwight Macdonald, George L. K. Morris, William Phillips, and Philip Rahv. First published in *The Nation* on 19 April 1941—a review of exhibitions of Miró, Léger and Kandinsky.

## 1942

In 1940 and 1941 published mainly on literature, in 1942 mainly on art. With the March 7 issue of *The Nation* became the magazine's regular art critic, a position held until late 1949.

In May–June issue of *Partisan Review*, published a translation of Kafka's "Josephine, The Songstress: Or, the Mice Nation." Continued to translate Kafka's short stories and essays for publication until 1948.

Late 1942. Resigned from the United States Customs Service and from the editorial board of *Partisan Review*. At about the same time was introduced to Jackson Pollock by Lee Krasner.

## 1943

February 1943. Joined the U.S. Army Air Force. In September was honorably discharged for medical reasons.

October 1943. Resumed writing for *The Nation*.

## 1944–1945

Fall 1944. Became managing editor of *Contemporary Jewish Record*, published by the American Jewish Committee. In June 1945 the magazine stopped publishing and was incorporated into *Commentary* (first issue, November 1945). Greenberg became associate editor of *Commentary*, a position he held until fired in 1957.

## 1946–1947

Fall 1947. Started to write occasional book reviews for the *New York Times Book Review*.

1 December 1947. Ridiculed in *Time* magazine for having declared in the October *Horizon* that Jackson Pollock was "the most powerful painter in America" and that David Smith was the only "major" sculptor in America.

## 1948–1949

1948. Wrote and published first book, *Joan Miró*, and wrote a series of longer articles for *Partisan Review*. In 1949 continued to concentrate on longer articles for *Partisan Review*.

11 October 1948. Appeared in *Life* as a "distinguished critic" in a round-table discussion on modern art.

25 November 1949. Resigned as regular art critic for *The Nation*.

Reflecting on his critical activities in the 1940s, Greenberg wrote that he had had "a belly-full of reviewing in general. . . . Art criticism, I would say, is about the most ungrateful form of 'elevated' writing I know of. It may also be one of the most challenging—if only because so few people have done it well enough to be remembered—but I'm not sure the challenge is worth it" (*Twentieth Century Authors*, 1955).

John O'Brian

# Index